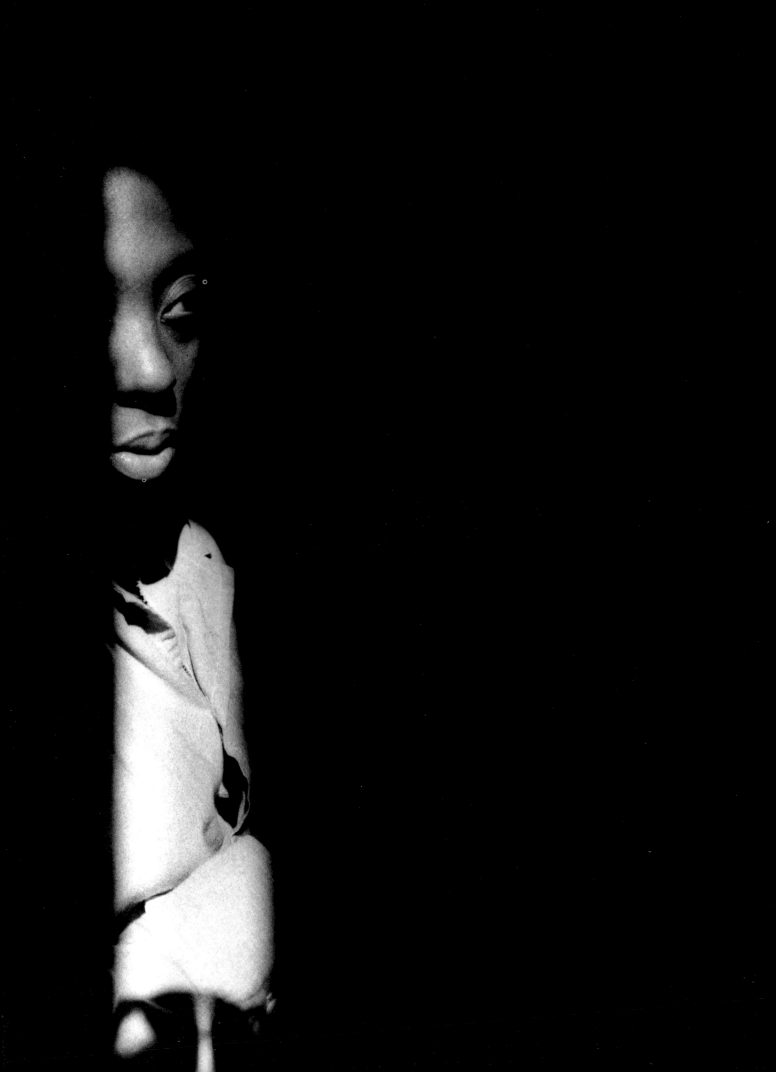

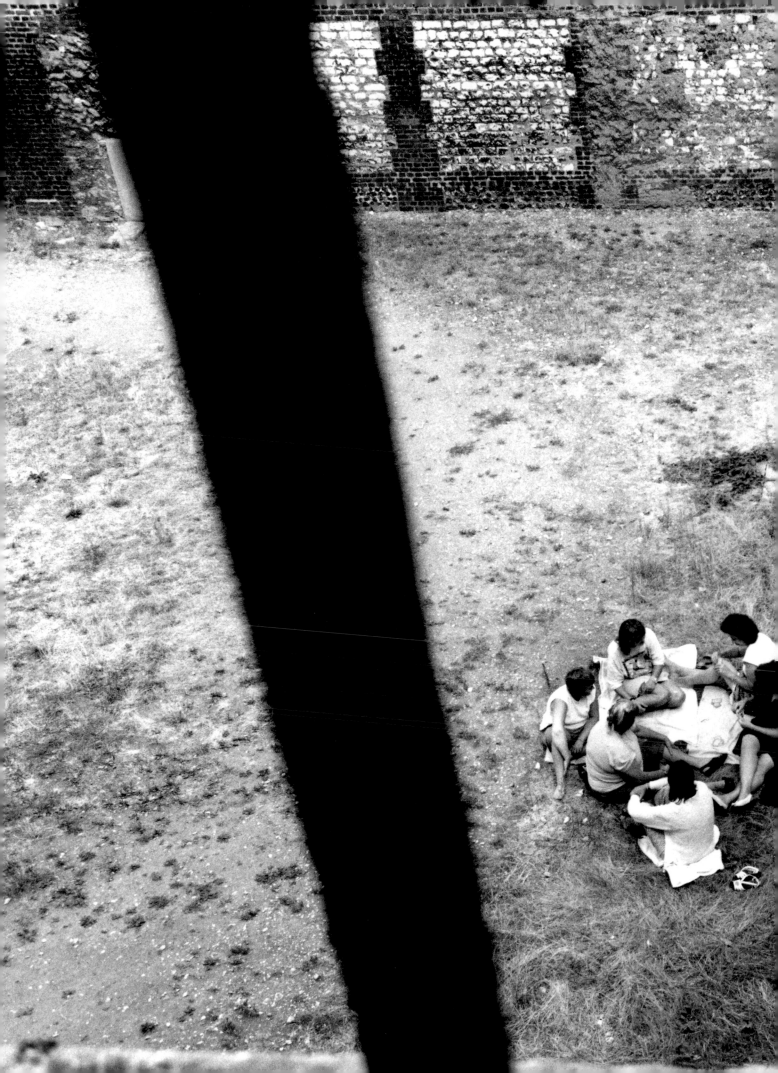

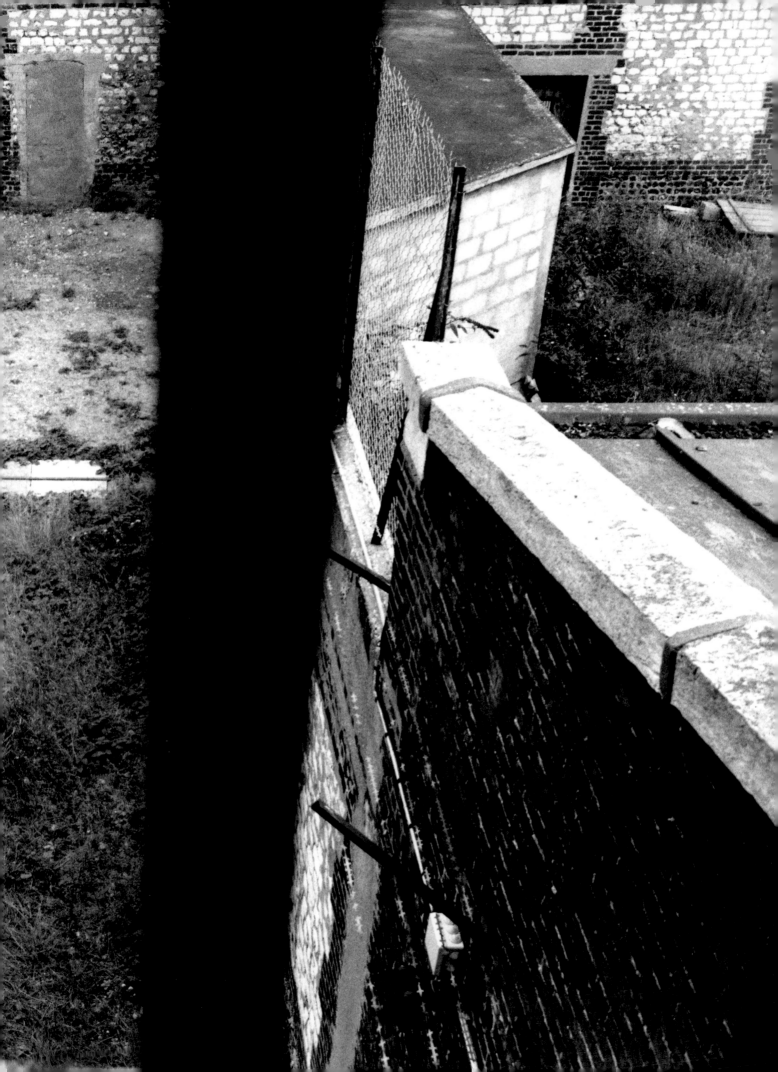

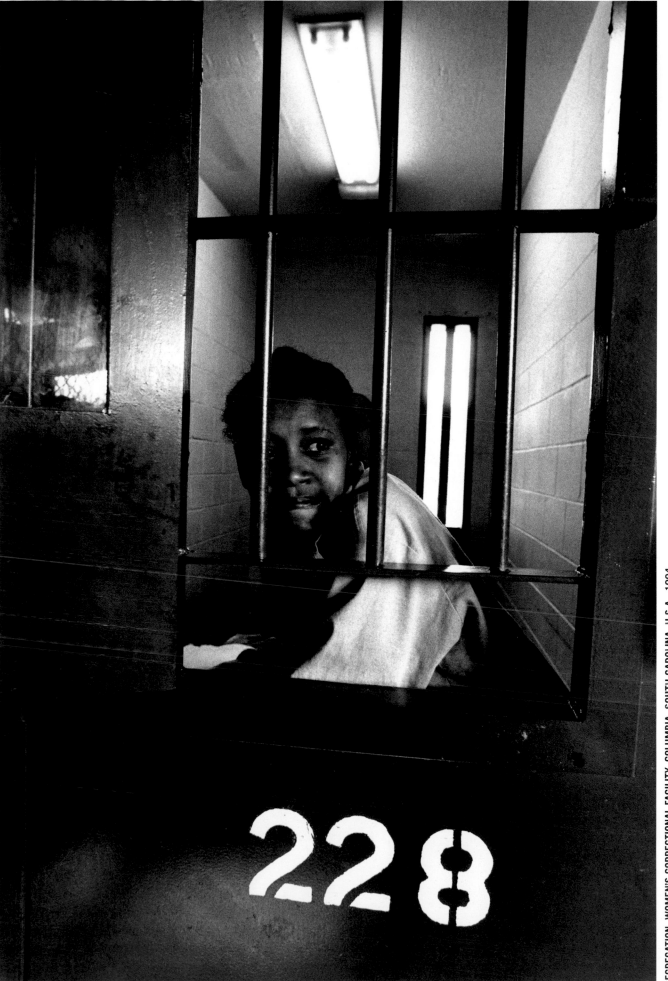

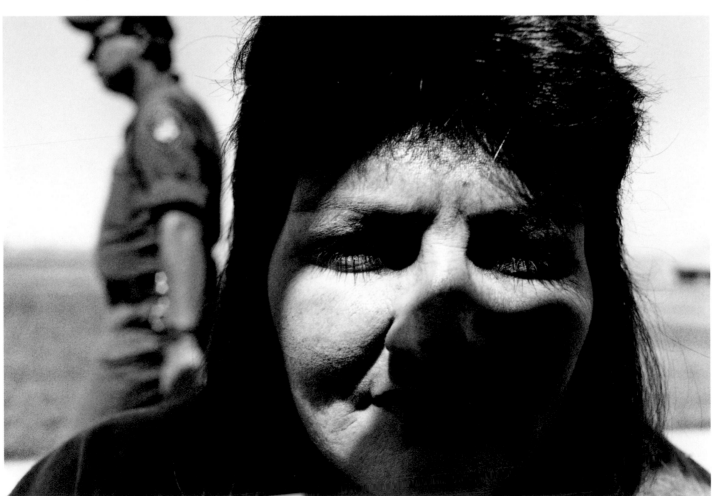

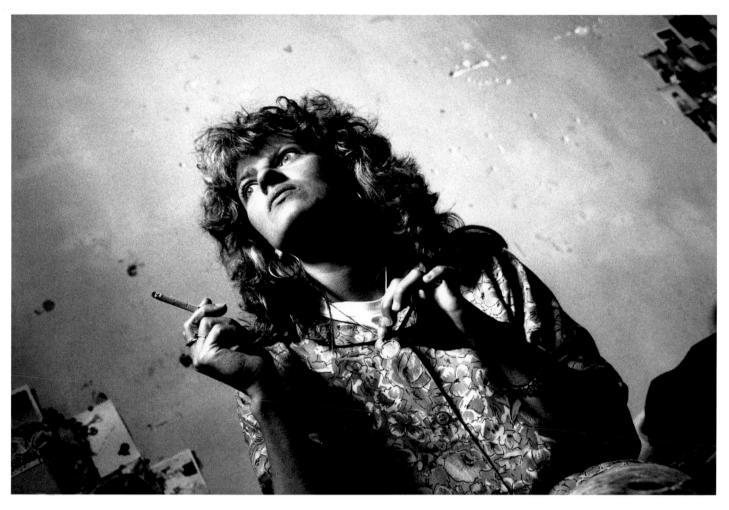

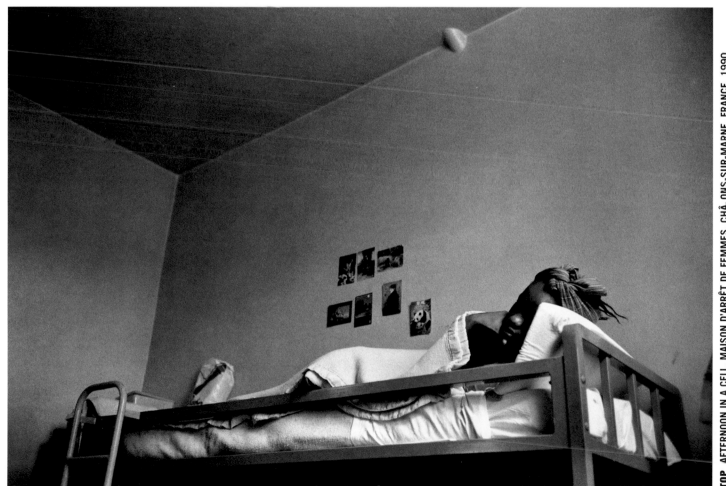

TOP AFTERNOON IN A CELL. MAISON D'ARRÊT DE FEMMES, CHÂLONS-SUR-MARNE, FRANCE, 1990.
BOTTOM PRISONER ASLEEP IN HER CELL IN THE MIDDLE OF THE DAY. MAISON D'ARRÊT DE FEMMES, VERSAILLES, FRANCE, 1991.

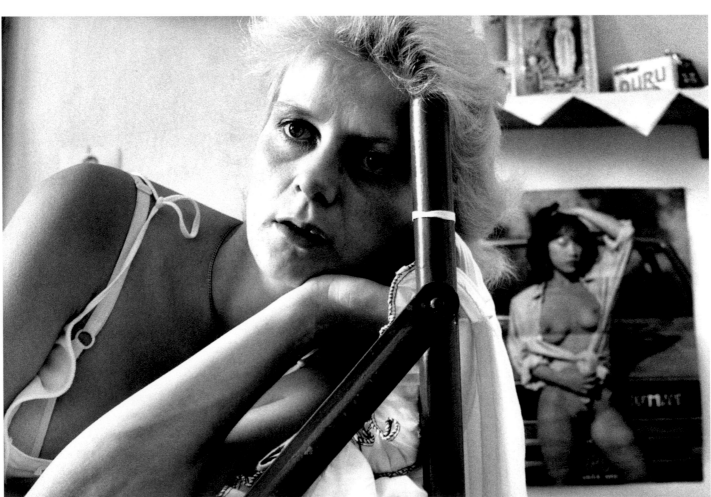

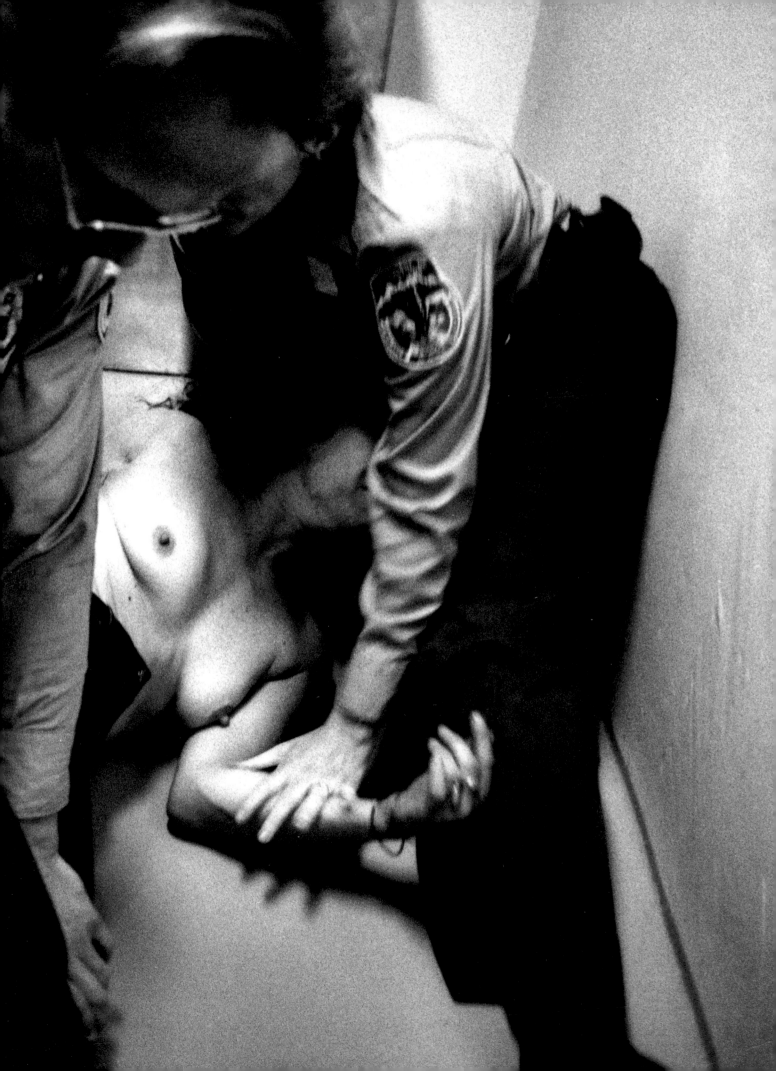

A SEGREGATION CELL

A string of low-slung wooden buildings surrounded by tall trees nestles in the woods of Eagle River, a half hour's drive from Anchorage, Alaska. Even from close up, the Meadow Creek Correctional Center could be mistaken for a university campus. It houses fifty-nine women prisoners and, on the "other side," roughly four hundred men.

The segregation cell I slept in was inside the prison, but isolated from the rest of the population. Before entering, I was required to sign a paper promising not to sue if I slipped on a banana peel. They even put a telephone in the cell with a direct line to the main control booth, in case of emergency.

The toilet and the sink, a dull stainless steel, jutted out from the wall inside the cell. The shower opposite was a spout above, a drain below. No curtain. The faucet on the sink was the kind used in airplanes: you had to hold it down with one hand and wet your other hand with the dribble that ran out. You never got your hands really rinsed. The toilet didn't have a seat. They never do in seg cells: nothing is allowed that might be used as a weapon. The bed was heavy steel, fastened to the floor. No mattress, but the prison gave me one, since I would be living there for a week.

There weren't any windows, and it was impossible to know what was going on outside, whether it was sunny or rainy, day or night. The only sound was the ringing in my ears from the silence. On Sundays, just two meals were served: brunch and dinner. If I missed brunch that was it until night. That Sunday I woke up suddenly, wide awake, wired. I looked at the clock. It was 9:15. I'd overslept! I slammed out of bed and under the shower. Ten minutes later I was ready to ring for the corrections officer to come and let me into the dining room, where the women would be helping themselves to pancakes, waffles, scrambled eggs, and bacon. They'd be piling the doughnuts on the plastic trays to save for later. Some of them would have their hair in rollers, plastic ones that were green or pink. Janine would be running her mouth and Pearl would be taunting her, "Yeah? Yeah!"

While I was waiting in the holding area outside the cell I realized something was wrong. I could see through the door slot. No one was in the dining room. It was dark. At first I thought I'd missed brunch after all. But the room was never completely empty—someone should still be there. I went back inside and looked at the clock. It said 3:10 A.M. I'd read it wrong; it hadn't been a quarter past nine, but a quarter to three.

I undressed and got back into bed and lay there in the black dark, wet hair clinging to my neck. Pulling the synthetic blanket up around my shoulders, folding the scratchy sheet down over it, I thought about all the women in prisons around the world. Women who had no sense of time, locked up in cells where they couldn't see.

JILL ACCREDITATION MANAGER

I concluded a long time ago that a majority of the women here are primarily guilty of bad taste in men and sometimes not much else. There's two kinds, there's your violent and nonviolent offenders. First you have to understand that even the violent offenders aren't violent. Because women don't kill strangers. Women don't kill people in the commission of a crime like men do. That's why you see no female serial killers. You don't see women going into a liquor store and robbing it and blowing away the clerk in the process. Women just don't do that. Women kill people who are hurting them or their children—almost 100 percent of the time. In the ten and a half years I've worked with these women, I've seen only three who hurt somebody who wasn't really close to them.

Then there are your nonviolent offenders: your check writers, your credit card forgers, your drug charge people. Even the ones here for credit cards or check writing are usually addicted to drugs. In addition to their own habit, they're supporting some guy's habit, too, taking care of some guy who's depending on her to get out and sell her body in order to support his drug habit, also. Then you have the ones that were with a guy, just coincidentally, maybe without having any idea that he has criminal intent. Like this story: Two couples in a car drive up to a motel "to get cigarettes." The two guys jump out of the car and kill the desk clerk after trying to rob her. The two girls had no idea what the guys were doing in there yet they were convicted and given life sentences. The guy who actually did the shooting got the death penalty. The other one got a lesser sentence than the females (fifteen years) because he agreed to testify. So he is probably

PRECEDING PAGES CORRECTIONS OFFICERS STRIP A NEWLY ARRESTED WOMAN WHO TRIED TO COMMIT SUICIDE BY SWALLOWING HER OWN CLOTHES. MALE CORRECTIONS OFFICERS WERE CALLED ONLY WHEN WOMEN GUARDS PROVED INCAPABLE OF HANDLING THE SITUATION. WILDWOOD PRE-TRIAL FACILITY, KENAI, ALASKA, U.S.A., 1993.

OPPOSITE, TOP THE YARD. MAISON D'ARRÊT DE FEMMES, "LES BAUMETTES," MARSEILLES, FRANCE, 1991.

OPPOSITE, BOTTOM PRISONER SERVING A MAXIMUM SENTENCE FOR KILLING HER HUSBAND WHO SHE SAID ABUSED HER FOR YEARS: "I DIDN'T REALLY WANT TO KILL HIM, I SAW NO OTHER WAY OUT. I SHOT HIM AS HE SLEPT AND HE ROSE UP OUT OF THE BED. I SHOT HIM AGAIN, HE ROSE UP AGAIN, I SHOT HIM AGAIN, HE ROSE UP AGAIN AND CHASED ME DOWN THE STAIRS AND OUT INTO THE STREET, HIS GUTS HANGING OUT. IT WAS FOUR O'CLOCK IN THE AFTERNOON. I HID AT MY NEIGHBOR'S HOUSE AND WHEN THE POLICE CAME, NOT KNOWING THE SITUATION, THE OFFICER SAID TO ME, "DON'T WORRY, WE'RE DOING EVERYTHING WE CAN TO SAVE YOUR HUSBAND." I WILL SERVE EIGHTEEN YEARS. MY TWO SMALL CHILDREN ARE WITH MY MOTHER. I WON'T SEE THEM DURING MY INCARCERATION. I WAS SORRY IT HAD COME TO THAT—BUT WHEN I GET OUT, I'LL BE AT PEACE FOR THE FIRST TIME BECAUSE I'LL KNOW THAT HE CAN'T HARM ME EVER AGAIN, ANYMORE." MAISON D'ARRÊT DE FEMMES, ROUEN, FRANCE, 1990.

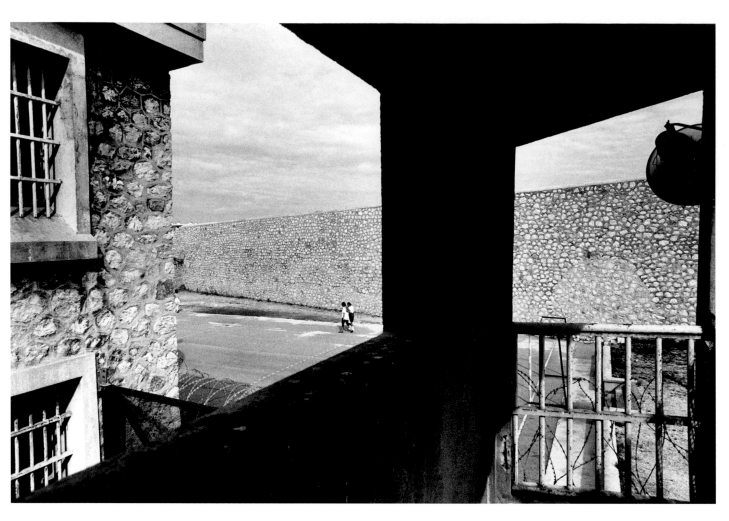

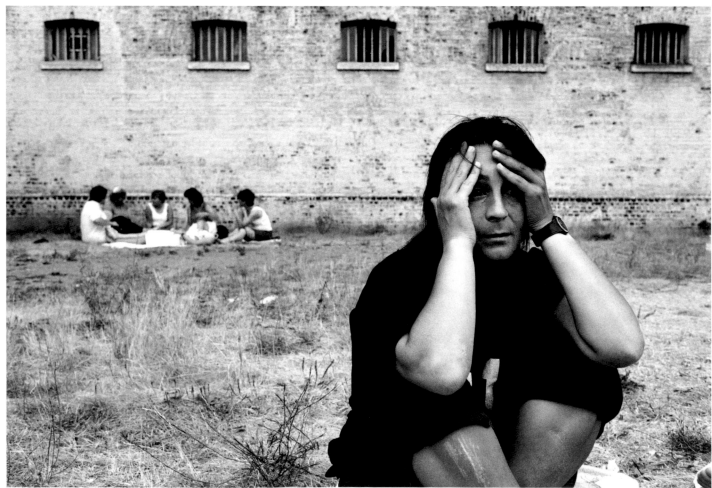

already out by now, but his girlfriend is serving life.

If a man kills a man, and there's a woman involved and they're both convicted of murder, frequently she gets more time than the man does. Very often the prosecutors seem to pursue the woman. We have observed over the years that many women here have male "charge partners" (two people charged with the same crime) and every day some woman will say, "Well, he got out and I'm still here." We get an annual report the department puts out each January with statistics from the prior year and the figures in there bear that out. The reality is that men tend to get shorter sentences. There's this idea that it's okay for men but not okay for women to be involved in criminal acts. We're all supposed to be home, barefoot and pregnant, cooking and cleaning and taking care of the babies, and therefore the penalties are harsher for women.

There is a range of sentencing for most crimes and often it's up to a judge (usually a forty- to seventy-year-old white male—90 percent of the judges in the state fit that description). And very often the defense attorneys will tell a male defendant, "You don't stand a prayer, you're gonna end up getting life or the death penalty, so accept a plea bargain for a lesser number of years." But they'll tell the woman, "Oh, you're a woman, you'll get off, it's no problem if you go to trial, because I'm such a great and wonderful lawyer I'm gonna make sure that you don't get convicted." But the judge will pursue the female if it's a crime that has both sexes involved. With women in violent crimes, you are usually dealing with someone who has no prior record, no experience with the criminal justice system, and knows absolutely nothing about the courts and legal procedures, so all she can do is look to her attorney to advise her. And if he tells her, don't accept a plea bargain, inevitably she ends up getting the full amount of time, life, or even, in some cases, the death penalty.

One case was of a woman who had worked and supported herself since she was fourteen years old, and did not have so much as a traffic ticket. No record of any kind of criminal activity. She had one child that she had raised. She owned her own home. Had always been employed, never been on welfare. I mean, just a good, good woman. This woman had a long-term, common-law relationship. He had a serious drinking problem. He had started beating her severely, and she put him out of her house. She put him out of the house again, and finally went to court, got a restraining order. And he kept getting drunk and coming back to harass her and to beat on her again. I have personally observed the records from the police department of the numerous times she called and asked for their help in keeping him off. The police just chalked it up as another domestic dispute and said there was nothing they could

do; they did not intercede. But there is a list of the many, many calls she made to them, trying to get their help.

Finally one night, she was in bed asleep in the wintertime, and she'd been out chopping wood for her fireplace; that's how she heated her house. And she had leaned the ax up against the fireplace in the living room, and went to bed. Her husband came in, broke into the house, surprised her, and started beating on her. She was able to get to her feet, and the struggle continued into the living room. He kept telling her he was gonna kill her, and at one point he saw the ax next to the fireplace and picked it up and they wrestled over it. She got it away from him and knocked him in the head with it. He was laying on the floor with his head bleeding, and because she didn't have a telephone, she ran next door and used a neighbor's phone to call an ambulance. He died a few days later from the head injury and she was arrested.

Her lawyer was a man who is now a state senator, appointed by the court to represent her. The D.A. offered her a plea bargain to a reduced charge of second-degree murder, which means she would've been out of prison within two or three years. Her lawyer strongly advised her not to accept, as he was certain that if they went to trial, she could be acquitted. She knew no better—she did what the lawyer thought best. He insisted that the best thing for her to do was to go to trial, where they would see that she was not responsible, and she would be acquitted. She was convicted of first-degree murder and given a life sentence. I have a signed affidavit by this state senator in her file, attesting to all these facts. And when this lady went to the parole board and applied for clemency and was approved by the parole board hands down, it went to the governor's office—and sat on his desk for five years. About three years into that process she got a letter from the governor's head counsel that said, "Don't worry, we haven't forgotten about you, we'll be making a decision very soon so keep your head up." A "don't-worry be-happy" letter. And then two years later, she gets a turn-down letter from the governor. Six months after that, she died.

Now it's been accepted for years for men to kill women. That's a common thing. Some people are even still in the old thing of whatever it takes to keep her in line is valid for a man to do. There's still a lot of that kind of attitude, unfortunately, particularly in your more rural areas and your poor areas. But God forbid if a woman strikes out in any way at a man! She's not allowed to do that—he's her master.

Jackie is a woman who grew up in a middle-class family, where her parents both worked and gave the kids everything. They just led an exemplary life, and never had been involved in any kind of criminal activity. She married the guy from the wrong side of the tracks and proceeded to have three kids by him. He became a very heavy drinker

and she fell into the drinking habit with him and she also became an alcoholic. They separated at some point. Now Jackie was a binge drinker, she wasn't an everyday drinker. She was able to maintain a job, take care of the kids, but she would binge drink on the weekends and not know what she was doing. She always left the kids with her sister, though, who took good care of them. The ex-husband, the father of the kids, came back into her life at some point and she was desperate for money. They were out drinking together one weekend and she told him, "I've got to have some money, something is coming up, the rent is due," or something. And she had gone out with some other guy there in town a few times and he said, "What about so-and so, down at the bar, doesn't he usually carry a lot of money?" And she agreed that he was a big spender. Her husband said, "I'll tell you what, let's go down to the bar and you go and talk to him, I'll wait out in the parking lot, you get him out in the parking lot and I'll come up behind him so he won't know who it is and I'll knock him down and take his wallet." Now she knew what she was doing, but she was drunk. She goes into the bar, lures the guy outside, and then she goes and gets in her car and leaves as soon as he comes out, goes to her sister's house where her children are and she is so drunk that her sister won't let her drive home with the kids but instead puts her to bed. She is there all night. And the police come to the door the next morning looking for her because her ex-husband and the guy got into a scuffle in the parking lot and he killed the guy. So they arrest Jackie, and charge her with exactly the same crime as the ex-husband.

True, she was guilty of setting this guy up for robbery, I've got no problem with that. But she is charged with murder, though she had no intent to kill anybody. Had she known that he intended to harm the guy, I don't think she would have been involved. The point is she didn't—and everybody believed her. She wasn't even there, it wasn't even like she was sitting there in the car. It was proven by her sister's entire family that she was at home in bed sleeping when the murder actually occurred.

Jackie had a smart attorney that played that difference up, got her to turn state's evidence on the ex-husband and got a lesser sentence. Twenty years or something. And she was able to plea-bargain. In fact, she actually became eligible for parole about six or eight months ago and it's rare in a violent crime for anybody to make parole on the first try. But Jackie was such an incredible person. She had been working for me, helping with all the files, staying late at night, coming in on the weekends, and all this for three dollars a day, which is what they get paid for these jobs. Three dollars a day is maximum pay. So I agreed to go to the parole board with her. Her whole fami-

ly was there (that's when I met them), they were just lovely people. At the parole board we had the hearing officer in tears by the time it was over. Jackie was crying, her family was crying, I was crying, the whole room full of people was crying. This lady voted for parole for Jackie but it had to go back downtown among the other board members (because you have got to have three out of five votes in order for it to carry). Downtown the others saw how serious the charge was and so they put her off for two years. Meanwhile, we rewarded her behavior by sending her downtown to work. That meant she was living at the annex and working downtown in the Department of Corrections central office. She wore street clothes instead of a uniform. Everybody down there thought she was the greatest thing because she just did everything and was so sweet and such a nice person. One of the perks that goes with working out there is to get these weekend passes— once a month they are allowed a sixteen-hour pass. Jackie's family would drive down, take her back home for the day, and then bring her back in the evening. One day when she was taking a Sunday pass, the victim's family saw her at church. They called the next day, raised almighty hell and we were ordered to pull her back in. I've never heard of that happening with a man, let me put it that way.

In your larger cities, occasionally you see racism. But in your small towns, your rural areas, you see an enormous amount of racist attitude. Lynn is a good example. A prostitute from New York, she came to a small town in a car with two men who robbed a drug store. But she was there, so obviously she was a participant and deserves some prison time. Two people were shot and neither died, and the men were the shooters, certainly not the woman, and that's a known fact. There was nothing that said she did the shooting; there were plenty of witnesses. The men that were with her were all plea-bargained. One escaped before he was convicted and was never found; the one that did the shooting plea-bargained down to ninety-nine years. She got life (which is far more than ninety-nine years) plus 150 years to serve even if she managed to make it through that life sentence. Nobody, nobody can outlive a sentence like that. But here she is, a black hooker from New York, in, God forbid, a small town. Racial prejudice, and the fact that she admitted to being a prostitute, adds another layer of prejudice, because we're in the buckle of the Bible Belt here. People down here don't trust Yankees and they don't trust black people, and they don't trust hookers, certainly, because they're seen as criminals. So she had three strikes against her right from the beginning.

Women go with sleazy guys because they have no self-esteem, they don't like themselves. These are women that

probably came out of homes where there was abuse and neglect, and they didn't feel loved, they didn't feel attractive, they didn't feel worthy. They felt like doormats. And that just naturally carried over into their adult relationships. They feel like dirt so they act like dirt. I've talked to previous wardens and a lot of people that I respect in this business, who all say that the number one problem with women in prison is lack of self-esteem. That's what gets them here. And it's a lifelong problem for most of them.

Inside the jail women act differently than men. They certainly don't act out violently like the men do—it's a whole different atmosphere. The women act out by whining and crying, running their mouths a lot, playing verbal games and that kind of thing. They don't run up and stab another inmate in the back or beat up on people. We've never had a violent encounter between inmates—unless it's from an inmate that thinks she's a man, in some kind of lovers' quarrel. But women just don't act out like men do, so as a result we get more lax about some things that men wouldn't be allowed to have. Women don't try to make zip guns and knives; that's a rare thing for a female inmate to do. The women are more concerned about their surroundings, about the furnishings and the decor and what they're allowed to have in their room in terms of their comfort: decorative items, pictures of their family, things hanging on the wall, craft items. Guys aren't. But because women are such a small percentage of the total population of the Department of Corrections, the department continues to write the rules based on the needs of a male population. There's only one separate policy for female offenders in the whole policy manual, and that's for health services. And that is a separate policy simply because they had to include provisions for maternity care and for some gynecological services. If it hadn't been for that, there probably wouldn't be any policies written separately for females.

A good example is medical care. There was a really good study in the military of the difference in health care costs for males and females over a period of several years. Providing basic medical care for females is 25 percent more expensive because women have more things that can go wrong physically in their reproductive organs than men do. Yet we are not allocated one penny more to our population than the male prisons are—yet women in here are having babies every day. Why are we not given more money for medical care? About 50 percent of our women have active venereal disease of one type or another. These women have engaged in prostitution over a long period of time, usually to support drug habits. Some had multiple diseases: syphilis, gonorrhea, and maybe hepatitis and AIDS, too. Some of these women have just not had any health care at all. We get them in pregnant all the time—

stone-cold junkies who are pregnant. And the bills are enormous in those kind of situations, and we have to pay. Yet our budget for health care is exactly the same as the men.

Clothing is not something that's up to the institution. The uniform, and what is allocated to each inmate, is decreed by departmental policy, not by the individual institution. Most of those things are male-oriented. Only in the last few years has an exception been made to allow the women to wear denim wraparound skirts instead of jeans. Some women aren't comfortable in pants, have never worn pants. Those steel-toed work boots? Those are decreed by the department. They wear these big old clunky, horrible, heavy work boots when they work in the kitchen or the warehouse. A woman who weighs ninety-eight pounds and walks around in shoes that weigh about six pounds apiece is going to have a hard time just walking. She is going to be exhausted before her shift is half over just because of the effort to lift her feet in those boots. For the majority of these women, there's no way you can feel really feminine in jail uniforms. That's why you'll see all these shirts with lines and creases in them. That is their only way of expressing their individuality, to take their shirts and do all these intricate spiderweb patterns with the iron. We've even had contests on shirt creases, to see who can come up with the most innovative design.

Clothing is totally dictated by policies that are written for men. In the wintertime, we allow them to have some kind of hat, supposedly to cover their ears. But there's a big difference in the type of hat that most women would wear and the type of hat that men wear. And yet it's very specific in the policy that they have to be knit stocking caps and that's it. There's no other way. In the summertime it has to be a baseball cap. Wear what the guys wear or don't wear anything at all. They can't have nail polish, they can't have hair spray. Now, hair spray is real important to a lot of women. We actually have inmates who use spray starch to hold their hair in place because they'll go down here to the beauty shop (it's their once-every-three-month treat to get this really nice-looking hairstyle) and they have no way to hold it in place. Those kinds of things are more important to women.

Women are overlooked, they are excluded from programming, opportunities, vocational programs, academics. Education is important for people who can at least get a high school degree. There are some people that simply aren't educable like that, but they are capable of learning job skills. So I think vocational education needs to be a biggie. Most women who walk out of here with good job skills aren't going to come back. We have some good programs but not enough to go around.

There was a big outcry in the United States a while

back when the general public found out that inmates in prisons all over the country were taking advantage of Pell grants (low-income government grants to cover the cost of tuition and books). The only criteria was that you be financially needy. And certainly these inmates are, since none of them have income over $100 a month. We had plenty of colleges willing to provide teachers, but even if they provided the teachers for free (which most schools don't want to do) there was still the matter of books and various supplies the students would need. So prisons all over the country had been applying for Pell grants for the inmates. We had three or four college classes going every semester. And we had a number of inmates who obtained associate's degrees and were going on to get their bachelor's degree, when suddenly the federal government started hearing all this outcry from the general public that murderers and rapists and child molesters were getting Pell grants to go to college for free, and "I can't afford to send my kid to college, and I work all the time." And as a result, Congress passed a law that denied Pell grants to anyone who was incarcerated.

The sad part is that we know that educated people don't come back to prison. It's the people who get out and don't have an education or any salable job skills that come back. I've never yet seen a person who got their education here who then went back to the criminal activities that got them here in the first place. It just doesn't happen. The recidivism rate drops to almost nothing when they obtain a degree. The public doesn't realize what they've done. It hasn't done a thing to help them send their kids to college. All it has done is raise the number of criminals out there on the street.

BRENDA

I had all kinds of friends on the street, I knew all kinds of people. So one day I got home and got a phone call. I knew the person I was speaking with, and he said, "You wanna make some money?" And I was like, "Yeah, sure I wanna make some money." And he said, "Meet me at the mall." At that particular time, I had my godchild, so I took her to the babysitter and went on to meet this man. When I met him, he said, "Well, we got a little thing to do, and all you need to do is just knock on the door." And he gave me a gun, and there was another guy with a gun, younger than I was. At the time I was nineteen, and this boy, he was seventeen. The one who initially called me was, like, thirty. I didn't know much about him—or the other guy. I just know they were hustlers from the street. And my thing was more or less that I didn't wanna work; I wanted fast money.

So I just asked what was it involving and what were we

gonna be doing. And they was like, "Well, it's just a drug dealer, it's nobody, and I know they done got you, so we gonna get them." I was young and real naive then, and so I listened when he said, "Instead of just standing out there trying to sell crack, and stuff like that, you can make money real quick." And, he was like, "I know you've been robbed, so why don't you rob some people?" And I was like, "Mmmm, no." He said, "You won't have to do nothing but knock on the door. You won't be taking no risk." I said, "Well, no." But he just kept on talking about the money, then I'm looking at the car he drives and him not working. He just made it sound good. It just sounded like good easy money.

Still I was like, "Well, no one's gonna get hurt, right?" And he told me, "There's no bullets in the gun. Look, there's one bullet in each gun, the rest of the guns are blank, the rest of the chamber part is blank." So I said, "Okay, fine," left my car at the mall, and got in the truck with them.

When we got there, I knocked on the door. First a man came to the door, then a woman, then another man, and they were all acting real funny. So I was like, "Oh, I must have the wrong address," whatever. We had a box, and we took the box out the truck. The box was kinda heavy for me to hold; I couldn't hold it. And we told them the package went to the wrong house and we were bringing it to them 'cause it was addressed to their address. So when they opened the door, the thirty-year-old guy (my charge partner), hollered, "Everybody down!"

And already someone at the top of the stairs started shooting. That made me think right then it was already something going on illegal when we got there. He was shooting at the door, so I ran into the house, over to the side. My other charge partner, the one that was younger, he took off after another guy. They went to another room, I didn't even see what happened, but I did hear them run. The guy upstairs was shooting downstairs at me, so I shot up at him. I didn't realize I had one bullet; he was right when he said I had one bullet, 'cause I did have one bullet. But I was really trying to stay out of firing range of the man upstairs; he had a nine millimeter. He was shooting down at me. I had never been caught up in nothing like this. Then my charge partner, the young one, said, "On the count of three we're gonna run out the house." And I was just so scared, I almost just froze. But on the count of three we ran out the house.

I heard police sirens, I had heard them pretty much when the shooting began, when we went into the house. The other codefendant, he never did come in, he stayed at the truck; he was the driver. He had told us he was gonna come in behind us or whatever. He got life with parole. And once we got out we had to run to catch the truck. We ran and jumped in. I was scared to death. And while I was sitting there, I pretty much had my head down. And that's

when I noticed a lot of blood on my codefendant, the one that's younger, that was in the house with me. And at that time I got real scared. 'Cause it was like, he had a gun. I had a gun, but I knew nothing was in my gun. And I like realized, "Oh, they've done this many times together. And they know each other better than they know me." So I got scared. I was really scared, 'cause I didn't know what was gonna happen. I was just saying to myself, "What have you done? What have you got yourself into?" 'Cause when I seen all that blood I knew somebody got hurt, there was a lot of blood. But when we got back I just hurried up and ran to my car; they didn't do anything to me. They just said, "Don't tell nobody," or whatever.

I was pretty much sick the whole night, I went and picked up my godchild and went back home. I worked it out where I got her back to her mother, and I guess pretty much I was trying to prepare to just leave out of town 'cause my nerves were really bad. I really didn't know what to do. I don't know if it was a day or two later, I didn't call my parents, or anything like that. I did go by the house. I had a young sister at the time, and she said, "Girl, the police were over here—what have you done?" She was going off the deep end, so I was like, "Don't worry about it." And I left. I had gotten up enough money to leave town, and I was trying to hustle some more money so I could leave the state. I was coming back from this guy I was seeing, at like three in the morning. I had just told him I was gonna leave for a while. I wouldn't say why, just that I was gonna leave, I was in some trouble—you know.

Then I saw my father's car over on the side of the road, so the first thing I think is that someone's got my father's car. I tell my guy to pull over and soon's we pulled over, my daddy got out the car and my mother got out the car and my little sister got out the car. And my mother, she was crying. My daddy was crying. And my mama said, "I brought you a jacket 'cause I knew you wouldn't have no clothes, I knew you'd be cold."

The police took me into custody, then, and they told me, "We know you didn't do the shooting, and we know you just really didn't do anything but be there. But we're gonna hold you until we get who we want." That's when I found out the guy was dead. I never did see the man, you know. I didn't get a good look at him to begin with, but when I saw the blood when we were in the truck, I knew something had happened. But I wasn't about to ask any questions. Too scared to death. People told me that they took him to the hospital, and that he lived for, I think they told me, a couple of hours, then he died. He'd been shot in the head; he had been shot execution-style. And so I gave the police the information I could. And they just come back to me, asking, "How did you get caught up in

this?" I really didn't have an answer other than money. At that particular time my motive was to get me some money to buy me a new car. But I really didn't mean for anyone to get hurt.

I guess that's what hurts. Taking a life. I would never take anyone's life. Not intentionally, unless someone was trying to hurt me. Then I'll try to hurt you back. But I'm not that kind of person. I was wild but not to the point where I'd just go around killing people. No. But I guess I never sit down and thought, "You got a gun. And guns kill." I thought I was smart enough not to be manipulated. And I'm not saying that I was manipulated. To a certain extent I feel I was, but I always had a mind where I'm gonna do what I want to do and no one can make me do anything. That guy didn't put a gun to my head to make me do it. I was looking at the greed part, the money part. But once we caught the charge, I found out he had a long history of doing time. He had a jail record. So did my other codefendant, the one that was underage—he had a long juvenile record. I didn't know that. I didn't take time to try to know. I really didn't care.

So I'm twenty-five now and I'm serving a forty-year sentence for first-degree murder. And I been locked up for six years already. I've tried to imagine if that was my family sitting in there. No one was supposed to get hurt.

When I was younger I used to say: I'm not gonna work, I'm gonna hustle in the street. Don't want to get up every day and go to work. I can make me a couple hun—maybe even a couple of thousand in one night. But I don't look at it like that any more; it's not worth it. Now I'm sitting here, with really what you call a baby life sentence. Sitting in here and all this time is passing by and I'm sitting in here. It's not worth it. Life is not long enough; it's too short, you know? I wanna get out there, get me a job, and spend my life right. I'm not gonna say I'm gonna be perfect. I would like to be, but I don't think any of us can be.

I'm gonna try to live life like the way I was raised. I'm from a real nice family. And they've been there by me. I dropped out of school because I just felt like, I don't know. I had problems with my mother, me and my mother always stayed into it, we stayed into it constantly. And at that particular time, I used to blame it on her, she was the reason I dropped out of school. But I can't keep blaming her, so I stopped blaming her, 'cause it was my fault. I dropped out of school and ran away from home and got into the street and it's nobody's ass. It's nobody's ass. I tried every kind of way and it's got me nowhere but in a prison. I'm blessed to be alive. Well, a lot of people aren't. And, you know, just think of those victims; they can't come back. And they have families, too. It's hard, it's real hard.

THE MAN WITH TWO FIRST NAMES

To spend time in the prison yard, I had to stay within sight of a corrections officer. It was especially important given the inmate I was talking with, Thomas Benjamin, perhaps the most dangerous guy in Alaska. One of the women I had photographed was best friends with him. He'd killed a few women, they knew, but they couldn't arrest him until he took the last one home and raped her on his living-room couch. They found her in a snowbank, with glitter all over her body, the kind of stuff school kids paste on Mother's Day cards. They traced it to the man with two first names. Thomas Benjamin says he's innocent, but he's serving hard time, "never-get-out" time.

Thomas Benjamin and his friend Pam moved in circles around the yard as we talked. He was big, maybe six-foot eight or nine, and black as ink. Pam, tiny with long blond hair, looked like an angel. She was serving two ninety-nine-year sentences, plus seven years, plus five. She told me her husband and a friend had been involved in drugs and killed some guy who'd owed them money. They'd taken him into the woods and shot him in the back of the head while she waited in the truck. She said she'd had no idea what they were doing. Then damned if she didn't get more time than they did. She'd turned down a plea bargain, having faith in the system. Guilty of murder? No way, she stayed in the truck! Even her lawyer was astounded when that sentence came down.

"So you claim you're innocent, too?" I asked Thomas Benjamin as we walked. (I was nervous, but hoped it didn't show.) "Yes ma'am," he replied. His eyes were dead, like those of the inmate the corrections officers told me about from their days in federal prison in the Lower 48, the one who'd made a weapon out of magazines. The guy subscribed to *Newsweek* and killed a guard by stabbing him in the stomach with fourteen back issues that he'd folded into a razor-sharp dagger.

Or like the eyes of the prisoner out in Fairbanks who'd been mopping the floors. Down the hall he came every night, inmate-turned-cleaner, with his mop, his pail on wheels, and the triangular sign he'd prop up warning WET FLOOR, after he'd finished wiping the linoleum. As the mop came swishing around our chairs I lifted my feet. Then I looked up and right into the deadest eyes I'd ever seen. They were pale blue and absolutely without expression. But they held mine. I had to blink and shift in my chair to break the spell. Then the guards told me what he had done and they only knew about two victims so far. He'd gone out with a woman who had a café in town. When she broke off the relationship, he strangled her with an electric cord. The cops ran him through the computer and found he'd been convicted of a similar crime in the Lower 48, did his time down there, and when he got out, split for Alaska—where he started all over again.

FRANCES

I have a life sentence for first-degree murder of my husband. I've done ten years. I was married when I was nineteen. I didn't know him long before I married him. He seemed to be a very nice person. Tom was twelve years older than I, and had two little boys. When we married, he went and got them from their mother, who had no interest in keeping them. So I raised them from a very early age. After almost three years, I had my first daughter, Mimi. Four years later I had another baby girl.

My father was abusive to me, so all my life I had been used to abusive treatment. From the first my marriage was just a real bad situation. My husband was promiscuous with a lot of different women. He would leave home, be gone, and sometimes he'd leave us with no food. From the very first of our marriage he would hit me, and tell me cruel things about myself—that I was stupid, that I would never be able to hold down a job, I couldn't get an education because I was illiterate. Over the course of our twenty-five years, I was thrown downstairs, which hurt my back and put me in the hospital; I was thrown out a door, I was on crutches for three weeks. I was slapped and beaten, I have no idea how many times. We moved every year, so it kept me on an uneven kilter. I never told people what was going on, because I never knew anybody well enough to talk to about it.

Tom was in construction. He said his jobs took him to different places, but I think now it was probably because he was an alcoholic and he had problems getting along with people on his job. He would be drinking—and, well, it entailed a lot of things. Sometimes he would just tear off my clothes, and—I guess alcoholism affects you sexually, especially a man. He would be very drunk, and he'd be wanting to have sex, and because he couldn't do what he wanted to, he would start beating me. He would say it was my fault, that I wasn't woman enough or something, just not attractive enough. A lot of times I got out of bed in the morning with black eyes. My hair would be pulled out. I would have pinch bruises all over me.

He hurt me sexually. After years, I started scarring inside. Sometimes he tried to put his hand in me, but it was his own sex organ that would tear me. When he'd want to have sex again, rough sex, it would re-tear me, and so after years of that, they told me I'd been torn so many times inside that it just wouldn't heal any more. They couldn't stop the bleeding, so they had to do surgery on me.

Some of my family knew what was going on. They didn't know much about the sexual abuse, because it's only been for the last few years, since I've had so much psychiatry help, that I've been able to be honest enough to tell someone what happened to me. I was ashamed and I didn't want people to know

what went on inside our home. I wasn't allowed to have any female friends, go anywhere, do anything. I lived a very isolated life. If somebody was friendly towards me, my husband would tell me to stay away from them, and he would be rude if they came over. Of course that would embarrass me. So I soon withdrew from people, because I didn't want him publicly embarrassing me like that.

He was extremely cruel to the children. The things he said and done, made the little boys grow up to believe that's how you treat women. And then the little girls—he sexually molested my older daughter twice. In divorce court, she got up on the witness stand and told it, and it was the first I knew of it. I blame myself for this, too. My daughter also said that my stepsons sexually abused their sisters. I did not know that. This was the last straw—I felt that my whole life had been a lie. I had never left the children alone with each other. I had always been so particular and so careful. There were never any dirty books or anything in our home, and I always made sure the children were in church, that they said their prayers and knew their Bible verses. So this was another terrible blow to me.

Tom became really bizarre the last few years. His alcoholism made him paranoid. He carried a gun all the time, and for a long time he thought somebody was coming to kill him. Then he changed the story, said somebody was coming to kill me, and that they would kill the children too. I felt like he made three or four attempts on my life that would have looked like accidents. We lived on a farm, and there's things that are dangerous, driving tractors and such, that I had to do.

He killed the children's animals in front of them. One time he killed a nine-hundred-pound bull calf. He was mad that the animal had got in with the neighbor's stock, so he castrated him. And then he just turned him loose, and the animal bled to death. Tom didn't bury him, just went back to work, and in about three days the animal started smelling, so the children and I had to take the tractor and bury him. Another time, he got a gun out and just started shooting the little girls' cats. He said there were too many. I begged him, please, wait until the girls aren't here, at least do that—and of course the children were screaming. He knocked my younger daughter off a horse, and hurt her badly. Once he was beating me, and she ran in between, and he broke her jaw.

After twenty-four years of marriage, I left and went into hiding with my younger daughter, Rossie. We rented an apartment next door to a police officer. We'd seen his patrol car there when the real estate lady took us, and we thought, well, this is what we want. My daughter was in college, studying criminal law. Mimi, my older daughter, had married by this time and had a baby. She and her husband and a lot of their friends and all, we moved the furniture out while Tom was away. I filed for a divorce.

We were all scared. He had a real bad reputation. He threatened to kill the kids, some of the boys. He threatened a friend of Rossie's who worked up at the Del Taco. He went in there and said, "I'll find out who helped her move, and when I do, I'm going to kill him." The police never did do anything. They all knew he was dangerous, it was common knowledge. We stayed in hiding almost three months. Then Tom found out where we lived, and started following us. He knew where I worked, and he would come up around there. I had a deep scratch along the side of my truck, and there were threats—I would find notes on my windshield when I'd get off from work. Sometimes he would be wanting me to come back to him. Sometimes he'd want me to come over, just to have sex. Sometimes he would threaten me.

I got my divorce. Tom had told me he had remarried and everything, so I figured, okay, it's finally over. But we had been being followed. Mimi was run off the road once, when we still lived in the apartment. We were still all afraid, and I couldn't sleep at night. This was a big problem. I worked as a cook during the day, all day long, and then I would sit by the window all night.

We decided to move back to our hometown, just about twenty minutes away. We rented a huge house there, Mimi and her husband, their two children, and my younger daughter, Rossie, and me. But we were followed, and threatened. Tom called me one day to come out to the farm. He said that instead of giving me the three hundred dollars a month in alimony, he wanted to give me the farm, and I should go ahead and make the payments. Well, it had been part of my mother and dad's farm. My mother had lived there for years and years. I took care of her for thirteen years and my grandmother for five years; they had their own little house, up the hill. We had got it at low interest and we'd been paying on it a long time, so I knew I could make the payments, and that'd give me and Rossie a home. When I went over there, he beat me up real bad, and he choked me real real bad, and he hit me in the ribs and made a big bruise there, and pulled my hair and beat my head against the wall. And I was still conscious. My older daughter came in, and I don't know. She seemed to think that I was really close to death, because I had urinated on myself; my bladder had just let go. And so she came in and made him quit choking me. He left, and he told her he should've killed me.

We went to the police that day and tried to get a warrant. They said that unless they had seen Tom hit me, they could do nothing for me. So the next night—well, we took pictures this time. I went to my doctor, and he put me in a rib brace.

Next day the girls went up to Knoxville to go shopping. They were coming back home—we lived only a mile from town—and Tom got behind them and started shooting. Whether or not he was trying to hit the car or just trying to scare them, I don't know. But he emptied a gun, and the girls almost wrecked. They come into the house screaming, hysterical. We called the police and made a report. Police said they couldn't do anything. So we called the district attorney, because the death threats were coming all the time, and we were scared to death. I would start home from work, and there he'd stand by the side of the road. He always had that .30-.30. He told my daughter how he was going to blow me away with it: "It'd put a little hole in your mother's front, but it'd blow her back all over the wall." I was afraid to go out at night. I would get down on my hands and knees and crawl around my truck whenever I'd get off from work, because I thought he'd planted a bomb in my truck. Every set of headlights was a threat. I didn't realize then how sick I was. One night, my daughter was bringing me home, and this boy Mimi had known hollered at her. He said, "I heard what happened—I hear your dad's been really dangerous." And she said yes, he had. The boy said, "I'm going to go out there and kill him." Mimi told him, no, you can't do that.

About two or three nights later, I'd taken sleeping pills to try to go to sleep. My little grandson and these two teenage girls from church come up to my room to say goodnight. They had some music, and my grandson was singing and dancing, and the phone rang, and it was Tom. I don't know what he said to me; I've never been able to remember it, or even talking to him. The other call was this guy my daughter knew. He came over, said he was going out to the house to kill Tom. I said, "You can't go out there, he'll kill you." But he insisted, so I said, "I'm going with you."

He got out of the truck and I went on up to the house. And I thought to myself, this is no good, so I got in my truck and I left. I got down the road and thought well, I've got to stop this, before somebody gets hurt. So I went back. I pulled up in the driveway, got out of my truck and walked. This big huge night-light was shining on me. I had no gun in my hand. I didn't see anybody around. As far as I knew, I was alone.

Well, Tom came to the door and he leveled that .30-.30 at me and fired. I hit the dirt. I could see the glass breaking. And I could hear another blast, by the time I hit the ground. This fellow had shot Tom. I started screaming, "Oh, please, let's go." We got in the truck and left. When I got back home, my daughters came out and said, "What happened?" I told them he was shot. "I don't know if he's dead or not,"

I said, "he may still be coming after us." We went in and my daughter said, "Mom, it's okay, you can go to sleep now. He won't be coming tonight." And I did, I went to sleep.

They arrested me six months later. I made bond and was out for about nine months. I went to Kansas City— that's when I first ever heard about battered women. They set it up for me to see some doctors and go to a battered women's group, and it was like all of them were talking about my husband. They all described the same things I had been through. And I got to thinking, we don't have anything in our state for battered women. I'd never heard of a shelter. I had never heard of anybody getting any help.

I came back in January of 1987 and stood trial. I tried to get my trial separated from my codefendant's, because my defense had nothing to do with his. But they refused. I was examined by three doctors who all said I suffered from battered wife syndrome, diminished mental capacity. My expert witness came down from Kansas City to testify for me. They wouldn't let her in the courtroom. It was well established that I was a battered woman. But I was only the second woman ever in the state to go to trial on a battered-wife defense. The way the law is written, I was guilty of first-degree murder, even though Tom was shooting at me. They found the shell there, it's in the police report, so it's not like I'm just saying it happened. I didn't shoot anybody, but conspiracy is the same thing.

I'd never been behind bars, I'd never run with wild people or anything like that. So prison was quite a culture shock. I came into this place hollering, "We have to do something for battered women." I was bound and determined—if this could happen to me, it could happen to other people. I had my ear tuned to the news, and I kept hearing of these women who were being shot and killed by their husbands. There just didn't ever seem to be any end to it. So I started making tapes, and sent them out at my own expense. Every week I made a tape talking to women about the dangers, and sent it to some shelter across the state. I started reading a lot of books on abuse, learning about what had happened to me, and why it had happened. And this Dr. Ruth Peachee, she stood right by me. The prison officials were good enough to allow her to come see me, and she counseled with me for well over a year. They also provided me with a psychologist, because I was still having horrible nightmares. I couldn't remember really what happened. When I went to trial, I thought I would know, but I couldn't really remember.

I took a couple of years of psychology, and I would've liked to have taken more, but the powers that may be— who are these people who stopped our education?

investigation would be done. I wouldn't even allow my people to do it, for the protection of the inmate and the staff member both. And if a determination were made, the information would be given to the D.A.'s office for prosecution, and the staff person would be terminated.

I knock on wood that that hasn't happened, and I hope it doesn't. But I do live in the real world, and know that stranger things have happened in corrections. There's a case where the particular inmate alleged rape, but then testing proved that the sperm belonged to somebody else, another inmate. I mean, inmates have twenty-four hours a day to sit and think. Some of them take the attitude, "How can I better myself?" And some take the attitude, "How can I outfox them?" Where there's a will there's a way.

My personal feeling towards the death penalty is that it doesn't remedy the situation: it doesn't bring back the victim of the crime. Sometimes the issues have to be really laid aside and questions asked, like, who is the most productive person to return to society? And it would be a little bit of a shock, but if we took the percentage of the people incarcerated for violent crime, manslaughter, murder or whatever, we'd realize those people could be more productive than your drug dealers or your cocaine addicts, because of the recidivism rate... Of course, you'd have to do it on a case-by-case basis. I would probably be more against the death penalty for the fact that it doesn't show a total answer. I've worked in the criminal justice system since 1982, in law enforcement and then corrections, and I've always had the same mind-set, that the death penalty is not the answer, to do an eye-for-eye doesn't solve the problem. But if the death penalty is state-mandated then it's my job to follow through, personal issues put aside.

THE LAST FRONTIER

The Sixth Avenue Jail in Anchorage is Alaska's main receiving facility, sometimes booking up to sixty offenders in a twenty-four-hour period. It looks like a jail you might see on American television, with bars for walls in the dorms and the perpetual clanging of iron doors being opened and shut. There's the stuffy sweet-sour smell of no air and many bodies in close quarters. Inmates are funneled into other facilities as soon as possible, but for some, this means months. The capacity at Sixth Avenue is 104, of which 35 to 40 inmates are female. When the number reaches 134, with inmates sleeping on the floor, the facility closes. Out front, they put up a sign that says, "No Vacancy," just like a motel.

Although a long hallway separates the men's and women's dormitories, male and female inmates have contact with each other everywhere at the Sixth Avenue Jail. The women work in the kitchen and serve the meals from a long, heated cart they park outside the men's dayroom. They bring the men their food, pushing the trays one by one through a single trapdoor slot. The men stand in line behind the bars catcalling the women and giving coded signals to the ones they know from the outside or are after on the inside. One of them called to me: "Are you the lady doing the book? Tell 'em my name is Richard and I got a raw deal!"

Alaska records the highest rate of alcohol-related crime and child sexual abuse per capita in perhaps the entire world. Most of the women prisoners I spoke to said they had been battered or sexually abused during childhood by men, often relatives. During coed activities between inmates (known as "co-corrections"), which I saw here for the first time in any prison I visited, I watched the women continue to play out a lifelong pattern of attraction to abusive men—here in prison, men incarcerated for violent crimes. The abuse these women suffered in childhood seemed to have trained them to expect, and so tolerate, a degree of invasion that healthier instincts would find unacceptable.

When the cops arrived at the jail through the "back door" (the front door is reserved for the general public, the back is for those in custody), the control room would announce each arrival: "female (or male) remand!" Arrested women came in handcuffed, often kicking and screaming. If they were too wild, the cops would cuff them to the long steel bar above the bench.

Sometimes they'd bring in "non crims," women not charged with any crime but considered too inebriated for their own safety. They were put into drunk tanks (cells equipped with cameras for continuous surveillance) for twelve full hours, then released. In winter the smell in the tanks is rank and rotten from the men who have been sleeping in dumpsters.

A native woman spat at me and called me a white bitch. "We don't like you, you stole our land!" Her spit smacked against the Plexiglas that filled in the spaces between the bars, and she clawed the air with one hand through the open slot. Another woman told me her uncle had beaten her severely when she was a child, convinced that she was hiding his whiskey bottle. (She'd had no idea where the bottle was.) When she held her arms up in front of her face to protect herself, he broke them so badly that she now has steel pins in both arms.

Lemon Creek in Juneau is a maximum-security prison. Even so, it also had "co-corrections." I was told one could even get it on. They showed me the blind spot, just about

five feet of yard, where a couple could touch and kiss undiscovered by either the guard with the machine gun driving around in the no-man's land between the two fences that surrounded the prison, the guard with the gun in the surveillance tower, or the guards walking the yard during recreation time. Inside the facility, there was reportedly even a closet a couple could use for a moment of intimacy.

At Meadow Creek, the women were constantly on the phone. They knew the COs (corrections officers) by their first names, and had keys to their own rooms. The superintendent made the rounds of the modules, often eating meals in the cafeteria-like dining hall with the inmates. When the women's softball team played the men on the other side, she played ball with them, or stood around with her walkie-talkie joking with the prisoners. Off to the side, male inmates grilled hamburgers and gave out soft drinks. Girls sat on the benches, and guys strutted by, sending secret signs to the ones they had targeted. Some wore boom boxes plastered to their ears as they navigated around the softball diamond again and again and again, passing in front of the women on the benches, making eye contact.

Sexual tension hung heavy in the air between these men (most of whom were sex offenders), and the women (most of whom had been abused by a man, somewhere down the line).

EVELYN

I was in the car with Lionel when he killed and robbed my stepfather. He was given thirty years at 30 percent. I got life.

My mother took Lionel in when he was twelve years old. He was my baby brother's best friend until he started getting in trouble, and my brother quit having anything to do with him. I was grown and had been married and lived away from home all those years. I had only seen the boy a few times.

The way the murder happened was like this. We were going down the interstate. We were in the truck with a trailer on it, and my stepfather was following us in his car. Lionel made an attempt to get off the side of the road—he said my stepfather was far behind. I said, "Look he's only a car length, let's get back, I'm tired." So we're going along and Lionel makes another attempt to get off. I didn't see it at the time, but the way I see it now, a car went by, so that's why he swerved back on. It was real, real dark, and I didn't see any oncoming traffic or nothing and it kind of scared me, and I said, "Gosh, I hope we don't break down out here, because they ain't nobody around for nowhere." And it wasn't five minutes later, Lionel pulls off the side of the road and I said, "What are you doing?" He said, "I'm going to get a cigarette from Gerald." I said "Well, you can have one of mine, Lionel.

Let's get the hell up there and get back." And he says, "No, I want a cigarette from Gerald," and I said, "What's the damn difference?" Gerald smokes Vantage, I smoke Ultra Lights; a cigarette's a cigarette, you know? But Lionel gets out of the truck, and he goes back to my stepfather's car. Well, I'm sitting in the truck and I'm thinking about the fight me and my boyfriend had and I start crying, listening to a song, and I hear a shot. Well I didn't think nothing about it, I thought maybe somebody was hunting out in the woods. It was cold, I didn't see any lights or nothing, and I looked ahead and I didn't see anything. And I swerved around and just then I saw Lionel standing by the truck with a gun pointed at my stepfather. And the second shot went off. And I remember screaming, "Oh my God. I've got to get out of here." I jumped into the driver's seat to try to get away, but Lionel run up to the side of the truck and pulled the gun on me and said, "If you knew what was good for you and your three m—f—ing kids, you'd keep your mouth shut and do what I tell you." And needless to say, I did. He told me, "You follow me and don't forget I can see every move you make." Well, I'm thinking, "What am I going to do? I'm next, I'm next."

He pulled off the side of the road, and (what was so bizarre) got in the car with my stepfather's body, moved it over, and drove it. And then when he got to where he was going to leave the car and the body, he ripped my stepfather's jewelry off and took his wallet and everything. He got back in the truck, he laid the gun down in his lap, pointed it right at me and said, "How's it feel to be right in the middle of a murder?" And I just screamed, because I'd never been in anything like this before in my life. I didn't even have a speeding ticket. And he told me, "You don't say nothing, you keep your mouth shut." Then he goes to his dad's house, and tells his dad that my stepfather was following us up there and he got sick on his stomach and he was going to get something for his stomach and meet us up there. Needless to say, my stepfather never showed up. And Lionel told his dad, "Maybe he went on back home." Then his dad took us back home. Lionel was standing over me the whole time. And all I could think was "I got to tell somebody." But he was always there and I couldn't get away. And then here comes the investigation and all, and eventually the detectives say, "Were you there?" I wasn't going to lie to them. I had to tell them, "Yes, I was there when it happened."

I got life. And Lionel got second-degree murder. He turned state's evidence on me, to get less time for himself. He originally said he was paid $10,000 to kill my stepfather. Then he said he was paid five for him and five for me. He told the state he pulled the trigger, but that I

39

knew it was going to happen. But after he got them to plea-bargain with him and give him second degree, after they'd done signed the papers, he goes in and testifies against me and says that I pulled the trigger, I committed the murder. I was convicted. So here I am left with a life sentence. In 1989 Lionel escaped and went to Florida but they captured him down there, and he's got eight more charges, after he said I pushed him into doing this. The truth is my mother pushed him into it. For two and a half years before it happened, she kept asking the family and everybody, "Do you know anybody can help me get rid of Gerald?" And everybody just thought she was crying out. When she asked me, I said "Mother, you're crazy." She wanted the insurance money apparently—$1.6 million. She got her part of it. She was charged for the same thing I was, but she was acquitted.

So I'm filing for clemency and the district attorney has wrote a letter on my behalf and explained that Lionel changed his story. The judge granted me a $5,000 bond and my husband paid it. I went home, I was home for almost nineteen months, out of which I worked eighteen. I got my children back, and my kids were in school doing great. My husband and I had bought a new home, had our life together, and we were happier than we'd ever been. And then on April 20 of 1995, my attorney called me at home and said, "Evelyn, this is the hardest call I've ever had to make in my life. I'm sorry, but you've got a custody hearing Thursday morning at the jail." I was just hysterical. I called my boss, and I told him that I wasn't going to be able to make it to work tomorrow, that I had to report to the jail. And so I did; along with my husband, my ex-husband, his wife, and my children.

The sheriff starts reading the paper off, and it said my appeal for clemency had been denied, the conviction had been reinstated back to the life sentence, my bond revoked, and I was remanded back into custody of the Department of Corrections. I screamed, "Oh my God, no, no. Why?" And my husband went hysterical. My children, my ex-husband, his wife, everyone was crying. Even my attorney couldn't believe it. What was so weird about the whole thing is, when the state contested the appeal, the district attorney said: "Evelyn, this is just a formality. We don't think it's going to go anywhere, but we have to show that we are doing our job." And the judge's clerk told me, "Evelyn, it'll be all right, you know, you'll be okay. You go on and enjoy your life—live it as if it was your last one." And I said, "I intend to do that." They locked me back up that same morning. It was the most devastating thing I've ever been through to see my husband cry and hurt like he did, and my children, not once but twice have their mother torn apart from them, just ripped apart. And I stood the night in jail,

and then my blood pressure went up, and they brought me down to the prison the next morning. I was taken and put in segregation all over again, just like a new inmate. The nightmare had started all over again. It was worse on me this time, because the first time I had no one who cared about me, no one that loved me but my children.

I met my husband while I was incarcerated the first time, and we've been together five years. This is a man who was well known in the community, retired from DuPont, and he believed in me. But he did his investigating, too. He traveled to Louisiana and Mississippi; he talked to people that have known me all my life, from a child on; and everyone said, "This is not Evelyn, she's not capable of this." And he finally decided I was telling the truth. To this day he has not stopped digging, trying to get me out of here. When we first met, Brian knew what it was like to have to deal with someone in prison. His son had got hooked on drugs and he'd been through all this for him. We talked on the telephone, we wrote to each other, and he wanted to come and visit me. We hit it off immediately, and only three months later, he asked me to marry him. First I told him, "This would not be fair to you. I have a life sentence." And he said, "Evelyn, honey, let me be the judge of that. I know what I'm getting into." I fought him for six months on this idea, but he kept on and kept on saying, "I love you, I'm never going to leave you. I know you've been told that before, but I mean it. No one's going to hurt you any more." So finally I said "Well, I'll tell you what I'll do. We have to request the warden for permission to get married. We have to wait a year, and get counseling. (That's the way it was back then.) And at the end of the year, I'll give you my decision." Well, it was so perfect. At the end of the year, Brian got down on his hands and knees in the visiting lobby and asked me, would I marry him. I told him yes, and he cried like a baby. And I cried. It was the best thing that ever happened to me, marrying Brian. Because both of us had been married before, and because of me being in here, the state only required three counseling sessions. We hired a professional counselor from the Baptist Church. We got married in the chapel down here. They allowed me to have a suit sent in. Chaplain Sands came out and he married us. Ms. Harding and the warden and four inmates was allowed to come. My husband's best friend and his wife were here, and my best friend. And then Bill Price, a church volunteer I met years ago who kind of took me under his wing like a father, he was here to give me away. After the ceremony we had a little reception, and then we were allowed an hour's visitation, just by ourselves. And then he had to leave, and I went to the dorm and cried all night. We were not allowed to consummate the marriage till I went home.

PARDUBICE

There were two hundred women in the Pardubice prison, the only women's prison in former Czechoslovakia. Every day the inmates woke up to no work and few activities. They spent time waiting for meals.

The main building was a dormitory with three floors. The women were forbidden to go from one floor to the other, but they could go to each other's rooms. They had their own keys. The inmates were allowed to wear make-up, and one of them told me that she put it on every morning so she wouldn't lose track of the woman she was, the femininity that being in prison silently killed.

Vaclav Havel had freed a thousand women from this prison when he became president of Czechoslovakia. He'd done time himself, so he was their hero; his portrait was on the walls (along with several posters of naked women, not banned here as they are in many Western prisons). Because of Havel, solitary confinement was forbidden for women. Every cell had to house at least two people.

The black sheep of the Pardubice prison were the gypsies. They pickpocketed on Wenceslas Square one day and were doing time the next. When they got out, they went back to stealing until they were locked up again. As women, they explained, stealing was expected of them; it was their contribution to the family. There was a group who all had the same first name. They told me it was like my own name, Jane. So they became the "Janes." When I didn't know what else to do, I'd say, "Let's go see the Janes." We'd spend time on their floor, drinking tea.

Kristina wanted me to photograph her tattoo. It was printed right on her neck, a necklace of purple letters spelling out her name. She took me into her room and locked the door so the other women wouldn't see her bare chest. Kristina had burned down a building, killing twenty-five people.

LINDA

I was married in 1972 to Bill, the good old boy next door. He was a coach—basketball, football, baseball, everything—well known in three states. Everybody loved him. But after we got married, I found out my husband was not what I thought he was. He had lied about financial things, and as one thing led to the next, his jealousy started coming in. It'd be just a friendly conversation with another man, and then he would make some response about flirting too much or something like that.

He was a good ol' boy, everywhere but with us. If I didn't want to have sex, he would use different ways and stuff that was not what I felt comfortable with. It would be anal sex. I did not feel it was the way God intended for a man and woman to have sex. I lost my respect for him. I hated him, is what it really turned into, over a period of years.

There was a man I had worked for before I married, and he was well off. Bill and I were having lots of financial problems, and my husband would bring me to have sex with this man, to get money. That was a thing I was not real proud of, but it was either do that or go home empty-handed. When our money would be slow, I would go out and prostitute. I'd go to bars and get pick-ups and come back and give my husband the money. If I didn't do that, he threatened to tell, go to the law and tell them that I was an unfit mother, tell my family. Plus the anal sex.

All this really started when I was pregnant, in '75. It increased as the years went on. My twins were born in February '79. I was working in the juvenile institution beginning in '82. I was never myself, it seemed, in the area where we lived: I was the twins' mother, I was my older son's mother, I was my husband's wife. Well, it just got to be that whoever I was friends with, that's who I was having an affair with, according to him. This started even before I was working. He was jealous and he would accuse me. It was always, I wasn't smart, I was dumb, I was a whore, I was a slut. He said he could do with me whatever he wanted, because he was married to me. The Bible says that you sleep with your husband and do what he wants you to do, that kind of thing. And I guess a part of me just got to the point where I thought well, this is what I was supposed to do. It scares me to think of it.

Finally, in '86, I went to my preacher and tried to explain to him a little, without going into detail, because my husband was a good person as far as the kids. He loved them, he went to church, he was involved in the community. But I had got to the point where I hated him. I mean, I would get sick at my stomach and throw up when he would come home and I had to be around him. I went to my preacher and I tried telling him that I didn't love my husband anymore, that I'd got to get out of that marriage, got to have some help. Well, he told me, "What do you mean? Just because the fireworks are not there?" saying that I should stay and try to make my marriage work. I left in tears, feeling worse than before.

Right around that time, I left my job and went to the city hospital as administrative secretary. I thought that if I got out of that other environment and into something more classy, I wouldn't be accused of doing the things he accused me of, and maybe we could get our marriage straightened out. The administrator was a tall, nice, good-looking fellow. He was a lot younger than I was, and he was dating a girl who worked at the hospital in Lansing. My husband got so jealous of this guy, though there was

nothing going on. A doctor at the city hospital finally said, "I want to talk with your husband and you." He had a little office in the mental health clinic. So we went. He saw us on separate occasions, and together. Bill sat right there in front of the doctor and said to him, "I promise you I won't touch her. If it takes six months, six years, whatever it takes, until she's ready," he said. Well, that did fine for a couple of months. And then one night he comes in and he rapes me. I told the preacher that he raped me, and the preacher said, "You're his wife." And, of course on one hand, there I was, prostituting because I was told to go out and get money. But at the same time, I didn't want him touching me, because of the situation, and what I was going through. It was kind of all twisted, and my mind got twisted, I guess. It was the mental abuse, the tearing me down. I had never felt good about myself as far as a man in my life because my father had never been there for me.

Finally we separated, in '88. I filed for divorce and told Bill he could have the house, everything, all I wanted was the car so I'd have a way to go to work. I had three sons, but I didn't have any way to pay for them. I didn't even know where I was going to live. So I left the boys with him. Nobody could understand that.

I got an apartment and moved in, and Bill said, "You can come see the kids anytime you want to." So one day I called and he said, "Yeah, come on over." When I got there, the kids weren't there. I said, "Well, where are the boys?" Bill had the prettiest blue eyes, but they were like ice at times. He just looked at me and he said, "One day, you're going to come in and they're not going to be here. The boys will be where you'd never ever find them." And I said, "What are you talking about?" And he said, "Just know you'll never ever see them again." Well, I took it as a threat to harm them.

It got to the point where I thought I was just going to lose it, so I stopped the divorce. We talked and decided I would move back home. Things were doing okay for a while. Then it just got to the point where every time I was around him I was sick at my stomach. I was miserable at home. In the meantime, at work, I got involved with a juvenile. I had a sexual relationship with him. We had conversations about going off when he got out and living together and I asked him, "Just what are we going to live on?" And he said, "Does your husband have an insurance policy?" And I said "Well, yeah."

The day of my husband's death, the juvenile had gotten out on a pass for the weekend. He told me he was going to kill Bill and though we had talked about it, it was just like a big fantasy to me, that he would kill my husband and we'd go riding off into the sunset. I never thought it would

happen. And so I asked him, "Stay home this weekend." Standing right there, he said, "Okay, I promise."

That night, I was awakened by him standing at the foot of my bed. He shot my husband right between the eyes. In my bed, with me next to him. He was covered in white from head to toe, and it was just like a dream or something. I woke up and everything was quiet. Bill was laying with his back to me, like he was asleep. And so the kid got me and took me into the bathroom, tied me to the towel rack. He stood there and looked at me, and all of a sudden I heard Bill, I heard this gurgling sound. And I thought, "What in the hell." I said, "You've got to get out of here, what's going on?" And it started dawning on me. When I realized that Bill was really shot, because I still had not seen any blood, I started pulling with my teeth at the thing the kid had tied my hands with.

Bill was laying there and blood was everywhere. He had a bullet between his eyes. I called the hospital. I told the police I didn't know who had done it. So they questioned me. Three days later my husband was declared brain-dead. We had like twelve hundred people at his funeral, that's how widely known he was; they had to have it in the school gym.

They never told me, "You're under arrest for the murder of your husband." They just said, "We're going to take you back to the house and let you say 'bye to your kids." I don't remember them ever saying, "You're under arrest"; they didn't read me anything. They didn't ask me to get a lawyer or anything like that. I had sat there from 10:00 until 6:00 that morning, and they had half a page written for my statement.

I didn't have a trial. I was put in jail in October of '89. I saw my first sign of a lawyer a few days later. I was so ignorant about the law, I didn't know you could ask for one, I didn't know anything about that. And of course when I did get my lawyer, I told him everything. But the night they arrested me, I never told. I just answered questions about my relationship with the kid, things like that.

We was preparing to go to trial, and I was terrified. I knew I was wrong—a man had lost his life because of me. My attorney said, "The assistant D.A. is going to make an example out of you. They're going to ask for the death penalty." He said, "Look, do you know Darlene?" And I said "No, I sure don't; should I?" And he said, "She's the only woman in the state that has the death penalty. You will be the second one if you go to trial."

OPPOSITE EARLY MORNING RUN FOR INMATES. CENTRE DE DÉTENTION RÉGIONAL DE FEMMES, RENNES, FRANCE, 1991.

OVERLEAF A COEDUCATIONAL YARD, ALSO KNOWN AS "CO-CORREC-TIONS," UNHEARD OF ELSEWHERE, ESPECIALLY IN A MAXIMUM-SECURITY PRISON. LEMON CREEK CORRECTIONAL CENTER, JUNEAU, ALASKA, U.S.A., 1993.

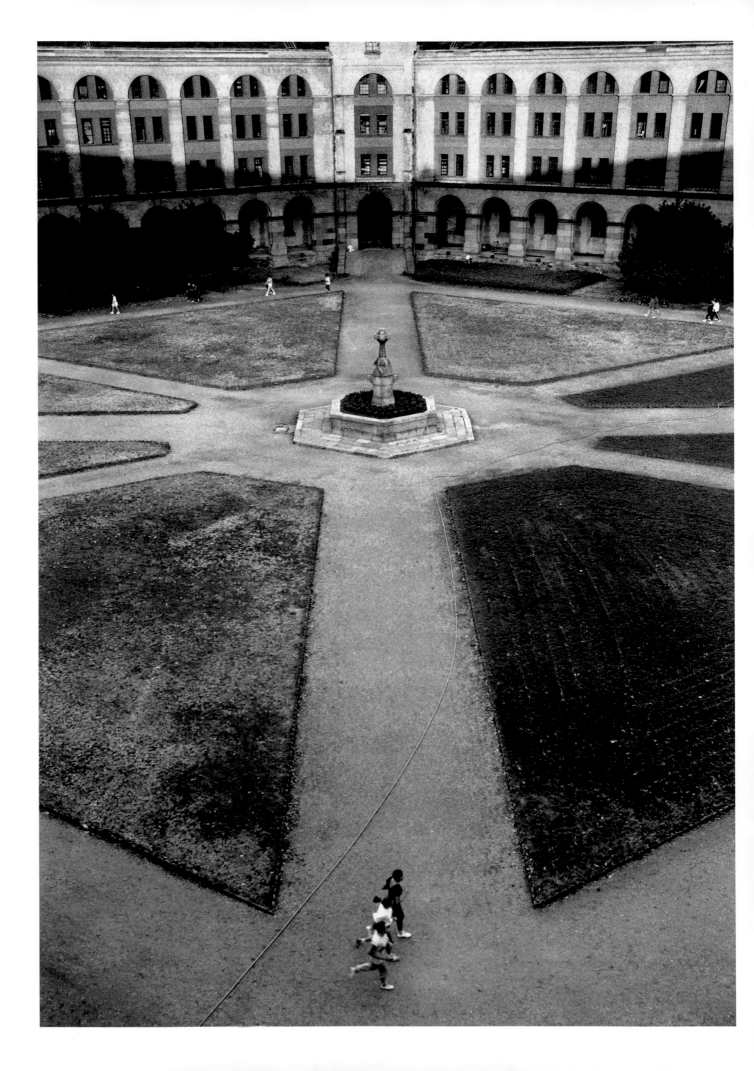

"HOG," AS SHE LIKED TO BE CALLED, WORKED IN AN AUTO-BODY SHOP FOR INCARCERATED WOMEN AND DESCRIBED HERSELF AS "A MAN, TRAPPED IN A WOMAN'S BODY." CENTRAL CALIFORNIA WOMEN'S FACILITY, CHOWCHILLA, CALIFORNIA, U.S.A., 1995.

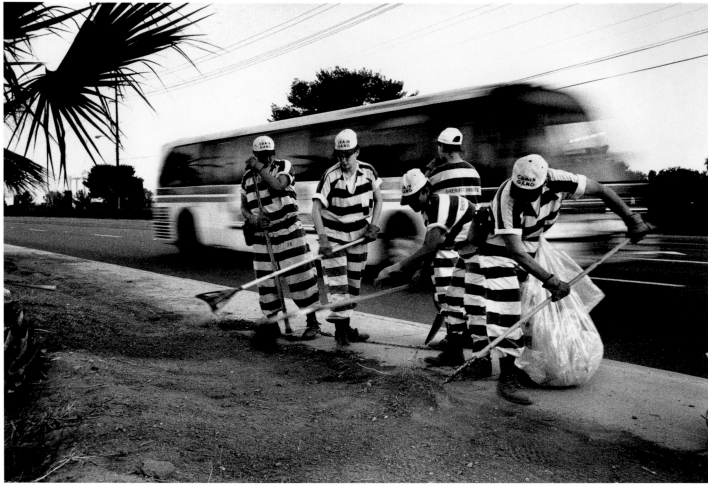

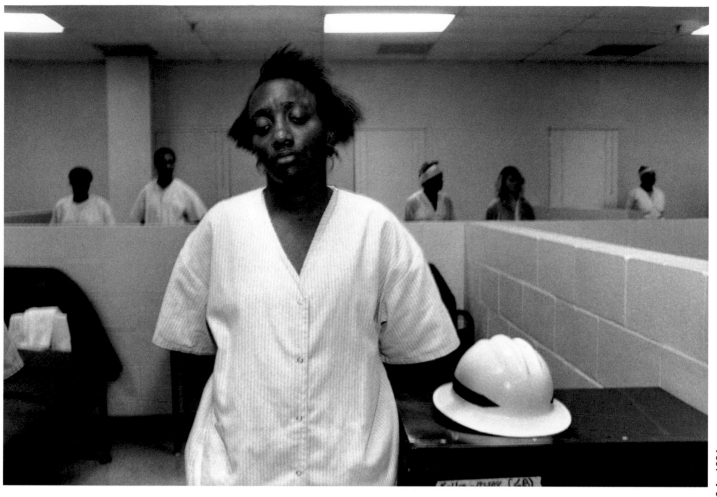

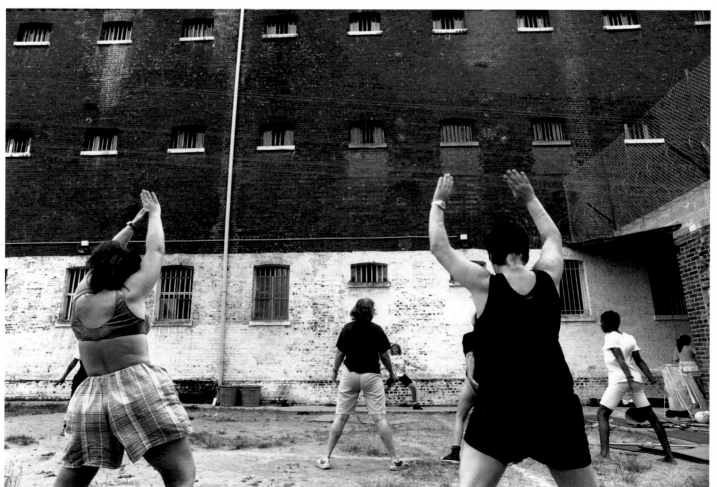

TOP INMATE AWAITING INSPECTION. WOMEN'S SHOCK INCARCERATION UNIT, COLUMBIA, SOUTH CAROLINA, U.S.A., 1994.
BOTTOM EXERCISE CLASS IN THE YARD OF THE PRISON. MAISON D'ARRÊT DE FEMMES, ROUEN, FRANCE, 1990.

TOP MALE AND FEMALE GUARDS PAT-SEARCH FIFTY-FOUR NEW ARRIVALS. PAT SEARCHES BY MALE GUARDS ARE FORBIDDEN, YET THEY OCCUR. CENTRAL CALIFORNIA WOMEN'S FACILITY, CHOWCHILLA, CALIFORNIA, U.S.A., 1995.
BOTTOM A CORRECTIONS OFFICER SHOWS A BATTERED WOMAN TO HER CELL. SIXTH AVENUE JAIL ANNEX, ANCHORAGE, ALASKA, U.S.A., 1993.

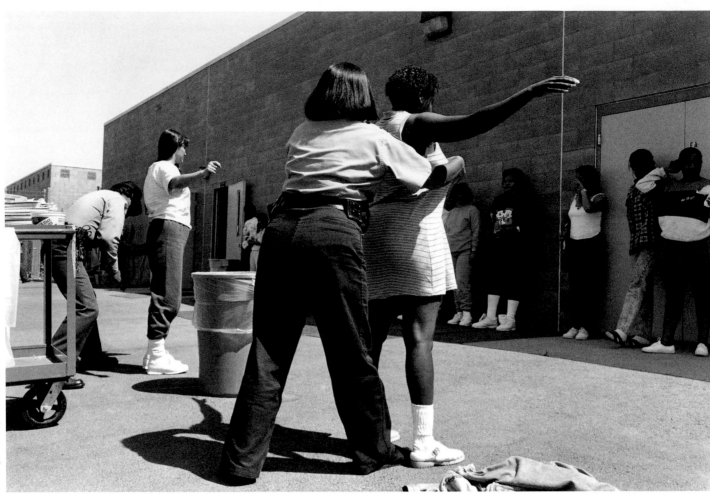

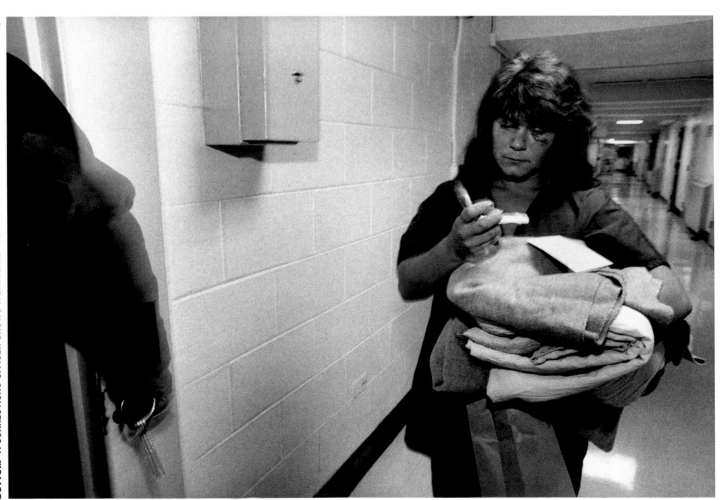

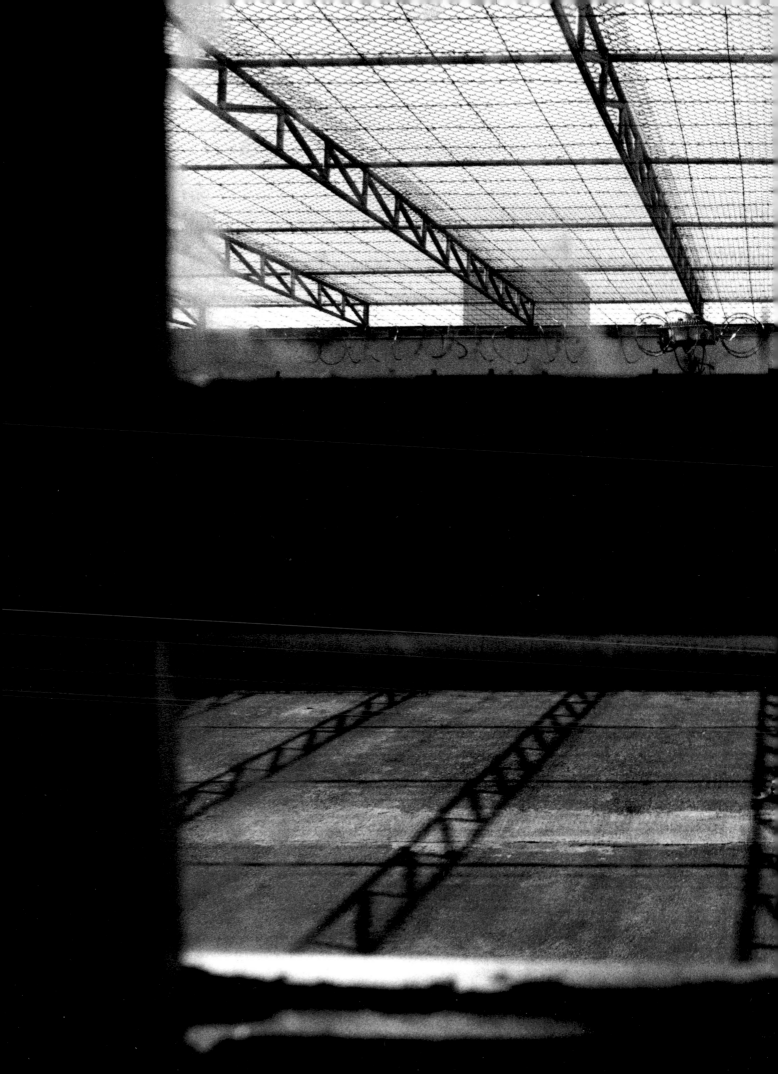

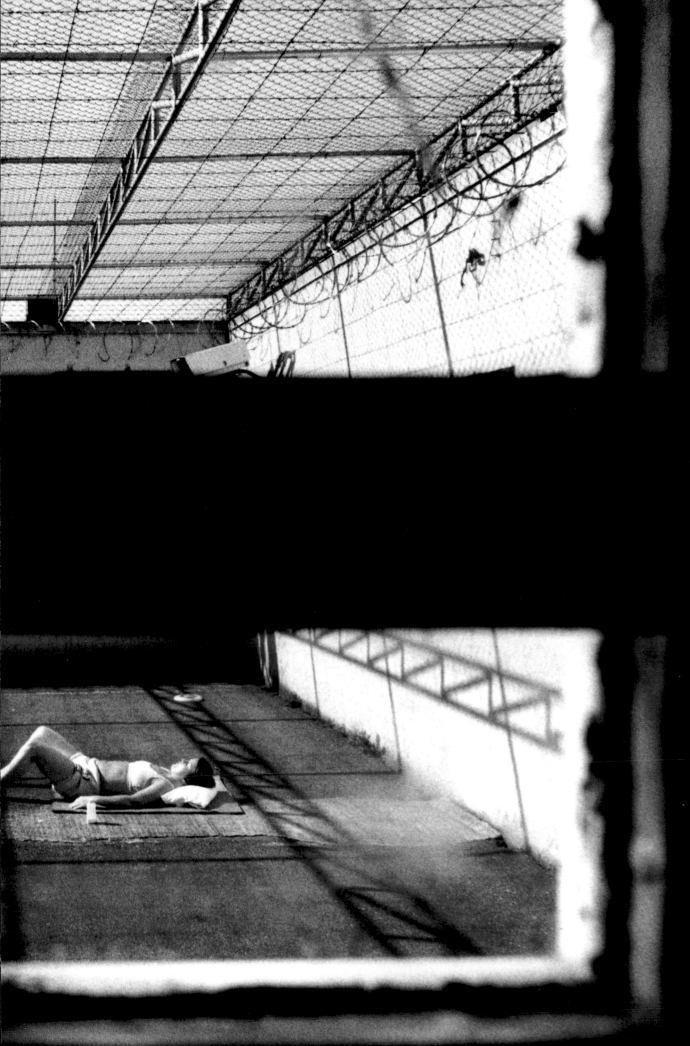

CRUMBLING WALLS

THE THREAD OF LIFE WEAVES AN ABSTRACTION
DIVERGING INTO CONSEQUENCES OF PREVIOUS ACTIONS
DUES ARE PAID WITH THE PASSAGE OF TIME
EVER SLOWLY CORRODING THE WALL TO FREEDOM
EXERTION OF MENTAL CAPACITY AND EXPRESSION OF THOUGHT
FLOW FORTH THROUGH CREATIVITY AND ART.
CONFINEMENT BREEDS OTHERWISE BURIED EMOTIONS
THE WALL TO FREEDOM CONTINUES TO DISSOLVE
UNTIL ONE DAY THE BRICK AND MORTAR FALL
THE ABSENCE OF LIBERTY AND JUSTICE MEANT FOR ALL
EXISTS ONLY WITHIN THE BOUNDARIES OF IMAGINATION
FOR PRISONS ARE BUILT IN MANY A FASHION
WHEN CLARITY OF THOUGHT IS ABANDONED
THUS CONSTRUCTING AN INVISIBLE BARRIER
THAT CRUMBLES WHEN REALITY IS EMBRACED
INDIVIDUALISM OF HEART AND MIND TAKES PLACE.

April Hill

POEM BY INMATE. TENNESSEE PRISON FOR WOMEN, NASHVILLE, TENNESSEE, U.S.A., 1996.
PRECEDING PAGES INMATE SUNBATHES IN THE YARD. SIXTH AVENUE JAIL ANNEX, ANCHORAGE, ALASKA, U.S.A., 1993.

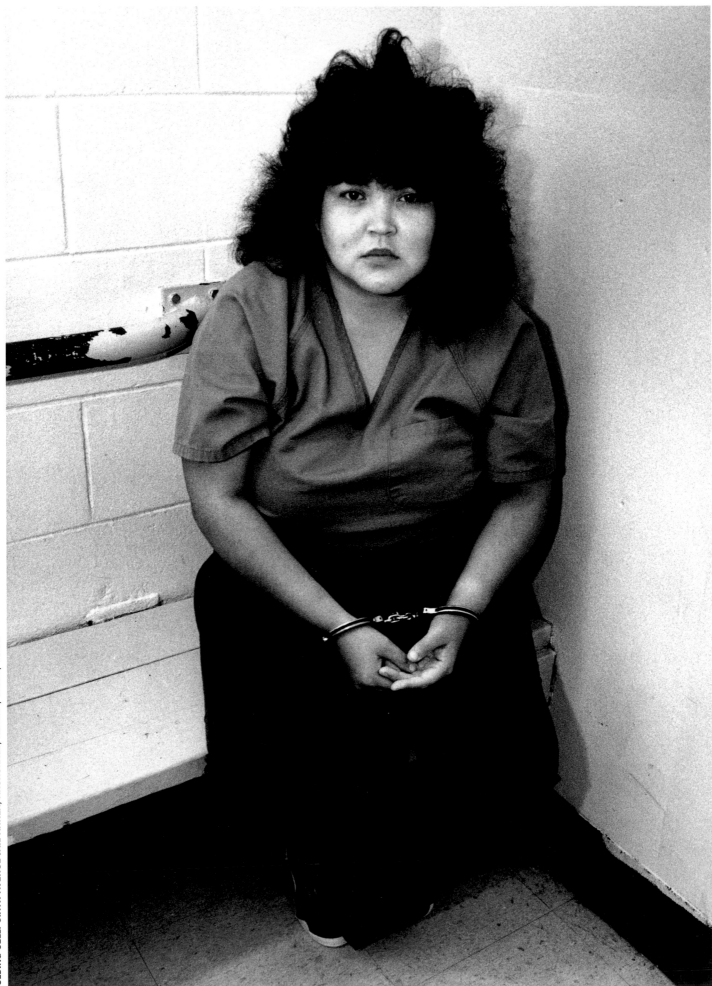

HOLDING CELL. SIXTH AVENUE JAIL ANNEX, ANCHORAGE, ALASKA, U.S.A., 1993.

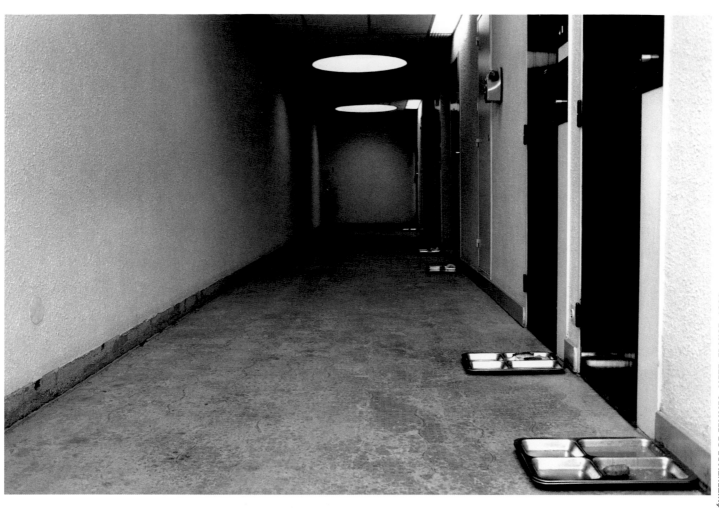

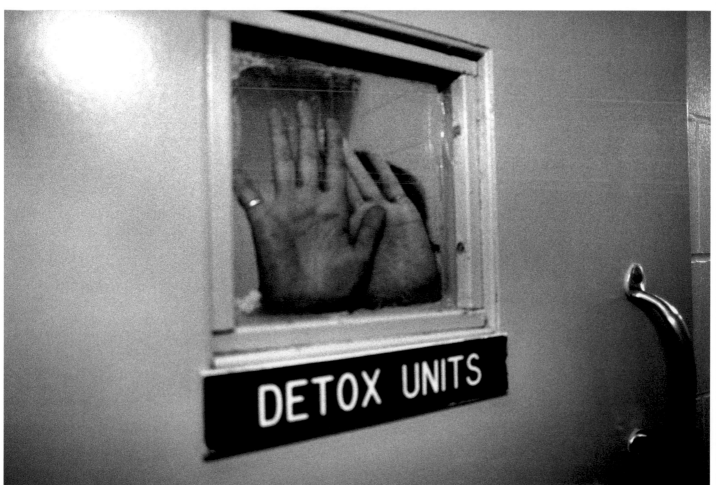

TOP AFTER MEALS, PRISONERS' TRAYS ARE METICULOUSLY LINED UP ALONGSIDE EACH CELL DOOR. CENTRE PÉNITENTIARE DE FEMMES, METZ, FRANCE, 1990.
BOTTOM ARRESTED WOMAN SOBERS UP IN A "DRUNK TANK" BEFORE BEING PLACED IN A CELL. SIXTH AVENUE JAIL ANNEX, ANCHORAGE, ALASKA, U.S.A., 1993.

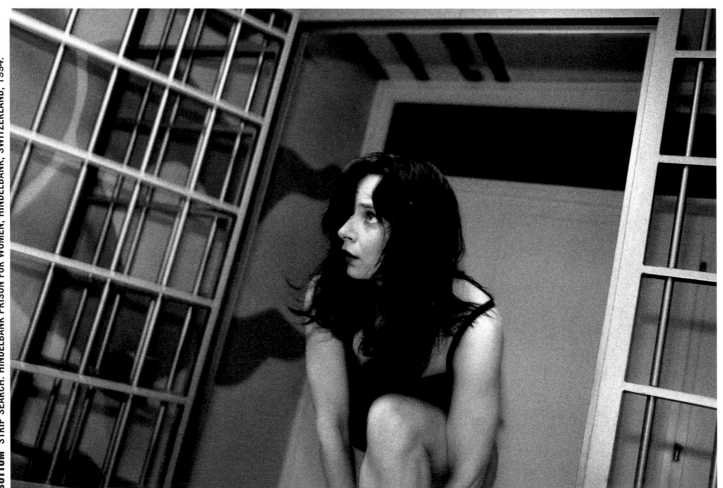

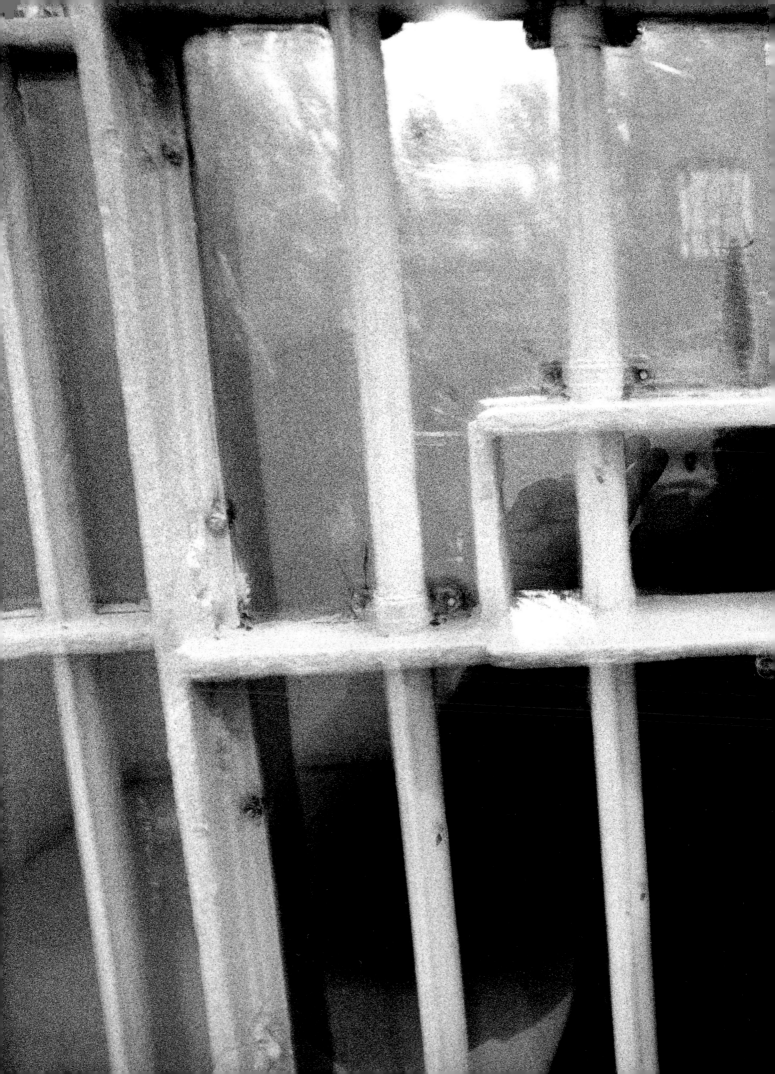

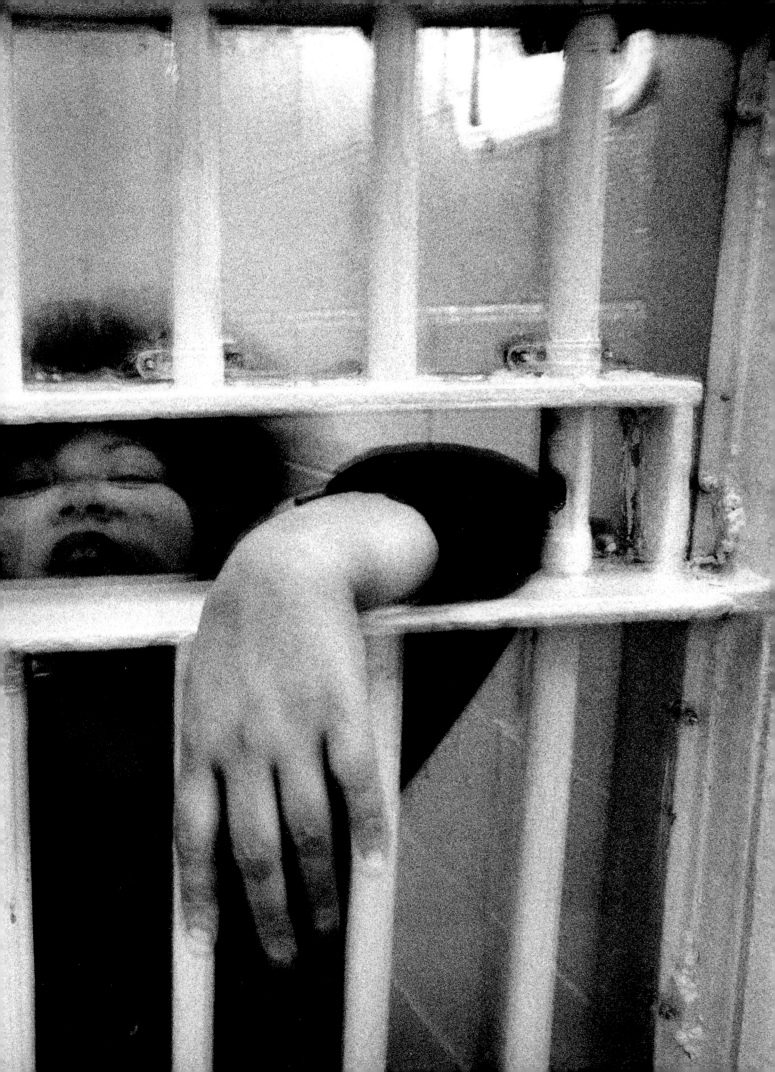

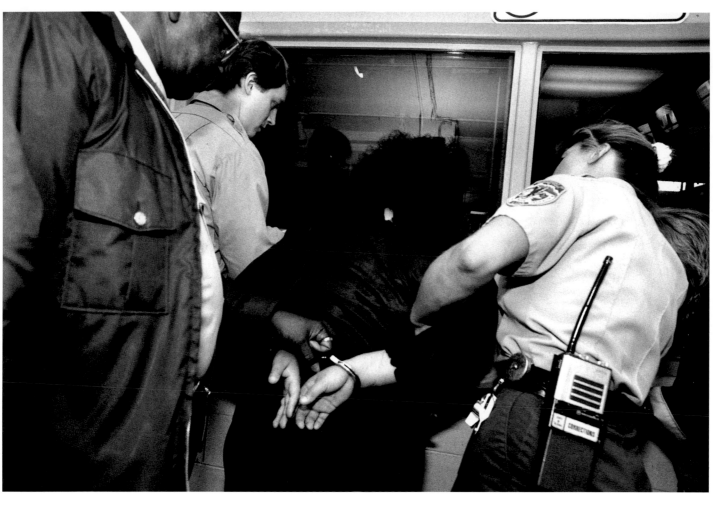

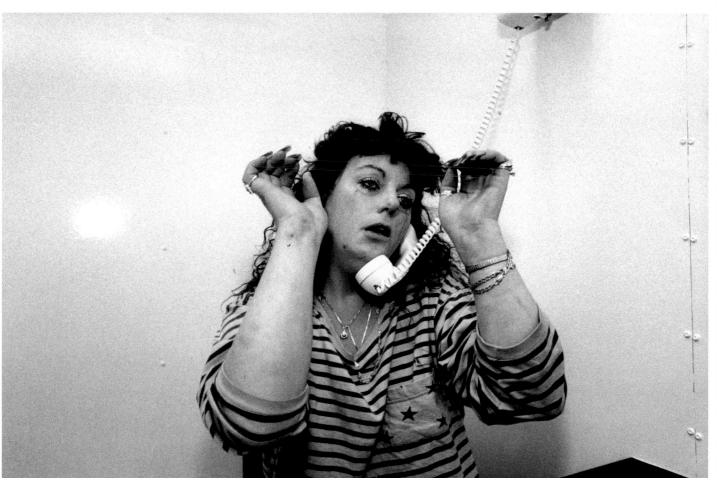

PRECEDING PAGES DRUNK INMATE DRIES OUT IN A SEGREGATION CELL. SIXTH AVENUE JAIL ANNEX, ANCHORAGE, ALASKA, U.S.A., 1993. **TOP** CORRECTIONS OFFICERS HOLD A WOMAN FOR BOOKING. SIXTH AVENUE JAIL ANNEX, ANCHORAGE, ALASKA, U.S.A., 1993. **BOTTOM** A NEWLY ARRESTED WOMAN LOCKED IN A HOLDING CELL BEGS HER FRIENDS TO BAIL HER OUT. WILDWOOD PRE-TRIAL FACILITY, KENAI, ALASKA, U.S.A., 1993.

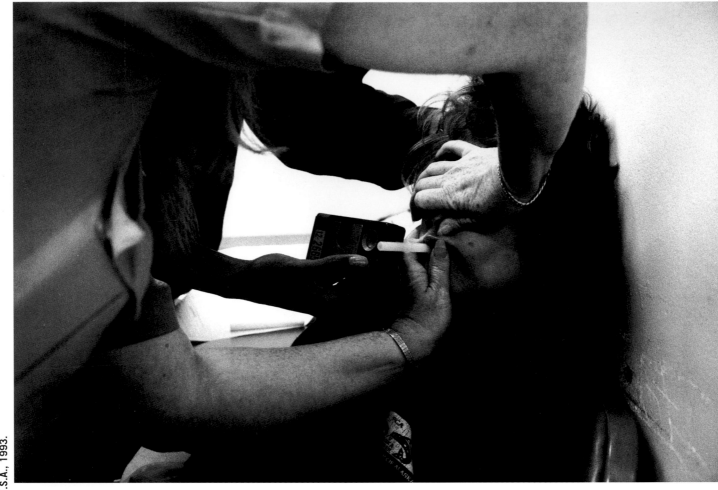

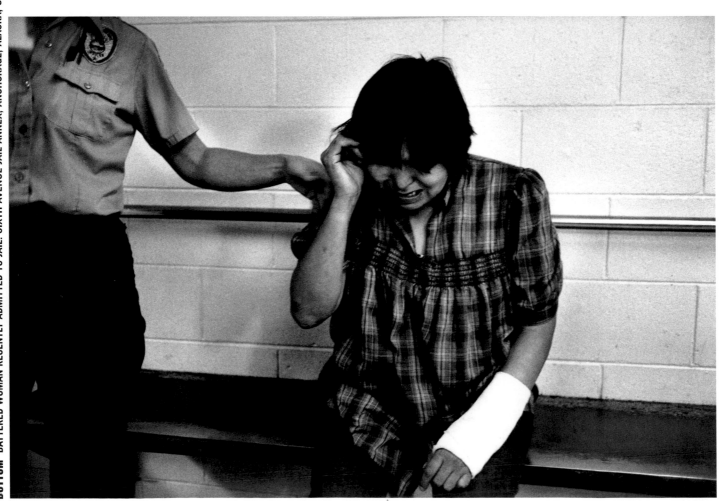

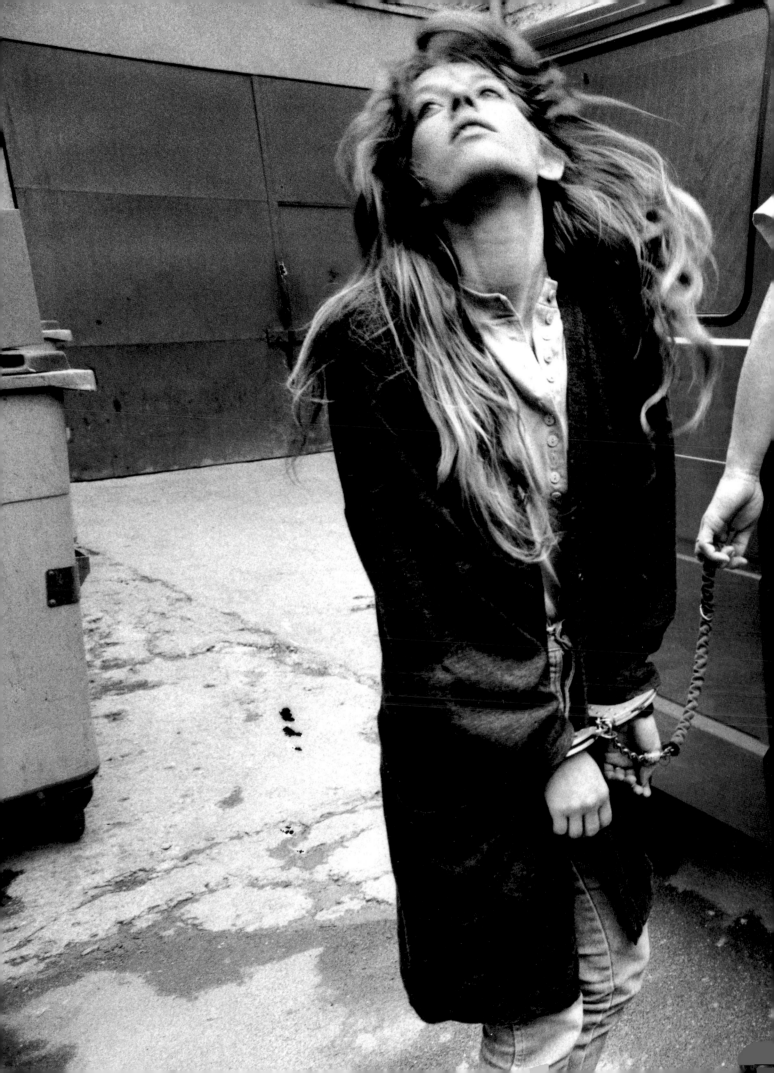

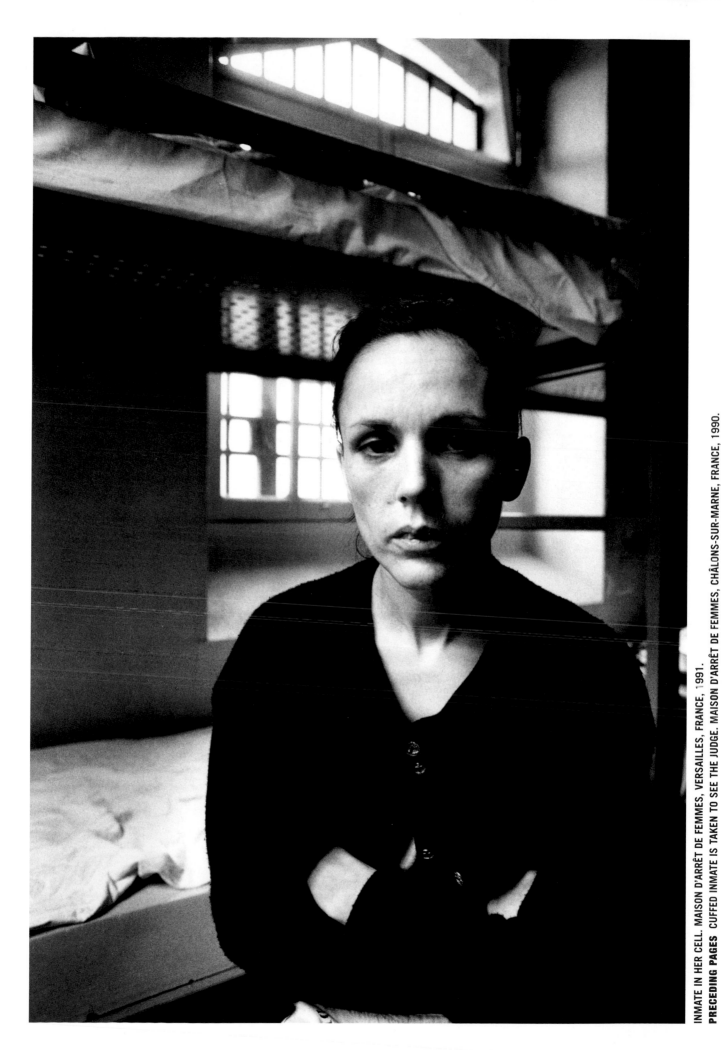

INMATE IN HER CELL. MAISON D'ARRÊT DE FEMMES, VERSAILLES, FRANCE, 1991.
PRECEDING PAGES CUFFED INMATE IS TAKEN TO SEE THE JUDGE. MAISON D'ARRÊT DE FEMMES, CHÂLONS-SUR-MARNE, FRANCE, 1990.

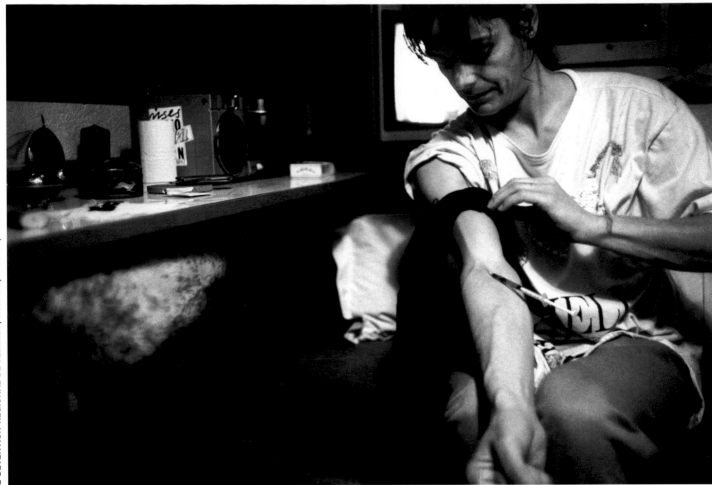

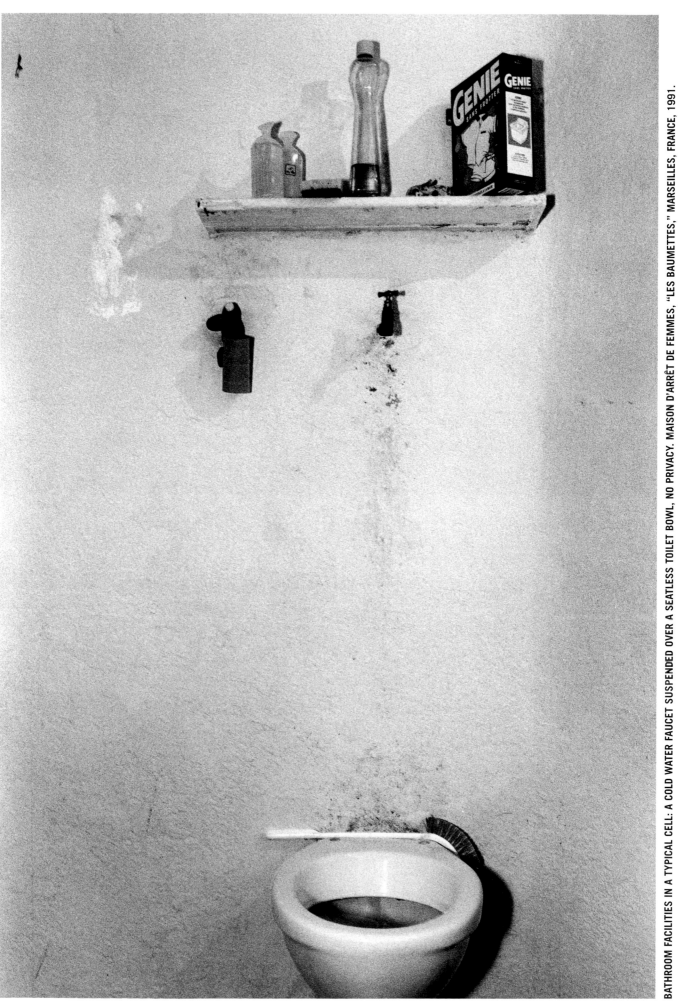

BATHROOM FACILITIES IN A TYPICAL CELL: A COLD WATER FAUCET SUSPENDED OVER A SEATLESS TOILET BOWL, NO PRIVACY. MAISON D'ARRÊT DE FEMMES, "LES BAUMETTES," MARSEILLES, FRANCE, 1991.

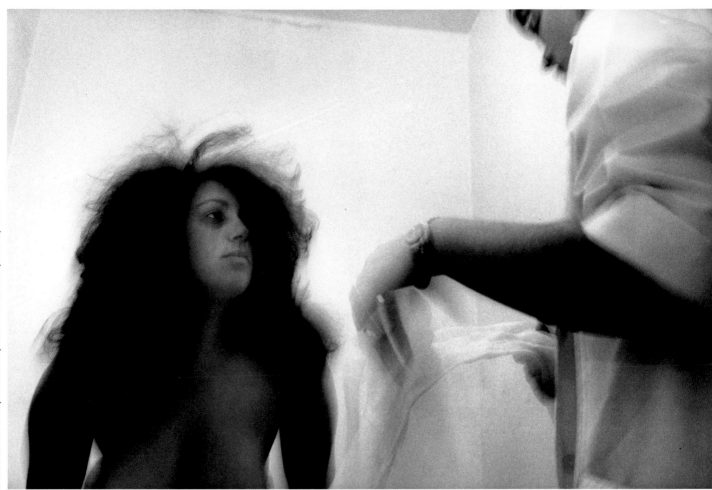

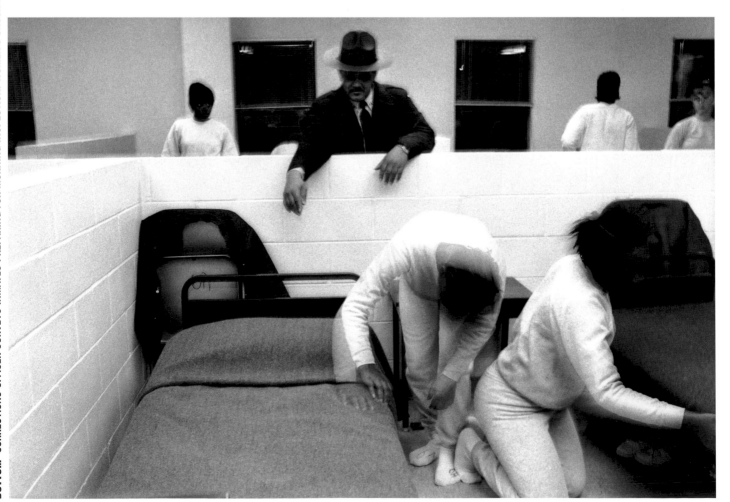

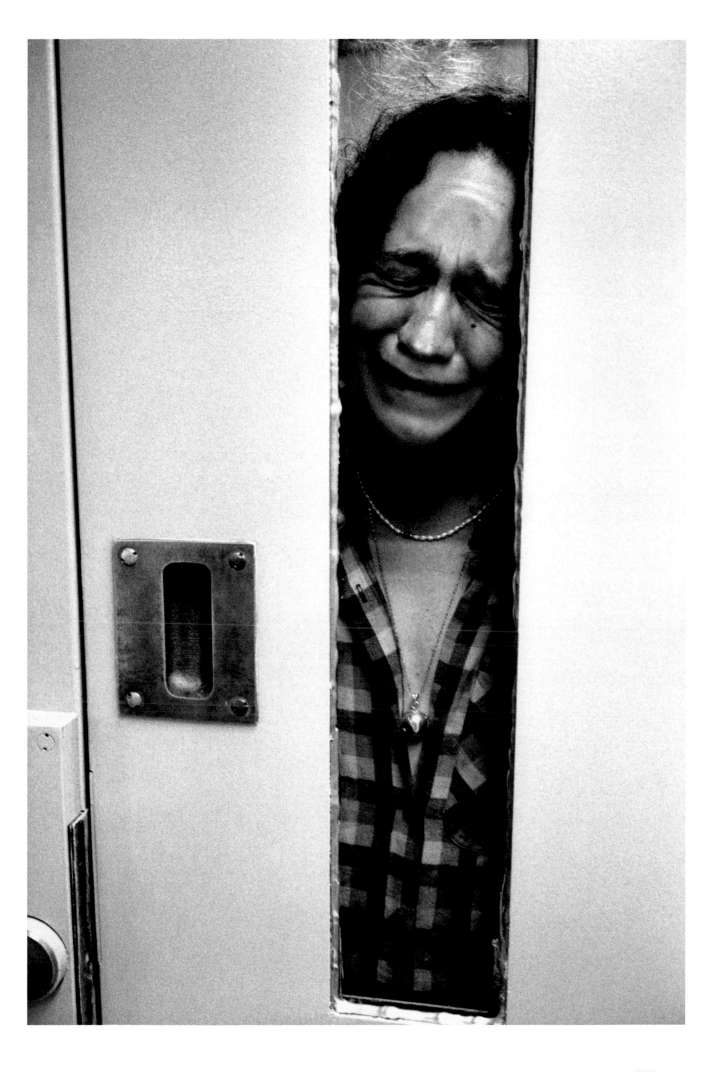

They charged me with conspiracy to commit a murder, first-degree murder, using a firearm I didn't even touch. But I guess that's the way the law works. I did a plea bargain for life in prison. My "red date" [first date one can apply for parole] is in 2022. It's come down two or three years. I've only been locked up six years.

I got life at thirty-six. Means I've got to do thirty-six years before the sentence is up. There was one insurance policy that my kids were able to get. The other one, I guess nobody got it.

My charge partner got life at thirty years. He contacted me but I never answered him. He married a correctional officer. She quit her job so they could get married. He's still in prison. I got one letter from him, that said his wife had left him. He thought I would be happy about it or something. He admitted shooting Bill. After the fact. Of course he was fifteen or sixteen at the time. I have to laugh sometimes to keep from crying.

I made choices. I was so insecure about whether I would be able to take care of myself, or my kids, whether I would ever get to see my kids again. Choices because of what the "public" would say: what my friends, my family, would think of me, if I divorced, left my kids. There's no way I could've supported those kids, other than to do the same thing I was doing when I was with Bill, prostituting. And I hated that with a passion. I mean, it was something I did to survive. And there were laws out there to help me out, but I did not know that because all I knew was the things he was telling me— "No, you're not getting the kids, everybody's going to know, you're a slut, there's no hope for you." It was the not knowing, the ignorance, my stupidity, really. It was my living in a fantasy world of I had to have a man, I had to have someone to tell me, "I love you, you do this, you do that." I'd always wanted it from my dad and I'd never gotten it. My daddy was a sheriff, and very domineering when he was home. I seldom saw him. The man was in charge of everything, he took care of everything. And I wanted my daddy just to pat me on the head and say, "I love you and I'm proud of you." But he was never there for me, right down to my wedding, when he would not even give me away in my own home.

But had I looked inside myself or had the knowledge, or somebody, somewhere, along the way that said, "Look, girl, let's sit down, let's go get you some help, there's more to it, there's a better way." I don't know then that I would have, you know what I'm saying? But I didn't. My stupidity, the choices I made, caused a lot of hurt for a lot of people. Yeah, because of men I'm in here, but also because of my ignorance. Reaching out to something that wasn't there, that really wasn't worth going for in the first place, you know? I've learned a lot since.

I thought to prove that you love somebody, you had to go to bed with them. I'd been doing that for years. I don't feel worthy of somebody that is dressed in a suit and tie and goes to work in a nice car. Oh, I can carry on a conversation with the lowest of the low, but you put me in a room with somebody that's got some kind of education I feel lost. My husband was educated, and very intelligent, and he always told me I was dumb and stupid. The man didn't make me do this, it was me. I made the choice. But had I been stronger, had I had some security....

THE WOMAN WHO LIKED KNIVES

In Juneau they were all talking about "the woman who liked knives." Max-max security, they said. She was that dangerous. Seems she stabbed a guy eighteen times, did not stop until they pulled her off him. Bonnie was in solitary and I spoke to her through the slot in the cell door. The prison would not allow the two of us to talk in her cell—too dangerous, they said, so they put her in a special room, the one where she showered and made her phone calls. The prison was short-handed and had to bring in someone extra, pay him overtime, to take me to this woman. When they moved her, prison policy mandated that the whole place was locked down; no one was allowed to move about in the hallways.

Bonnie was wearing an orange jumpsuit and her ankles were chained. Her wrists were cuffed and a chain stretched down from them and attached to another one that went around her waist. Between her hands she had the little rectangular black box that kept her from being able to twist her wrists in the cuffs. She was small, and the chains all over her weighed her down. The three guards, Bonnie, and I shuffled down the empty halls. The guards sat the prisoner at a table by the window and cuffed her to a long steel bar on the wall.

Bonnie looked at me as if she wanted to spill her guts, but she had a hard time getting started. Her eyes, sad and resigned, said she'd nowhere left to go, she'd reached the end of the line. Bonnie didn't look twenty years old.

Between the silences she told how her father-in-law had done it to her, cornered her in their own house, how he'd

OPPOSITE NEW ARRIVAL IN A HOLDING CELL. WILDWOOD PRE-TRAIL FACILITY, KENAI, ALASKA, U.S.A., 1993.
OVERLEAF GUARD SURVEYS INMATES AND THEIR GUESTS IN A LARGE, CROWDED VISITING ROOM—NOTORIOUS FOR BEING UNCONTROLLABLE. RUMOR HAD IT THAT PRISONERS WERE OFTEN PREGNANT AFTER VISITS. A GUARD EVEN POINTED OUT A MAN WHO PASSED DRUGS TO HIS GIRLFRIEND WITH HIS FOOT. MAISON D'ARRÊT DE FEMMES, "LES BAUMETTES," MARSEILLES, FRANCE, 1991.

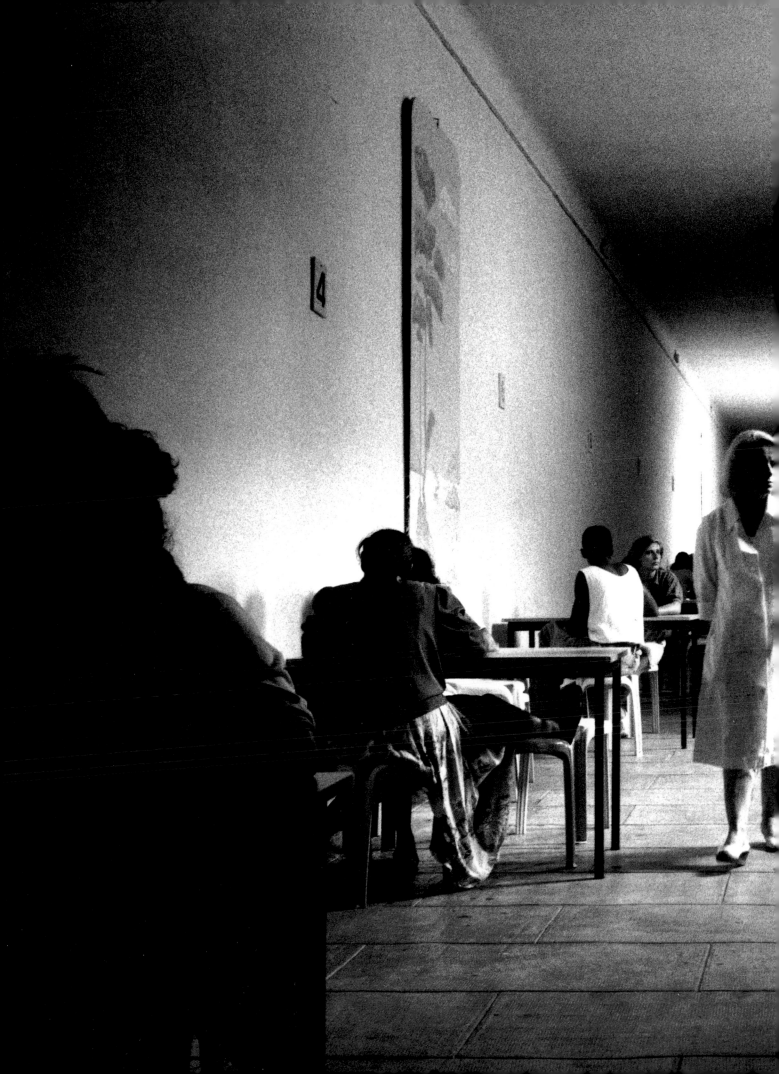

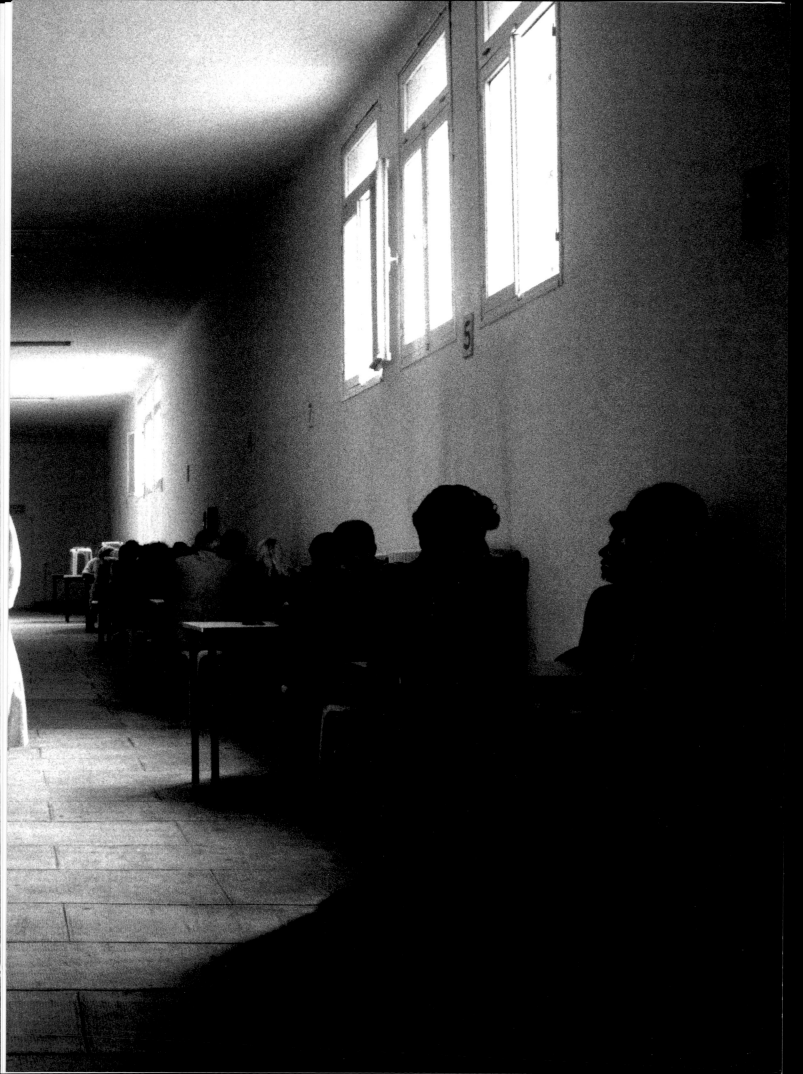

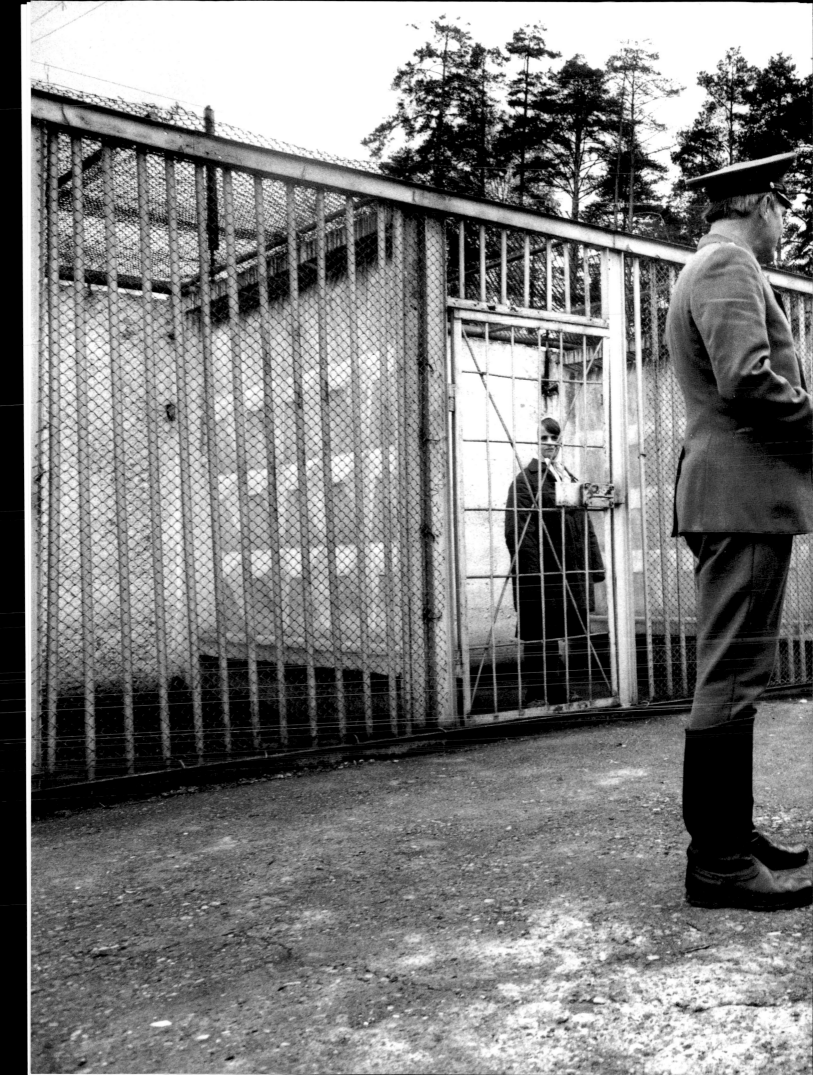

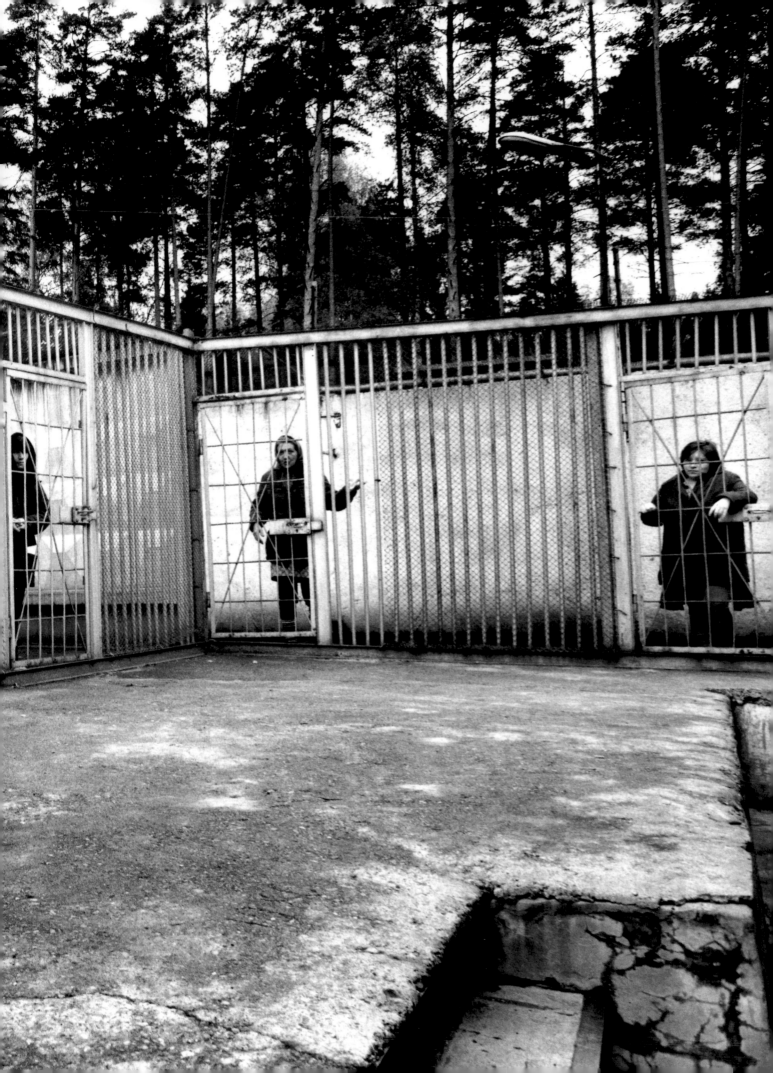

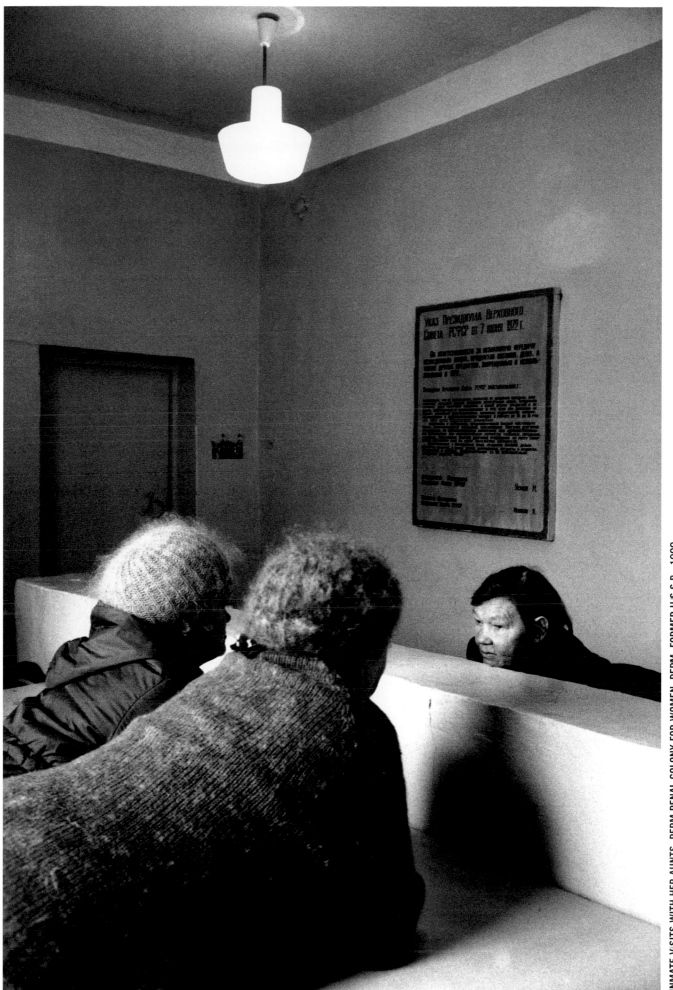

INMATE VISITS WITH HER AUNTS. PERM PENAL COLONY FOR WOMEN, PERM, FORMER U.S.S.R., 1990.

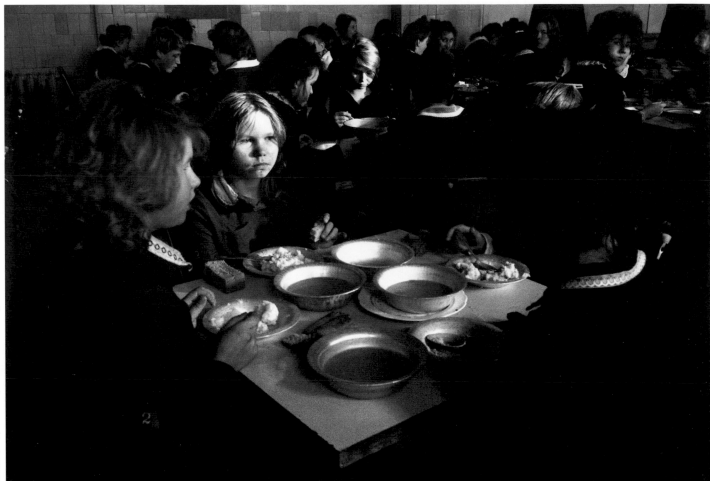

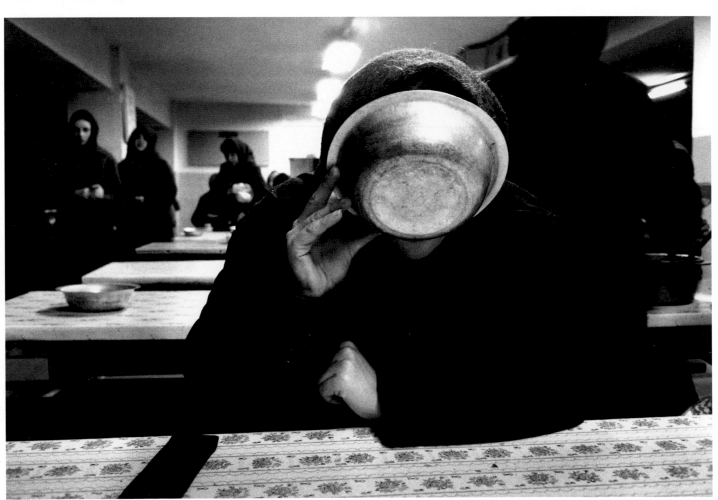

TOP INMATES' DINING ROOM. RYAZAN CORRECTIVE LABOR COLONY FOR JUVENILE DELINQUENTS. RYAZAN, FORMER U.S.S.R., 1990. **BOTTOM** INMATES' DINING ROOM. PERM PENAL COLONY FOR WOMEN, PERM, FORMER U.S.S.R., 1990. **OVERLEAF** PRISON SAUNA FOR INMATES. RYAZAN CORRECTIVE LABOR COLONY FOR JUVENILE DELINQUENTS, RYAZAN, FORMER U.S.S.R., 1990.

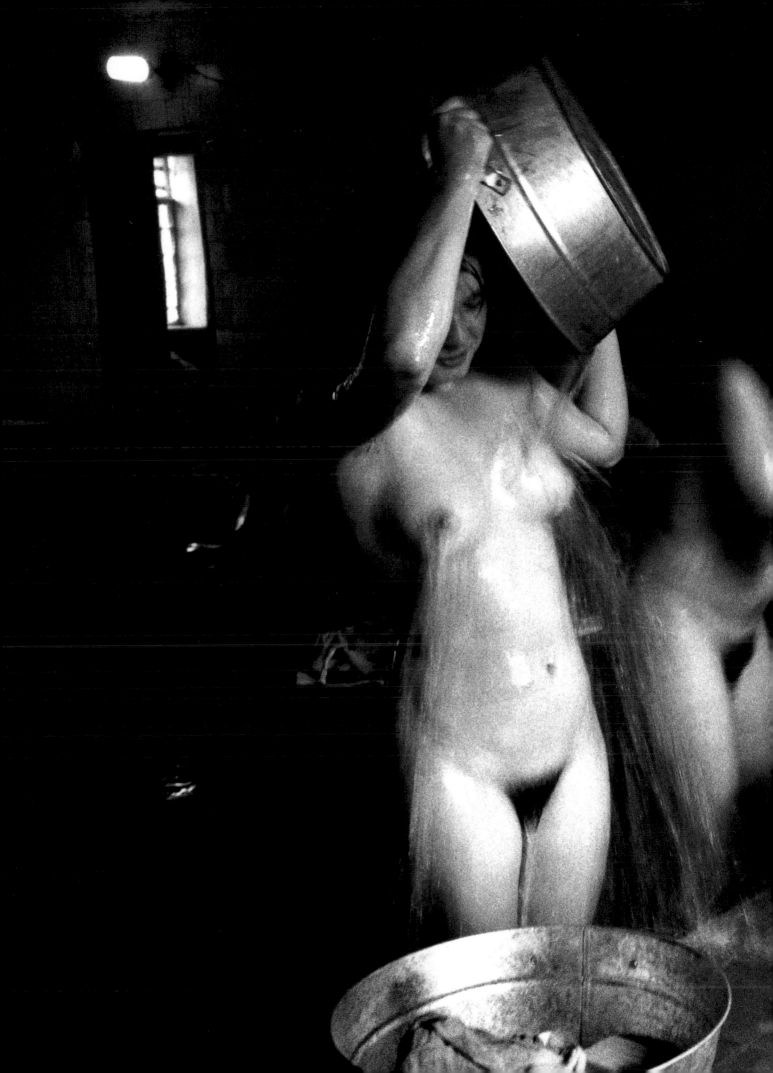

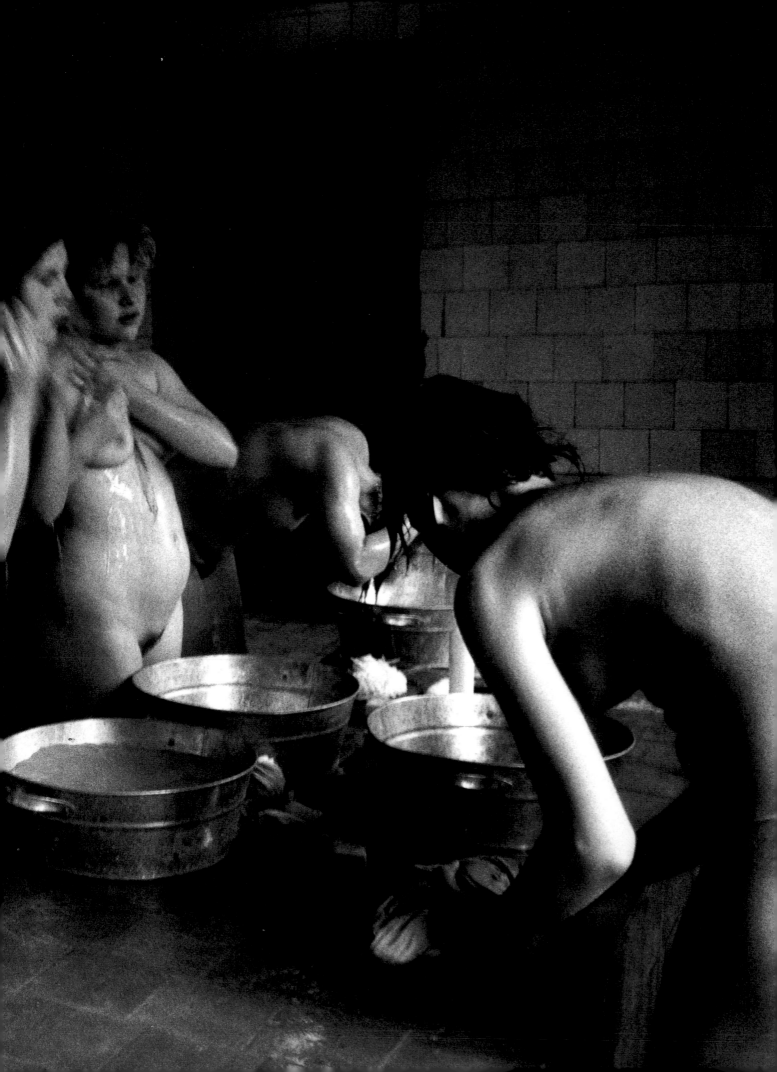

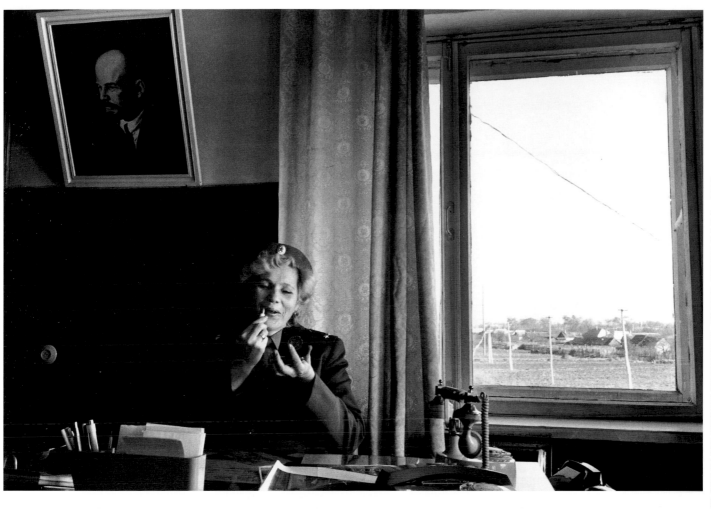

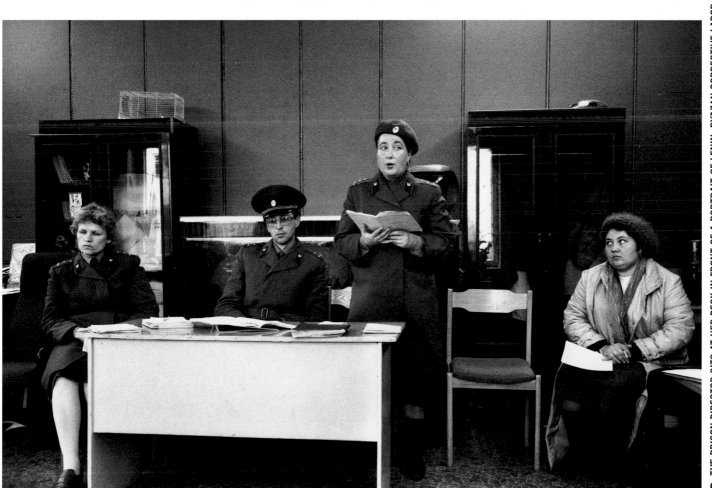

TOP THE PRISON DIRECTOR SITS AT HER DESK IN FRONT OF A PORTRAIT OF LENIN. RYAZAN CORRECTIVE LABOR COLONY FOR JUVENILE DELINQUENTS, RYAZAN, FORMER U.S.S.R., 1990.
BOTTOM PRISON HEARING TO DECIDE THE PUNISHMENT OF AN INMATE WHO MISBEHAVED. RYAZAN CORRECTIVE LABOR COLONY FOR JUVENILE DELINQUENTS, RYAZAN, FORMER U.S.S.R., 1990

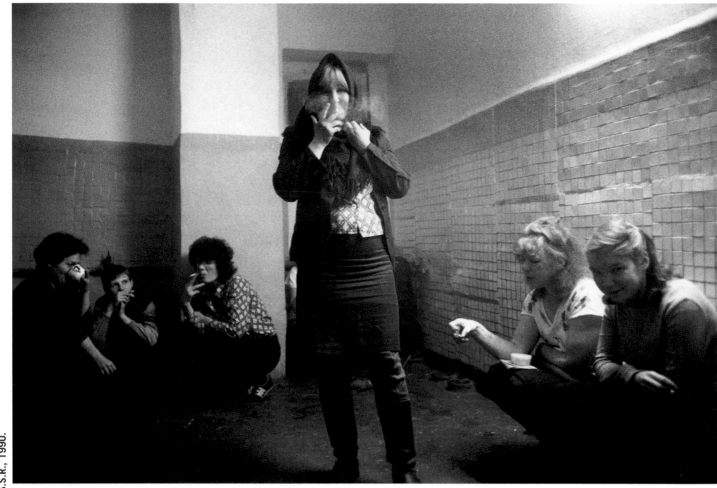

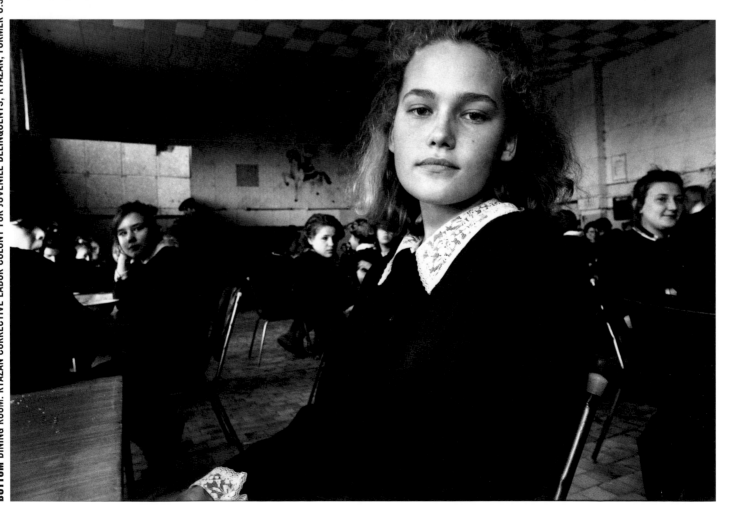

the only thing that stopped him was that last shot. Then he stopped and he said, "Oh, Cherise." I grabbed my grandbaby out of his arms because he was falling backward and I ran out of the room. And I had my daughter call the ambulance for him. And then I went back in the living room. That's the first time I saw anybody die. I saw his eyes roll up in his head and I knew he was dead.

I felt helpless. I felt helpless because it wasn't my intention that he should die. And nobody ever understood that. I didn't know what to do. I went into my bedroom and I got lost. The police came, they beat the ambulance there, and they couldn't get in the front door because Fred's body was laying across the front door. And so I helped them to get the living room window up, they had to come through the living room window. And I had to get dressed, I had to go down to the station to make a statement and I was still confused as to what had happened. Nobody told me for sure that Fred was dead and I didn't know for sure if I had shot my grandbaby when trying to get Fred off me. All these things were going through my mind, I wasn't understanding very well. I heard people talking. They asked me if I understood, I told them yes, but when I was really honest with myself I didn't understand anything. I didn't know my rights. They said they read me my rights, but I didn't know my rights.

First, I had a lawyer that one of my girlfriends had sent to represent me. And I didn't have $10,000 to pay the lawyer, so I had to let him go. Then the state appointed me a lawyer when I was ready to go to trial. He never asked me anything. During the trial all he did was sit there. The prosecutor witness, state witnesses came up, and they had my children. And the only thing I could do was say, "This is turning the children against the parent."

This is my first bout with trouble. I haven't even had a speeding ticket. My kids came to visit me about once every three or four months. When they had transportation they came. I have one son living in California and he comes twice a year to see me. And he brings his little boy and I can call him any time. At first the kids held it against me that I killed their father. At first they did. I think now I may have maybe one or two that have a little bit of feeling left inside about it, their personal feelings. Their father would cater not to the boys but the girls. They still loved him because I taught them love—even for all his bad points. But now they are finding out as they get grown and are able to look back on the situation that some of the things that he did wasn't quite right.

I had to get to the point where I realized it was me or him. And that it was all right that I chose myself. Now I did grieve quite a long time and instead of me letting the grief out, I would bring up anger to cover it. I'm angry. Well he shouldn't have done this, he shouldn't have done that. I couldn't think

anything good about it. And then it all changed. I started to see things in a different perspective. I wish it could have been different. I wish he could have been a person who could talk and who could understand, not someone always thinking he has got to get ahead, always thinking he has to use somebody and he has to be the boss.

My sister-in-law tried to get the death penalty. She got this line on me saying that it was premeditated, said that I had called her a week before and told her that I was going to kill him. Because she had been looking at television and on television for premeditated murder you get the death penalty. She has been trying to get it out of my children when I get out. We are in the same city, but in different parts of town.

I guess I'm afraid as to how people will react to me having been in prison and what I was here for. I'm afraid for their attitudes, how they perceived how I should feel and how I feel. Because I would explain myself to them if they wanted to hear it. I had nothing to hide. It wasn't as though I sneaked up behind Fred and killed him. To me there is a difference between killing and murder. Murder is when you lay little plans on how you are going to do something. Killing somebody is for the moment, when you don't have a choice. I would explain to them, I take my time and explain it to them.

I'm going home on the bus. My family will meet me. They wanted to come, but it's a three-hour drive both ways. And so I said I would take the bus home and they could pick me up at the station as I wanted a little time by myself, too. A guard takes you to the station because they have to purchase the ticket, they put you on the bus. The first thing I'm going to do when I get to Gary, with my daughter and my grandchildren is go to McDonald's. I've been thinking about a McDonald's burger for the longest time, a McDonald's burger and maybe some french fries.

CHERYL

I suffocated my oldest daughter. Jody was seven and a half. One night I decided that I couldn't take it anymore, I'd had it, this was the end of the road. I was supposed to go to work that night at my part-time job, and I called in so I could stay home with my children. About two o'clock in the morning I woke up and it was just weird, weird, weird. I tried to kill Helen, too, and she was jumping all over the bed screaming. She looked at me with these big blue eyes and it just hit me: "Cheryl, what are you doing,

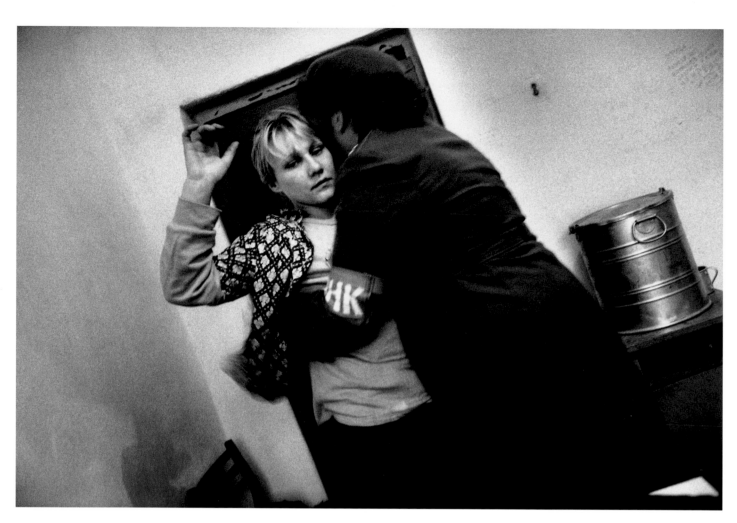
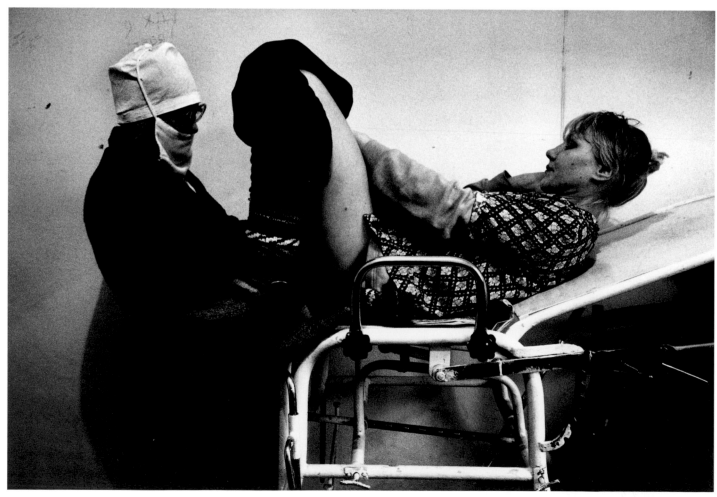

what have you done?" Then total panic set in.

I went over to Jody and she was already gone. I stood there and looked at her, and I remember feeling the skin on her face. Helen had fallen back asleep. I got dressed and I thought "Well, I have to call the police." I called 911 and told them I just smothered my child. I said, "Just please come, just please help me."

I went back with the police to the bedroom and this one guy looks at me and looks at Helen and Jody and at the picture on my wall, my nursing portrait, and he says, "Are you an RN?" I said yes. "Well, did you try CPR or anything with this child?" And I was like no, thinking, "Get out of the room, get out of the room put her somewhere else, put that baby somewhere else." I was like, Oh shit. I did not know anything. I mean, I was so stupid. I had just murdered one child, I tried to murder another.

It's really strange. I try to think back to that night, as horrible as it was. It's like I totally snapped, almost like I was in a disassociated state. The children had just gone back to school: daycare for Helen, and Jody had started second grade. I was paying the baby-sitter to watch them when I worked. I was totally sleep-deprived, at the end of all ends.

I have not seen Helen since I was arrested. They terminated my parental rights three days later. My mother and my sister, who lived together, were granted full custody. Now she is with them. She was four and a half. When I spoke to her on the phone she asked me point-blank: "Mommy, why did you kill Jody? It was the hardest question I think I've ever answered. I told her, "Helen, I don't know. Mommy was apparently very—something happened, I don't know." And her dad, he brought her up to the county jail and said, "This is the hotel where your mommy is going to have to stay." I'm forty-one. I've been here five years. The father of my children is my ex-husband's best friend. We were never married. He was married to someone else and still is. The girls' dad came up to see me once, and the only thing he had to say was that if there wasn't glass between us he would have tried to kill me.

We are a close-knit family. I have three brothers and three sisters. My mother had three sets of twins, a year and a half apart, all boy-girl. I'm the oldest by eleven minutes, and I'm extremely close to my twin brother. Both my parents were alcoholics. My mother has been recovered now about eighteen years. My dad is dead. All of a sudden, at the age of eight, I realized there was this man in my life screaming at us, and I was supposed to call him father. He was extremely abusive physically, mentally, sexually. I never told anyone about the abuse. At the time I didn't know you could prosecute. It was like one of those family secrets, so I never thought about that. My dad

threatened me continually. In the culture of that society in southern Missouri, it was just rampant. It was taken for granted that fathers did this to young girls. This went on from when I was eleven into my high school years—every kind of sexual activity, including penetration. In the shed, in his bedroom, where he worked, just everywhere. My mother said she didn't know, but I can't help but think, as I am going through the recovery and healing, that she knew something was going on. My father attempted to abuse my second middle sister, Judy, but she was real obstinate and wouldn't put up with it. One night my mother saw him standing over my younger two sisters and she kicked him out of the house and they got in this big fight. She filed for a divorce. My dad was disabled but he would get his Social Security check and be up and gone, drinking, migrating around like a gypsy, from Kansas to Missouri to Oklahoma. When the money ran out he would go somewhere else, stay in little seedy motels drinking. In '76 I got this call from my mom, "They just found your dad in a motel, dead three days of a heart attack." And I'm like, "Thank God, now he can't hurt anybody else." I had so much hate for my father that I don't believe I'll ever be able to forgive him. I don't have to, that's part of what I understand about my healing. His whole family was screwed up—there was a lot of brother-sister incest going on. My mom then told me he was molested by his mother— no wonder he was screwed up. When I was in school I had to prove to Dad I was an excellent student. I think it came from his belittling, his always making fun of me: "You are fat, you are going to be stupid and barefoot like your mother, you will never get a good job, you will never find anybody that will want you."

I was scared into the incest. It was like, don't tell anybody. I think that's why I learned to just separate myself from the situation at the time. One of his favorite spots for having sex was at this club where he worked. He would sit me on top of the coolers with the door that slid up. He would open the door and have me sit there, and he would do all these things he wanted to do, and then after that I would go clean up, and he would throw money all around the different booths and tables, on the floor, and anything I found I got to keep. I'd come home with twenty dollars in change. At the time, I was so excited about all this money. And years later, I realized it was just like he was prostituting me. We were a very poor family growing up. I started at the age of eleven working, washing dishes for fifty cents an hour. He would take the whole paycheck, plus his Social Security checks. My mother was working— everyone worked. When I went to school, he told me he'd give me five dollars for every A I made. When I'd ask him for it he would say, "You already got paid, you know."

I wanted to become a nurse ever since I was a young child. When I was in junior high I took every course the counselor told me to: chemistry, physics, Latin. I got in with no problem, because I was an excellent student. I was nursing supervisor on the night shift at a large hospital, about 250 beds. I worked that job for fourteen years. I also worked part-time in the intensive care unit of a different hospital. Usually every other weekend I was off, and I had a full-time job to make extra money.

At times I felt like I was a super nurse compared to my mothering instincts. I didn't feel like I could handle things with my children, whereas in nursing, in any situation at work, I could. I was the coordinator for the organ transplant team. That takes a lot of dealing with physicians, staff, different agencies. I always felt proud that I could handle that kind of stuff without even thinking. But when my children would get sick or something, I'd feel, here I am a nurse and can't even deal with my children. They didn't give you that manual in school. I punished my kids too much. If I had been tired and had a bad day at work or something I was easily irritated. At one time I thought I needed to talk to somebody about the sexual abuse, because it was really bothering me. I knew there was something wrong. I tended to have this obsessive-compulsive nature that was causing me financial problems even though I had two excellent jobs, bringing home over $3,000 a month. If my kids wanted or I wanted it, I pulled out the plastic and got it—paid more money for my credit card bills than my home. I did go to talk to someone at the hospital. The lady was real blasé—like, well, you are making more money than I am—what are you doing here?! I felt belittled and humiliated.

The thing for me is the guilt. It's tremendous. I've been active in groups and intensive therapy to try and help myself. But I just cannot forgive myself. One thing that has helped me is here the women know me as a person. [Crying] I told myself I wasn't going to do this. But when I first came to the county jail, everybody and their dog knew what I had done. The publicity was horrendous. The men on the other side would scream, "Send her right to the chair!" I was segregated. There were men on one side and women on the other, and at night they would bang on the door and the wall screaming, "Jody wants you, Helen wants you, their mother is in jail, she is going to get fried." The good Lord was the only thing that kept me sane in there. Every time my name would come over the radio, on the overhead speaker with the TV on, the shouts would start.

At two o'clock in the morning, I was allowed to take my bath. They would lock everybody down and come and get me. The first time I went back there, the women were screaming at me and taunting and I said, "Well, I was

ready for this, I knew it was going to be horrible because of what I did." So I just walked to my bath, and someone had cut out the picture of the girls from the paper and put it up on the wall, and then they poured pee in the bathtub. So I kept that picture, cleaned out the bathtub, said, "It's okay, we'll get through this." I still have that picture. It's in my photograph album. I've since met with the woman who did that. I've never said anything to her about it, but I have thought maybe God was meaning it for me to have. She is still here, and we are best friends. I'm a nonconfrontational person. If there's anything going on, I'm the other way and I'm in my room.

I had a hysterectomy in August and was supposed to have a postop check in four weeks. Twelve weeks later I had to remind the infirmary. "Oh yes, I guess we kind of forgot." So I went out that day with six other women, chained up like dogs—handcuffs, black box in between the handcuffs, chain around the waist, shackles on our ankles—and they had Susan Smith, the woman who drowned her children, on the news all morning. I thought, "O Lord, why are you sending me out to clinic this day?" The comments of all the women about a mother that would kill her child, how horrendous, went on and on.

One lady I worked with just could not understand how someone could do that. I had done an article in July of 1990 for the *Star* about parental burnout, and I shared the article with her, and it kind of opened her eyes. I don't want people to think that because of sexual abuse from your father that twenty years later you are going to kill your kids. I made choices that night, and they were horrible choices. As a result, I am here. I am accountable for what happened. One of the psychologists I talked to wondered if perhaps I was protecting my children from the horrendous abuse I had been through. I don't know. I just wonder why—that's been a wrenching question in my mind— why, why would I do it? Why would I go from being productive, a nurse caring for everybody, doing what I can, and then kill my kid?

I was never seen by a psychiatrist. Every time I went to court, my case got postponed because of this man who was arrested six months before me. He murdered his wife, and the prosecutor in South Bend was out to show the nation his notoriety and make a name for himself. It was almost a year later, prior to my sentencing, they thought maybe she needs to talk to somebody, have a presentence report or something. First they said I was going to the Regional Diagnostic Center for Men. But I couldn't go there, because I'm a woman. So they said, "Well, you can go to the women's prison and talk to the psychologist here on staff." So I waited almost three and a half weeks before I talked to the intake director for forty-five minutes

and talked to the psychologist for an hour. Then he brought me back. It didn't make any difference: they already knew what they were going to do with me.

In July of 1989, a law was passed that they would seek the death penalty for anyone responsible for the death of a child below the age of twelve. So my case continued and continued because of that wife-murder case, and finally they thought well, they had really nothing much to work with. No motive, no defense. I was so honest and tried to help myself, not knowing that I really didn't help myself. Then they decided that in order for my daughter not to testify against me, in order to protect her and not put this four-and-a-half-year-old child on the stand, they would bring me a plea agreement. If I would agree to thirty to sixty for the murder charge, twenty to fifty for the attempted murder charge, they would try to run those concurrent, and drop the death penalty. No postconviction release, no further avenue to get a new trial. So my lawyers were like, "It's your decision."

I was scared to death. It's like you are either going to die, or going to prison for 120 years. I got fifty years for the murder charge, forty for the attempted, running concurrent. Right now I don't feel like I've done enough time. I don't want to be a mockery to the court. If I had to do twenty years total, that would be wonderful. We have done modifications down here in the law library. I did them all the time. One lady had a murder charge, conspiracy to commit murder, two forty-year sentences to run concurrent, and she got out after eleven and a half years, from the legal work we did.

If I had to do twenty years, Helen would be about twenty-five years old, so she'd be an adult. I get to call her once a month, talk to my mother, my sister occasionally. When I first got here, I wrote to Helen's psychologist. I just wanted him to know that I was here, and would it be okay if I wrote to her and had telephone contact. He wrote, "I will leave all those decisions up to your mother and sister. Helen will be the one to decide when she wants to have contact with you, if ever." Grandma tells me her grades. She does very well. She will be in fifth grade. I send her many books.

The hardest thing is not seeing my family. I've seen my twin brother once, last year for the first time. Some people I thought would be there for me are completely the opposite. I had this thing about being honest with people. I wrote to my girlfriend who was my roommate in nurse's training. Well, she just freaked. She thought I would be in prison for check writing or something stupid like that. I got one anonymous letter. It was very special, a Valentine's Day card. The person just initialed in "L" and said, "Everyone deserves a valentine." Come to find out, it was a gentle-man that picked up the paper and just happened to read about it on the airlines going out to Texas or something. He started writing to me and came to see me. We wrote, and he sent me flowers—roses. I was totally shocked. There was no romantic interest, he was just a nice guy who wanted to be my friend. The last time I tried to call, his number had been changed. I haven't heard from him.

I know that regardless of my situation, there is always someone worse. I know I have to be here. Society says when you commit this kind of crime you go somewhere. Some in here are never going to get out. But I don't know how anyone can say that if you go to prison and stay in this room for twenty-five years, that will absolve what you did. I have a real problem. I read the Bible and it says thou shalt not kill and talks about murderers and rapists and all this, and I think, well, how do I know? I've asked for forgiveness from God. I remember having a kind of a conflict with that, because I know He forgets, and it's like the little sand pebble washed out to sea, never to return. If I can't forgive myself, how do I know that He can? This is really hard for me. I have always believed that things happen for a reason, but what kind of reason is that? I'm trying to make this totally irrational act rational. I'm trying to make everything intelligent. Well, it doesn't work that way.

Of course you learn to wait, you learn to take turns, that's life. But I have adapted my schedule so I'm the first one in the shower, the first one to get clothes in the washer. It's not that I'm trying to manipulate the system, I just know what works, it's the way I make it in this kind of environment. I have always had compassion. It has made me realize how vulnerable people are in this situation. Being photographed is healing for me, it's cleansing. If anyone can be helped by this, it will help me deal with my situation. If it could help just one person, save one child's life, it would be worth it.

It's overwhelming when I think, here I am, sitting in prison for killing my child. I can't comprehend it. Since this happened, certain things in life have passed the point of no return. One of them is, I'll never have Jody again. I have to live with that every day of my life. And how it's affected my family. It's really scary to think what Helen might be going through, and to know that one day she may not even want to be part of my life. That's why I try to maintain contact with her and treasure those moments. I realize when she gets older she may say, "Well, you're not my mother." But that's also one of the reasons I've been honest with her.

I think prison is harder on women because we are mothers. Being separated from your children is overwhelming. And the loss of a mother in a child's life. It's

hard for me to ask somebody for something. I have goals of saving money so that when I walk out this gate, wherever I'm going, I'll have enough to secure a place to live. If I get out after twenty years, I'll be fifty-five. I'd like to go back to work as a nurse, but I don't know if that will be possible. They took my license away when I came here. Hopefully I'll be able to do something. I'm going to work somewhere, even if it's cleaning toilets the rest of my life.

SALLY'S POEM

A native woman whose last name was so long everyone just called her Sally S., she'd been in prison in Alaska for almost twenty years. She spoke about the infanticide that would lock her up for so much of her life.

Sally's cousin raped her, again and again. When she became pregnant and confronted him, he told her she was on her own. She recalled the cruel way he'd laughed at her, how he'd mocked her, saying she was just a native woman; he was a man. Hiding her pregnancy wasn't too hard for Sally in the cold. She was always bundled up. She knew when it was time, and went deep in the woods to give birth. She was completely alone. Squatting over the frozen ground, she clutched the branches of a pine as she writhed in labor. The needles pierced her palms, but she said that their pain dulled the pain in her belly. When it was over, hours later, she cut the umbilical cord with a pair of scissors. Then, Sally told me, she plunged the same scissors into the child's tiny chest, shielding the baby's eyes with her hand. Later, one of the tribal elders saw the body floating on the partially frozen lake where Sally had thrown it. This is the poem she wrote:

ONLY WISH
I feel trouble insight of me, it isn't the
kind of trouble I see everyday.
I feel trouble insight of me, only wish
I had tell my baby I didn't meant to hurt her.
I only wish how much I can show her
I needed her around; I only wish how much
I wanted her to be alive and to be around.
I only wish I hadn't killed her so I can
be with her to show her the things I
use to do, and to tell her "I love you."
I only wish I can tell her so much that
I had never told her the things I went through.
I only wish. . . . But I do know somewhere in
my heart she knew them all. But how does
she know? I'll never know!
BY SALLY S

KILLERS

The women's prison in Rouen, France, is a former convent, unrestored, with inmates instead of nuns living inside. One tiny window, too high to see from, offers the only daylight for these high-ceilinged, damp, stone-walled cells. Most are cramped with two single beds, two night tables, two armoires, a sink, and a toilet without a seat jutting out of the wall and into the cell space, without even a curtain to hide it. Even before they are tried, the accused live for years in France in prisons like this one. (In November 1993, France was ordered by the European Court for Human Rights to pay 225,000 francs (about $45,000) to Michael Kemmache, convicted in 1991 for trafficking counterfeit dollars, after he was forced to await trial almost four years in prison.) Cell doors open onto narrow parapets that rope around a wide-open space in the middle, covered with a suicide net to keep inmates from instant death if they throw themselves over the edge. These are the galleries, where guards rush, carrying old-fashioned bunches of keys. Their clashing sounds, along with the slamming of heavy, dungeonlike doors and the ring of harsh voices, echo through the cavernous space.

While a male inmate who is clever can stay outside his cell all day, going from one activity to another—gym, library, work detail, classes, arts and crafts, canteen, visiting rights, medical appointments, drug or alcohol rehabilitation meetings, religious groups, not to mention showers and meals—female inmates spend twenty-three of the twenty-four hours in a day locked in their cells. The little work that exists for women prisoners in France remains purposeless and degrading. Women in the Châlons-sur-Marne jail sew the cuffs of Benetton sweaters by hand, for a pittance, while others put together French briquets (cigarette lighters), pushing the metal part at the top of the lighter down onto the plastic base. Sometimes there were designated work areas, but often these activities took place in the cells. Piles of undyed Benetton pullovers filled the tiny spaces until the work was finished, and metal dust from hundreds of lighters coated the surfaces. Because there was nothing else to do, the inmates were reluctant to complain about the little work that was offered. And of course, only the select few who had proven their capabilities were even given the available work.

Gym or exercise classes for women were sporadic. Sometimes, in summer, an instructor was brought in to conduct classes in the yard. The detention centers at Rennes and Joux-la-Ville were exceptions; there they had regular activities. But those women were in for

long terms—ten years to life—and there were many more of them. The excuse elsewhere is always that because women prisoners are so few, no budget exists to provide activities for them.

Although France allows its women prisoners to keep their babies with them until they are eighteen months old, of the twelve prisons that I visited, only Fleury-Mérogis had a true nursery. In the other prisons, the babies lived in the cells with their mother and her cellmate.

In France, the women who were in for murder convictions, who had killed, lived in shame. They rarely wanted to speak about their crimes, even when they believed they had killed to protect themselves or their children. Two women who shared a cell at the Châlons-sur-Marne jail never came out, not even for yard privileges. One was serving fifteen years for failing to report her husband when he molested their four-year-old child. The other woman was serving time because when she learned that her husband had been raping their daughter she killed him. In Rouen, a battered woman whose husband had burned her with cigarettes finally killed him with a knife. The same policemen who had repeatedly come to their house before nevertheless testified in court that this husband was "not violent." The wife is serving twelve years.

Another woman, twenty-two years old, was waiting to be sentenced for the murder of her father. When her mother came to visit, they communicated by telephone, separated from each other by thick glass. The guards told me that the gyrophone, as it is called, is used only in situations the authorities consider potentially dangerous. "My father collected women the way he collected guns," the girl told me. She had killed him with one of those guns. Why? "He cheated on me, the way he cheated on all his women."

A young Algerian girl was sharing a cell with two other teenagers at the Maison d'Arrêt in Metz. She was seventeen when she discovered she was pregnant. She couldn't tell anyone, or ask for help, because she was sure her father would kill her if he found out. So she hid her pregnancy, gave birth all alone, and threw the newborn baby into a dumpster. When they found the child, he was dead. She was awaiting trial for murder.

In men's prisons, a man who has killed or molested a child is typically separated from the rest of the inmates—or they will tear him apart. In the women's prisons, there is often no such segregation policy, though unofficially it is still the unspeakable crime, the lowest of the low. One particular woman was serving time in a French jail for infanticide. Reluctant at first to get near her, the other inmates did eventually include her in their circles. But they talked about her in horror behind her back. Did they see themselves in her—and hate her for

it? With many women who were serving time for infanticide, their stories varied, but revealed a common theme: a woman's fear, a man's power.

In Versailles, a large, depressed woman asked me to come to her cell. On the walls were pictures of her children, six years old and six months old. She strangled them both when her husband said he was going to take them from her. Afterwards, she tried to kill herself with pills. When I asked why she wished to be photographed, she said it was important—it helped her to accept what she had done. I learned later that she hung herself.

One woman, Nathalie, then spoke about the death of her child. She claimed it was her husband who did it, but she'd been sentenced to ten years for assault and battery. She began to cry as she told me the story. My instinct was to take her in my arms, not take photos. I wondered if she was telling the whole truth, but finally, it did not matter. Whatever had happened, she was not the only one to blame in what was an unimaginable nightmare.

Arlette was serving time at the Maison d'Arrêt in Versailles. She had been a teacher and the director of a private school, which already set her apart from the others. Strait-laced and conservative, she spoke in short, dry sentences. She was quiet, her face expressionless, with large vacant eyes. She told a story of how her marriage had fallen apart, how her husband had had one affair after another, how he had left her alone in their house while he stayed out and carried on with his girlfriends. He had finally demanded a divorce, threatening to use her drinking in order to get custody of their son. Arlette decided that the only way out was to kill herself and the child. She said she had taken her six-year-old son and jumped out of the window of one of the highrises at La Défense with him in her arms. The child died. Arlette was in the hospital almost a year, and was now awaiting trial for homicide. In the meantime, her husband sold their house and started a new life. He had never come to see her. The teachers in Arlette's school and the mothers of some of her students remained loyal to her, and visited her in prison.

Quite a few months later, I ran across a different account of her story. According to a newspaper article, Arlette's husband had indeed threatened her with divorce on the pretext of her alcoholism. Arlette was sure she would lose custody of her son. The day before the crime, she went to a clinic that measured the degree of alcohol in her blood. When they told her it was well above normal, she panicked, called a friend and babbled in a confused manner about prison and divorce. The next night, at 1:00 A.M., she went to the station to throw herself under a train, but no trains were running at that hour. She

returned home and called her sister, delirious, claiming responsibility for a deadly car accident. She took her son ("I wanted to die with him. I loved him too much," the paper quoted her as saying) and returned to the station; still no trains. They waited, returned, went back home. Finally, she took the child to a pond in Vélizy. When she walked into the water, he followed. According to the article, Arlette didn't remember much after that, only that, "There was no one to hold my head under water." It was later that day that she opened the veins of both wrists and threw herself off a building at La Défense.

Why did she change the truth of what happened? The newspaper said Arlette's relationship with her son was "fusionnel," fused, merged as one. It said Arlette had spoken of them "working together" at her school where she brought him each day, of having lunch together. It said she and the little boy slept in the same bed; her husband had long since moved to their son's bedroom.

A year after her suicide attempt, her body mended but her mind confused, Arlette doesn't recognize her own sister, still thinks her son is alive, and speaks of an imaginary conspiracy. She was transferred from prison to the psychiatric hospital, but the experts later rejected the idea of insanity. One psychiatrist views what she did as "an act certainly directed against her husband," but, he claims, "she is not sick, and though she has signs of a psychopathic personality, it doesn't fit into any defined pathology." A colleague drew a similar conclusion, stating on one hand that Arlette has "lost touch with reality," but on the other, that she "doesn't belong in a psychiatric hospital." A friend blamed Arlette's husband: "He drove her to despair." At the trial, the husband actually wondered why he and his friends hadn't heard her repeated cries for help, or seen her slow yet inexorable journey into an imaginary world. He even pleaded to the prosecution, "It's useless to put Arlette in prison—what she needs is medical care." Instead the jury sentenced Arlette to seven years. A year into her sentence, Arlette was haunted by the story of another prisoner who killed both her children and tried to commit suicide. The woman did her time, and the day they let her out, she killed herself.

VANESSA'S BABY

Vanessa was seven months pregnant in jail. When her water broke, she was taken to the city hospital by two armed men: the first, a prisoner transport officer (PTO), the second, a contract security officer. When Vanessa had to be examined, the shackles on her legs were lifted and handcuffs were snapped around her wrists. Her baby was delivered by cesarean. This

Alaska hospital does not like an inmate to be cuffed while giving birth, and sometimes can push the authorities to forgo it if she's been sedated. But the prison is responsible for the inmate. During Vanessa's cesarean, the doors of the operating room were wide open and the male armed guard, decked out in mask and gown and sterile slippers, stood just outside, staring in.

Vanessa was scared and agitated. They had given her an epidural and a tranquilizer. Her wrists were cuffed. Was there really a chance she'd be able to get up off that table and walk out? Ten minutes later her baby was plucked from her body and whisked away—all two pounds and twelve ounces of him. The new mother was sent to the recovery room. The transport guard ate a take-out dinner at a counter a few feet from her bed. When Vanessa later asked to see her baby, she was pushed out on a rolling bed, her legs shackled, armed guards flanking either side. We made our way doggedly down the halls to the neonatal care unit. This was a vast, open room dotted with knots of people clustered around too-tiny babies, some in incubators and some, like Vanessa's, lying naked and purple under hot lights. Like newly hatched chicks, but with no fluff.

When I tried to photograph Vanessa looking at her son for the first time, a man in a suit stopped me. He came out of nowhere, suddenly. He told me I couldn't take a picture of the baby because Vanessa, a prisoner, did not have legal custody. Everybody stared. I tried to explain that I didn't need to photograph the baby's face; I could just take one photo from behind, showing Vanessa's expression as she looked at him...."You may not photograph any part of the baby at all," the man broke in. "This baby has rights, you cannot abuse them. Please respect this baby's rights!" I stared in disbelief at this satire of American ethics. But the man had a badge with his picture on it and the word SECURITY above his name. I had just walked in with the guards and Vanessa and, in fact, didn't have official permission to take pictures in the hospital. I didn't want them to kick me out now. I lowered my camera. The next day Vanessa told me that although she did not have full custody, she had the right to "parental decisions." She made one then: she signed a release.

Vanessa leaned over the tiny body of her son, crying. Under her hospital gown, the long slit across Vanessa's stomach was held together by a jagged row of metal staples. Once again, her legs were in iron chains so she wouldn't run away.

OVERLEAF THIS FOURTEEN-MONTH-OLD BOY SPENT HIS LIFE IN PRISON WITH HIS MOTHER AND HER CELLMATE. MAISON D'ARRÊT DE FEMMES, "LES BAUMETTES," MARSEILLES, FRANCE, 1991.

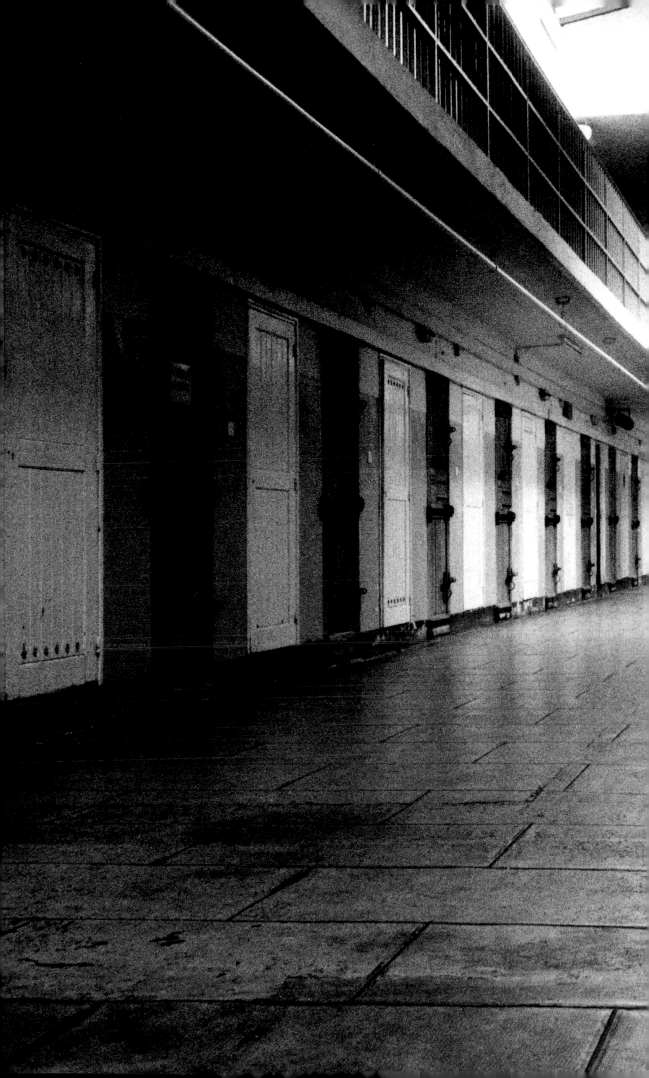

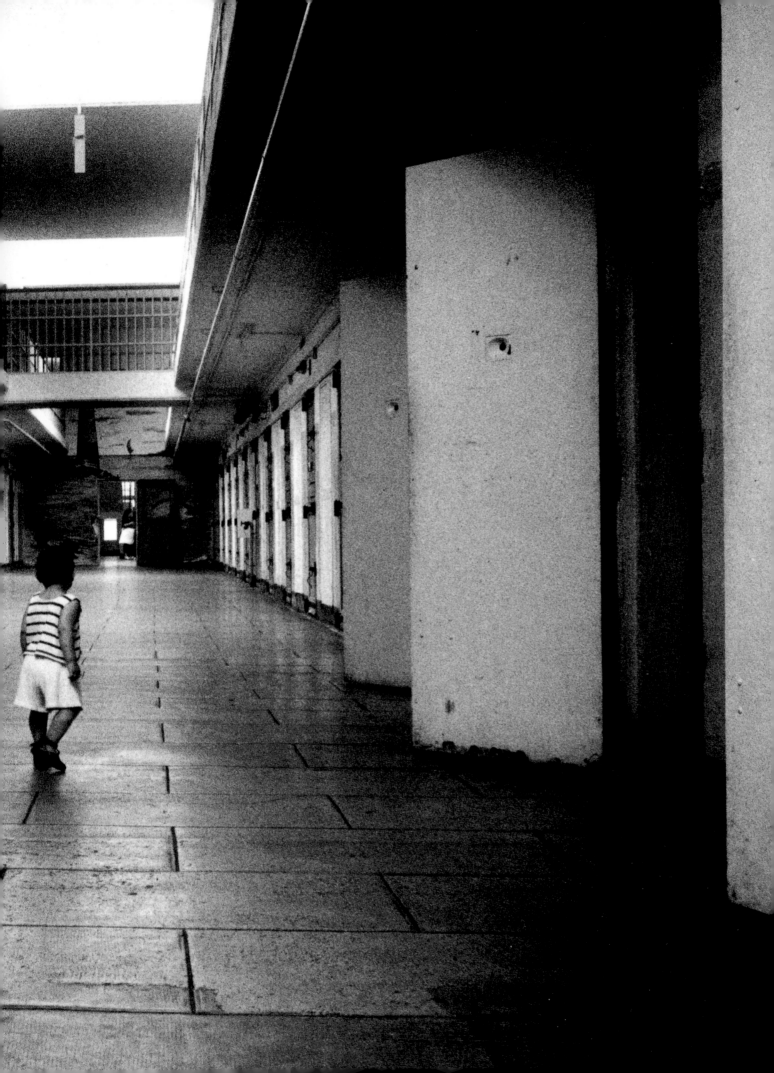

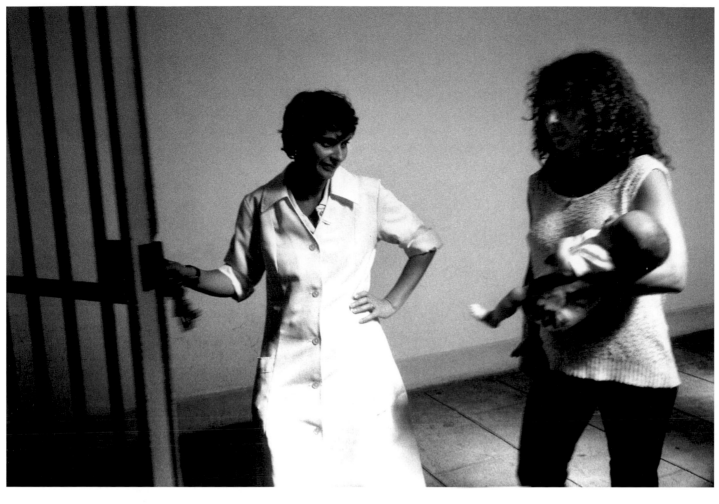

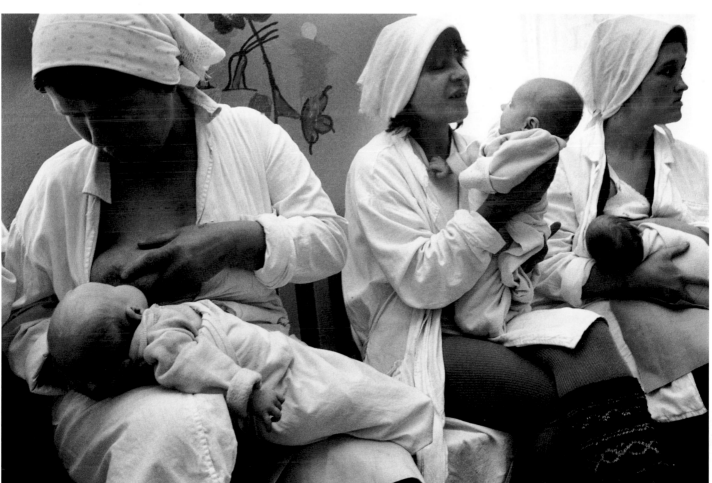

TOP INMATE LEAVES THE VISITING ROOM WITH HER BABY. MAISON D'ARRÊT DE FEMMES, "LES BAUMETTES," MARSEILLES, FRANCE, 1991.
BOTTOM PRISONERS ARE ALLOWED DAILY VISITS WITH THEIR CHILDREN IN THE NURSERY. PERM PENAL COLONY FOR WOMEN, PERM, FORMER U.S.S.R., 1990.

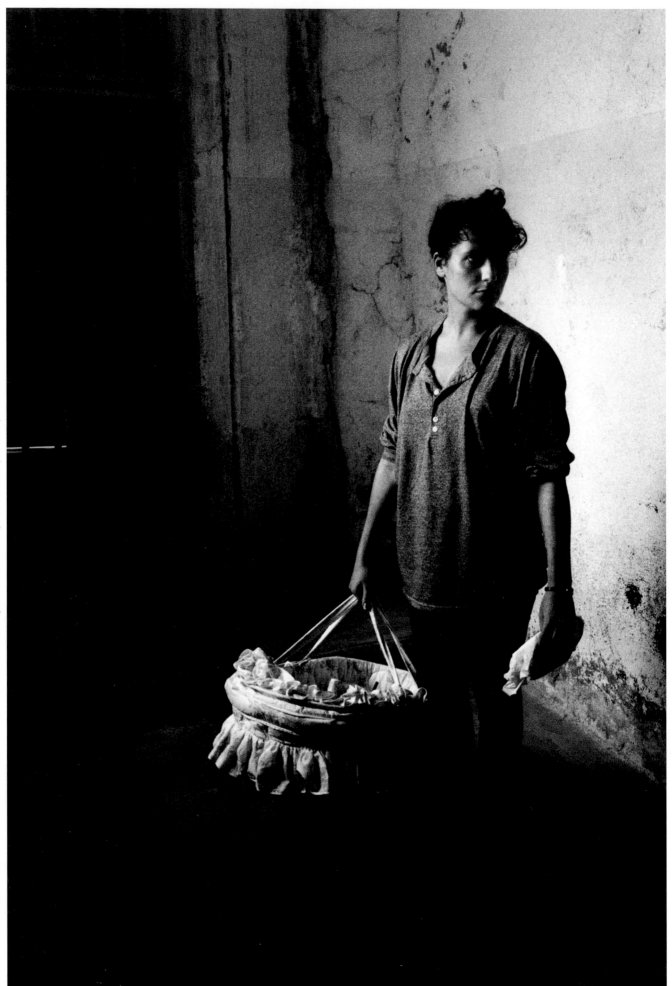

PRISONER WAITS WITH HER BABY TO GO TO THE YARD. MAISON D'ARRÊT DE FEMMES, "LES BAUMETTES," MARSEILLES, FRANCE, 1991.

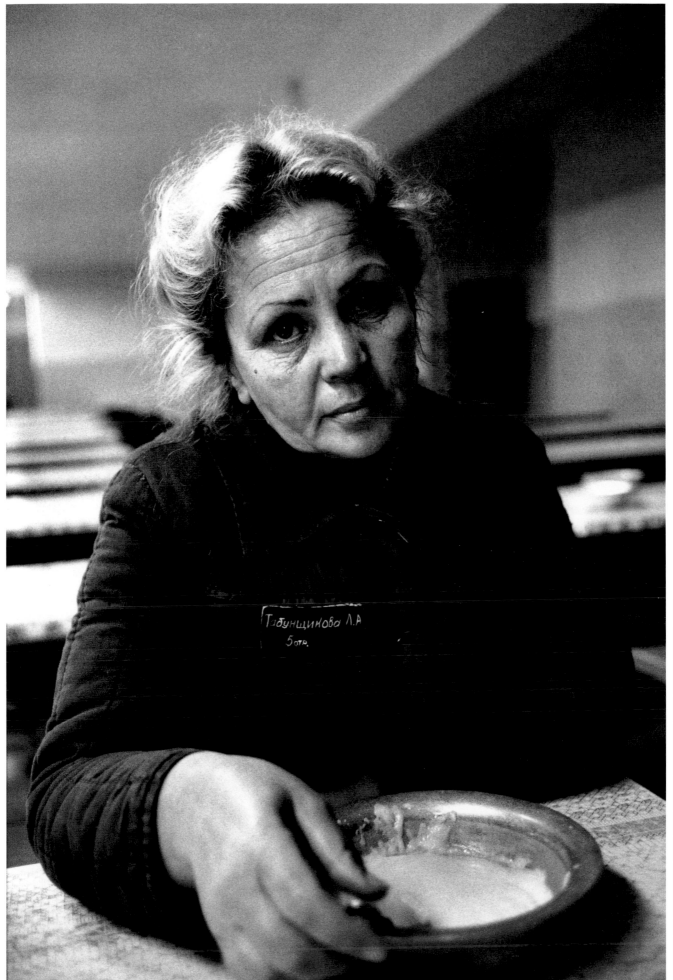

Габунщикова Л.А
5 отр.

PRISONER IN THE DINING ROOM. PERM PENAL COLONY FOR WOMEN, PERM, FORMER U.S.S.R., 1990.

MOTHER'S DAY CARD FROM A TEN-YEAR-OLD BOY TO HIS MOTHER, WHO IS SERVING TWENTY-FIVE YEARS FOR KILLING HER HUSBAND AFTER YEARS OF ABUSE. SHE'D GONE TO TRIAL INSTEAD OF ACCEPTING A PLEA FOR TEN YEARS WHEN HER LAWYER SAID HE COULD WIN. SHE GOT MORE TIME, SHE SAID, "THAN MEN GET WHEN THEY KILL THEIR WIVES." TENNESSEE PRISON FOR WOMEN, NASHVILLE, TENNESSEE, U.S.A., 1995.

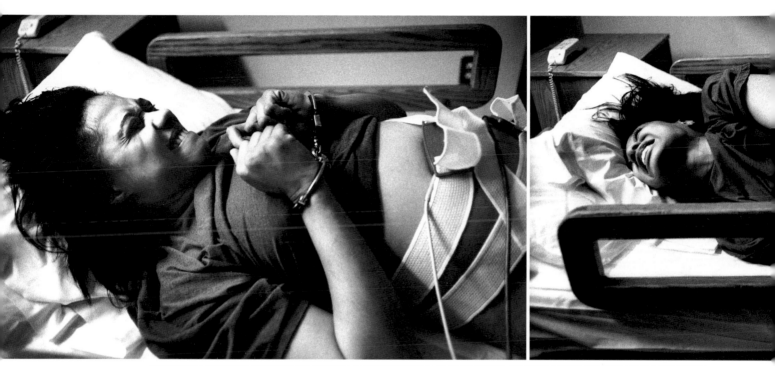

HANDCUFFED, PREGNANT INMATE WRITHES IN PAIN DURING GYNECOLOGICAL EXAMINATION, MOMENTS BEFORE SHE GAVE BIRTH BY CESAREAN.

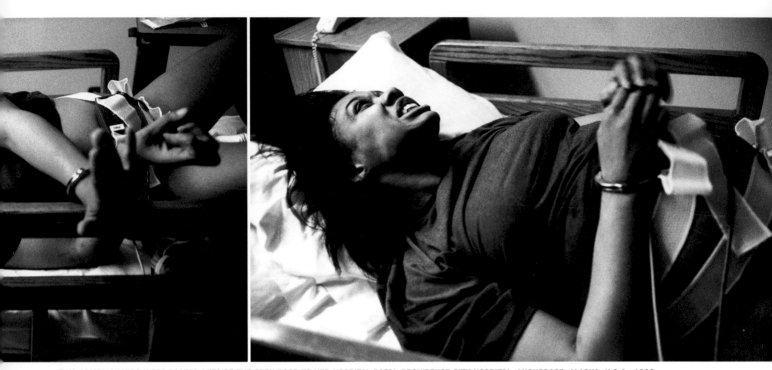

TWO ARMED GUARDS WERE POSTED OUTSIDE THE OPEN DOOR TO HER HOSPITAL ROOM. PROVIDENCE CITY HOSPITAL, ANCHORAGE, ALASKA, U.S.A., 1993.

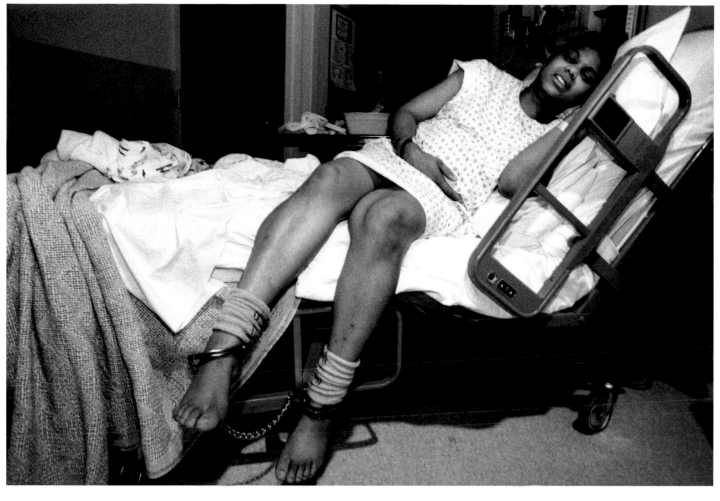

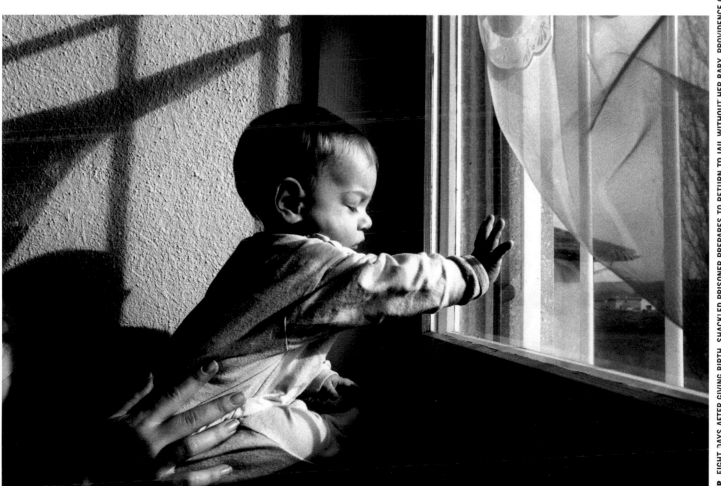

TOP EIGHT DAYS AFTER GIVING BIRTH, SHACKLED PRISONER PREPARES TO RETURN TO JAIL WITHOUT HER BABY. PROVIDENCE CITY HOSPITAL, ANCHORAGE, ALASKA, U.S.A., 1993.
BOTTOM BABY BORN IN THIS SWISS PRISON IS PERMITTED TO STAY WITH HIS MOTHER UNTIL HER RELEASE. HINDELBANK PRISON FOR WOMEN, HINDELBANK, SWITZERLAND, 1994.

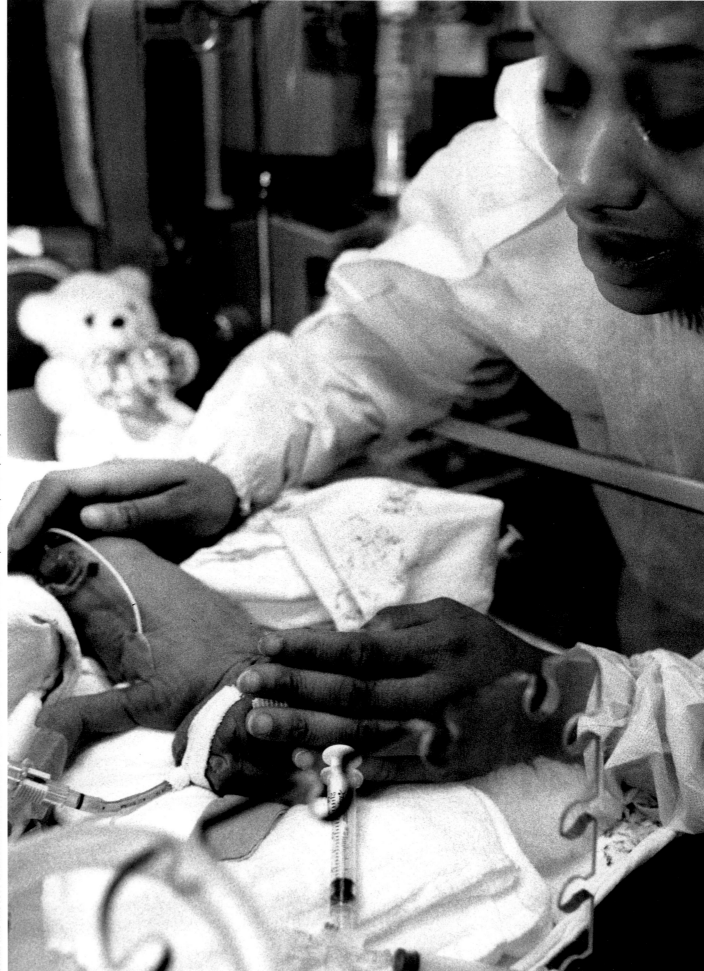

PRISONER WHO HAS JUST GIVEN BIRTH VISITS HER BABY IN THE NEONATAL UNIT. PROVIDENCE CITY HOSPITAL, ANCHORAGE, ALASKA, U.S.A., 1993.

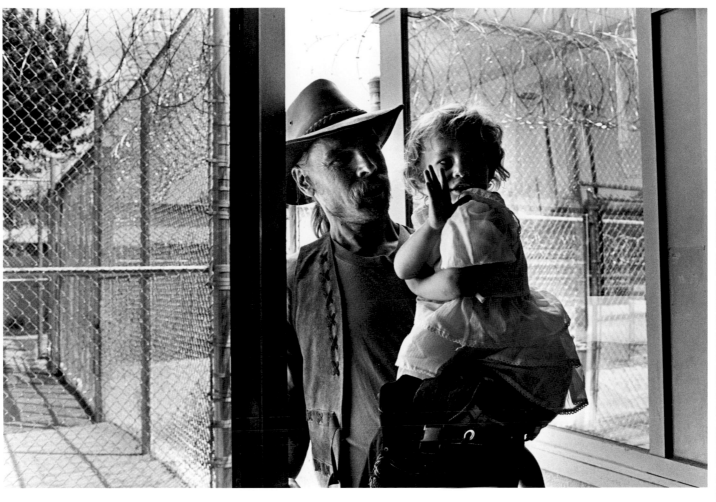

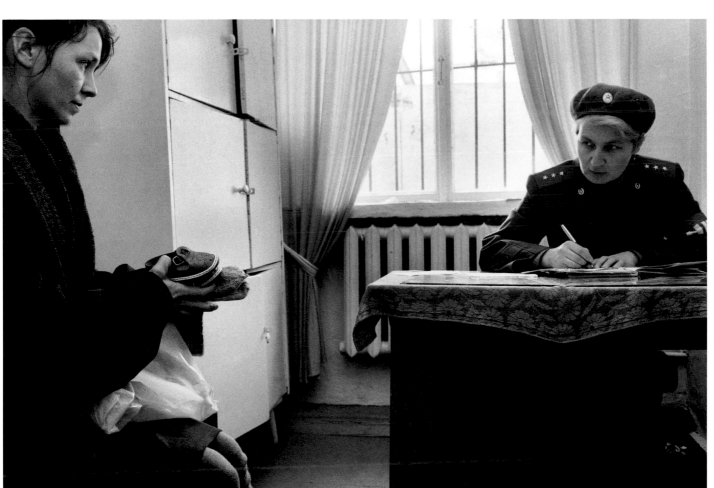

TOP FATHER AND DAUGHTER LEAVE PRISON AFTER VISITING MOTHER INCARCERATED FOR SEVEN YEARS FOR DELIVERING MARIJUANA. NEBRASKA CORRECTIONAL CENTER FOR WOMEN, YORK, NEBRASKA, U.S.A., 1997.

BOTTOM INMATE GOES THROUGH FORMALITIES OF RELEASING HER EIGHTEEN-MONTH-OLD SON TO HER MOTHER. RUSSIAN LAW REQUIRES CHILDREN TO LEAVE PRISON AFTER THIS AGE. PERM PENAL COLONY FOR WOMEN, PERM, FORMER U.S.S.R., 1990.

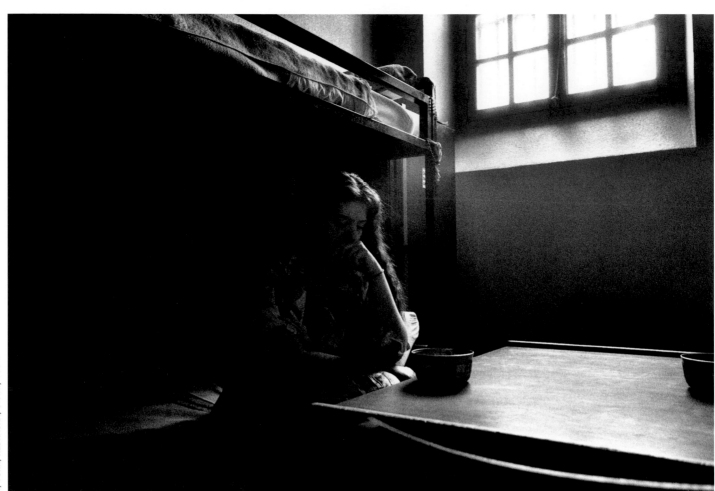

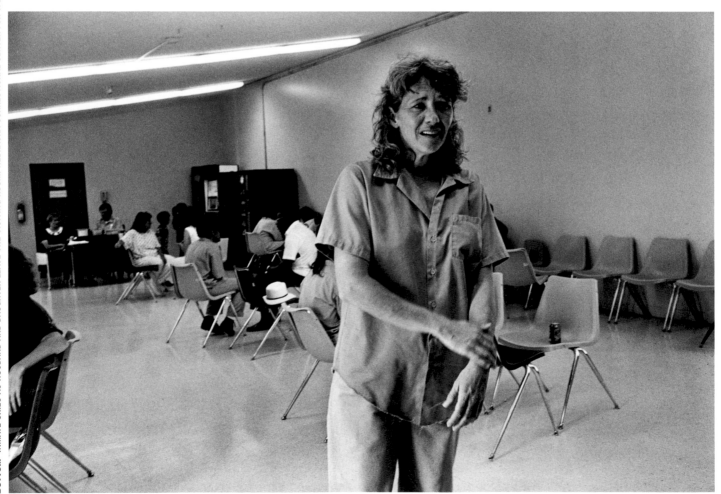

TOP THIS WOMAN STRANGLED HER TWO CHILDREN AND SAID IT WAS IMPORTANT FOR HER TO BE PHOTOGRAPHED BECAUSE IT HELPED HER TO ACCEPT WHAT SHE HAD DONE. LATER, SHE HUNG HERSELF. MAISON D'ARRÊT DE FEMMES, VERSAILLES, FRANCE, 1991.
BOTTOM INMATE CRIES AS HUSBAND AND DAUGHTER LEAVE THE VISITING ROOM. NEBRASKA CORRECTIONAL CENTER FOR WOMEN, YORK, NEBRASKA, U.S.A., 1997.

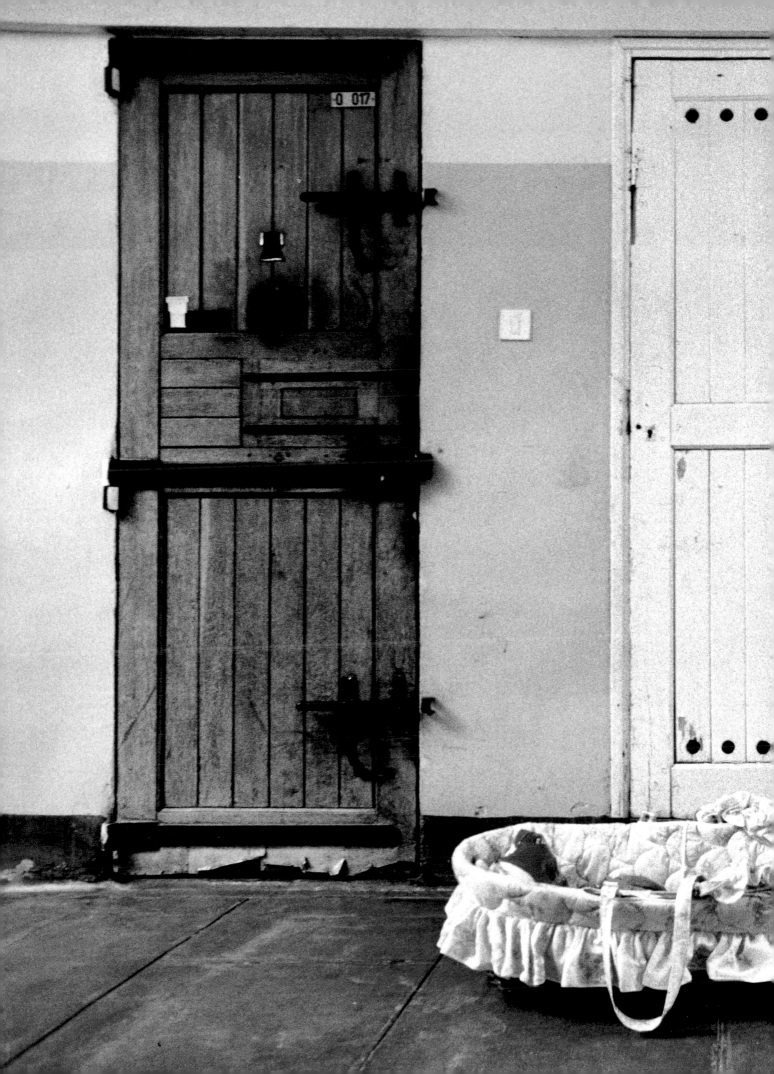

A SHOCK THING

Arriving at the Women's Shock Incarceration Unit in 1994, the singing is the first thing I hear, a mix of blues and gospel and military chants: "Mama, Mama, can't you see? What Shock has done to me." And then I see them, a small but perfectly appointed group of women in formation, dressed in blue, moving forward as one. The sun glints off their white hard hats, shooting silver arrows into the sky. Leaving the parking lot in front of the unit, the troop moves up the hill for dinner at the Women's Correctional Facility. It's 4:00 in the afternoon. But these prisoners have been up since 5:00 A.M. "Here we go, we're at it again, we're movin' out, we're movin' in." The last row disappears over the rise.

These women have opted for an alternative to traditional incarceration, choosing ninety days of mind-and-back-breaking boot camp instead of what could have been as many as fifteen years stagnating in the prison "up the hill." The Shock barrack is just below, below the roughly three hundred other women locked up in "cottages," waiting years for their release. The women up the hill are a constant reminder to those in Shock of what is in store for them if they can't hack the rigorous training, if they have second thoughts about following the orders that are barked at them from morning to night, until they collapse on their beds from sheer exhaustion. Unlike hundreds of female inmates all over the world, prisoners in the Shock Unit don't need tranquilizers to fall asleep.

The unit was started in 1986. Initially, offenders were sentenced to it by the courts. The idea was to "shock" inmates into avoiding repetition of the prison experience—by imposing a tough, short incarceration term followed by a long probation. The women's unit really exists because of the necessity for parity treatment with male inmates—but whereas the 192-bed men's shock unit has always had a waiting list, the 29-bed women's unit at first had only five or six inmates. Judges seemed reluctant to sentence women to shock probation. Now, new legislation permits corrections officials to propose the program to offenders who have already been sentenced. And women who choose it realize that days of almost anything is better than years away from their babies, and the deadening of the mind that awaits them in regular prisons.

Shock is not for everyone. A volunteer must be seventeen to twenty-nine years old, and cannot have been in a shock program before. (Eleven states now offer a shock program for women.) She must be a first-time offender of a non-violent crime, typically drugs, bad checks, fraud, or assault and battery (the last is considered nonviolent in South Carolina). Daily life is controlled through discipline. Typical prison amenities are considered privileges in the Shock Unit, perks to be earned by good behavior, not taken for granted. Telephone calls, visits, and canteen purchases are limited to once a week, and allowed only after thirty days of acceptable time. Eating between meals and smoking are forbidden. The inmates live in total silence, like cloistered nuns, and must ask permission to speak or move. They stand at attention and parrot: "Inmate so-and-so, number such-and-such, request permission to speak, Ma'am!" When an officer enters the room, the first inmate who sees her barks "Atten-SHUN!!" and the others snap to in unison.

The women wear sweats or blue uniforms, and black combat boots they must polish every night. Monday through Friday, they slog through seven hours a day of diverse work details: horticulture in the greenhouse, cutting trees and repairing fences on the farm, clearing brush from the prisoners' cemetery, loading and unloading male inmates' belongings from one bus to another during transfers. Every morning there's physical training: sit-ups, push-ups, squat-thrusts, running. Dinner precedes three hours of mandatory schooling. Women can study for their GEDs (high school equivalency diplomas), and at least three were in college the week I was there.

Inmates must keep their dormitory spotless, with the few belongings allowed to them organized perfectly in metal cabinets, clothing rolled into neat cylinders and stacked on the shelves. The shiny boots, running shoes, and shower thongs must be lined up under the beds in rigid formations of three, with the toes pointing out. Each woman makes her bed with military corners, pulling the blanket tight across the top to nickel-bouncing standards and aligning the fold with a small mark inscribed on the side of the bed frame. At evening inspection, it is not unusual for a corrections officer to rip apart bed after bed because she finds them unsatisfactory. Throughout the day, sloppy performance is punished. An officer orders an inmate to "Drop!" and do any number of push-ups, sit-ups, or squat-thrusts—ten if the inmate has been there less than thirty days, twenty for thirty to sixty days, and thirty for sixty to ninety. Even at night, the women may be ordered out of their beds to get dressed and run up the hill in the dark, or dig holes, or move piles of dirt from one place to another for punishment. Sometimes they are ordered to do these things just to keep busy.

The brochure visitors are given calls the program "strict, but not harsh." This follows the recognition that most women are in prison owing to lack of self-esteem, and that most have already suffered years of abuse, so it is considered counterproductive to "get in their faces," in the style of the men's unit. The same logic saves the women from having their heads shaved like the men. But the military drills are the same, designed to develop teamwork and cooperation. The idea is to "break them down, and then start building them up." And once a woman has signed up for Shock, she cannot leave. If she messes up, she may be sent to lockdown rather than kicked out of the program.

"Daddy, Daddy, don't you know, your little girl is out the do'." The women are in formation in the parking lot in front of the barrack. A small white girl who is incapable of marching in step with the others is in tears. "Ms. Rand!" the corrections officer bellows, "Left! Right! Left! Right! Right! Ms. Rand! RIGHT!!!!!" One of the inmates mutters under her breath. "Drop!" orders the CO. "One, Ma'am, Two, Ma'am, Three, Ma'am." The breathless inmate gasps out the count as she does push-ups on the cold pavement. The others stand at attention. "So keep looking for me, in ninety days, I'll be free!" "Sound off!" chants the leading lady. "One, Two," the others reply. "Sound off!" "Three, Four." "Break it on down!" "One, Two, Three, Four!"

The Bureau of Corrections says that the "mission" of the Shock Incarceration Program is to "change lives by instilling discipline, positive attitude, value, and behavior. "March us, march us, march us some mo-o-re!" They say that it combats overcrowding, cuts costs because it's short term, and saved the state $2.6 million in the first year. "I can march on home, jus' like this! All the way to my family, Jus' like this!" Since 1990, only 12 percent of the women who have gone through Shock have been reincarcerated, defying the average 35 percent recidivism rate.

'Cause this ain't No-thin', No-thin', A mind game! A mind game! A shock thing! A shock thing! Sound off! One, Two! Sound off! Three, Four! Break it on down! One, Two,Three, Four!!

KAREN

I'm charged with first-degree murder and arson. I was in the wrong place at the wrong time, hanging around with the wrong people. I had briefly met a girl, and knew her about two months. Supposedly she had known this man for quite some time. Turns out she had worked for him in a local bar and prostituted for him. She was talking about going to this man's house because he had owed her money. We went to his house, and probably thirty minutes after we were there, she shot him from behind. And then she told me if I did anything to get her caught, she'd shoot me, too, so I obeyed everything I was told to do. She told me to just sit there, don't move. I did, and soon she came out and took off with me.

It was kind of like I depended on her for survival, but at the same time I didn't know what else to do, 'cause I was just young and naive and stupid. Two of her friends were in this motorcycle club, so we moved from place to place. But the first time I was left alone I took off. I didn't want them to catch me, because they knew I was the only eyewitness. But during that time I was running, she came back and turned herself in and blamed everything on me.

Soon as I called my parents, they told me that I was being charged with a crime. I said, "It didn't happen this way." I turned myself in. She took a plea bargain and I went to trial; and she's been out for about six years now, and I got stuck with life.

I was offered ten years, but my lawyer—he was a court-appointed attorney—said that he just didn't believe there was any way that I would get a life sentence. He did say it was possible, but at the most he thought I would get the same as my codefendant. And, plus, I didn't want to say I was guilty for something I didn't do. I really didn't know that you could "best interest plea" then. And so I turned it down, of course, and took it to trial. I got convicted of first-degree murder and arson and received a life sentence. I have appealed three times, at the county, appellate, Supreme courts. And I have filed three clemencies thus far and I'm fixing to start on my fourth one. Basically what I'm filing for is a commutation of sentence. If this doesn't work, maybe I'll go federal and go back to court, and maybe be offered a plea bargain over again. I don't know. The appeals have always been refused. I've always had support of the parole board, but at the last minute the governors have denied the clemencies.

I have a roommate that's in a similar situation. She went through quite a few appeals and is fixing to file for clemency also. She had a court-appointed attorney as well. She was fifteen and she was with an older man, and he stabbed a woman to death. He stabbed the woman and she ended up with a life sentence. She was in the car, and the man was outside of the car when he did this. The man who did it even said she had nothing to do with it whatsoever. She didn't know he was gonna do it, didn't know it was coming or anything, but the man was a black man, and her lawyer had told her if she had not been with a black man she probably wouldn't've done a day. She was threatened that if she did not take a life sentence she probably could get the death penalty, so she ended up taking a life sentence. At fifteen.

It's very hard to see this happening when you're raised to believe in justice and fairness. And even religious-wise to believe in justice. Then you can't understand why it happened. You know there's justice in the world, but yet, where is it? It's a battle inside to try and understand why people are so crooked, why people are the way they are.

Well, in prison it's true that some women turn to other women. I used to be a very affectionate person. But because you have to stifle that, I'm not near as affectionate as I used to be. I have a friend who will hug me every now and then, and she'll hug me, but my arms will stay down; I don't hug her back. I stifled it for so long, it's not a spontaneous reaction any more. You miss companionship. You miss. Because there's no conjugal visits or anything like that. Of course,

PRECEDING PAGES PRISONER'S BABY BASSINET OUTSIDE CELL DOORS. MAISON D'ARRÊT DE FEMMES, "LES BAUMETTES," MARSEILLES, FRANCE, 1991.

some of us take care of our own needs. It's a natural, normal female urge, but we get written up if we're caught. Actually I went to the doctor after many years, and told him I was going crazy, he'd got to do something. They referred me to the psych, and the psych put me on Mellaril for a few months, which didn't help to curb the sex drive, because after so many years, you do go nuts. Normal urge, and other than turn to a woman, you take care of it personally, and that's not always the same either. We just deal with it. Long for it, you know, and go on. You get depressed, you get lonesome, but you don't have much control over it.

NOTHING TO DO AT ALL

On the Kuskokwim River delta, in the remote northwestern part of Alaska accessible only by plane, Bethel has no paved roads and the houses are built on pilings over the permafrost. It looked like Russia or parts of Africa: a hodge-podge of low-lying wooden houses out in the middle of nowhere, surrounded by mud. Many had no toilets, and "honey pots," the white buckets they use instead, were lying out in the yards.

The population at the Yukon-Kuskokwim Correctional Center is mostly native, drawn mostly from the fifty-two surrounding villages. The prison was built for ninety-two male inmates and 99 percent of the men present were in for alcohol-related crimes. The alcohol problem among the natives is so serious that one village requires everyone to be pat-searched for booze before coming in. Bethel is "damp": alcohol cannot be bought or sold there. But you can buy a bottle for fifty to a hundred dollars from any cab driver in town.

Because of this, the prison is sugar-free and all drinks are made with NutraSweet. The yeast and sugar used in baking are kept under lock and key, just like knives in other prisons. This is because the inmates will make pruneau (homemade wine) with the sugar if they can get at it. Lysol is locked up for the same reason. The facility buys reindeer meat, and the male inmates are taken fishing for salmon, whitefish, and smelt, enough to eat throughout the winter. In the shop, they carve ivory that is sold out front.

And the women? The women sit in smelly cells—and wait. Women arrested in winter can be wearing six or seven coats they haven't taken off for months. Sometimes you see them lying along the side of the road drunk and passed out, quilted lumps in the snow. And when their boots are removed in booking, toes remain inside, rotten from frostbite.

In the Ketchikan Correctional Center three women were housed in one male segregation cell. The food was brought to them on trays. During the day, they had nothing to do at all. Two of them held up a huge pair of prison-issued underpants so I could take a picture. As in the other facilities, they were required to wear uniforms here, and as usual, the uniforms had been made for men. The tops had plunging V-necks: when a woman bent over, her breasts were fully exposed. And then there were the jumpsuits, invented by a man who hadn't considered that a woman handcuffed and dressed in one of them would be unable to go to the bathroom.

MOTHER AND DAUGHTER

MOTHER He started by cutting me off from my friends. When they would come up to see me at the door, he would welcome them with a loaded gun, jealous or enraged by the fact that I had friends. I worked full-time. I'm a registered nurse. We married in July, and in August he forced me to quit work. He came in my office and just drug me out by the hair and said, "She's quitting, she's not working with you bitches any more." But then he continued to terrorize the people I worked with. I worked for a home health agency, and we rode around in little cars with our company logo on the side, and if he saw one, he would run 'em off the road. At first my friends would come to the house and demand to see me. Of course, he never would let 'em in or let 'em past him. And once they were threatened with guns, they more than likely were prone to never come back. So I was caged up in my home. I actually felt like I had more freedom when I was locked up in jail than I did in my own home. That's how bad it was.

He had been following me around for about a year, just waiting for the time for me to be a target; he told me that later on. He said, "I've known you a lot longer than you think.... I fell in love with you when I saw you." That kind of thing. It was almost like a stalker. He would come to my neighbor's house—though they weren't necessarily friends, they worked at the same plant. And I can remember back now, going to the garbage can or going out to feed my dog, seeing him watching me. But I didn't know who he was at the time. And it never really clicked in my mind who he was until he told me that.

I wrote a diary when I first went to jail. I really blocked a lot of it out of my mind, but I do have it all written down in a journal. Everything, from him taking me out in the country and slaughtering animals (this was one of his favorite things), to riding around to old family cemeteries out on country roads, and digging up skulls from graves that had washed away. And his favorite thing was to make me take my clothes off and take pictures of me on these old graves and skulls and stuff. (Of course the D.A. confiscated all the pictures, and the D.A. turned around and said I was a Satan worshipper.) I just felt so isolated, so hopeless.

He had this fear of starving. He would get up every morning at 4:00 and cook cheeseburgers and put 'em in his pocket and take 'em to work. So his idea sometimes of good sex was to make a hot cheeseburger and put it on my stomach and eat it off. And he would do crazy things like that. It was unbelievable.

He would like ride around and shoot his gun and, because his big rich family raised cotton, he would go out and shoot holes in the blocks of their combines and things because they had more money than he did. And if we saw an animal, especially one day in particular I remember seeing an otter, and I thought, "Oh, that's so beautiful." 'Cause I liked to take pictures, you know, with my camera, as an amateur photographer. He'd get out and slaughter it and say, "Now is it beautiful, bitch?" His dream was to take a black person and take them out to these woods in the middle of his family land, and hang them up by the heels, and go out every day and skin them a little bit at a time, until they died. Just torture them every day until they died. That was his pleasure.

He had this obsession. We'd go into a motel room, specially if I was on my menstrual cycle, and having sex and taking blood and smearing it all over the walls and the mirrors and gross things. Completely trash the room and leave it. I thought if he stopped the car on the way home, I would run, even if he shot at me, but I never got the chance. He was real careful about not stopping. He'd tell me every day, "I'm the Son of Satan." I think he really thought that. No, I didn't tell anyone about this; I didn't think they would believe me. I really had reached the point of hopelessness.

He told me he was a gun collector. He went into the local barber shop, which is off a gun shop, and came out with cases of guns. And I know nothing about guns, or the laws that regulate guns or anything. I should've known that you don't go in the store and stay ten minutes and come back with a trunk full of guns without any paperwork. But I didn't think about it. So he sold guns to people. But then it came to the point that when we needed to go to the grocery store, we would go to another county nearby ('cause we lived in a small town), to shop at a big market, and he would carry guns inside the market. And at several points we would ride around the bypass and he would see someone riding a bike, for instance, and take the gun out and just start firing.

He knew that I was terrified of guns. And he would come home, get drunk, eat, and pass out. So I would want to sit up and watch TV. But even if it was five o'clock in the afternoon, I had to go to bed when he went to bed. He would take me and handcuff me to the bed. So one night there was something I really wanted to watch on TV, and I begged him, "Please let me stay up and watch this program." He said okay. So it went off about ten, and I sneaked in the bed and when I crawled in, he woke up. And immediately he started on me, "Who have you been out screwing all night?" And that's when he took the gun. He took the gun—it was loaded—he inserted it into my vagina, he raped me with it. And the sight from the gun just really tore me up really bad. And he would cock the gun, and he would roll the little chamber around.

After he had pretty much severed my ties from my friends, he started on my family. I had no family in the state besides my daughter Lisa, so when they would telephone, he would cut 'em off, saying "Don't call here any more"—those type things. He was pretty sick, I guess— really what I would term a sociopath, he wasn't capable of love. I made the mistake of taking him to meet my family. And he came across as pretty nice and all, you know. But after a couple of days of visiting, he saw how close I was to them, and he immediately took me back home and said, "You're never going to see them again." When the abuse started and I threatened to leave him, the first thing he said (besides threaten to kill my daughter Lisa) was, "I know where your mother lives, I know where your brothers live." And he was serious. I mean, I do believe he would've done it.

I developed a communication line with his second wife, who lived with him for nine years and went through the same thing. And she told me to be careful, saying, "He's serious; when he makes a threat, he will carry it out." She had two small children and he would keep them every other weekend; he had visitation rights. And we would talk every chance we had, which was very little, but enough information was exchanged that I knew that he was serious. She warned me. Because he was abusive to his children. It was to the point where the children would not— they loved me, but didn't want to come over and see him any more. They knew that if I showed them more attention than I showed him, then I got beat up for it. They knew that. Even at four years old and eight years old, they knew what was going on.

I had been single a while, and I had thought I would never sign my money over to anybody, but he was good. He talked me into it. Once he got possession of my house and my money, my car, whatever, it started. I guess abusers know their victims, and as my psychologist said, I'm a caretaker, and they tend to target those types of people. That's how he knew I was gonna leave him. He knew I was at the point where it didn't hurt when he hit me, and I was planning something, you know? And he would do things like not let me go to the grocery store, not let me go to the post office (which was a block from my house), and not let

me talk on the phone. I don't know how many phones we went through; he would demolish them. But when he took over everything, finances, and everything, and the money I had saved up, I found out that he wasn't supporting his children at all, he was not paying their medical bills. Their mother couldn't take them to the dentist because he hadn't paid the bills in a year. Well, more bills started coming in, and I found a bill from the state hospital and found out that he was a patient there. That he was diagnosed as extremely paranoid schizophrenic with violent outbursts of behavior. And I never knew that till I started writing out the checks for those bills.

I never really involved my daughter Lisa with the things that he did until I just couldn't handle it any more. Then I told her. Like if I had a broken nose, or cuts from hand-cuffs, how would I hide that, how could I? He isolated me from everybody in my life. Lisa was his last threat. He could not run her off like he did everybody with guns and words and threats.

DAUGHTER He did more to her, naturally, than he did to me, because I could always go home, so he couldn't isolate me like he could her. He did threaten me. He pulled a gun on my boyfriend. He threatened to plant drugs on me and turn me in. He threatened to blow up my car with me in it. He said something about how somebody could pick up a lighter and it would blow up while I was going down the road. He threatened to kill my dad, too. But the main thing he did that really hurt me, was to threaten to move my moth-er to another state if he had to, to keep us apart. And I know he was serious because he had already isolated her from everything and everybody else. Then he started using that. He said if he killed somebody, he'd just do eight months in a mental institution and be free. All kinds of stuff.

He mostly physical abused her. When we were in jail after we got arrested, she was still bleeding from it. One time she burned the hush puppies and he stuck her hands down in the hot grease and burned her hands. She was ready to commit suicide to get away from him. She only told me cer-tain things—only part of the worst of it. And all this hap-pened, you've got to consider, over a six-month period.

I went to Illinois, to try to get back together with an old boyfriend. He said his parents were going out of town for two weeks so why don't I just come up here and just relax, take a break? That sounded heavenly at that point, so I went up there and stayed for about two weeks. The same day I was leaving to come back, two of his friends were leaving for Texas, and they're like, "Why don't we just travel together? We can stay at your house for a cou-ple of days, and then go on to Texas from there." And I said. "I'll have to ask my dad." So I called my dad—he was all for the idea. I mean, he didn't like the fact that I

was eighteen traveling that far by myself. So we headed back and we stopped by mom's house when we got back.

Russ, my friend, and my stepfather were both gun fanatics. Russ was trying to sell a gun to my stepfather but he wouldn't give him what he wanted for it. So my stepfather said, "Okay, well, I got a buddy with this gun store, we'll go see if he'll give you what you want for it." So they went to the gun store together, and they're gone for about forty-five minutes. And Russ, the guy that did it, comes in and goes, "Let's go." So we went to my dad's house, and about a day or two later Mom and I are on the phone, and she's telling me about some more of my step-father's abuse that I don't know about. And Russ says, "I'll kill him." And he didn't even say it like you hear somebody get mad and say I'll kill you, but with no emotion at all. I thought he was joking; we even laughed about it. Then he asked all these questions, like where my stepfather worked and if he was ever there by himself. Well, if he was gonna do it, it was supposed to be on his own initiative, you know what I mean? I never did take him and show him where my stepfather worked.

So, we get up the next day, and he doesn't even say any-thing more about it. And then Mom calls and tells me she's got to go over to the plant at work to take my stepfather a gun to sell. So again Russ is chiming in on our conversation. About noon, he decides he wants to go get something to eat. So we're driving down the road, and he says, "I still want to drive by and see where your stepfather works." So I just think he's trying to act macho, you know what I mean? So when I get there, he pulls the gun out from behind the seat. Same gun he was trying to sell him earlier. Well, naturally, I asked him if it's loaded and he says no. So I'm stupid, and I say, "Well what do you need a gun for?" He says, "For the scope that's on the gun." Cause it was a deer rifle and it had a scope on it. Well, I'm stupid, I'm thinking, he's just gonna go up here, and sit on the railroad tracks that are by the plant and just look. He watched him for like, thirty minutes before he even did it. While we're sitting on the railroad tracks, Mama drives up, and she's in a loaner car that day; she didn't tell me she was gonna be in a loaner car. All I could tell is that it was a woman. So I'm sitting there look-ing, trying to figure out if it's my mom or not. So they come back, they get in the car, and then they leave and go get something to eat. And he says, "I want to wait till they come back." So we sit there smoking a cigarette or whatever, and then they come back. I'm about thirty feet away, still trying to figure out if that's my mama or not. He's directly in front of the door where my stepfather was coming in and out of. My stepfather gets out of the car to go back in the building, and Russ says, "Get ready to move," and he fires.

Bam! I heard that gunshot and take off running. I didn't

even see my stepfather fall or whatever. I just took off running. Mom was coming this way, and she saw us running down the railroad tracks. So she comes around on the side street and we're running and she picks us up. This is in broad daylight. And he made no effort to conceal the gun. In fact, a train even went by, and he was just holding the gun like it was nothing.

He admitted he did it. In fact, I've got his statement in my room. He tried to blackmail us. I've got letters where he tried to blackmail me when we were in jail. He said he would take the blame if we would give him X amount of money. But we got forty years. Each of us.

But on the computer, the computer can't even compute our term. The computer is set up according to the guidelines. I can't be considered anything but a "range one," as I don't have a record. So for a range one, class A, standard offender, according to the 1989 law, which is what's on my judgment papers, the guidelines are fifteen to twenty-five. And they gave me forty. But when they try to put forty into the computer, it won't compute it. It says, nah, that's not right.

The abuse was never even investigated, and it very easily could've been proven. Very easily. In this county and in this state it is totally acceptable if your wife burns the biscuits and you beat the shit out of her. It's acceptable, period. It just is.

MOTHER So we were indicted. I was told by my lawyer if I did not sign the plea bargain, I was going to prison for life and possibly the death penalty. The lawyers told me that there were 139 jurors out there, only 5 percent women, and the rest all men who believe in beating their wives (because this county is real redneck, like that). If I'd known the law and the rules and that second-degree murder only carries fifteen to twenty-five years by state law, I would've never signed it.

My lawyer really tricked us. He said we had mitigating circumstances because we were victims of abuse, and that would be 20 percent time off. He said he could get me involuntary manslaughter, I might do three to five years. He told me this and my family this, up until we walked in there to select a jury. And then he said,"No, you sign the plea bargain or you're gonna get life or possibly the death penalty. " I said, "What about the abuse? Can't you use the abuse defense?" He said, "No, we don't know how to do that in this county. It don't do no good; it has nothing, no bearing on this case; useless to even bring it up." In April of '95, he told me that. We're talking about good old boys, where the judge and the lawyer and the D.A. are all cousins. Where what you tell your lawyer is not confidential. But it took every penny I had to hire that lawyer.

Really the only evidence they had against us was the word of the killer. They put us in jail, pitted us against each other. The killer got life, which means he'll be out sooner than we are. Life is thirty-six years, from what I understand. And if he does 30 percent of that he will be out before us. He got first-degree murder, and pled guilty from the moment they picked him up, and said he would do it again. And he said, "If I'm going down, you are going down with me." We got second-degree murder, and forty years each.

And once I get in jail the sheriff tells me that the deceased, my ex-husband, my dead husband, had a record ten miles long of all the times they picked him up for abusing two previous wives and his children. He was adopted as a child, but the family he was adopted into was the money in the county: they owned the insurance company, they're state representatives; that kind of people.

I remember one important statement that my psychologist made to me: you can't do anything to change what happened, but there are a million more out there just like him; don't get involved with them again.

SURROUNDED

The three women in the Fairbanks Correctional Center were in a small dormitory off to the side, near the segregation cells. Two hundred and sixteen male inmates surrounded them. All the dormitories have picture windows so that you can see right in. Anyone walking in front of the women's dorm can see the inmates lying on their bunk beds or combing their hair in front of the metal plates screwed to the wall for mirrors. Here the women can have makeup but no nail polish, electric hair curlers but no emory boards. So they file their nails on rough places under the sinks and use magic markers and floor polish to paint them.

In December in Fairbanks, there are days with no light at all. Special lights are installed inside the prison to fight depression from the endless night. The temperature drops to sixty below zero, and when you park your car outside, you plug it into sockets on posts provided by the town so the battery won't die. The prisoners never go out—it's too cold.

I'd never heard of "water intoxication" until Alaska. Apparently, women would drink water until it killed them, craving it as an alcoholic craves booze. One woman was kept in a cell whose toilet had to be turned off so that she would not drink from it. Another had to be closely watched in the lunch line or she'd go after the ice cubes. A doctor explained to me that this condition usually goes along with mental illness—and so it seemed in both these cases. Inmates said that one of the women had been repeatedly sexually abused by a male corrections officer as she was locked up alone, in segregation, "for her own protection," trying to keep from drowning. Later they told me the guard hadn't been prose-

cuted when he was caught, just transferred to another facility and told to behave himself next time.

Sue tried to kill herself by eating the toilet paper in the holding cell. The COs had to undress her because they were afraid she would hurt herself with her own clothes. Five COs were in the cell, three of them men. They held Sue down, pulling at her jeans, their rounded backs straining under their blue uniforms as they hunched over her, bunches of keys flashing from their black leather belts. A small bare foot stuck out; a red sock jumped into the air. They stripped the prisoner, then moved back as one. The door was slammed and a "suicide blanket" (one that wouldn't knot) was shoved through the slot. Later they saw her rip it to shreds and stuff it into her mouth, so they took it away, too.

Sue stood naked in the cell, drunk, screaming, and shaking, in full view of all the guards. "This is so degrading!" she sobbed again and again, before, mercifully, one of the men hung a strip of paper towel over the glass slit in the door.

LYNN

I've done fifteen and a half years for armed robbery. I'm thirty-eight now. My sentence is for three hundred and something years. I haven't really grasped that yet. I was a prostitute, twenty-three at the time, living at this motel. The guy I was living with had a friend who wanted to go somewhere, but they didn't tell me where. It was between them; my friend just told me to take him. Being that he knew where he wanted to go, I let him drive. I had been out all that night, so I was sleeping in the back seat. When I woke up, there was another guy in the car. Two guys and me. We stopped at a store in Columbia, and I was like, "Where are we?" They said, "We just stopped to get something to eat, but we're on our way back." So I'm thinking they finished their business, whatever it was. It was getting dark, so he was like, "We need to stop, and then in the morning, we'll finish our ride, okay?" We stopped at a motel, and I stayed up all night because I didn't know this guy, and I sure didn't know the other one. Everything went fine; they didn't bother me or anything. That morning, when we got ready to go back, they stopped at this building—it was big, it was huge. They say, "Do you want something to eat?" I say yeah, so I went in with one guy. Next thing I know, here comes another guy through the door with a mask on. The whole time I was with these guys I'd never seen a weapon or anything. They didn't let on to me they was going to rob anything. This guy came through the door with a sawed-off shotgun and he said, "This is a holdup." I never knew it was the guy I was with—never knew until later on.

Everybody held up their hands, four or five people in the store maybe, and I was with them, so I held up my hands. And he said, "Everybody go to the back of the store." The drugstore man was beside me. I looked at him and I said, "I'm scared." He said, "So am I." We all went to the back of the store. And when I realized this was the man I was with, the other one, and this other guy came in, and then I'm like looking around the store, I done lost my hearing by this time because I'm so scared, everything to me just went. So I'm standing here watching all this like I'm watching a movie or something.

I was in a state of shock. They was yelling and the people was lying down on the floor. And they had the guns on the people. The guy got the keys from the drugstore man and locked the store so nobody could get out. The rest of the people was in the back, lying on the floor. And I was back there, running back and forth just looking, in a state of shock, because I had never in my life seen anyone get killed, stabbed, shot or any of them. I'm standing there like, how am I going to get out of this? And I'm panicking. And there was a baby, I saw it. Somebody put the baby up in a chair, and he was screaming and crying. So I reached over and picked him up and, you know, tried to keep him calm. One of the guns went off, and it went in the floor next to one guy's head, but nobody got shot then. But everybody was screaming. Later on I found out two people got shot, but I wasn't there. I went back to the front room, where the drugstore man and the other guy was. And he was telling the man to open up the cabinets, he wanted drugs, and this and that, and the man was so scared he couldn't get it fast enough for him. Finally he got everything he wanted and then he gave the keys to the other guy and opened the door and left. And I went to the car and I laid on the floor and just prayed.

Once we got away from the store, there was this police car coming down the street, nobody knows anything, and they panic. They started speeding, and they hit a reflector on the side of the road. They jumped out and started shooting at the officer, and he started shooting back. Then they jumped in the car and took off, so we was on a high-speed chase. The car stopped for some ungodly reason, just cut off. It would not start up again. They got out and ran and left me in the car. I'm in the back seat on the floor, nailed to the floor. So the first thing come to my mind is, "You need to get out and run." So that's what I did. And I ended up in a bunch of bushes with one of the guys. I don't know where the other one was. That night, a lot of helicopters was surrounding the area and we could hear them say, "Come on out," but we never moved. We stayed there until morning; then they got us.

I was arrested. Armed robbery. Attempted murder. One of the guys escaped, never went to trial. To this day, they've

never found him. The other one plea-bargained for ninety-nine years. Both are presumed dead—I know one is dead. He got killed in prison. I was from another state. They don't take too kindly to that, outside people coming in, so they made an example out of me. They were harder on me than they were on the men who actually did the shooting. They say the family that the men shot didn't want me to plea-bargain for ninety-nine years (They was a husband and a wife who both got shot in the leg.) I never robbed anyone, I never hurt anyone, I don't have that type of record. I have shoplifting, or prostitution, but I don't have violent crime.

The other women inmates were at least like me: in here for some man or something like that. For a lot of women, something's missing in their lives. I don't guess men really feel the way women do when they love. Deeply. I don't know. I had no skills, I had no education, I was a dropout in the ninth grade. And I couldn't help but go to crime. What else could I do, you know, unless I would go back to school or something? My boyfriend wouldn't even allow me to work. I was merely surviving. You know what I'm saying? I was prostituting and I was shoplifting. But I didn't feel like I was doing that bad that I had to go rob somebody.

My sentence is three hundred years. I have good friends. They come see me, bring me picnics, share their families with me. My uncle came down, two of my uncles and my brothers. I write, yes, and I call. I haven't had any contact with my boyfriend since I've been here and didn't even miss him when I got arrested. I think I was glad to be away.

I'm not a murderer. And I'm not violent. But I learned a big lesson out of all this. I learned never to trust any man, or anyone with him, to the extent where I give myself. You know, I'll trust people, but I'm saying not fully. I learned that people let you down. But I don't feel like I lost out all the way. I learned a lot of lessons in here.

MULES

Hindelbank is one of the two prisons in Switzerland for women, and the one that is known to be the easiest, from every point of view. Out in the country, fifteen minutes by train from Bern, it nestles into the side of a hill that overlooks the tiny village of Hindelbank. All around are pine forests or rolling meadows with single-lane roads crisscrossing through green pastures and disappearing abruptly into tiny clusters of perfectly arranged farm buildings—a house, a barn, a silo. It is a storybook picture of the Swiss countryside.

At 7:30 the women are already up and away, working in the various shops or studios where they will spend four hours in the morning from 7:30 until 11:30 and then

again in the afternoon between 1:00 and 5:00. There are ninety-six women at the Hindelbank prison this week, and all of them work—it's compulsory.

Each inmate has her own cell. She can decorate it as she wishes, and she can keep the door locked or open with her own key during the day. These spaces don't look like cells, but that name is preferred here to the euphemism "room" sometimes insisted upon in other facilities. Every morning at 6:30 a *gardien* opens the cells with a master key. Cells are left unlocked until 9:30 P.M., when they are closed for the night. There is no word in English that appropriately describes the gardiens' job. Gardiens, who are both men and women, do not wear uniforms. More than anything else, they accompany the prisoners in their daily routines. They explain that their training consists solely of working with the women and learning as they go along. Generally, gardiens have been nurses or social workers before coming to the prison. Because of their many nationalities, they speak several languages—a prerequisite of working here. The job is well paid and in great demand.

Just about every prisoner in Hindelbank is here because of drugs. Of the ninety-six women incarcerated in 1993, forty-six were Swiss. The rest were from various countries, including fourteen from South America and sixteen from Africa. These are the "mules," women used by traffickers to transport drugs because of a once-common belief that women were less likely to get caught than men. This is not the only reason mules are notoriously women, however. They are cheap transporters; no one really cares what happens to them. Many women arrested as couriers do not know what they are carrying, and are taken by complete surprise. Others have a vague idea, but are ignorant of the consequences. Prisons in the United States and Europe are filled with mules who have gotten no farther than the airport with their cargo. Sometimes they are given a sentence as heavy as twelve or fifteen years. Swiss authorities have begun to change the sentencing for these women. Some would like to simply send them back to their own countries when they are caught, but others feel that drug traffic will continue if someone is not actually punished. With some exceptions, sentences for mules in Switzerland averaged about five years in 1993.

In the Hindelbank prison the Nigerian women tell me that their government will arrest them again when they are evicted from Switzerland after doing time for drug trafficking—that it will punish them for having been arrested in the first place. For this reason, none of them allow me to photograph them. They fear that the photos might be used against them by their government. While I have no way of knowing whether or not this is true,

OVERLEAF INMATE AND GUARD. NÉVÉ TIRTZA PRISON FOR WOMEN, TEL AVIV, ISRAEL, 1994.

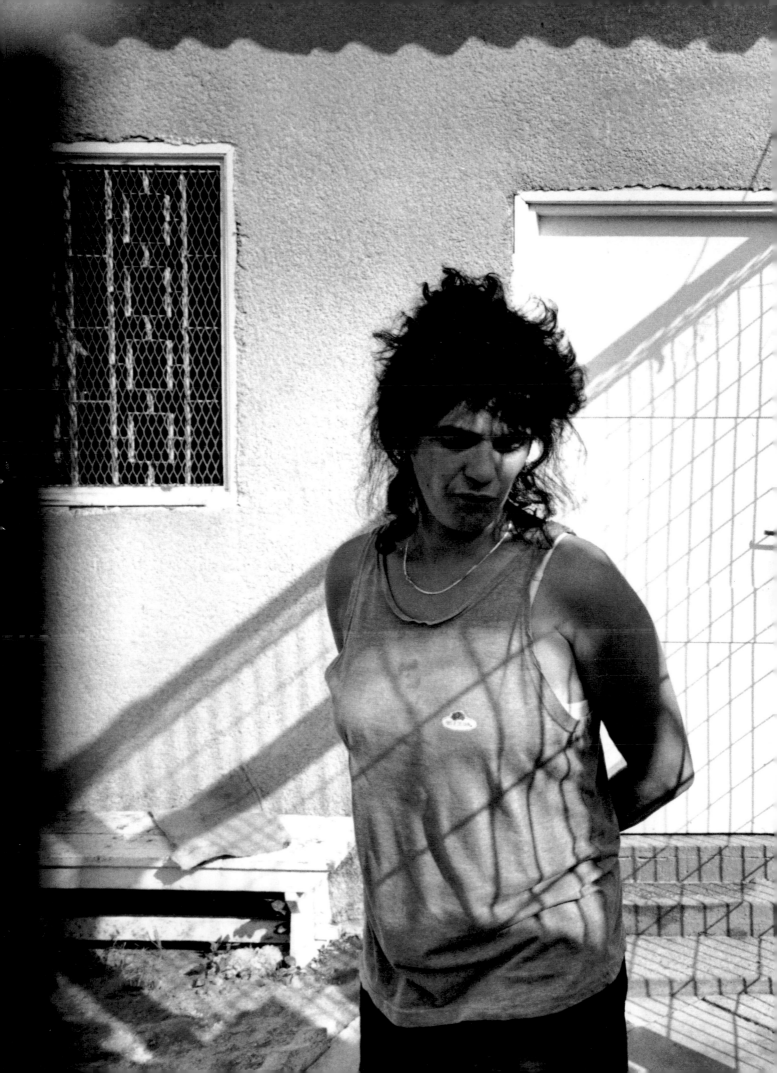

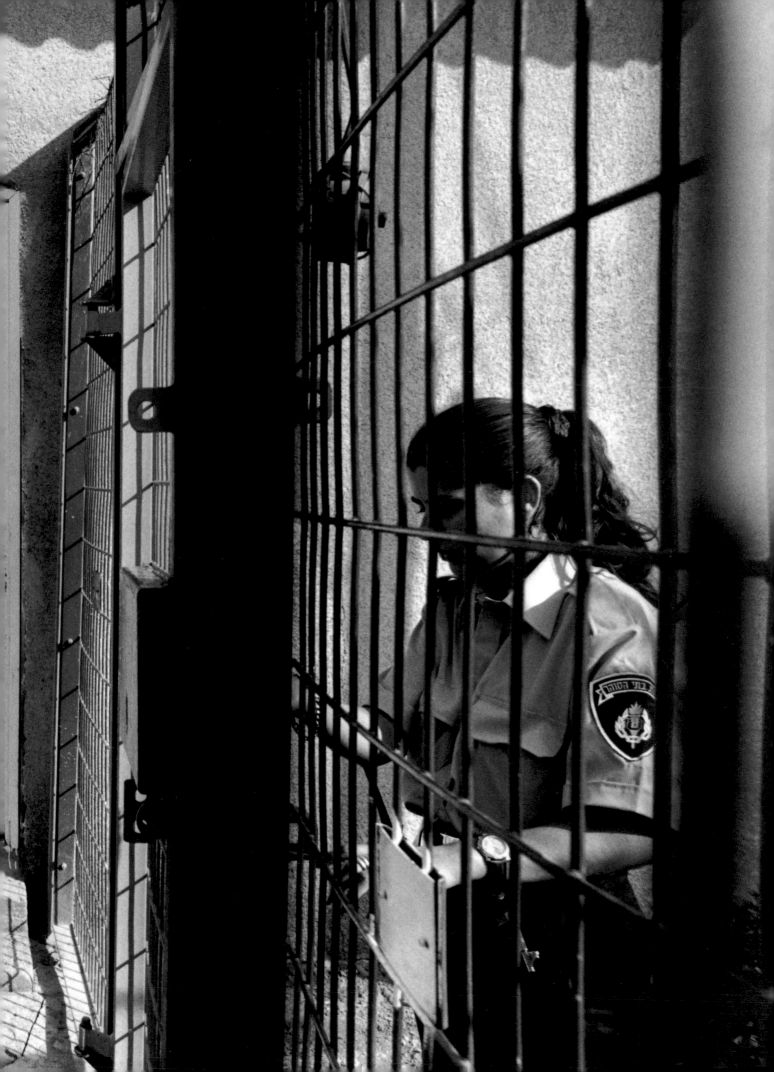

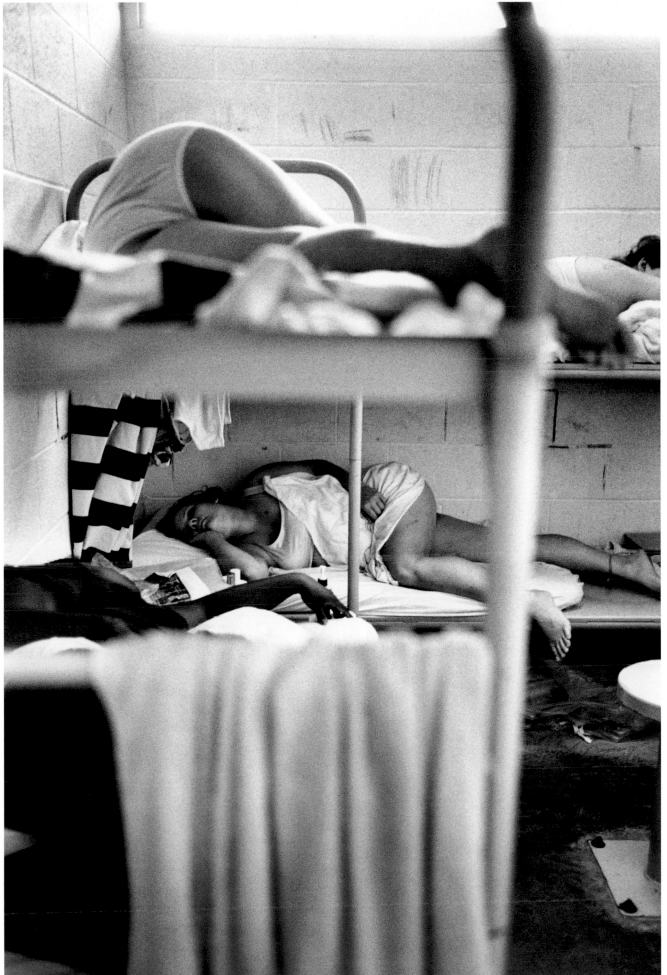

AFTER EIGHT HOURS ON THE CHAIN GANG IN 110-DEGREE HEAT, INMATES SLEEP IN CROWDED CELL WITH NO AIR CONDITIONING. MARICOPA COUNTY JAIL, PHOENIX, ARIZONA, U.S.A., 1997.

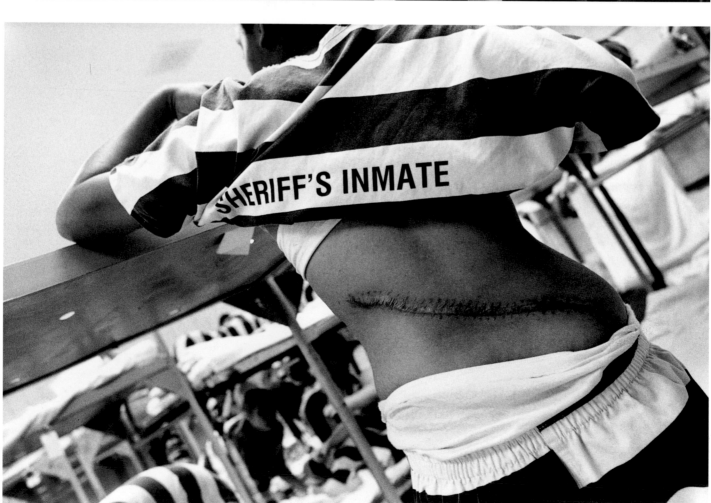

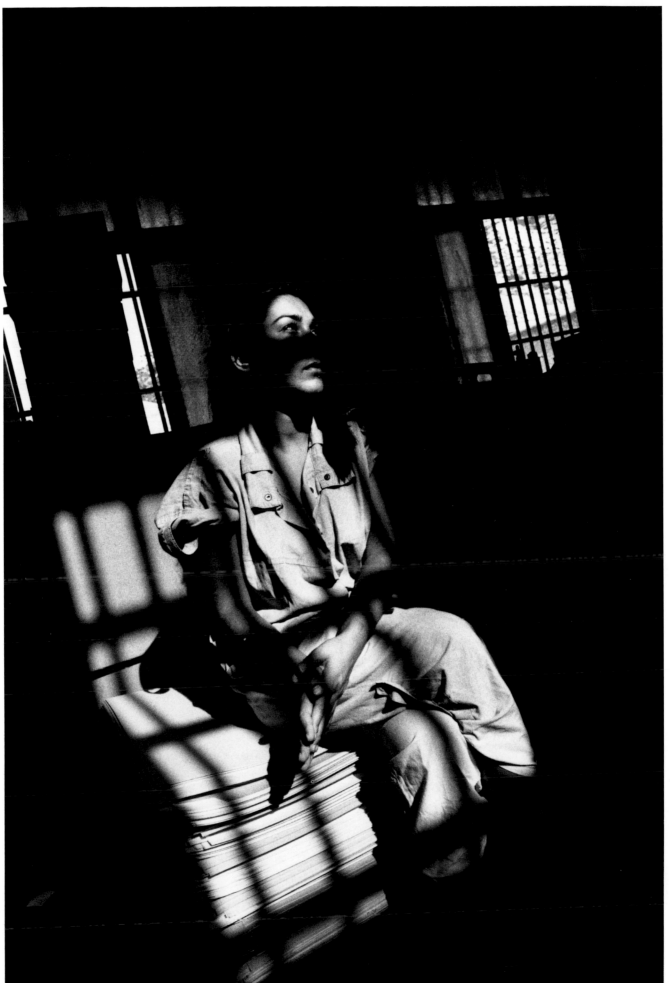

PRISONER IN THE PRISON WORKSHOP. MAISON D'ARRÊT DE FEMMES, "LES BAUMETTES," MARSEILLES, FRANCE, 1991.

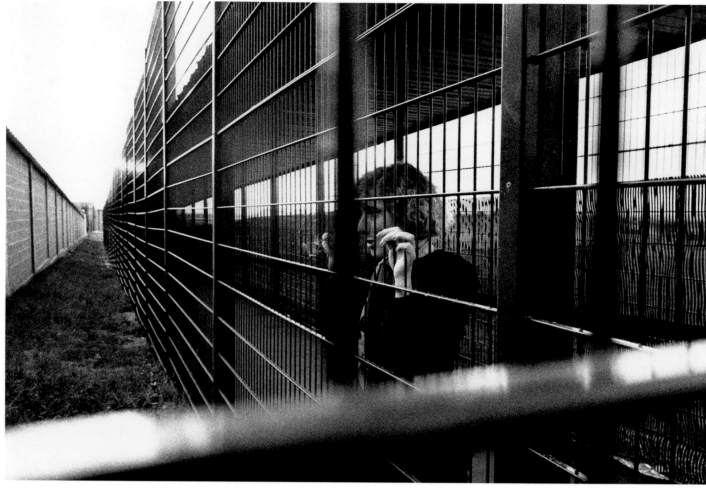

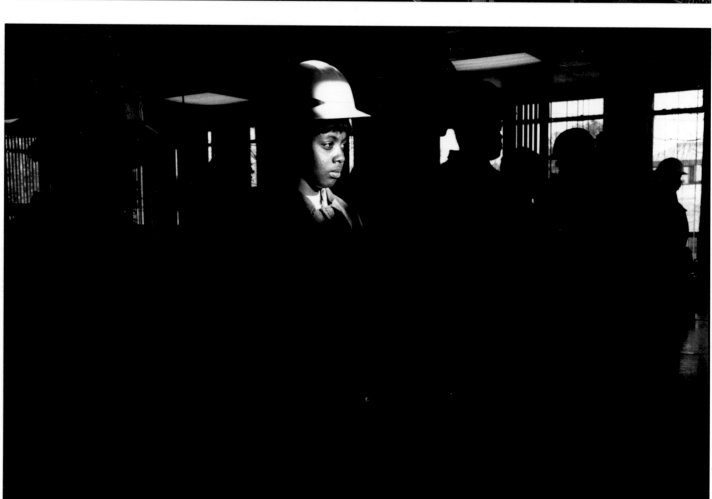

TOP AFTER VISITING RIGHTS, A PRISONER GETS A LAST LOOK AT HER SISTER BEFORE RETURNING TO HER CELL. CENTRE DE DÉTENTION RÉGIONAL DE FEMMES, JOUX-LA-VILLE, FRANCE, 1991.

BOTTOM THE FIRST DAY FOR A YOUNG PRISONER, WHO WAITS IN SILENCE IN THE DINING ROOM FOR PERMISSION TO SIT AND EAT. WOMEN'S SHOCK INCARCERATION UNIT, COLUMBIA, SOUTH CAROLINA, U.S.A., 1994.

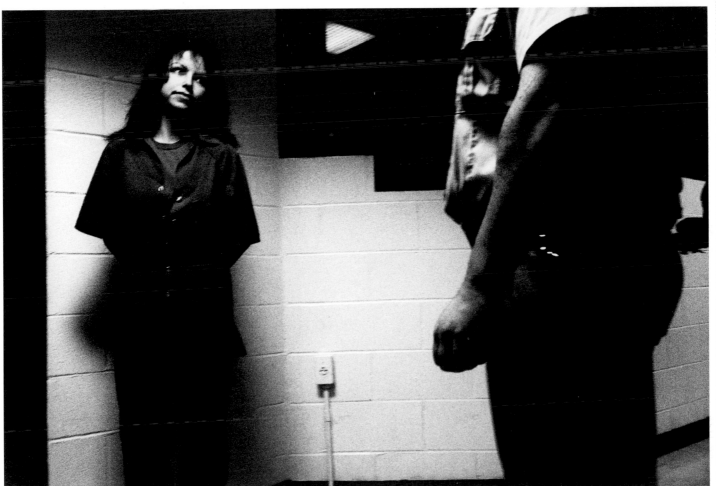

TOP PRISONER SERVING TWO NINETY-NINE-YEAR SENTENCES AS ACCESSORY TO MURDER—MORE TIME THAN THE MAN WHO PULLED THE TRIGGER. LEMON CREEK CORRECTIONAL CENTER, JUNEAU, ALASKA, U.S.A., 1993.

BOTTOM MAXIMUM-SECURITY PRISONER AND GUARD. LEMON CREEK CORRECTIONAL CENTER, JUNEAU, ALASKA, U.S.A., 1993.

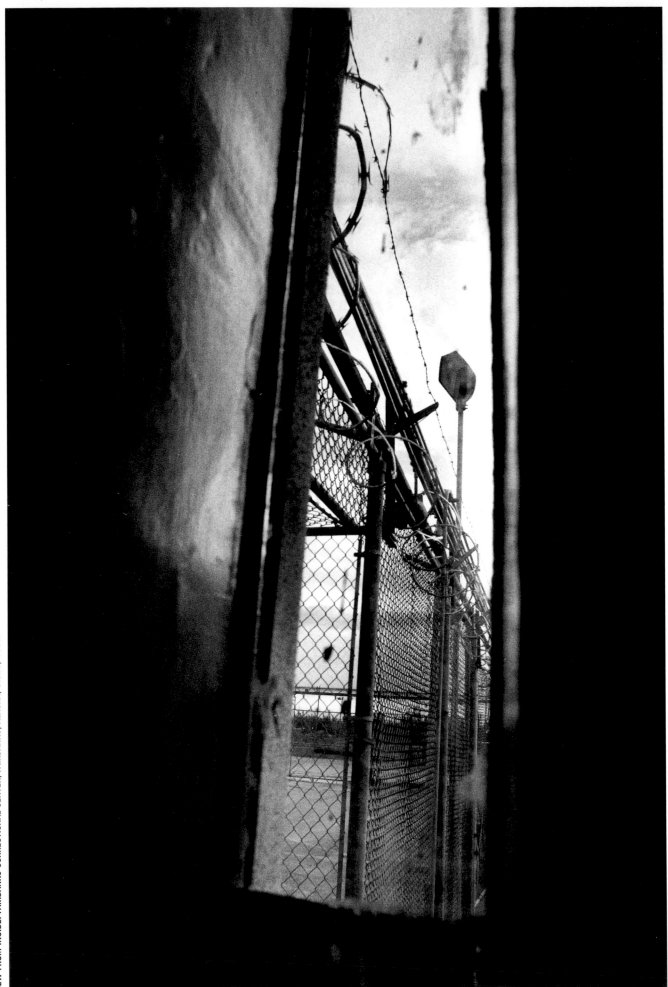

VIEW FROM INSIDE. FAIRBANKS CORRECTIONAL CENTER, FAIRBANKS, ALASKA, U.S.A., 1993.

the women are shocked by what has happened to them, and paranoia is high.

None of these women are big drug dealers. Some are undoubtedly guilty, but others have been swept up in events that feel utterly random to them. Their lives have been irreparably broken. Often, their husbands have abandoned them, their children are scattered, and their minds are slowly dying with years of incarceration. When mules do return to their own countries, expelled forever from the country where they have lived in prison for years, they are often ostracized by a society that cannot understand or forgive a woman having done time. Why were women like these, employed for $5,000 and a round-trip ticket to Europe or the United States to carry a suitcase lined with heroin or cocaine, not checked before they left home? Isn't this because that would undermine the interests of their countries, which actually want the drugs exported— and do not mind risking their own women in the process?

Three women with babies—two African and one Swiss— do not allow me to photograph them, but the Swiss woman lets me take pictures of her baby. The little boy was born just three months after his mother came to prison. She will be leaving in several months, and has been able to keep her child with her throughout her incarceration. The mothers with children are housed in a wing they call the Muki (for *Mutter und Kinder*, mother and child). Everything is provided for them. In the morning mothers can play with their children, feed and bathe and dress them. In the afternoon they go to work with the other prisoners, and women from the outside come to care for the children. The inmates in the Muki wing are particularly paranoid about photographs. No Africans will let their babies be photographed, and when I take a picture through the door's thick glass as one of the little girls presses her hands against it, her mother yells and screams that I am hurting the children, that the pictures will get them in trouble. I try to show her that no one is recognizable through the glass, but she is too fearful to listen. What have these women suffered that has terrified them so?

Margaret is a single mother of two, with a college degree in catering and food management. Born in England of well-educated African parents who had good jobs, she grew up in Africa. Margaret wanted the same things for her children that she was able to have, but as a single parent, found it hard to provide for them. One day a catering contract was cancelled, and she found herself owing money and materials that she could not pay back. When a woman who had been Margaret's client approached her suggesting they "do business" together, Margaret expressed interest, never suspecting her ex-client of any illegality. The woman said she had a brother in the States who would finance them to

import goods from Europe to sell. He came to Africa and the three met. It was decided that Margaret, with her British passport, was best suited to travel for their "business." She would go first to Zurich where she would meet someone who would take her to various textile companies to be briefed about future business. Then she would continue on to London. The ex-client and her brother asked Margaret to take a small suitcase to give to the man in Zurich. She was to pack her clothes in it and carry it on board. At some point she began to get suspicious, but as she told me, she didn't want to know, because she needed the money. And so she closed her eyes to it.

Margaret landed in Zurich around six in the morning. She stepped off the plane and started down a ramp toward the building. She noticed a man fall into step next to her, but decided he was merely walking the same direction, not following her. At customs, she was stopped and asked to open her bag. She watched the customs man slide his hand inside the suitcase and along its bottom. He told her to wait at passport control while he finished inspecting it. There, they asked her why she had left so many hours between her arrival in Zurich and her scheduled departure for London that evening. She said she needed to go into town, and was told she could not, but would have to wait in transit.

When Margaret went back for her bag, the customs officer helped her close it, pushing the clothes down flat and snapping the clasps tight. Margaret had been told by the people in Africa to call them as soon as she had delivered the suitcase, so she did so then. They told her that London was out, and asked her if she thought she was being watched. Upon hearing this, Margaret became scared. She said she had noticed two men in the terminal avert their eyes whenever she looked at them. One was the man who had walked alongside her as she left the plane. Her contacts in Africa then told her there was a problem, that she should destroy her ticket to London and buy an Amsterdam ticket. They said they would make some calls, and asked her to call back later.

By this time, Margaret was terrified. She destroyed her ticket and bought the new one, as she'd been told. She waited in the transit area all day, the two men watching her from a distance. When it was time to leave, she checked in and was given a boarding pass. As she was about to step onto the plane the two men pulled her aside. They took her into a room and asked what was in the suitcase. She said that apart from her clothes, she didn't know. They asked her again, and again she demurred. The process was repeated a third time. Then they asked her if she thought there was something in the suitcase that shouldn't be there. Margaret said yes, she had a sense there was something not right with it. Finally they told her she was being

charged with transporting drugs. They never showed her what was inside the lining of the suitcase, and did not browbeat her into admitting anything. As she put it, it was more like "sweet persuasion."

Margaret was taken to the central police station, where she spent a week and underwent more questioning. In three days she had a lawyer. She was put into preventive custody and finally, after three months, Margaret was sent to Hindelbank. She was arrested at the end of May, but it was not until September that she called her sister. Margaret has never told her family that she is in prison, only that she had trouble with the law and must stay in Switzerland for the time being. She works in the prison and sends money home every month. When she is released, after serving two years, she plans to go to England because she fears she will be killed if she returns to Africa. "In my country, going to prison is unheard of if you are a woman," Margaret explains. "It's the end of your life. People usually accept crime when it comes from men. But when it's a woman... you understand."

The atmosphere at Hindelbank is calm and low-key, unlike any other prison I have visited. Swiss prisoners who have served a sixth of their sentences (foreigners must serve half) may leave the prison for five hours, twice a month. The director tells me he knows that inmates return from these furloughs with drugs hidden in their vaginas, but there is no way to control this. To perform a body-cavity search, the prison must have an order from a judge, and the search must be performed by a doctor. The authorities find this complicated and counterproductive. Thus the women, rarely in for anything but drugs, are rarely cuffed, rarely searched.

One inmate, serving time for murder, confesses that she strangled another woman because her boyfriend told her to. She says she never would have done it if she had not been on drugs. She lets me photograph her in her cell while she shoots up. There are reportedly so many drugs inside the prison that next year the administration plans to install a vending machine for syringes to protect the women from the risk of sharing needles. This week, on three different occasions, inmates are caught shooting up. They are hardly punished—a few days of isolation or loss of visiting rights—and the emphasis seems to be more on their well-being than on any kind of sanction. Many inmates are on methadone. Again and again, when asked how they got involved in drugs, the women's stories begin with a man—someone they loved, whom they wanted to impress; someone they copied, whose orders they followed, someone they believed, a man they are now doing time for.

In the visiting room, though, there are very few men. Most of the women prisoners sit at tables with their sisters, mothers, or girlfriends, volunteer visitors, nuns, or old women in Salvation Army uniforms.

DARLENE

I think he liked to see the fear in my eyes, that's what excited him. He was a person that didn't feel pain. He was in a car accident once, and he had a steel plate in his leg, and sometimes a little screw would come loose. He would take his knife, cut it open, take an owl wrench, tighten it up and sew it back together himself; it didn't affect him at all. One time he had me in his trailer, and he was playing Russian roulette with my head. He had this thing about guns. He put one bullet in and spun the chamber and held it to my head. And if it had been the one with the bullet, I'd be dead. One time he carved my name in his chest with a knife. Another time he jumped off a roof, landed on the cement on his head, got up and laughed. And once he had this dirt bike he ran up a tree, flipped it over, fell and got a broken leg. He was crazy. And he was sixteen.

He killed the woman who lived next door to my grandparents. She was sixty-six. I have no idea why he did it. He didn't need money, he didn't need a vehicle—he had those things already. Then, I don't know why, he made me come with him to California. I begged him to let me come home, because I was pregnant. But he kept driving past a police officer in an arrest area and said: "If they stop me I'll let you go, and if not, you'll never see Illinois again." Well, he looked up in the rearview mirror and there were about twenty-six police cars behind us. They chased us for miles through the mountains of California and on the first straightway we got to (it was about a mile from the California-Nevada border), he purposely drove off the side of the mountain. He said, "We're going over, I love you," and he held my hand real tight. If the car had rolled over one more time, I would have landed in a lake. It was thirty-five stories down, and it was God that saved me—couldn't be anything else. I still have dreams at night about it. I have dreams that I feel myself falling, and I can see myself in the shadows. I can tell you almost everywhere I went in that car, how my body was tossed and turned because when the cops got down there, I was still awake. We went over, my body was just lifted up and over into the back seat. They tried to tell me I was in the back seat when we went over, but I wasn't. When the car stopped, my face was pinned underneath the front seat and my back was over the hump. And the piece between the door windows, that metal piece, was in my foot. I was banged up pretty good. But he died. And ultimately they charged me with everything he did. They questioned me and then brought me back to Illinois. They didn't arrest me for a month and a half.

I was a child and had never been in trouble before so I

had no idea how everything worked. I was the only one alive to be able to tell anybody what happened. There was nothing to say I wasn't telling the truth. But I got forty years. I never really thought they would convict me. It never entered my mind, because I knew that I hadn't done anything. I was fifteen, pregnant, all broken up, and the only thing I wanted to do was come home. So I was not prepared in the least. When the jury came back in, they were crying. They were vomiting. They threw up, but they still came back with a guilty verdict, and I think that's funny, because to me you can't find somebody guilty beyond a reasonable doubt and be sick about it. They had my fingerprints, all they had was my statement. Currently I have an attorney who has taken my case for free because he believes in me.

At fifteen, I was in a hurry to grow up. My boyfriend was seventeen. At first he was really nice to me, and then as time went by he started to beat me up. I couldn't explain my bruises to my grandma, and because my mom had been beat by my dad for so many years, I was afraid my grandmother would be ashamed of me, that I let the same thing happen. I didn't want to subject her to the things she had witnessed before. Both my parents were alcoholics. My mom and dad got divorced when I was eight, and my dad used to beat my mom up a lot. They had a trailer on my grandparents' farm, but it was a really bad environment, so I always stayed at my grandparents' house. When I was twelve or thirteen, my dad got custody of my younger brother and sister. I was worried about them. There were times when I stayed with my mother, and one of the reasons he got custody was that my mother would leave me in the house alone with them for weeks on end, and he found out we didn't have any electric or anything for about a week. I was only twelve, taking care of them, trying to make sure they were fed and bathed and everything else, and my grandparents were on vacation, so I couldn't call them. After my boyfriend had beat me up I called my mom and asked if I could come stay with her. I told her he was beating me up, and she said, "I'll make the rules so strict that he won't come around." Well, mom never comes home from the bar at night so it would be four o'clock in the morning and he was beating my door down and we'd have no phone. Finally, I went to my grandparents. He said he would never hit me again if I just came back to him. And for about a month, maybe two, he didn't. Until the night everything happened.

I think my mother hated me. She wasn't proud of anything I ever did. My grandmother said she was jealous. My grandparents loved me with everything. But I was fifteen and I just wanted to be out on my own. My grandparents hardly said no to me and if they did I would whine and cry

and get my way eventually. I wasn't a bad kid, just thought I was grown up and could be whatever I wanted. So I was having sex and things that I didn't have any business doing when I was fifteen.

When I had my baby, they told me she was stillborn because I had her in jail. But since I've been here I've gotten an attorney on that. The attorney got the medical records, but there is a lot missing, and the autopsy report said the baby was dead a week prior to delivery. As soon as she came out, they cut the cord and ran out with her. They brought me a baby to hold that was already decomposing. The whole time I was in jail, people kept writing me and wanting to adopt my baby. The law threatened me that they were going to take her as soon as she was born. I didn't pay any attention to any of them. Because this was my baby. The county paid for a funeral, but the casket was already sealed by the time I got there.

My boyfriend can't take all the blame, because I was ignorant, in a rush to grow up. I couldn't judge people right. I didn't have enough life experience to see things for what they were and judge the good things from the bad. My boyfriend would tell me different things he had done, like beat people up. He even told me he killed somebody once, but I didn't think he was serious. I mean you just don't, when you're fifteen; it's like, "You're just trying to impress me." Initially he was sweet as gold to me. My grandparents thought he was the perfect gentleman. He was trying to help around, cut grass, do the bushes, like he was just perfect, and he was, for a while. And then after he reeled me in, I guess he just snapped. Once they feel like they have an emotional hold on you, they change. Nothing is that good. I don't know what happened, other than he was a psychotic. He was into some drugs, too. But he didn't do them in front of me, because I didn't like it. I've never been drunk and I've never been high. That was all by my choice, because it was around.

I didn't want my grandmother to know, because she had respect for me, she was proud of me. Had I told her, she would have helped me out with all of that trouble. But at the time, I couldn't see that. She needs somebody to take care of her now, and I can't. That's what being in prison is. It's not this place, these grounds, this fence. It's the fact that you can't take care of the people you love, you can't be there when they need you. That's what prison is.

My mother doesn't write me, she doesn't send me money, I don't think she even knows my address. Just in the last year, my dad has made an effort to be a part of my life. On the Fourth of July he came to see me. Finally, after all these years, he admitted the things he had done wrong. Because he beat me when I was little. He was an alcoholic, and he was very violent, and I remembered all

the bad things, and none of the good things. He asked me if I could forgive him. It took a lot of debate, because I'm really vulnerable, and because I feel so alone, too. I want my family to support me. And, of course, as a child you always wonder: what did I do that made him do that to me or my mom, and why didn't she love me? My grandma, my friends, and my cousins were warning me about my dad, "You'd better be careful!" But I decided to give him a chance. Because part of me always wanted him. My grandpa was my dad, but still—I guess it's like being adopted—you always want to know who your real parents are. When my dad was here, he just said, "I wish there was something I could do," and told me he was sorry. And when a grown man forty-five years old comes and says, "Look, I know I've made all these mistakes, can you please forgive me," well, it's hard to tell him no. Everybody deserves a second chance.

I've grown up. Ever since I've been here, I've been in school. I was drafting for five years then in building maintenance. Before getting my GED I was a literacy tutor, helping people to get theirs. I was in health occupations, business classes, I got my bachelor's with honors. Mr. Sands has a group of juvenile girls that are either in trouble or on their way there. They come in and I spend about an hour, at least twice a month, talking with them, telling them this can happen to you, you don't necessarily have to do anything to get involved with the wrong people, and then, you know, your life can be taken away. And they just kind of look at me sometimes. I get some real smart kids, but they all got attitudes.

I talk to the juvenile groups so they don't make the same mistakes I made. One girl wrote after she was here and asked me what to do so she doesn't make mistakes. She had sex for the first time, but when she thought they might become intimate, she went to Planned Parenthood and found out everything she needed to know. I told her I was really proud of her for doing that. Because it takes responsibility. It made me feel good. Because I was kind of nervous giving her advice. I thought, "My God, what do I say?"

I didn't grow up in a normal world, so for most of my adult life, prison is what I know. Relationships in here are not like what you see on TV. It really is more of an emotional bonding than anything else. I didn't feel ashamed about the crime, because I thought I had been wronged. I feel responsible in the sense that it was my lack of judgment that ultimately led to the situation. If I had actually been grown up, instead of just thinking I was, this probably wouldn't have happened. But because I brought him around, ultimately it is my fault. So I do feel a lot of guilt and responsibility for that. So many people have been hurt behind this, and it's my fault.

A couple of people here have seen something on TV about me, but after you've been here so long, and after you've gone through a trial and everything else, you know how the media twists things for a story, and you don't pay a whole lot of attention to that. You judge people for who you see them as, rather than what somebody said they did. I used to have a real problem with women who killed their children. But it took until one woman admitted that she did it, for me to get over that. You know I shouldn't judge anybody anyway, but I felt cheated. You are killing your kids and I can't have mine and you know this is unfair. But when this woman admitted what she had done, and the tears and—hell, everyone has a breaking point. It made me realize that things happen. And she stood up and said, anybody who wanted to throw any names at her, go ahead, she felt like she deserved all that. So I knew she was sorry. I know what it felt like to lose my child, and I can imagine what she feels like losing hers because of something she did. That's got to be worse than any pain that I know.

Women are raised to be the caretakers, even in the nineties. I mean little girls get dolls and you are supposed to take care of them and feed them, and as you grow up you're supposed to take care of this, take care of that. You have to be responsible and polite and all these other things, and then you get involved with somebody and those womanly tendencies come out. I think women even with their mates turn into their mother. You take care of this other person and he depends on you. Even though it's not a motherly type of love, it kind of fills that position, and so when something happens, you are so emotionally involved with this other person you would do anything for him. There's all this competition: you've got to have the best boy, the best clothes, so when you finally feel like you have something that is the best, you cling to it with everything you have. A lot of times women are just to the point of being beat that they kill their husbands or their boyfriends. But a lot more women take the fall as far as drugs and murder—they take responsibility for everything because they feel they've got to take care of their men.

LENORE

The maximum-security Indiana Women's Prison is the oldest prison for women in the United States. Russian prisons offered more access than Indiana, where policy prohibited speaking freely to the inmates or spending time with them in the detention area even if accompanied. The assistant superintendent had preselected eight of the 350 in the prison for me to interview. No one was on death row, so I asked to see someone who had received the death penalty and whose sentence had been

modified. I was allowed to speak with only one.

Outside it was ninety eight degrees. An air conditioner whined from a corner of the small office, which was decorated with the false-rustic wooden furniture made by inmates and used in the administrative buildings of prisons across the United States. Five feet away the assistant superintendent shuffled papers on his desk. There was nothing remarkable about the middle-aged black woman who sat across from me. Her voice was a monotone. She never raised it, even for emphasis. Questions were not needed: she started talking, reciting a litany of sad events that got her where she is today, doing a long sentence for killing her ex-husband. She spoke as though we were the only two there, oblivious to her surroundings. She began to weep, silently, talking the whole while, and continued to cry for the duration of the interview, never making a sound. Her cheeks were round, like a squirrel's, and she wore prison-issue glasses of clear plastic. The frames rested right on top of her cheeks, and as she cried, the tears built up behind the wall of glass until they became a tiny sea that sloshed to the right and back to the left, held captive by the glass wall pressed against her flesh. When the salty liquid was just about to flood back into her eyes, Lenore would press a Kleenex to her face, tilt her glasses slightly, and the tears would be absorbed into the white cloud of tissue. Then she'd let the frames fall back onto her cheeks. The interview lasted over an hour. She never stopped talking.

It took a long time to realize that maybe I reacted in the only way that I could at the time. But you don't come to that easily, when you are taking the life of somebody you really love or have loved. When I first went to court I asked myself, "How could you have done this?" and then I thought, if you are fighting, and you know this man, and he was coming at you with a hammer, would you act rationally? The courts are more lenient with people who have alcohol and drug problems, but I didn't have one. I had just left work, and people who saw me all that day probably wondered what happened.

The first time the police came, it was ridiculous. We had been in a fight and I called them. Instead they asked me, "Where is your rent receipt?" and walked through our apartment and said, "Nothing out of place here, you don't seem like you are badly hurt. Why don't you talk this over?" So then we separated for a time, and this time I got my own apartment with my own name on it. Doug took me to court and said that I had moved out of the house he was providing and got another house so he didn't have to pay rent anymore. The judge agreed. I said, "Do you know why I did this? Because he comes here any time, any time of night, knocking on my door, demanding to get

in, and when he gets in I can't get him to leave. He demands that I be his wife, and if I call the police they are going to say it's his house. So where was my safe place?" I wrote the judge about this, not two months ago: "You said I was in a place that I shouldn't have been. So where was my protection, where was my safe place?" I found out from my son, who I never allowed to be in court, that this man had been to my house. Had I come and said that, you know what they said? The police said, "Well, if he had come to your house and you killed him there, you wouldn't be sitting here!" A woman has no safe place. It's a man's world. It's his rights, he can do whatever he wants to do.

I stayed in jail for ninety-four days. There is no bond for murder, but the judge gave me one because my son was still going to school, because I still had a house that was being maintained, because my employer said I could come back to work, and he didn't see murder one. But knowing nothing about the law, I still went for a jury trial when I should have had a bench trial. I had a six-day jury trial. None of the police who had come to the house for the domestic violence testified at my trial. None, none, none. My attorney was a noted judge in our city who lived in the same neighborhood as my mother. She was desperate for me, and just went to his house and knocked on the door. But he did absolutely nothing, I can say now. I went to court so many times with this man and he never once showed those documents—though I knew he had them. I gave them to him. To this day I still don't have those documents—he kept them all.

I got thirty-one years. Judge Ward said I was convicted, and the prosecutor immediately said that we would revoke the bond, so that meant I had to stay in jail, I couldn't go back home, I couldn't prepare my son. And I had gone back to work and everything, because I just believed I wouldn't be convicted. So I was totally unprepared to go to jail. Why did the judge give me thirty-one years? He could sentence me anywhere from thirty to sixty years and he gave me the minimum—fifteen and a half with parole. The only hope I have of doing less time is getting a two-year education class. If he grants me class, then I could get out the next year. I got six months off my time when I received my associate's degree, and next year I should receive my bachelor's, and I could get a one year cut for that. So without the courts doing anything, my earliest release date would be '97, after fourteen years.

There was only one woman on the jury. One black man and the rest white. There was a man who said he had had some dealings with Judge Ward and had problems. But Judge Ward didn't say he couldn't sit on that jury. But I saw nothing. I didn't know I was supposed to question

him; I trusted him. I know now that you have to be aware of the law and your rights and what you can say and what you can't say. But at that time I didn't know anything.

I'm forty-eight. My mother was only fourteen when she got pregnant with me. My father was nineteen and in the navy. My mother died when I was eight years old, so I was raised by my grandparents, her mother and father. They had ten children, a big family. We were very poor. My grandfather was a drinker and an abuser. My grandmother had rheumatoid arthritis, so she was crippled all her life. I can't remember her never having to walk with crutches, although she could move around the house without them. She was diabetic, sick a lot, and my grandfather was a very abusive man. but that never stopped her—I can't remember a day when she was not up fixing breakfast. My grandfather sold vegetables on the truck every day, so we had plenty to eat.

When I decided to get involved with my husband, Douglas, my grandmother just saw no way in the world for me to even be with him. But I was determined to. I was eighteen and very wilful. I had never been disobedient until I met this man. He was twenty-three years older than me. I had never really dated anybody. I just got wild—like I was in a different world. He had been married and had three children and he had a record—he had been in prison as a youngster in what they call a Gary gang or something. I quit school but I was still at home, and my grandmother said, "You can't live in the same city with us and be with this man," So I told them, "Then I'll go to Gary, get a job." I knew it was bad, but I just didn't want to admit it. You don't look at that when you fall in love, you really don't. I can remember my grandmother going into the pantry and just crying. At that time she was in a wheelchair. I don't know how I left with her like that, but I did. I didn't want to hear it.

It was not an easy marriage. I got pregnant right away, got married in May, and my son Bobby was born in September. Right away, even before the baby was born, our problems started. I went home to Alabama to have the baby and the doctor told me I had syphilis. I had no way of even knowing, no symptoms or anything. I was treated, and I called Douglas on the phone and told him, and he didn't deny it. He said he had been treated seven weeks before, but because I was having a difficult pregnancy and we were not really having a lot of sex, he didn't believe he had infected me. I just said, "Why?" I stayed there and had the baby. I had to have a cesarean, and then I was very sick, I had a blood clot and contracted pneumonia. But the baby was fine. That was my one worry, that something might be wrong. I stayed in the hospital thirty-two days and said to myself that I was not going to go back, I

was never going to go back. But when Douglas came to get us, I flew home, back to Indiana.

I thought it was all right. I thought I could never get over that, him having sex with a prostitute, because that's what he said, and he just made it sound so matter-of-fact. When I got back it was never mentioned, never. But afterwards I couldn't trust him, didn't trust him, and that's when our problems started. He was a womanizer, and I found out years ago that there was another child about the time Bobby was born. Even to the day Douglas died, he was with the same woman. I had contracted a disease of the lymph system, so from that time on I was just sick all the time. It wasn't until Bobby was five that they diagnosed me, and they couldn't tell me where it came from, whether from the syphilis, or from something that happened to me when he was born.

Douglas was not a heavy drinker. But when he would come in from work he had a drink, and this is when he got started. He was drinking and he'd go to make love—he could do this, but for some reason I couldn't. He raped me, sodomized me. So we separated finally, although we never divorced because of the medical insurance. Douglas worked in the steel mill, so he had insurance, and because I was constantly ill all the time, I needed it. So the only thing he was doing was basically paying for medical bills, because sometimes I was on welfare, and then I worked and went back to school in a concentrated employment program where they train you and pay you. He was just not a big support person, though he was a loving father, as far as being with Bobby and taking care of him. Whenever I was in the hospital he would take care of Bobby for me, but that was it.

I separated from Douglas and lived on my own, worked and everything. I was involved with another man for seven years and didn't need anything from Douglas, nothing. Somewhere in 1982 my friend died—he had cancer. So I had to go to Doug for some care for Bobby and he thought we should get back together. He kept calling the house, kept coming back, and I didn't want that. So in November I filed for divorce.

On the day the crime happened, I had gone to talk to Douglas about him not complying with the court's orders, and we got into an argument. We were in his garage—he turned it into a workshop and he was working there. He picked up a hammer and threatened to kill me and I shot him. That gun was not fired in all the time I had it—until that day. My husband bought the gun for me. I lived in an apartment complex and we had several break-ins and he put some bars on the windows and took me to the pawn shop and we got the gun. It was not an illegal weapon—I just didn't have a permit to take it on the street. This was

the first time I had even fired a gun, and I was so afraid of it that I usually kept the bullets separate. Had I not had it I probably would have run. Guns are so evil. I even told Bobby not to ever buy a gun, because sometimes you don't act rationally, you just don't, and I was afraid. And I would be afraid of people thinking you might click or something. You think it yourself, that I must have gone crazy. I was arrested. I thought when I was in the police station that my husband would tell them what really happened, even if he was in the hospital. I had no idea he was dead. I kept thinking, "Douglas, just tell them what happened." They tried talking to me, but the only thing I could think about was my son. He was at home. I had told him, "Turn the Christmas tree on, I'll be back, I'll be back, I'm going to talk to your father." Finally they allowed me to call the house, and it was Bobby who told me his father was dead. I said, "No, he's not, he's..." And then I realized. I don't know who called Bobby. You know, I can't imagine the police calling a fourteen-year-old and telling him that. I called my closest friend—his godmother—and her husband and asked them to go pick up Bobby and take care of things until I got out, because I just knew I'd get out. I just had no idea I'd be gone.

Bobby stayed with his godmother until the next year, and then I sent him to my younger sister and she took care of him. He was married last year. He doesn't come to visit me in prison often. When I was in jail he came every week and his godmother would bring him every month. When he was eighteen and graduated from high school he drove himself—maybe three times. But he doesn't come every year. I call him maybe once or twice a month.

When I got out on bond and went home, before my trial, I was sitting around crying every day: "Why did your father have to die, why do you have to go?" And my son was really angry. Every day he would do just anything to make me angry, and I was so scared of maybe hurting him or reacting in a way that would hurt him. One day he did something and I just reacted and he said, "Now I'm getting my mother back." He said, "You know, if dad had not died and he had done something to hurt you, I would have killed myself." And then it hit me, it hit me that he never cried. And we talked about it, and I could still see him hurting. He told me that people at school were saying, "Man, I'm sorry about your father," and he was thinking, "My father? What about my mother?" My aunt kept saying it was unbelievable and asking me, "Did you drink something that night?" I said, "You know I don't drink." My family was supportive, but they just didn't know, they still don't understand prison, they just don't understand.

What would I have done differently? Just stayed away from him. It was not until I got home, after being in jail

ninety-four days, that Bobby said, "Momma, I talked to daddy that day; he told me not to tell you." I didn't know, all the days I was in jail, that he had spoken with his father. See, before questioning Bobby, "Has your father been here?" "No, mom." "Well, how did his jacket get in the house?" "Dad told me not to tell you." And I'd say, "How could you let him come in this house and you not tell me, Bobby?" But Bobby was just in the middle. I said, "It's not your fault, you know it's not your fault." So I never let my son come into the courtroom to testify for me. I couldn't do that. I said to the lawyers, "You know he has already lost his father and there is no telling what is going to happen to me. Do you know what that will do to him?"

Bobby never had any therapy and I realize he should have had some. My son was an excellent student—he had the highest grade point average in his ninth grade class. When he got to Alabama, he was in ROTC and he loved it. My best friend from high school taught math there and wrote me that he was nominated as cadet in the city. But when they called his name for his award, he never went up and got it. I said, "Bobby, why didn't you go?" And he said, "I had nobody to share it with. What good was it?"

What will I do when I get out? Being away from the outside world for so long, and realizing how it's going to affect your life—getting a job and being able to support yourself—I think about how people would react to you. Especially those people that you worked with and went to church with and you haven't seen or talked to. If you run into them, how are they going to receive you, if at all? Some of the girls I have worked with have been down to see me. The pastor in the church, I write to her often, and my best friend, my son's godmother, as well as some friends in my son's high school that I went to school with, girlfriends. People like that. But after a while you lose contact with them, and they stop writing, and then you stop writing, because they don't respond. I don't think I'll go to Alabama where my family lived. My son's grandmother, whom I call my mother, is in Gary, so if I'm on parole I will probably visit her in Gary and then hopefully get a job and stay there. If not, I might consider going back down to Alabama, because my son's there, and I would like to be free of any obligation to the state. I've tried to better myself. Hopefully, it will open some doors for me, if I have a degree and get a job. Right now, the only thing I think about is working with children.

You meet other people, other women who have been in situations like yours, and you learn about yourself and how you allowed yourself to get into these situations. Strange realizing that if I had waited one more day, things would be totally different. And realizing that nothing was as bad as it seemed, because I've lived with women who have had much worse. And gaining knowledge about how to rationalize in a

situation, like going through all those procedures, getting a restraining order, and then going to talk to a violent man.

I am much stronger, more independent now. Realizing that I didn't need my husband as much as I thought, and that no matter what my condition was, he was probably the reason for it, and the reason I was in the hospital. I'm losing my hearing, I wear hearing aids, my eyesight is poor, and it's all because of that. Oh, I think I've always loved him. That's why I hurt so bad, because I did love him, even after all he has done. But you have to separate yourself— you can love someone and know that, but not be in love with them. I was not in love, but I loved him. I don't know.

PHOENIX

Of the 6,500 inmates in the Maricopa County Jail 227 are women living in tents. These tents are old army issues left over from the Korean War. The temperature this week in Phoenix hovers around 110 degrees— typical of Arizona summers.

Maricopa County is the fourth largest jail in the United States: four hundred inmates a day are taken to court from here. Joe Arpaio is proud of his reputation as being the "toughest sheriff in America." In the belief that people return to prison because they "like it," Sheriff Arpaio thinks jails should be made so disagreeable that the inmates "won't want to come back." He boasts about a "humane," but "uncomfortable" jail. He has eliminated "frills" found elsewhere—coffee, cigarettes, hot lunches, girlie magazines, television (unless it's what he has decided the inmates should watch).

People go to jail when they receive a sentence of less than a year—if it's one year and a day or more, they're sent to prison. But Maricopa's inmates aren't only those with misdemeanors. Some are felons who have taken plea bargains for ten years' probation, plus a year in the county jail.

Inmates wear stripes, just like in the old days. All the underwear is dyed pink, to be easily recognized (and disliked) as jail attire. Inside the detention area is a device they call the "restraint chair." Unruly prisoners, wearing a motorcycle helmet to protect the head, are strapped in it for up to eight hours at a time. Although this contraption looks just like an electric chair, it's not supposed to kill you. But, according to an article in the *Phoenix New Times* (January 23, 1997), it broke one man's neck. A neon sign atop the surveillance tower overlooking Tent City announces *Vacancy*. While prisons all over the country are releasing inmates before their time is done in order to make room for new arrivals, Joe Arpaio won't do that. His policy is to put more and more in jail, however petty their offenses. When there's no room in the

buildings, he sets up tents to house the overflow.

If an inmate swears at a guard, fights, or hides contraband like cigarettes or candy, she's kicked out of the tents and sent to lockdown—a tiny cell ten by twelve feet that houses four women, instead of the two it was built for. They're inside twenty-three of the twenty-four hours. There's no television, no phone, and no air conditioning. Even though most of these women have drug problems, programs like NA (Narcotics Anonymous) or AA are considered "privileges" forbidden to those locked down. The only way to get out of lockdown is to volunteer for the chain gang—the first and only female chain gang in the United States (as of August 1997). Volunteers sign a paper that says they know and accept the conditions on the chain—cleaning Phoenix streets, painting the center strip of miles of highway, and burying Arizona's indigent. The accusation of "cruel and unusual punishment" is quashed by the argument that the chain gang is purely voluntary. After all, if you prefer, you can spend the whole year in lockdown instead.

At 3:00 A.M. the women are dressed and in their cells, cleaning and shining the stainless steel sinks and toilet bowls, pulling the blankets tight across their beds. A pink towel is stretched around each mattress corner. Then they line up in front of their cell doors for inspection.

Downstairs in the hallway, three long chains lie waiting, stretched out on the floor. The detention officers attach an inmate's foot every few yards, the chain padlocked around the ankle. There are five women to each chain, three chains in all. The inmates chant prison songs as they march along to the bus. One woman carries a huge covered bucket filled with sand, as punishment for something she did the day before. She will carry this bucket with her all morning wherever she goes, chained to the other women on her work detail. "Daddy, Daddy, can't you see? What chain's done to me!" In the dark, the bus rolls down the highway. Inside, the prisoners eat their breakfast: two thin meat patties, three pieces of bread, a small, gnarled orange.

It's 5:00 AM when the women get out of the bus, and still dark. They sit on a dirt mound along the asphalt road, waiting for light. It's already 86 degrees. At 5:30 they move out, with pitchforks and shovels, dragging their chains along the dirt. Above, a full moon hangs like an ornament in the sky.

They make their way doggedly down the highway, one

OVERLEAF AN INMATE LOOKS OUT TOWARD THE ALMOND AND ALFALFA GROVES THAT LIE BEYOND THE 50,000 VOLT ELECTRIFIED FENCE THAT SURROUNDS THE BIGGEST WOMEN'S PRISON IN THE UNITED STATES, 1,340 ACRES AND UP TO 8,000 WOMEN. CORRECTIONS OFFICERS USE GOLF CARTS TO GET FROM ONE PLACE TO ANOTHER INSIDE THE DETENTION AREA. CENTRAL CALIFORNIA WOMEN'S FACILITY, CHOWCHILLA, CALIFORNIA, U.S.A., 1995.

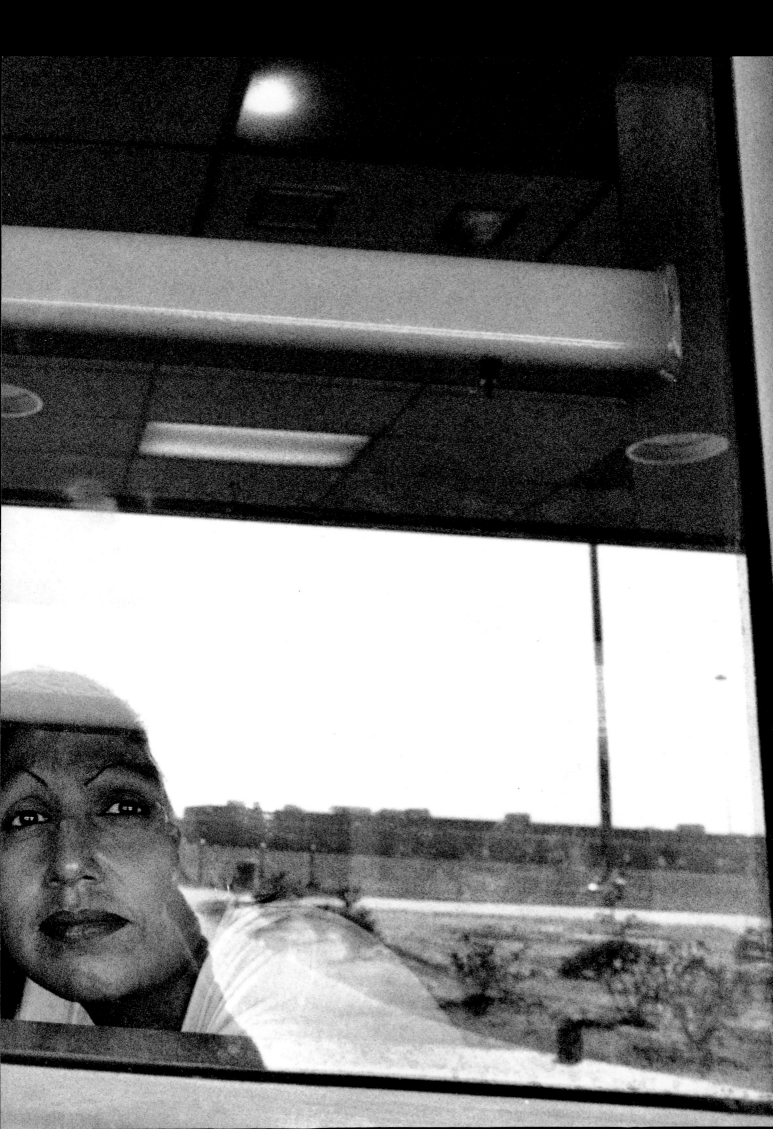

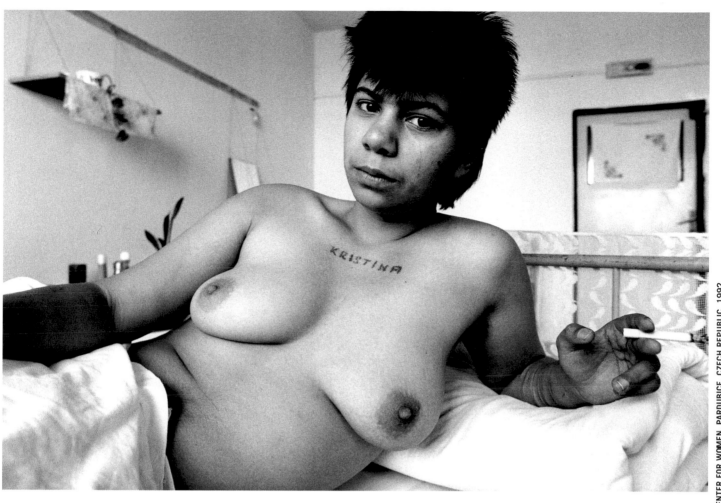

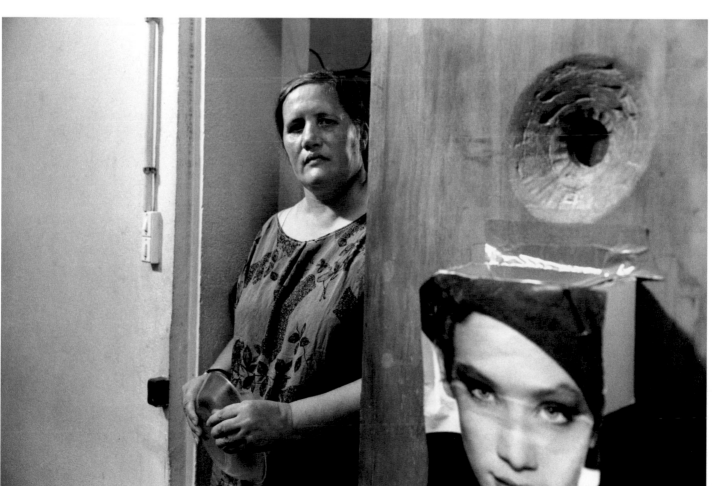

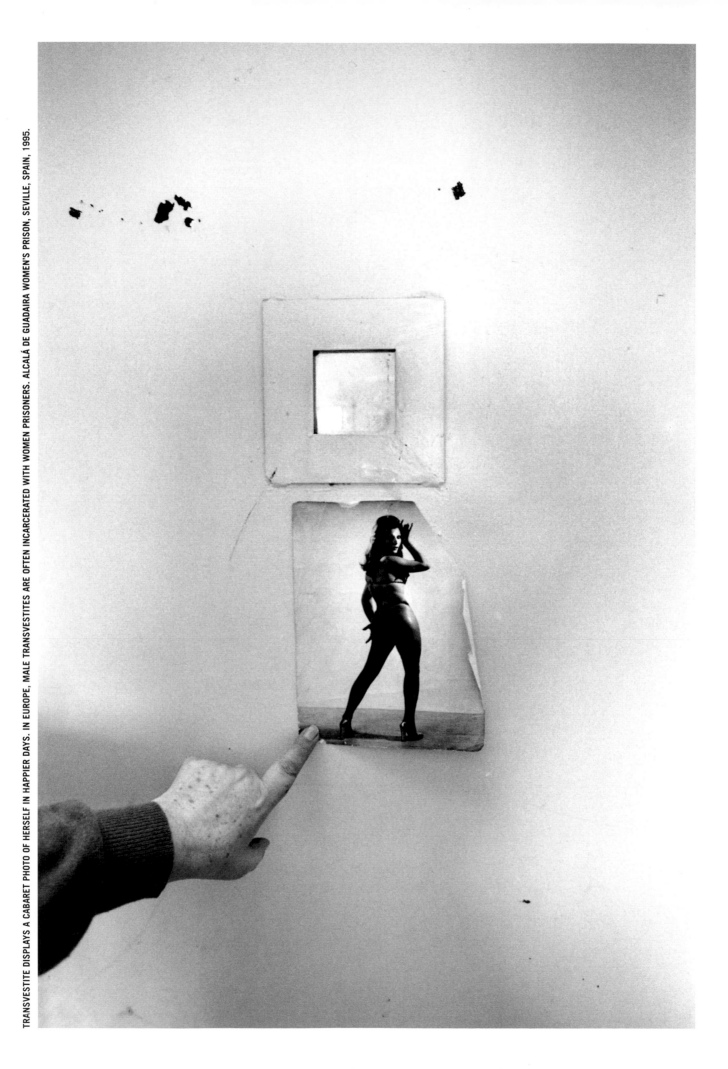

TRANSVESTITE DISPLAYS A CABARET PHOTO OF HERSELF IN HAPPIER DAYS. IN EUROPE, MALE TRANSVESTITES ARE OFTEN INCARCERATED WITH WOMEN PRISONERS. ALCALÁ DE GUADAIRA WOMEN'S PRISON, SEVILLE, SPAIN, 1995.

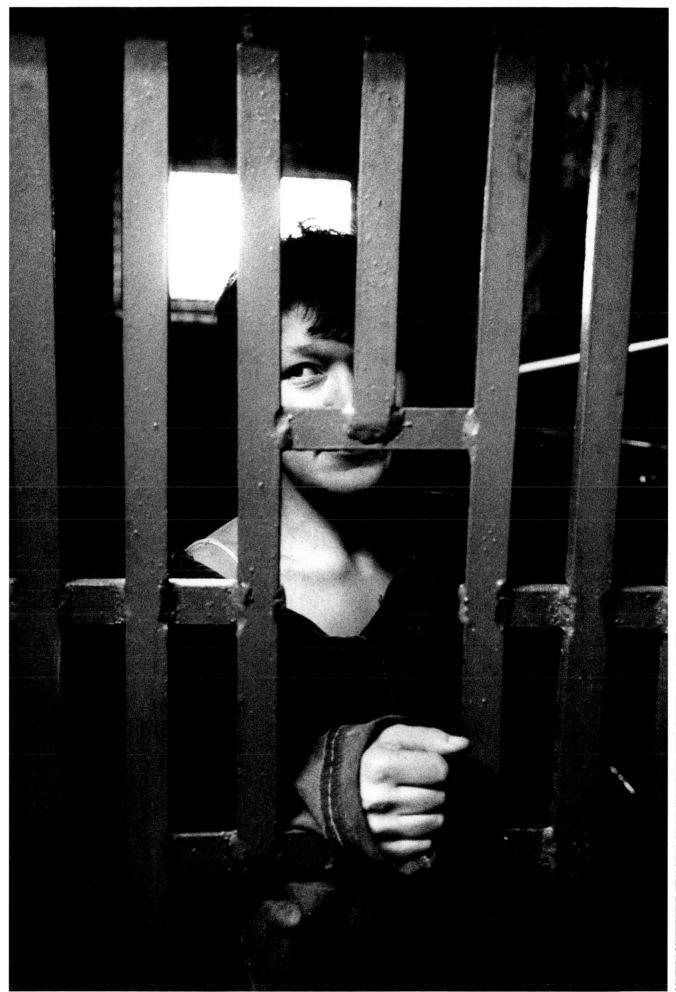

SOLITARY CONFINEMENT. PERM PENAL COLONY FOR WOMEN, PERM, FORMER U.S.S.R., 1990.

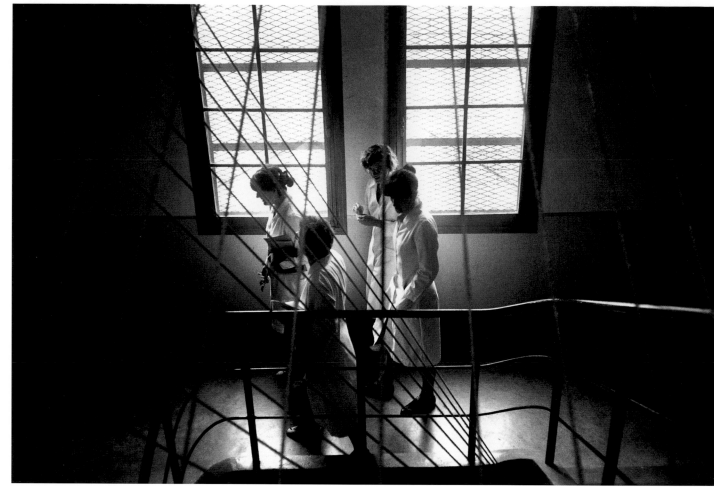

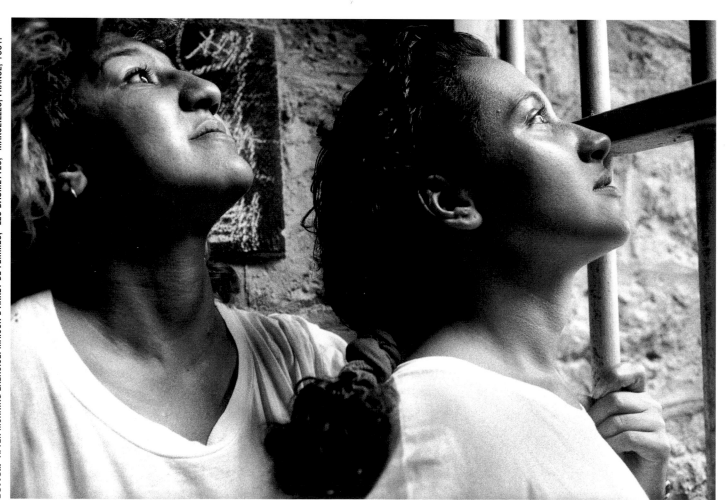

TOP GUARDS LEAVE THE DETENTION AREA AT THE END OF THE DAY. CENTRE DE DÉTENTION RÉGIONAL DE FEMMES, RENNES, FRANCE, 1991.

BOTTOM AFTER MORNING EXERCISE. MAISON D'ARRÊT DE FEMMES, "LES BAUMETTES," MARSEILLES, FRANCE, 1991.

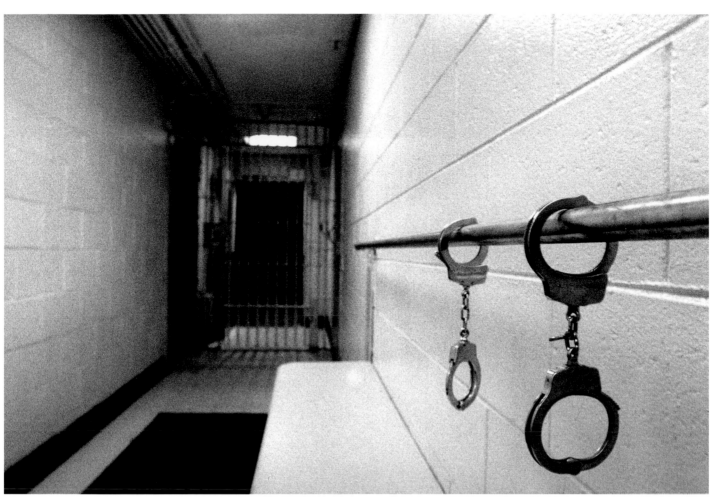

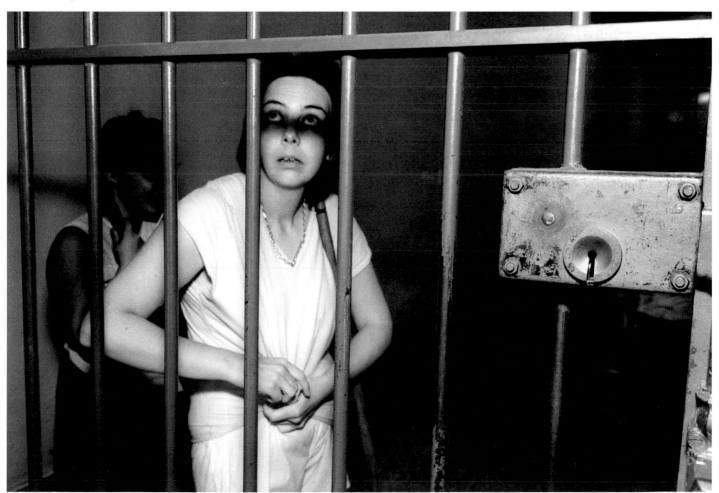

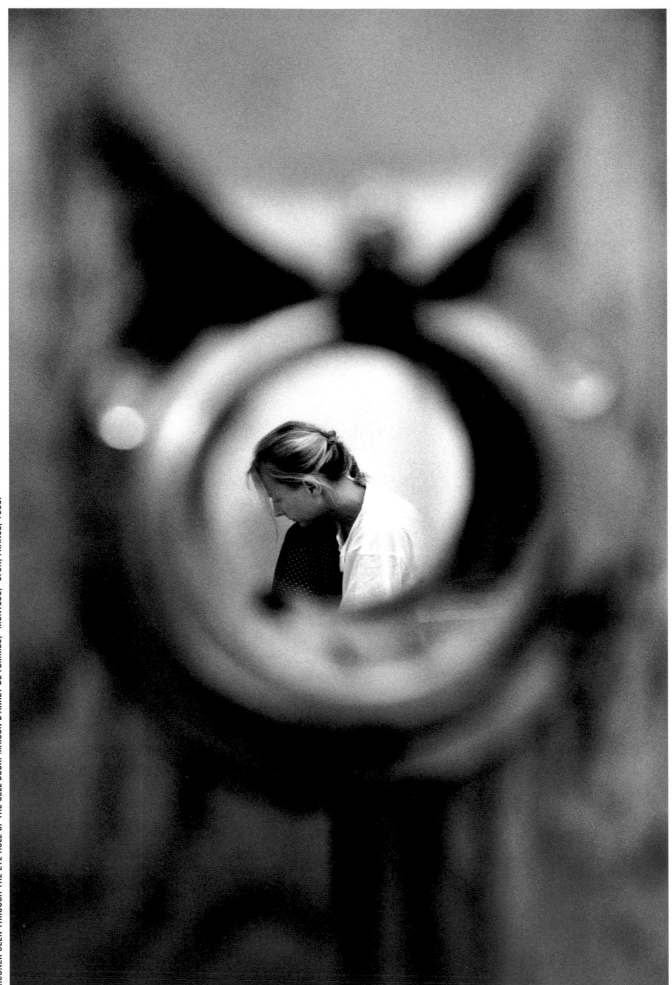

I guess a good place to start would be the very beginning. Ronnie (victim) and my mother first met through a neighbor. My mom was beat up at the time they met at the neighbor's house. I think he saw her as an easy target and I guess she was. After two weeks of wining, dining, and sending her flowers she married him. I felt her that something was wrong be ant and wouldn't let anyone be wedding. About two weeks after married the abuse started. First gradually esculated into physica solated her from the outside w egan to physically and sexual

He ran off everyone from com the house. Then he embarasse at work that she quit. He th low the place she worked up if quit. As far as I know he even tore up her nursing license. He had even attempted to keep us apart. He threatend to kill my father, blow up my car with a lighter somehow, plant drugs on me and turn me in, and to kill my boyfriend. He even pulled a gun on my boyfriend at one point.

MOTHER AND DAUGHTER DOING FORTY YEARS FOR KILLING THE MOTHER'S

another state if that's what he had to
do to keep us apart. Needless to say I
never really let his threats get to me. I
kept going over there; but mostly at that
point when he was at work to avoid conflict
with him all together.

 As far as the abuse goes that I know of

countless times, raped her
...ked and loaded, burned her
... fryer for burning the hushpuppi...
... to the bed many times, put
...the door where you had to
...t in or out, beat her, drug
... house by her hair, and many
...e had even threatened
...o get away from him. There
...n she would have to urinate
...use she was handcuffed
to the bed. There were also times when
he would handcuff her to the bed, forget
that he had, and come home from work
because she didn't answer the phone.
(Not that she obviously could) None of this
was ever investigated. There were also
times when he would ask me to come over
...I got dinner... the time I got ready

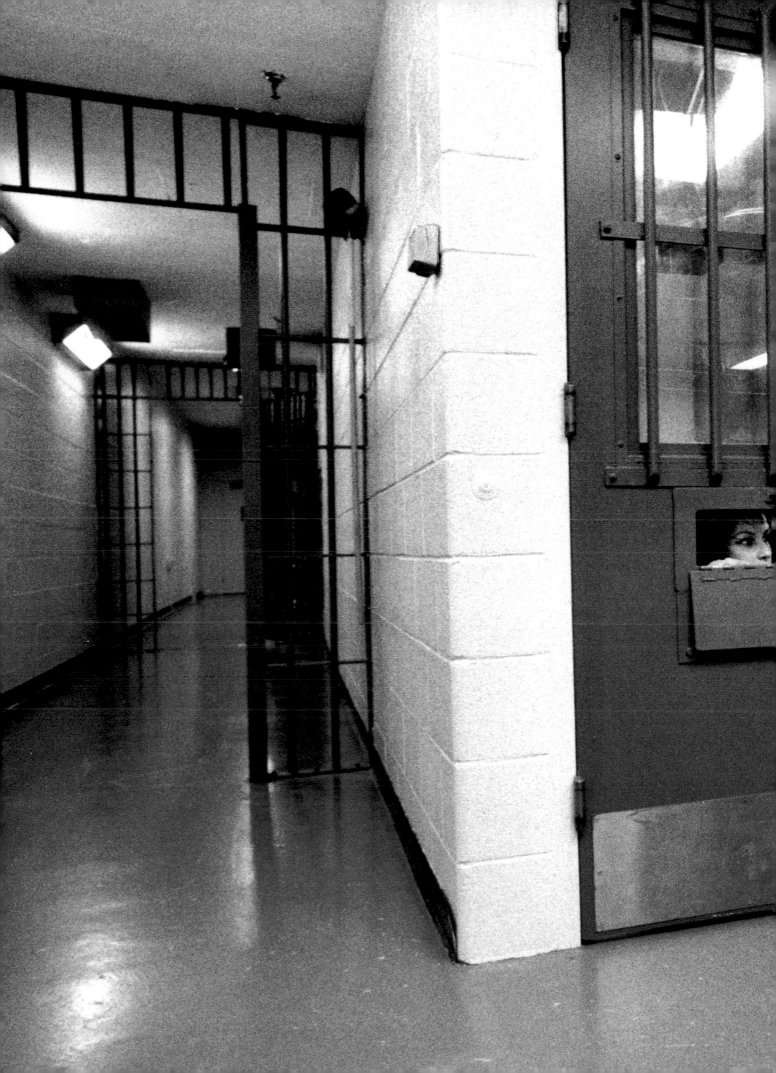

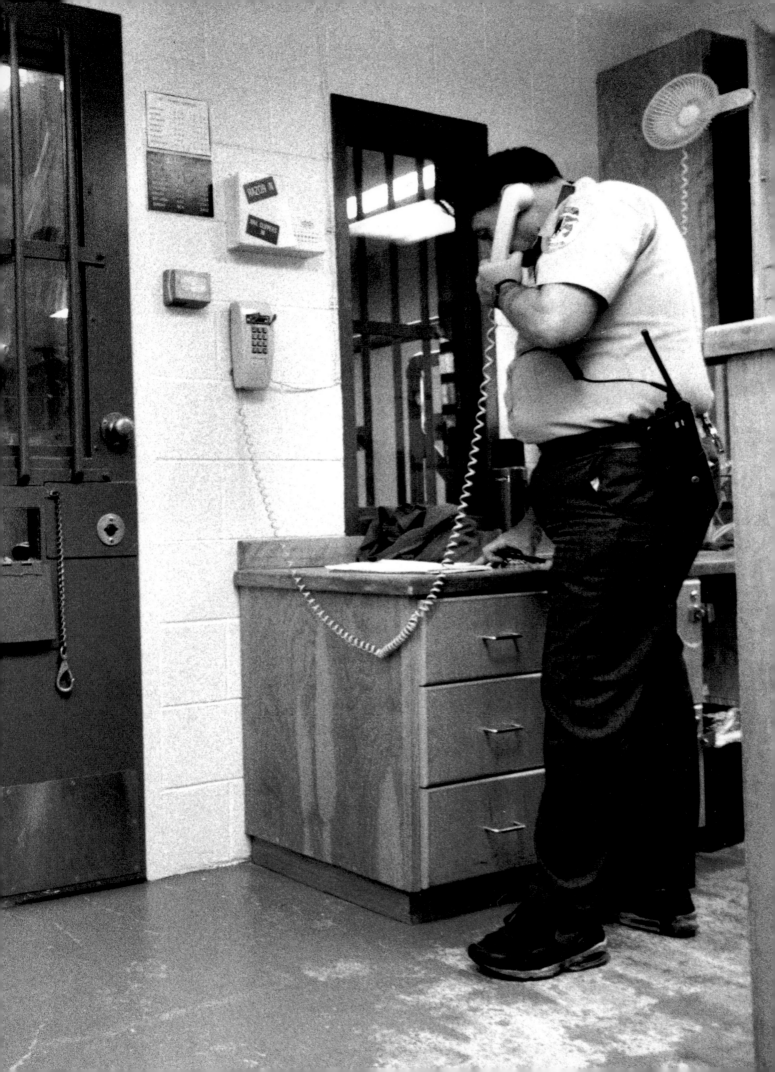

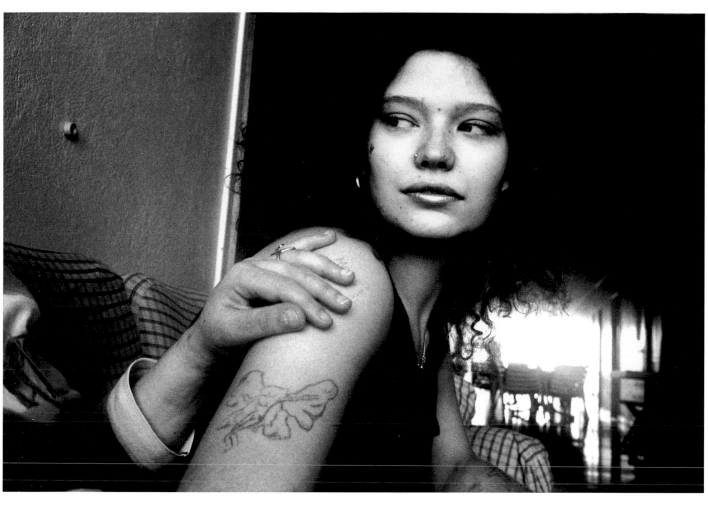

PRECEDING PAGES. CORRECTIONS OFFICER PLACES A CALL FOR A MAXIMUM-SECURITY PRISONER. LEMON CREEK CORRECTIONAL CENTER, JUNEAU, ALASKA, U.S.A., 1993. TOP FRIENDS. HINDELBANK PRISON FOR WOMEN, HINDELBANK, SWITZERLAND, 1994. BOTTOM INMATE SERVES BOILED WATER INSTEAD OF TEA OR COFFEE TO PRISONER IN SOLITARY CONFINEMENT. PERM PENAL COLONY FOR WOMEN, PERM, FORMER U.S.S.R., 1990.

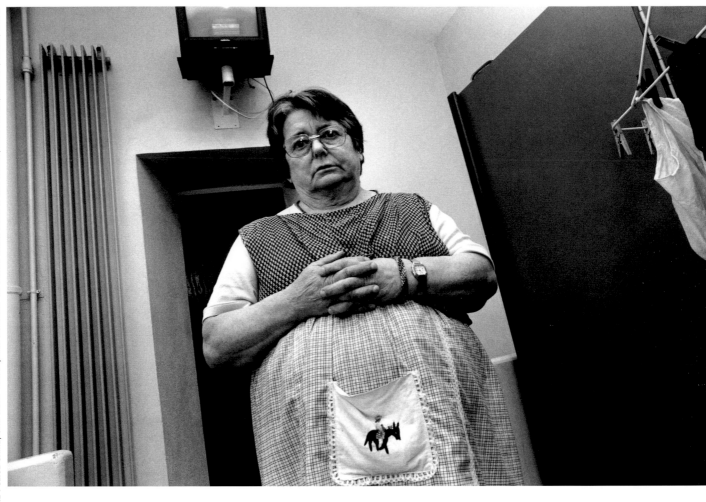

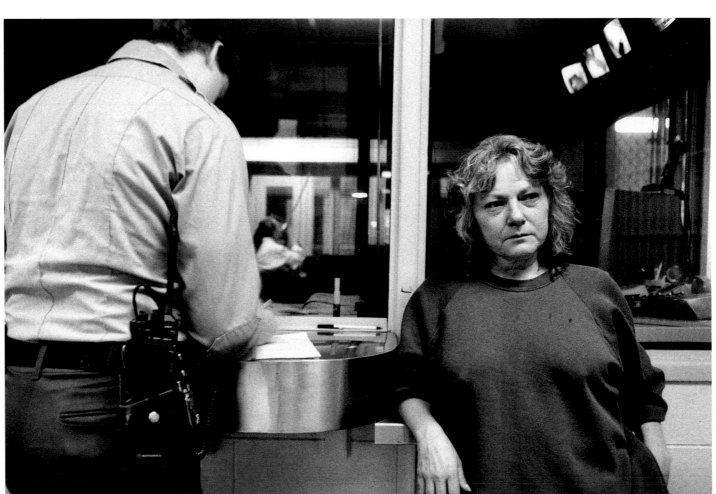

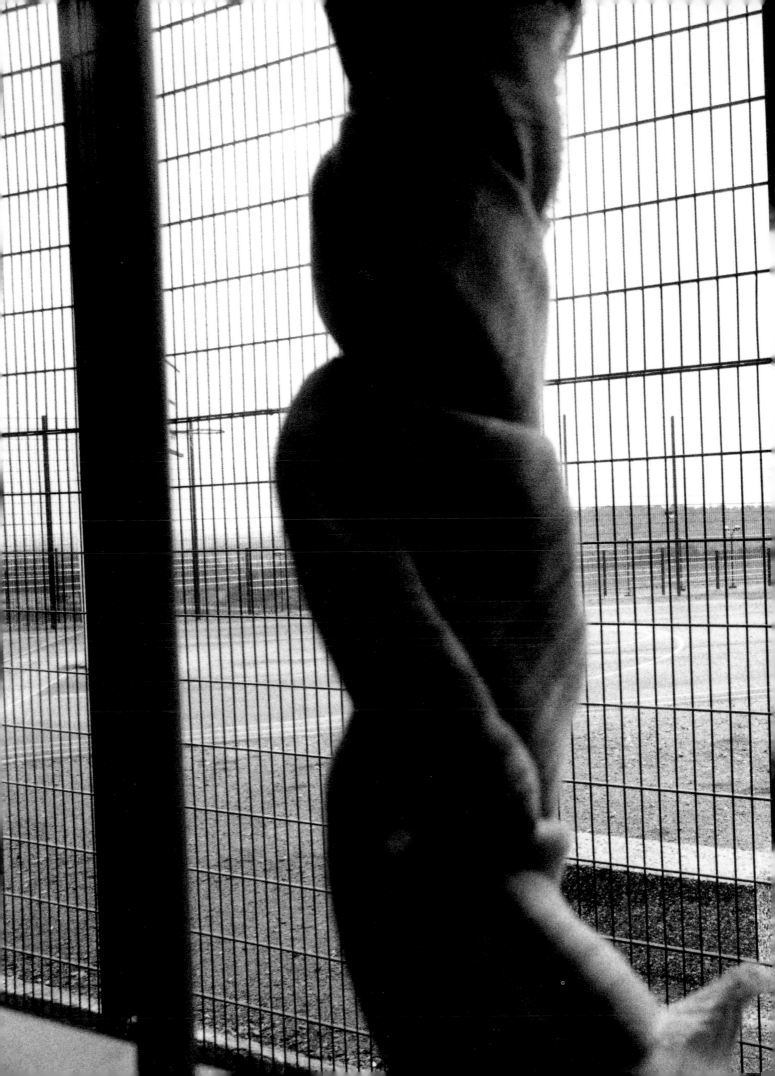

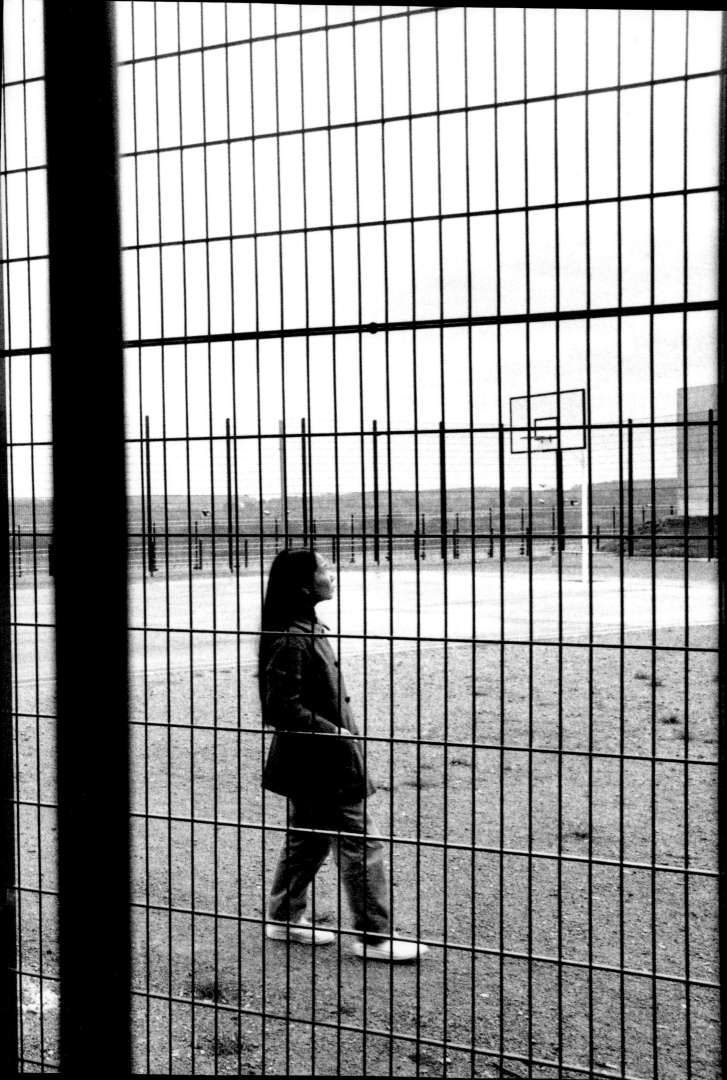

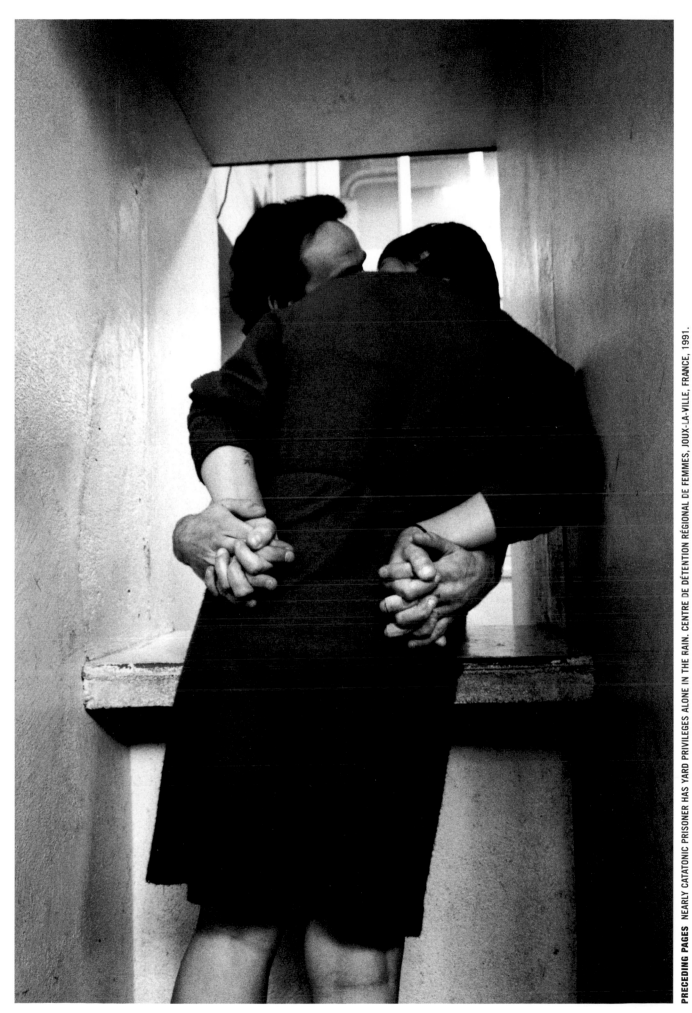

PRECEDING PAGES NEARLY CATATONIC PRISONER HAS YARD PRIVILEGES ALONE IN THE RAIN. CENTRE DE DÉTENTION RÉGIONAL DE FEMMES, JOUX-LA-VILLE, FRANCE, 1991.

VISITING RIGHTS FOR A MARRIED COUPLE JAILED FOR STEALING A PAINTING FROM A MUSEUM. MAISON D'ARRÊT DE FEMMES, DIJON, FRANCE, 1991.

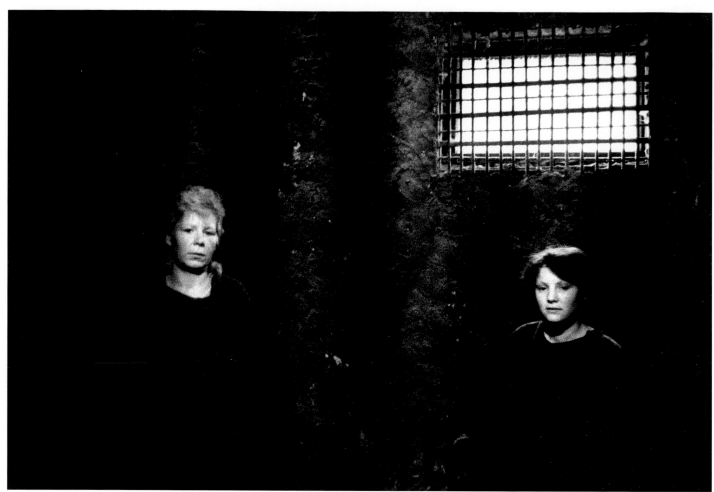

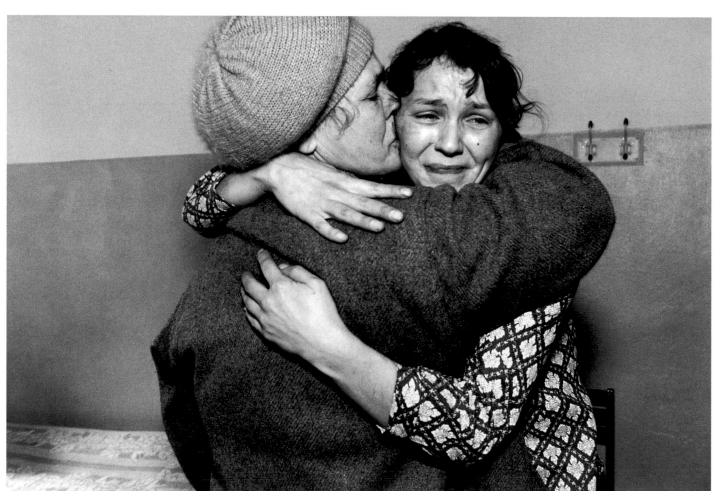

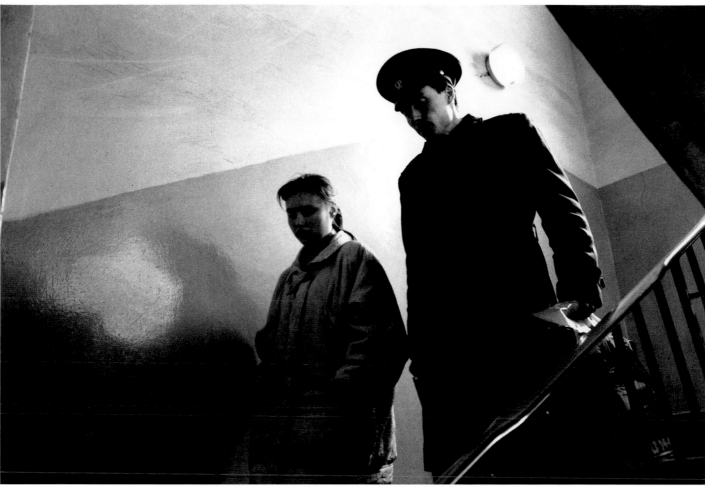

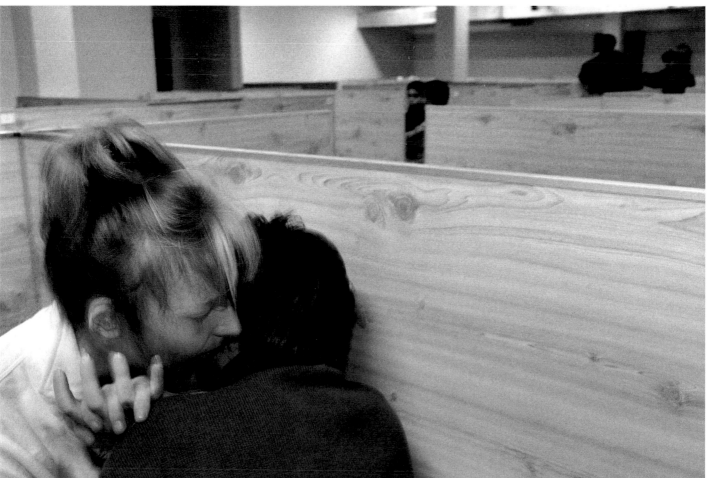

TOP GUARD ACCOMPANIES GIRL BEING "FREED." INMATES SAID LATER THE PRISON STAGED THIS SCENARIO—THE GIRL WAS BROUGHT BACK AND HIDDEN IN ANOTHER BUILDING. RYAZAN CORRECTIVE LABOR COLONY FOR JUVENILE DELINQUENTS, RYAZAN, FORMER U.S.S.R., 1990. **BOTTOM** INMATE WITH HER GIRLFRIEND IN THE VISITING ROOM. CENTRE DE DÉTENTION RÉGIONAL DE FEMMES, JOUX-LA-VILLE, FRANCE, 1991.

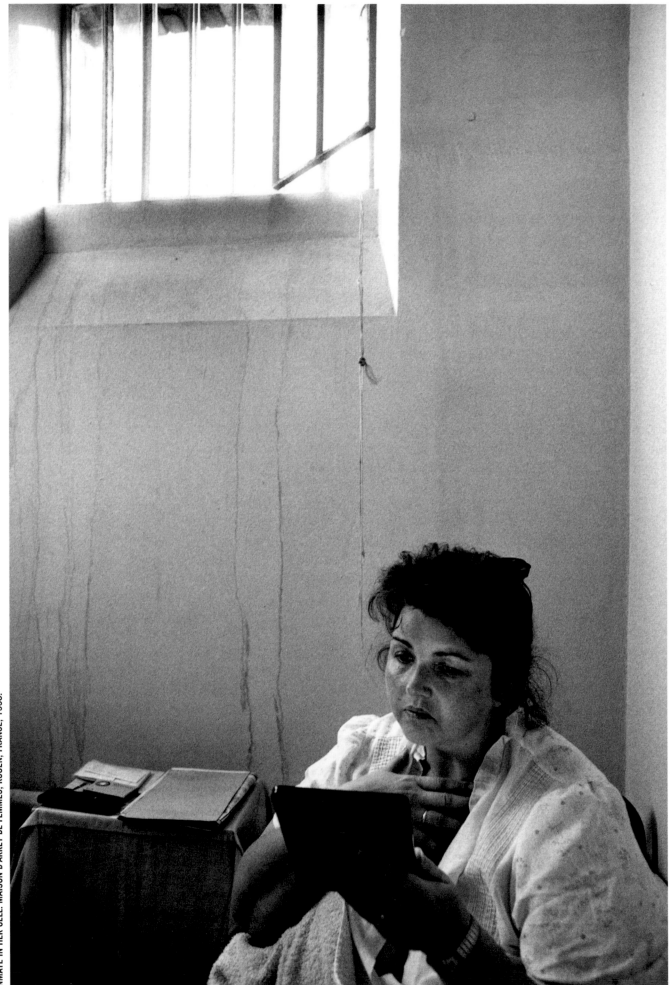

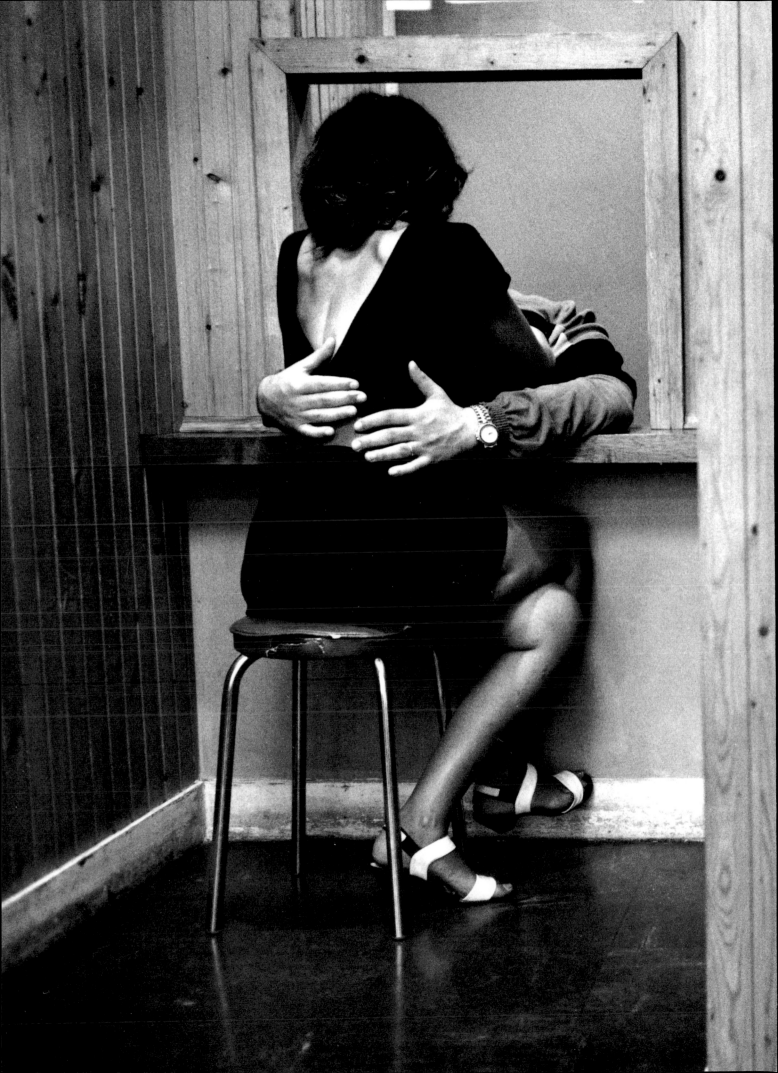

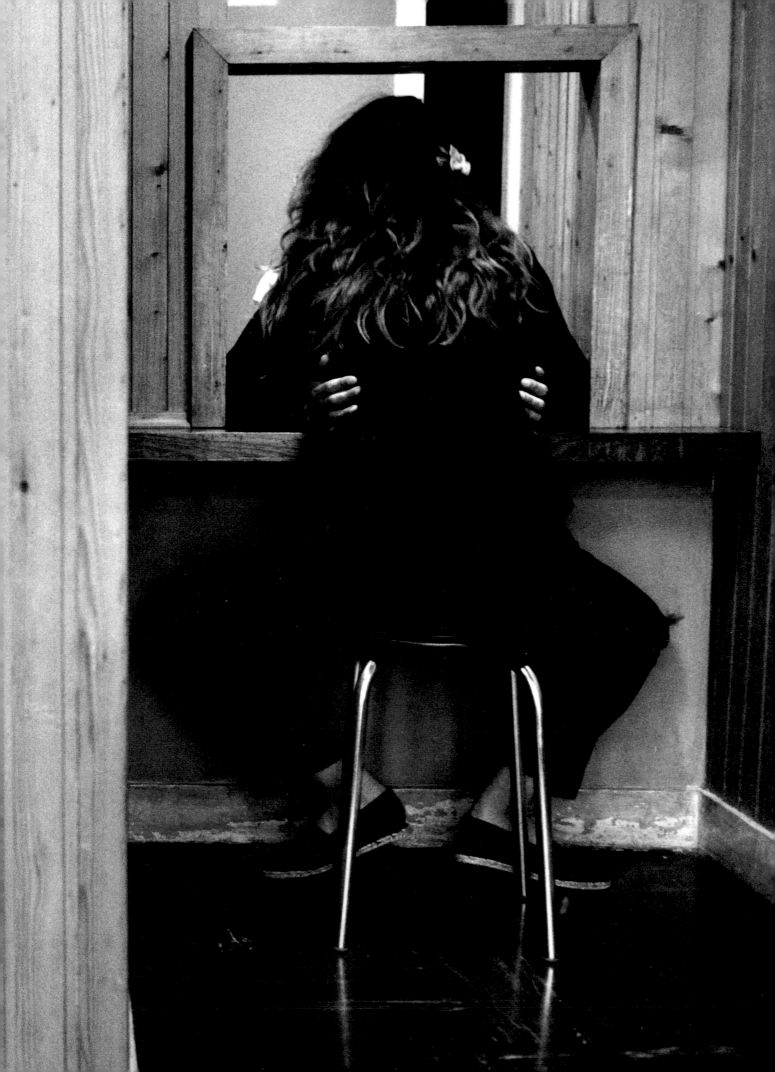

or two women pulling jumbo-sized black plastic bags along with them. At first the wide road—four lanes and a center strip—is almost deserted. But as the day begins, more and more cars stream by. When the drivers are men, they honk their horns or make obscene gestures. The women, obeying orders, ignore them.

The sun beats down, painting the inmates' long shadows on the pavement. Now the women are sweating, their hot faces shiny in the yellow light. The dust of the desert billows up around them as they hack at the dry dirt. Later, to cool off, they'll pour water over their heads from the canteens they carry on their belts as they move slowly down the highway, raking and hoeing and picking up trash, stuffing it into the plastic bags. If one woman needs to go to the bathroom, the whole chain moves down to the portable toilet that is pulled along behind the bus. She closes herself inside the tiny cubicle, hot as a furnace, the chain snaking out from under the door, attached to the leg of a fellow inmate who waits her turn outside.

At 11:00 A.M., it's 110 degrees under the Arizona sky. Time to go back, pick up the bologna sandwich bag lunch, and return to lockdown. Before she enters her cell, each woman is subjected to a body search: "Drop 'em, spread 'em, and check 'em out!" The next day there will be other tasks. The women are kept in the dark as to what these are so they won't be tempted to contact their friends on the outside who might try and meet with them or pass them contraband.

A few days later, closed inside an air-conditioned cab on my way to the airport, I see a female chain gang moving doggedly up the street. It hugs the curb closely as the women paint a thick red line on the side where parking will be forbidden. I search for faces I know, but their heads are bent too low for me to see.

JENNIFER

Why could he convince me to kill that lady? I loved him so much that I didn't want to lose him. My first marriage had failed and no matter what I did, I was wrong. Like one time I was late coming in and I had a flat tire, and the tire was in the back seat and I had put the spare on myself and I was covered from head to toe in dirt and was on the highway and cars were flying by and dirt was going on me and I got beat for that because I was late. I got beat one time because I fried pork chops and he wanted chicken. I've had black eyes, split lips, loose teeth from beatings. I lost my ovary and fallopian tube and appendix from blows to the abdomen area. I had already failed— you know what I mean—and I didn't want to fail again.

I was afraid. I loved him, he was my first love. When he told me, "We should kill this woman," all I could think about was that I didn't want to lose him, that was the main thing.

MONICA

To this day, I've never had a normal, healthy relationship with a man. I don't think I ever had the skills to do that. I don't have a history of violence, I've never been violent in my life. I was always the doormat, and you could abuse me. There was no proof. I wasn't even there when Brad got killed. However, the statement I made could've put me here for life on a felony murder charge.

Okay, the crime was a murder. My participation in it is not real clear. I was in and out of a blackout that night. I plea-bargained out, to robbery and kidnapping, instead of going to trial on a first-degree murder charge. My ex-husband took the murder charge, and he is currently serving time for it. He plea-bargained to fifty years. I'm only doing one to fifteen. Joe was already my ex-husband at the time the crime took place. I had divorced him somewhere around December of '91. There was physical abuse, sexual abuse, emotional abuse. That was the basis of my divorce. We stayed apart approximately six months, then I let him back into the house. Why? Today I would tell you sheer stupidity. But then it was a process that he started immediately when he got out of jail from the last time he beat me up. He appeared on my doorstep after getting out of jail that day, and I was strong enough to turn him away then, because I was still wearing the bruises. But he kept showing up, any time of the day or night. I got restraining orders, protective orders. The two times I tried to have those executed, it was a joke. They weren't worth the paper they were written on.

The last time, he had appeared on my doorstep at three in the morning, intoxicated. It was myself and our baby there. He cut my phone line that night. I had to be at work at 4:00 A.M., and when I got there, I called the police. They came to my house and investigated and said yes, the line had been cut, but unless I physically opened the door, it wouldn't do me any good to prosecute him in court. That was the straw that broke the camel's back. I never called the police again. Shortly afterwards I started drinking again. And for me and my addiction, I ended up letting him come back.

I have three children. I worked most of our marriage. It's hard, trying to raise three kids. This was my second marriage—my first one played into why I stayed with it as long as I did. There wasn't really any physical abuse in the first one, but a lot of mental and emotional abuse. I would beat myself up with what I had been raised to

believe: once I got married to a man, I was supposed to stay married to him from now on. And if I put him away, I was supposed to stay by myself from now on. Also, you're supposed to forgive if they come and ask you to. I have changed my views on these things since I've been incarcerated, I must say. Why did I let him come back? I think the biggest thing was that I started drinking again.

As long as I was sober, I could keep Joe out of the house, because the logical part of me knew he wasn't going to change. Physically, it always got worse, never better. The last time, before I filed for divorce, he beat me black and blue, bruises all over my face, my body, back, front, legs, arms. He dragged me through the house. The only way I got out that night was when my son attacked him from the back. That's when I knew I had to do something. Because it wasn't just me any more. If it had not been for Bob, I feel certain Joe would've killed me that night. He's maybe six-three, six-four.

Joe was a truck driver, long haul, where he'd be gone weeks at a time. He was raised in an abusive home. He watched his mother and father fight physically; guns were involved in their relationship. My father was physically abusive, but my mother divorced him when I was three, to keep us from being raised in that. I did not sober up until I was pregnant with Jean, the baby I had with Joe. I stayed sober almost four years, and just kept taking the beatings. I always blamed his physical abuse on his youth. I was headed towards relapse for a long time.

I lost a lot of respect in my children's eyes when I let my ex-husband come back. My oldest daughter, Cheryl, was not living with me then, because she was afraid of him. And my son and baby daughter, who is also Joe's child, witnessed the last beating that I took. I was back with him two months, maybe, when the crime happened.

The morning of the crime, I started drinking about 8:30. I was off from work. He was at home. He was working a job three to eleven, so he was in bed. I remember his check came in the mail, and he got up, and we went to cash his check and put money in the bank. He had gotten a DUI (that's a citation for driving under the influence) prior to this and was about to go to jail for six months. It was his second offense. They had given him a date to start serving his time. So he had promised he would leave me financially set before he went into jail, as far as the rent and utilities, whatever. That's why it was important that I get the check into the bank.

He joined me in the drinking, knowing he had to go to work. I drove, and about the time we got there, Joe had decided he was too much under the influence to work, because he knew if he went in like that, they would fire him. The place I chose to turn around was a bar I frequent-

ed. In that parking lot was a "Jimmy," a Bronco-type vehicle belonging to the man that ended up murdered. Kitty and Carl, two of my kids, were in the car with us and Kitty said something about it being Brad's Jimmy, and this sparked something in Joe as Brad is a man I dated right after my divorce. Joe talked about rolling him and robbing him. I didn't take it seriously, because that type talk went on with Joe all the time. It would be, "I'm going to roll him, I'm going to whip his ass." To my knowledge, he'd never gone through with it. Needless to say, the district attorney didn't see it that way. I should've taken it all very seriously.

I don't remember what really happened that night. I know the result, though. The man was brutally beaten, cut up and what technically killed him was being run over. They say my connection to it was that I acted as the lure, or bait, to get Brad outside of the bar so that Joe could get him off somewhere and rob him. I don't remember leaving the bar. It was storming that night. My first memory is that I was in my car, and I got rear-ended and run off the road. I can remember the Jimmy going by. I somehow got out of the ditch and back to the bar, and I ended up at my sister's house for the night. I remember that my brother-in-law came to the bar and picked me up. And I remember him taking me to my apartment and not letting me go in because Joe was there.

When I woke up the next morning at my sister's house, she was raising hell because I was drinking again. I picked up the phone to call Brad to come pick me up. He was a drinking buddy, is about what he was. His mother then told me they found him with his throat cut, dead. Gutwise, I knew everything. I started drinking again immediately. When my sister took me down to pick up my car, the police were waiting, and said they wanted me to make a statement. I told them Joe had talked about rolling Brad. They asked me if I knew where Joe was. I ended up taking them to the apartment that afternoon, and letting them in. They arrested him then. I continued to drink and they arrested me at 3:00 the next morning.

When I got here, I corresponded with Joe just long enough to get him to admit that yes, he had murdered Brad. My last communication with him was around February of '94. He'll probably do ten or twelve years before he goes up for parole. I'll do at least four and a half. I feel certain he'll come looking for me when he gets out. From what I understand through my daughter, he's doing very well. She corresponds with him, and part of me wants to prohibit that completely, but then the other part

PRECEDING PAGES VISITING RIGHTS FOR COUPLES WHO ARE INCARCERATED AT THE SAME TIME, MALE AND FEMALE, IN TWO SECTIONS OF THE SAME PRISON. THE COUPLE ON THE LEFT WAS SERVING TIME FOR SELLING KITCHEN CABINETS THAT DIDN'T EXIST; THE COUPLE ON THE RIGHT WAS ARRESTED FOR CURRENCY TRAFFICKING. CENTRE PÉNITENTIAIRE DE FEMMES, METZ, FRANCE., 1990.

of me, that grew up without a daddy—I won't do that. Last letter that he wrote me, he was still in counseling for the physical abuse, AA and NA. But as far as whether he was really doing that, I don't have any idea.

I was a doormat. Period. You could run over me. I was a bitch, some people tell me. Created a monster. No, really, I agree with that. Now I feel that I've gone to the other extreme. I don't have to settle for—you know? You're going to treat me how I want to be treated or I won't be there, period. I've gone kind of overboard with that, and I'm looking for the middle ground now. I attend AA and NA regularly. I've gone through codependency; that helped me immensely. I would personally like to see them get more in depth with that because the biggest majority of the women here are codependent: "depending on you for how I feel about me." I don't do that any more, or not as bad. But that's the way it was as far as my relationship with men. I see that today. I think a lot of it goes back to being raised without a male figure at home. There was a lot of dysfunction. I never had a good male role model, I never did.

My first husband was a little over fourteen years older than me. I now think I was looking for a daddy and this ex-husband codependent Joe was five years younger than me. At that time, I had been divorced seven or eight years and wanted to be married again. That was the bottom line. I knew it was all wrong because I had been taught in my first trip for treatment that you don't get involved with anybody in the program, much less turn around and marry him. This man beat the hell out of me and then two weeks later I married him. That's how much self-esteem I had.

I was active in my addiction. The police stepped in this last time, and took it out of my hands—they pressed charges. Which I'm grateful for today. I'm grateful for my family, too. As far as the public's opinion on my situation, I don't totally disagree. And as far as resentment, I don't have any.

WENDY

Typically you have a woman that comes into prison that is married and the husband won't stick by her. But you've got a man that is incarcerated and the woman will stick by him through all of it, just like we do in relationships—we will stay in even when we're being abused, for whatever reason we think we have to. It's just a different chapter in a book and women get less support from the outside than men do. So it's more accepted if a man has been to prison than it is for a woman.

I think women learn in prison to be harder than they normally are. You bring a female into an institution where everything is geared for the men: the clothing, the programs. I look at the women's prison basically as a

stepchild for the Department of Corrections and the stepchild is the one that does without and does with the least. The money that's available for this institution is more for men than it is for women. We have a budget in our dining room to feed the population but I bet you couldn't feed men on it, because when you don't feed them enough, they tear the place down. Yet the women will accept a whole lot less than the men without acting up. Oh, they run their mouth, lie and do all those things, but as far as acting out, most of them won't do that. The regulation clothing was just jeans and a shirt and they finally just get a skirt. No hair spray, no fingernail polish, though makeup is limited to what they sell in the commissary—if you can't use that, then you don't use it. The reason we can't have fingernail polish is because it's toxic and flammable. But a woman that wants fingernail polish does not want it to set a fire; she wants it to do her nails. She doesn't want hair spray to set a fire, she wants it to put it on her hair. But because that's what the men would do with it, we can't have it.

GWEN

Gwen had been on death row for nine years. She was willing to talk only if I agreed to change her name and not divulge the name of the prison she was in. She would not go into details about the crime she was condemned for because she wants to protect her two sons from information concerning her late husband too painful for them to learn. Even during her trial Gwen didn't tell the whole story; it has only been in the last two years, with the help of therapy, that she has managed to admit what had happened to her in her marriage that provoked her to murder as a solution.

At one point, the legality of the death penalty was overturned. But the legislature then passed another law that met constitutional requirements, and capital punishment was reinstated. The federal judge in this state is very much against the death penalty and will hold his position for life. He has vowed to stall the death sentence cases on his desk. Because of this, there has not been an execution here in over thirty years. This explains why Gwen has only had one appeal and is still awaiting execution. It also explains why there isn't yet a true death row for women in this state. After years in isolation, a policy was created for Gwen (the only woman condemned to die at that time) that as long as she conformed to prison rules she could stay in the general population, but if she leaves the confines of the institution she would be treated as "segregation status." This means that if Gwen is taken out of the prison, for any reason, she has to have two cars and armed officers accompany her at all times.

I'm in here for the death of my husband. "Accessory before the fact" is what my charge is. That I had hired someone to kill him. Now I don't claim that I'm innocent. I have to take the responsibility for what put the wheels in motion but those wheels were to have been stopped, and they weren't. Some money was paid as blackmail money so that nothing would happen but the crime ultimately did take place. When it actually happened I wasn't aware of it myself.

My biggest fear (and the reason I ended up in the blackmailing thing) was that the idiots I talked to said they'd go to the police. I thought I could get in trouble just because I had contact with them. So I paid them not to do anything, thinking that they would stop. There was a phone call made from me to meet someone as they wanted some more money. But I didn't go to pay them; I went to tell them that I didn't care what they did anymore. (I didn't know what had happened, didn't know whether they had done it, didn't know anything.) But because I met them they arrested me. But the money transaction was to stop it; not to put it in motion. There was never any money passed then. And when I started trying to stop it, it was like, gimme *X* number of dollars—naw, you got to get back in touch with me—no, I got to have more money. And finally I said, "There is no more, there is no more money to be paid. Go do whatever you have to do." Well, I figured they were gonna go to the police, that's what I thought. That was in November 1984, and my husband was killed in February 1985. Why did they kill him? That's what I want to know. Why did they kill him?

To everyone on the outside we looked like the "all-American family," a nice home, two children, both of us with good jobs. He was assistant director of nursing for one of the hospitals. But behind the door there was a whole lot of things that were different. There was mental and sexual abuse, numerous years and years of affairs, some physical abuse, although more of it was mental and sexual than anything else. Just in the last year and a half have I even been able to talk about it. There are people that have known me for years that have just recently found out some of the details and they don't even know the tip of the iceberg. And I'm still working through that because I didn't realize that some of it was abuse at first. I thought it was what I was supposed to take as a submissive wife. I had never had another sexual partner that I had ever been to bed with and I trusted him like I trusted my daddy.

We were married thirteen years in October. We discussed a divorce about a year before this happened and he went nuts. He told me I would never get Sam and Gary, that he made more money than I did, and that with his job and who he was, he would get the boys before I did. All I asked him for was a divorce. I wanted the kids, but I didn't care

if he took the house. I made enough money to raise Sam and Gary without his help and we would have been fine. I had sat down and figured out and I knew that I could take care of them. He told me other people would never believe me and with his personality, they probably wouldn't have. He could charm, and was well respected in the medical field. That's why there was as much publicity with it as there was. He told me that I would be dead before I got a divorce. He couldn't tell me why he wanted to stay married with all the other things he was doing. But then he would never ever admit those to me.

And as he went from one relationship to another I would ask questions and he would say, "I don't know why you would ask me that." So in my fantasy world that I lived in, I thought that as long as he didn't admit it, maybe it was not going on. But I knew it was. My dad had questioned me numerous times about different situations. The second time I ever remember seeing my dad cry was when he was sitting in the jail and he asked me why I hadn't told him the truth, because he had suspected. I don't know what daddy picked up on, I really don't know. There were some bruises I think he saw but I told him it was something else. Daddy always accepted whatever my answer was. But the day I was incarcerated he sat there and cried just like a baby and kept asking me, "Why?"

It's interesting because a lot of friends that I thought were really true friends, friends that are there no matter what happens, just vanished. I don't believe they could deal with it. It was devastating—devastating is probably not even dramatic enough a word to describe how it affected everyone that had touched our lives. And the big question with everybody was why (if things were not as they appeared) could I not have found someone to talk to, why didn't I trust some of them? But I had been pushed emotionally. Though I realized what had happened and tried to stop it and wasn't able to do that. I didn't want him dead. Even after he was not dead when we got home, I said over and over again that if he lived, even as a vegetable, I would still take care of him. From the time that he was beaten and they determined that happened, he lived about eight or ten hours. He was unconscious. I was there in intensive care with him before he went to surgery but we couldn't communicate. And I can say today that I hate what he did but I don't hate him.

I can't tell you a whole lot about anything that went on in the courtroom. I remember the sentencing, I remember that the reason they waited until January 6 for my trial was they wanted to put Sam, my oldest son, on the stand. For nothing in the world but sympathy. And all they asked him was to point his mother out. They showed him a picture of his dad and asked, "Was that his dad?" and asked

if he loved his mother and his dad. Had he ever heard us have an argument? And that's all they wanted. Well, my sister would not agree to it but when he turned twelve they could subpoena him. His birthday was January 4 and he turned twelve so he was subpoenaed to court on January 5. I was against it. I even tried to plead guilty as opposed to having the kids go to trial. They wouldn't accept it. In the courtroom Sam was crying, I was crying. I remember him sitting and I could still see him to this day. I had asked mother and dad not to come to court. At my request they didn't. I didn't want them to go through it. I had no idea what it was fixing to be like but I had had enough up to that point with the media and I just didn't want them having to fight that.

I remember the judge asked the jury if they had reached a verdict and they gave him a piece of paper and they read guilty, accessory to the fact of first-degree murder. For the first time the harsh reality of everything that had gone on for that whole year finally hit me. I broke down in the courtroom. I couldn't believe it. Looking back the worst thing I didn't do was that I didn't testify, because I thought I was protecting the boys as far as things that I didn't want to come out about their dad, because to me there was nothing I could have said in that courtroom that was going to justify what had happened to him, nothing. I was incarcerated four days after the crime, and then my sister took custody of the children. I didn't explain to my kids because I wasn't real sure what had happened. The court wouldn't accept a plea bargain. We went into the judge's chambers and tried to plea-bargain for life but because the codefendant wouldn't, they would not accept mine. I believe it was two days later we went back to the stand. I remember that the judge had me stand up and he told me that I had been sentenced to die in the electric chair and he gave the number of volts of electricity that would be surged through my body until I was dead. It was two thousand, I think. I used to know the number but I probably just tried to block it out. And we sat down and he started telling the jury what a good job they had done and when they did that my attorney just stood up and took me out of the courtroom.

I remember feeling just the shock, like somebody had just slapped me completely off the face of the earth and the next day or so I got to the point where I really didn't care whether I lived or not. It was like all this had happened and I was ultimately responsible for it, though it was not what I really wanted to happen, not just because I got caught, but because it was not what I wanted to happen. And then I took responsibility for everything, for my whole family destroyed. There was probably more guilt at that time than ever. I started crying and could not stop

and it was like the pain that I felt inside was pain like I had never felt before because I just realized that I had just totally destroyed the family. I called my parents but daddy didn't understand. He didn't understand how they could give a death sentence. He didn't even know that it existed in the state until all this started. Daddy wasn't educated in that way at all. During the first visit that my father was able to come to the jail daddy said, "I guess if I was a millionaire I could pay your way out of this." That was all he was thinking about.

The media was the worst thing for the kids. There was mega media coverage the first Mother's Day that I was locked up. They wanted to do an article on me on Mother's Day. I said no. I found out they had contacted Susan, my sister, and Susan had said no. They were trying to find my kids, Sam and Gary, and somehow, they got a picture of the kids when they were younger. Susan fought to find out where they had gotten it, how they found out where the kids were in school, and the whole bit. It turned out that they got a picture through the police department and one of the reporters got in some serious trouble over it. The reporters were convinced Sam and Gary would be coming out the same door of the school together and they were asking all these kids to point them out. The lady that worked with the traffic—well, Sam was standing right beside her, and she said "Why do you want to know where the Bard children are?" "We want to take their picture." She said, "I don't think so," and pushed Sam back. Sam never said a word; he heard, but he didn't know what was going on. And the traffic lady went and got the principal who came up and they ended up ordering the reporters off. In the meantime, Gary comes running out, and hollers, "Sam!" And that's when they turned and snapped the picture. The police were called. That was probably the most traumatic thing that they went through with the media.

My sister and I grew up real close, she has had a real hard time with everything they have been through and she has had the responsibility of my children by her choice, she wanted to take them. At the time of the crime they were eight and twelve. The boys have done real well. Their lifestyle changed drastically but as far as what they were interested in as children, sports and school, none of those things had to suffer.

I don't have contact directly with my boys. They have never really wanted to talk to me. What contact I've had with them, the conversation that I had, has been around birthdays or that kind of thing. I talked to them, of course, when my dad died. I wrote them every week, and still do. Every Tuesday there are two letters that go out of here, one to each of them. I didn't tell them I received the death penalty. I'm sure that they learned it through the

media. I have learned through correspondence with a cousin of mine that they had gone through some hard times with it. I don't think I really knew what to expect and then when I stop and think about the age, kids are cruel. Sometimes they don't mean the things as vindictive as they sound whereas an adult may mean exactly what they say. A lot of the time a child would speak what they hear a parent say. Right now there are some things going on that make me think that maybe the oldest one is ready to come see me. They have asked for some visitation forms, so we are waiting to see where that's going.

I was not treated any differently in the jail once I was sentenced. They didn't see me as a threat. I had been there almost a year working and hadn't caused any problems so they didn't take that away from me. I didn't go back to work for three or four days. They ended up medicating me. They said I needed it, though I never asked for medication. I remember coming up on the floor after being sentenced but I didn't remember a whole lot of what anybody said for several days. There have always been comments: some to your face and some behind your back, so you just have to let 'em roll off. I know it's there and I know it's real but the reality of the sentence is I go to bed every night knowing I have it, I wake up every morning and I know that I have it. But somehow I'm able to walk through the day doing whatever there is that keeps my mind busy. There were times when all I did was dwell on it and it can destroy you because there is nothing you can do about it until the courts rule. You can read all you want to, you can educate yourself, but there is nothing you can do. It's in the hands of the attorneys that are representing you.

And I had to learn that somewhere I had to start the best I could taking care of Gwen, whatever that was, and whatever it was that would keep me busy. I took cosmetology courses, I did a lot of reading, I wrote a lot of letters and did a lot more than what I do now (you go through stages of that) but you had to get out of the mind-set every day that you get up that maybe your appeal is going to go through that day. And finally one day I woke up and I realized it's not going to happen next year. I will not allow the state to be the one to kill me. I believe that my family could deal better with me if I committed suicide. A situation happened several years ago where I went from the state court into the federal court and somehow the paperwork was messed up and they didn't have a stay of execution and the warden at that time was notified that within five days, if they didn't have it, that I would have to be transported to the death house, and death watch. Well it got down to four o'clock the day before I would have to die at noon, and my gut feeling told me, no, it was not going to get carried out. I knew that it was the bureaucracy downtown within the courts and the paperwork that made death come that close. My gut feeling was no, but it was a scary time. I knew I had the right to those appeals and I knew that we were talking about paperwork and I knew that no way on this earth was someone going to be executed over paperwork not being there, and I wouldn't believe that.

My execution date was set for thirty days after I got here. I was sentenced in January and it was set for, I believe, June 27. I've forgotten all those dates. But even though that date was given in the courtroom there was a stay of execution that was put into place within just a few days of me being sentenced—so I didn't come up here thinking well they might come for me today and execute me, you know. So that's another thing that gives you security—the fact that you know that there is that stay that they can't do anything until something happens in the courts. There is security in that, that gives you a security within yourself—although it's not enough. I walked down here and I thought I had walked into a zoo. It looked like a bunch of monkeys the way the intake was set up, with all the officers hanging on the bars just staring at me. And at the time I didn't know I was supposed to have been six-foot seven inches and weighed about 300 pounds and been mean as hell. Here I walked in at five-foot three inches and about 125 pounds scared as hell. But I later learned that they just couldn't imagine what I looked like and in their own minds was this stereotype.

After they processed me in, all of a sudden there were all these phone calls made because nobody knew how to take me anywhere, and all I kept thinking, "I got two feet, what do you mean, how do I get anywhere?" The man that was here didn't know what he was supposed to do with me. It was a huge dilemma for the warden of security but there had been apparently no definite plans on how they were going to house me. I was put into the dry cell and spent a little over twenty-four hours there. A dry cell is for an inmate that has acted up—that's where they were put for observation. Finally they moved me into the segregation unit and that's where I lived for a little over six years because there was no policy for death row inmates here.

Now the way this institution is built, the segregation unit was also for inmates who got disciplined or write-ups. However, at the time I came in there just weren't any inmates back there. I was the only one back there the majority of the time. I had an hour exercise every day in a fenced-in yard with two officers. And I would go back out and walk that yard and sit out in the sun.

The one thing the warden promised me was that I was not going to the men's prison. I needed to quit worrying even though I kept hearing some mouth saying that's what they were fixing to do, send me to where the men were on

death row. It was other inmates and some other guards that said it to see what kind of reaction they could get. I started in room nine and that was my room for three years. I was pretty much the only one back there except for a few inmates that would come in and out that I would know. And the rule back there is you are not allowed to stand and talk at the doors, because you are being punished, though everyone back there kept telling me I wasn't being punished. I hadn't done anything to be punished, but living in that situation it was hard not to think so because you were locked down with the exception of the time that I had on the job and the time that I had to shower and use the phones. I learned to appreciate a whole lot about the sky and the trees and the grass and things that I had just taken for granted. How pretty the colors are and just what nature is all about.

After they closed the exercise yard they put those cages back there and, as a result, for three years I didn't go outside. I was locked in my room, I was locked in my work area, I was locked in a shower, and I'll be damned if I'm going to be locked in a cage outside. The first night I walked out of the dorm I was escorted on the sidewalk. It wasn't that they didn't allow me to touch the grass but the path they took, from point A to B, was the sidewalk. The first night I wanted to go out, when I got to the door, I couldn't breathe, I was frozen. So I went back to the room, which was just horrifying. When I finally went out, I think it was the third day, the yard was open and I had to take my shoes off to be able to feel the grass next to my feet, something I never would have thought would make any difference. A lot of people just really didn't understand why it would be a big issue but it just is—it's hard to explain.

And then there was a change in administration. All of a sudden they come to me one morning when I'm going to work and said, "Gwen, starting today you got to be handcuffed." And they didn't know if I would go or not. And initially, my reaction was "stick that job." I sat there on the bed and I cried—I don't remember how long—thinking, but the job is the only outlet I have, it's the only interaction with a variety of people. And so I had to weigh that. First they thought I could be handcuffed in the front. Well, I was okay with that. Then they decided I had to be handcuffed in the back. Now to some people that doesn't make any difference. But being handcuffed in the back makes you feel like you have absolutely no control or protection of anything. There is a sense about the breasts when it gets right down to it that makes you feel exposed, though I never fell, because the officers were always attentive to make sure nothing happened. Your gut feeling is, "I'll fall flat on my face and I've got to lay there until somebody can get me up." You can't get up on your own

without some assistance, so it's the most helpless thing.

My attorney contacted the Department of Corrections and the warden to see if there was something that could be worked out, for me to be put into population. You see, you are segregated because they don't want population to get to know you in the event your sentence is carried out. Because they don't want to deal with the atmosphere. But at any rate my attorneys pursued it, there were letters written by staff members here saying they did not have a security concern issue of me living in population.

Now I was fortunate—they went to the property room and they built a cage. I call it a cage, it was a fenced in area with a lock. And I started to work down there doing clerical work where the new admissions come in and the monthly packages come in. I would be escorted from my room to this area and locked in. I always had to have the two officers come with me and the whole bit, but it was a job so I got to go down there and I would work whatever hours they worked, I didn't care how many. I stayed until January 21, 1992. That's the day that I actually moved into population. They went through a lot of legal steps and the attorney general said that there was not a law that said I had to be locked down. The big issue was that they could not give me the programs that the men [on death row] had.

I had to have a partial hysterectomy in '87 and I had been up for a mammogram and they sent me out for some tests. First time I went out it was a shock. You know you are not going to do anything, you know you are not going anywhere but they had you in all this gear with shackles on your ankles and there is a waist chain that hooks to handcuffs and a black box that hangs on the front of you that gives you no movement whatsoever, and then you turn, and everybody had a gun and one of them had to be a rifle. There are two officers in a chase car—the car that follows the vehicle that you're in—and they have to ride right behind you. And two in the car with me—the security has to be four. Armed. Now when they were doing tests like I had to have, they take off the shackles while you are in the test area, but then they have to put it on you when you come outside. You get a lot of stares, you get kids running everywhere, you are in an orange jumpsuit that says prisoner. The elevator opens up and you hear squeals and you just kind of stand there, but you can't say, "I'm not dangerous," because they wouldn't believe that. The hospital staff came back just to see what I looked like. I don't deal with that as much now being in population— invariably the grand jury comes to visit, and then if there are any legislators that want to come they are allowed in segregation for tours, and then new employees, and there were curious people who wanted to know where the death row inmate was. Some officers periodically want to tell

them that they have one in here.

They left me in a single cell for six months. They asked how I felt, if I would have a problem living with someone. There was a certain type inmate I didn't want to be a part of, and I was real vocal about the fact that I didn't want to live with someone that was in trouble all the time and always stealing or doing something just to get in trouble and that kind of thing, but otherwise, no.

I feel like I'm accepted pretty much. I knew I would be real nervous, but I didn't know that I would be as awkward as I was. I couldn't hold a tray when we went into the dining room and I could not go into the lobby with all the people and that was real hard because the first few days everybody wanted me to come out. I got a lot of hugs that I didn't want but I knew that was something I was going to have to contend with. And then in my mind I wanted everybody to think that I was okay but yet I knew they were all watching to see if I was, because they weren't sure, they didn't know what it was going to be like. The transition was hard. I can sit here and tell you right now it was a solid year before I felt okay.

There are some days that the death sentence is real emotional because you think about the reality of it. Days when you think that with the change in the federal administration, the state, and the governor, that they are so for the death penalty that they want to end all the appeals. For the first time I had fear of actually seeing it carried out. I always said they will never do that to a woman, but I don't believe it today. But though the governor is so adamant, society is changing. Look at people like myself and some of the women in here. There are a bunch of women in here if they were let out today you would never hear about them. Never. I would say 80 percent of them. I would imagine that the majority of the charges are because they did something for their boyfriend or he did something and she was just there. That's scary. You have to be real careful not to just have a real, real bad attitude about men in general when you look at that and realize they have ended up in here all because of a man.

BOB ACCREDITATION MANAGER

Three days prior to the date of the scheduled execution, a man or a woman—the procedure is the same—would be moved into the rear of death watch, building eight, into the death watch area. We get the court order assigning the execution date. Now the governor's office, the attorney general's office, our legal department, and the attorneys of record for the inmate all have copies of this same court order. Central office will notify us whether or not there has been a stay granted. The courts notify us also. In the thir-

ties, the state executed three or four in one day. We had four scheduled at one time here and of course, some were in the early stages, some were in the mid stages, some were late stages of appeal, but they did not take place. The closest we have ever gotten to a death watch is about forty-eight hours. You would select your officers to move the prisoner into the execution chamber from those who were not part of this ward. I think you have to have a minimum of one ranking correctional officer and about four or five correctional officers guarding the prisoner twenty-four hours a day. They just supervise the normal, everyday routine things, like maintaining cleanliness and seeing the prisoner gets a shower, seeing he gets mail. But at the same time you don't wish to assign someone who has a personal feeling against the death penalty. So, the men and women working on death row would be looked at and scrutinized as to mental stability, personal outlook, and three or four other things. Because we do have people who flat don't believe in it—they don't mind being corrections officers and do anything you ask of them except that one component and you have got to respect that.

The death watch inmate can have a TV and a radio in the catwalk area outside his cell. He can have his clothes and his normal hygiene items in his cell, except for a razor. The razor is handed to him, he shaves with it and gives it back and we make sure that the blade has not been removed. If he wishes to write, he is given a writing instrument, a pen or a pencil, and we get our pen or pencil back and make sure that he didn't use it on himself. There is an officer in that catwalk twenty-four hours a day to watch him to ensure that he did not harm himself, whether he was self-destructive or whether he was using it as a ploy to prevent his execution. At that point, the prisoner truly no longer controls his life. When he gets to the death watch, that's it—the state really owns him twenty-four hours a day. He would be authorized visitation for forty-eight hours, contact visits, depending on his history of assault and his mental outlook and things like that. He could be granted contact visits. If his family wanted to come and sit with him for three or four hours, there is no problem. His minister might come and visit him, or his attorney. Normally our chaplain would do his thing at the door, he would not do it in the cell. Now if the man asked, if he was Catholic or something and wanted the chaplain to pray with him, they would permit him to be in the cell but there would still be an officer there to see nothing happened to the chaplain. The meals would be the same as everybody else. If he asked for something reasonable for his last meal, it's up to the warden's discretion.

The time of the execution depends on the schedule. You see the state does not assign a time. The law allows

a warden to choose. He could do it at one o'clock in the morning or he could do it one o'clock in the afternoon. You generally want to do it early in the day so it doesn't interfere with your daily activities. The inmate on death watch gets everything but packages. He gets his mail and his visits, though he does not get any exercise because there is no exercise areas tied to that building. His packages are held for him in case he gets another stay, at which time he would get his packages. He would fill out a will to indicate what he wanted to do with his personal belongings and his body and things along those lines. But it would be a normal, everyday routine function in there. Just before the execution, his head is shaved and his legs are shaved between the ankle and the knee. No tranquilizers. The law doesn't provide that. He has got to be conscious. He is taken in, he is put in the chair and the execution is commenced. As far as witnesses go, it's very restrictive. Some judge, the sheriff of the convicting county, the prisoner's minister, and the inmate's family. No glory-mongers, no oddballs, no prosecutors, no investigators, nobody else. And then you have seven members of the news media—that was the number that was settled on based on a pool of results. Since 1960 was the last execution, the first one is going to be a circus: news, print, radio. They have departments working on a policy on exactly how it will be done and how the media will be chosen so that everyone gets a fair shot at it. The law says a prisoner can have their personal minister. Now if you are a Satanist and you want a warlock to see you off, then it's a personal minister. But I mean if you are a Zen, who do you send for, the Dalai Lama? I don't think so, it just depends. Just immediate family is allowed, not a girlfriend. Wife, mother, father, grandparents, kids—that's immediate family. Though who would want to take a child to watch someone be executed? I think the line would have to be drawn someplace. The state buries him. The body has got to go the morgue for an autopsy because a doctor is not present at the time of death. The doctor pronounces him dead afterwards. If the prisoner has family they claim the body from the coroner.

If we get a court order that says execute, we log it in the book out there and we just wait. If the time comes to go on death watch, we'll call legal and say, "You guys got anything?" If they say, "No, ain't got nothing," we get ready to do what we are going to do.

I've been working for corrections for the last nine years. I don't care about the death penalty. Doesn't bother me one way or the other, though it's not cost effective. It costs $10,000 more a year to keep a man on death row than it does a regular prison. The states of Arkansas and Missouri mainstream their death row prisoners, have for years, in an open population with the rest of the inmates. They eat with them, work with them. Just like a normal inmate. And it cost them no more than that other inmate: about $37,000. Maximum security is probably about the same, $37,000. But the point is, if you take your death row inmates (right now we have ninety-four) and you classify them as you would in a normal custody assessment, you are not losing anything. If you look at it from number current standpoint, it's cheaper to mainstream. They won't do it. We have death row because the state isn't ready to take their inmates off max custody. The population is not ready for that. The state is going to lock them up and throw away the key, you might say. Ohio built ten new prisons. California built, what, seventeen. I don't remember how many Indiana built, about fifteen. People are building because they are tired of crime out on the street. Last year they tried to change means of death from electrocution to lethal injection. And the legislative body said why should we spend $45,000 on a lethal injection machine when we have a $50,000 electric chair we have never used? Makes sense to me.

GRACE ACCREDITATION MANAGER

In the late sixties or early seventies when the Supreme Court found the death penalty unconstitutional, the court virtually wiped out the laws in most of the states that had death penalties at the time. It also automatically excluded everyone who had been sentenced to death up until that point. The state had to turn around and either decide to retry a person in a different manner, or convert the sentences to life. There were no death penalty cases as of that moment. Then the legislature came back the following year and passed another law that would be constitutional and it has upheld all the court challenges since then and people started being sentenced to death again.

Some of the federal judges have stalled. One judge has a case that I know of sitting on his desk for almost nine years now hung up on appeal (because it's a very lengthy appeal process). There are about four levels of appeals that are automatic for a death sentence; it can drag on for years and years. These people have been on death row for twenty years.

In my opinion, the death penalty doesn't make sense:

OPPOSITE TOP CELL WALL. MAISON D'ARRÊT DE FEMMES, ROUEN, FRANCE, 1990.

OPPOSITE BOTTOM IN AND OUT OF JAIL FOR PETTY CRIMES, THESE IDENTICAL TWINS PREFER TO BE INCARCERATED TOGETHER. TENNESSEE PRISON FOR WOMEN, NASHVILLE, TENNESSEE, U.S.A., 1995.

OVERLEAF CELL. NORTHERN CALIFORNIA WOMEN'S FACILITY, STOCKTON, CALIFORNIA, U.S.A., 1995.

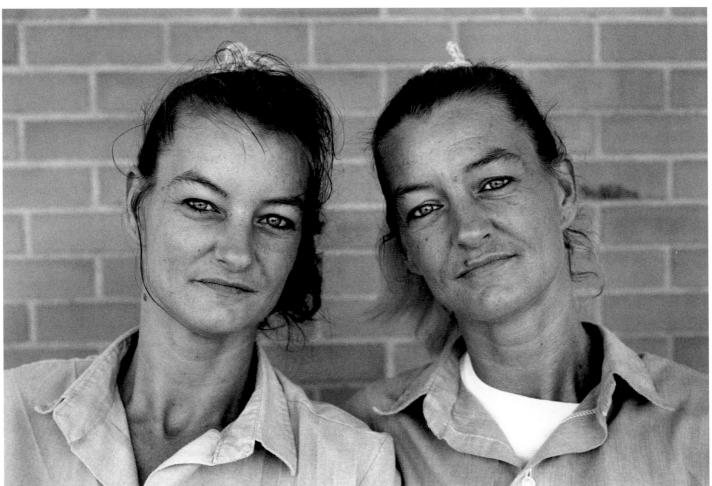

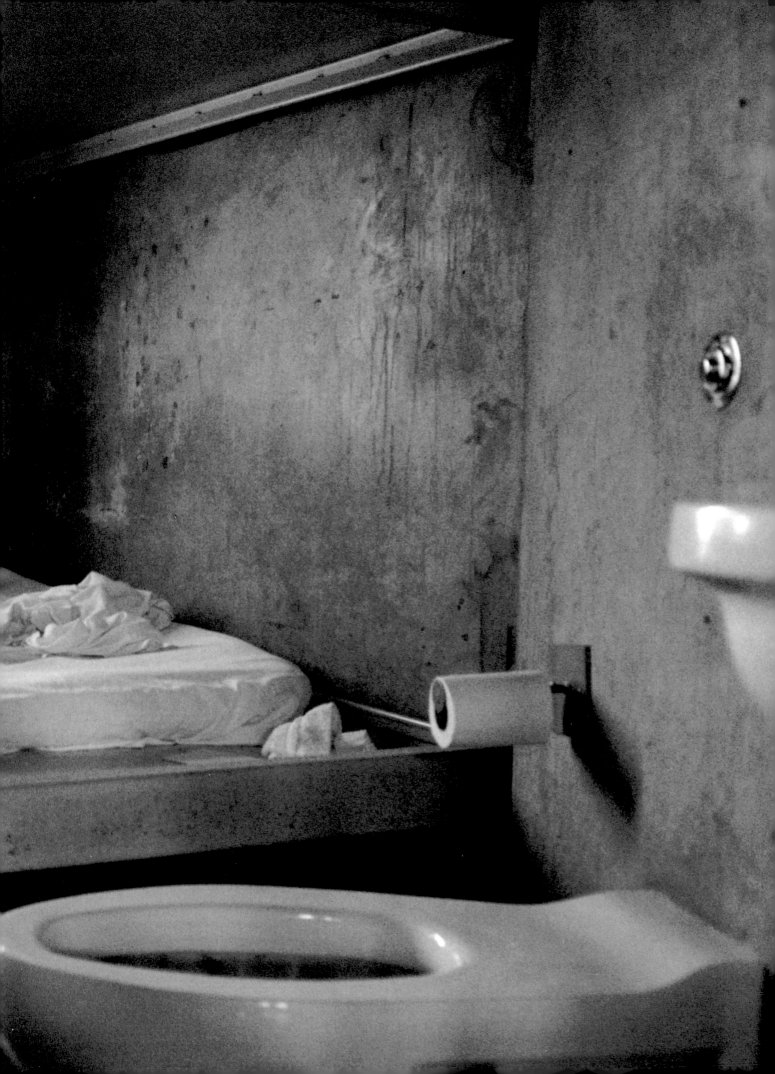

killing people to prove that killing is wrong? Even if somebody did something very heinous, like serial killers, you ought to take those people and study them under closely guarded situations and try to find out what makes that happen, what makes these kind of personalities develop that do that kind of thing. How could you take a kid and sit him down and say now I want to teach you that killing is wrong—unless the state decided to do it, and then it's okay. And why assume that the state is right in everything they do?

When I was in elementary school they took us on a tour of the main prison. (When I think back now I think, why would you do that to little kids?) It was a really horrible place, all dark and damp and ugly. Now before we went inside, we were first taken to a little market where the inmates sold their handmade craft stuff to tourists that would come in and tour the darn prison. And they had these miniature red wooden electric chairs that they sold for five dollars apiece. I thought they were kind of cute, but I wasn't thinking about what they really were. Then we went in to see the real thing. I was so horrified because it was this ugly brown mud color and I was shocked by the idea that they are trying to peddle these little cute bright red chairs when the real thing is so ugly. Never even thought about what they were used for. I was just ticked off that they were trying to rip off the consumer. And to make matters worse, my mother is a nurse and during my growing-up years worked in the office of the doctor that got called to the prison when they had an execution to pronounce the prisoner dead. My mother would come home from work in a bad mood when that happened, and we would say, "What's wrong?" And she would say, "They're executing another prisoner and Dr. Green got to go out there and he is always a grouch because he hates so bad to have to do that." But again for some reason it never sank in. I was exposed to it but I didn't think about it. And when I came to work here I thought, well they hadn't used the darn thing in thirty-something years, and I thought if they decide they are going to start using it again, then I'll just quit.

The majority who work here probably are for it, yes. And a lot of them just won't bother to question it—they don't want to delve into anything that might hurt. It's not talked about much. When they use it there will have to be intensive psychological counseling done with all of our staff. It would be a horror, it really would. Like if they tried to execute Wendy—no, there is no way. I don't know how any of our staff, having gotten to know her, even people who say that they are very much for the death penalty, could stand the thought of that happening, would survive that. The authorities don't want us to get to know the inmates that are under sentence of death. And they don't want the other inmates to get to know them. Because you can have a major riot on your hands if you went to execute somebody that they had all gotten to know and love.

ANGEL

When I met Angel she was twenty years old and the youngest person on death row. She had just been sentenced to die in the electric chair. In order for me to speak to her, she was put in one cage and I was put in another one next to her. Because she was appealing, she was forbidden to talk about her case.

I'm accused of killing Tina Darden, of taking a piece of asphalt and hitting her in the head with it. She was a student at Job Corps with me. I had my trial and I was sentenced the day after my trial was completed. They got the slip from the jury, and the judge had to read it to me. They told me about heinous factors of my case that they found outweighed the mitigating factors. And told me that my body will be put to shock until death on January 12, 1997. Now, it will not happen that day because my lawyer has filed a motion for a stay of execution until my appeals go through. But that was the date that they set. She said my body would be put to shock. I think she might've even said "by electrocution," but I think after she said all that, I was kinda in shock for a minute.

I was looking at the judge when she read me my sentence. When they read my verdict and told me that I was found guilty, I was looking at the jurors, because the chairperson of the jury read that to me. They all just had kinda blank faces, a few of them looked sad. Some of the jurors were upset during the trial. There was one man I remember that every time I would get upset and cry, he would get upset and cry. And when they brought out some of the more gruesome evidence, the jurors would get upset. And while some of 'em were kind of cocky, a little bit, some of them were just very sympathetic. But I could not really tell. I had so much going on in my mind at that time. At first I just kinda stood there and looked at the judge. She was getting real upset and starting to cry, while she read it to me. And then I knew when they started reading the heinous factors that I had got the death penalty, because you didn't have to read off any of the other sentences. And then I heard my family start to cry, and get real upset, and that's when I broke down. The judge told the bailiff to lead me out of the courtroom, and I didn't wanna leave because my mother was upset, and I asked the judge could I just hug my mother before I went back downstairs. She took me in the hold-

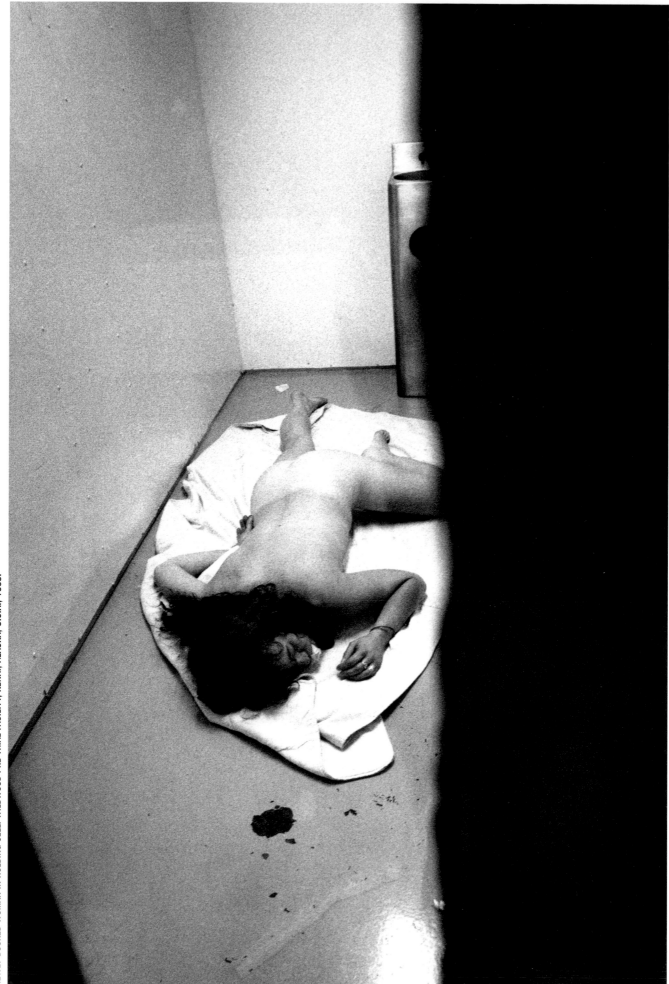

NEWLY BOOKED WOMAN IN HOLDING CELL. WILDWOOD PRE-TRIAL FACILITY, KENAI, ALASKA, U.S.A., 1993.

ing block for a minute and cleared the courtroom and then let me come back out and visit with my family for a minute. They were really upset. So that was probably the hardest part of all of it. My mother, my aunt, my father, and my stepfather were there.

I really can't say that I expected it, but I had prepared myself for it. Through my whole trial, my whole stay at the jail, I found it easier to just expect the worst, and if anything different happened it would always be good. I've been in trouble before, only as a juvenile and it wasn't anything serious: running away from home, truancy from school, just things like that, you know.

When I was nine years old, I was abused by a man that lived in the same trailer park I lived in. And when I was sixteen, I was raped by a man in my best friend's neighborhood; I was walking to the store. Just a man that was walking down the street.

I have two court-appointed lawyers: one's male and one's female. They've helped me out a lot. Anytime I've needed anything, legal or not, even if I just needed someone to talk to, they would come talk to me. They've both been to visit me since I've been here, and my male lawyer is coming back to visit me sometime before June. So, they've been very helpful and they're still trying really hard. They were very upset that this happened, and I do not put any of this on them because they tried everything, and tried as hard as they could to get me off.

I haven't seen my friends since I got locked up, but I still write them in letters. There's a lot of 'em that have dropped me and they send messages to me through my other friends. You know, "Tell her I said hi," or "How is she?" but that's all there is to it. I have maybe three or four friends that still keep in contact with me. For me the hardest part of being here is being away from my family, being so far away from them. It's about a nine-and-a-half-hour drive for them to come up here. They haven't been up here yet, but they plan on coming soon. I call often. And they've never refused a phone call from me, from here or from the jail. They're very supportive of me. Get me the things I need and everything.

I just have a lot of time to think. If I get a new trial, it could be anywhere from getting life without parole or to drop down to second-degree murder. There's a number of possibilities. If my sentence just gets converted, then it'll be probably to life without parole, so I haven't given up at all. I know that I still have a lot to look forward to and a lotta hope.

I let too many little things get to me when I was on the street. Now that I've been incarcerated this long, I've learned a lot. I've grown up a lot. And I realize that I should not let little petty things get to me the way they used to.

They don't any more. Now, even serious things don't bother me. And if I had it to do all over again, I would definitely not be here. I get sad because of my family. And how much pain they're going through because of this. And just the fact that I'm only twenty years old, I have my whole life ahead of me and the only thing that I really have to look forward to right now is spending it in here.

My crime is very out of my character. I'm not a mean, violent person. That's not me. And I was accused of doing a lot more than I actually did, and I said I did a lot more than I actually did because I didn't want my two charge partners to be imprisoned. They came and got me first and questioned me first, and I thought "Well, if I tell 'em I did everything, then they'll just let them go." There were three of us charged. My boyfriend is still at Knox County Jail, and the other girl just got released on six years' probation after they dropped her down to accessory after the fact. She lied. They had enough as it was to get me, and so they didn't really need her. But they're gonna get her to testify against my boyfriend, and try to get him life. I don't know what I was thinking. I haven't really ever been in trouble to know how the system works or anything. And so I told them that I did basically everything that there was. And I didn't. That's why I'm here now, and why they're gonna get less time than I am. I didn't feel like everybody should go down for the same thing. I wanted them to have a chance at life.

RUTH CORRECTIONS OFFICER

I've been guarding death row since 1983. Some confide in me, but you have to build up that trust. Females are more inclined to just bust up and tell you their whole life story. Men aren't. You have to get to know them, build up their trust.

I have been with the Department of Corrections about twelve years, and this is one of the least problemsome units or I should say group that I have ever worked with. I've worked with women before and prefer men. Women are difficult. They will play upon your sympathy, use it to their advantage. They whine, complain, have little petty catfights among themselves and it's always something, whereas men don't do that. I did my internship and doctorate at the women's prison. I would say that they probably have more things that they do which makes the time go by faster. At the women's prison they have cosmetology school, arts, sewing, they actually work up in the administration building. Back then, which was 1982, they even dressed as civilians. Oftentimes you wouldn't know that a person was an inmate. Sunday they had talent shows, and more things to keep them going. Most are in

TOP NIGHT ROUND: THE GUARD SNAPS ON THE LIGHTS AND LOOKS INTO THE CELLS FOUR TIMES EACH NIGHT TO MAKE SURE NO ONE IS MISSING—OR DEAD. MAISON D'ARRÊT DE FEMMES, FLEURY-MÉROGIS, FRANCE, 1991.
BOTTOM "SHAKEDOWN" OF A CELL. MAISON D'ARRÊT DE FEMMES, ROUEN, FRANCE, 1990. **OVERLEAF** PRISONERS REST FROM BACKBREAKING MANUAL LABOR. WOMEN'S SHOCK INCARCERATION UNIT, COLUMBIA, SOUTH CAROLINA, U.S.A., 1994.

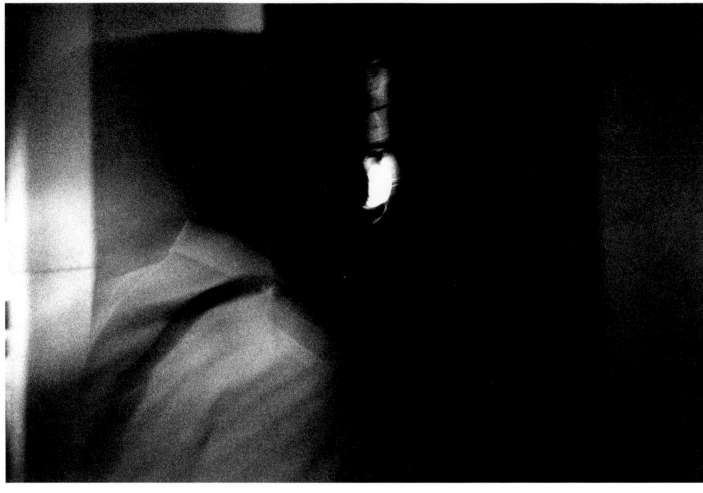

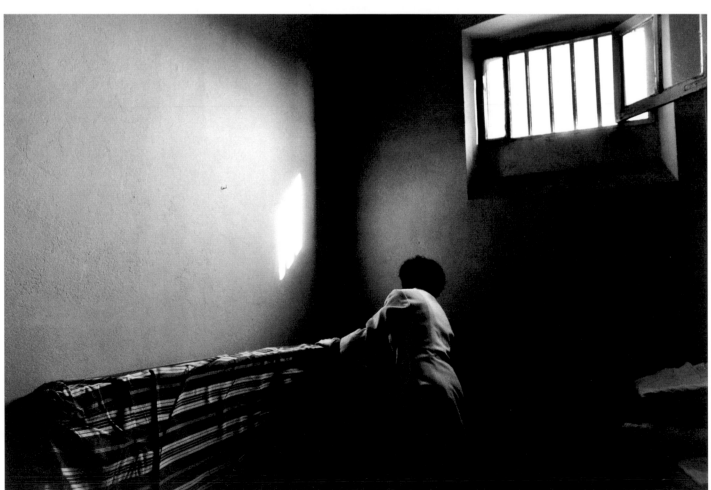

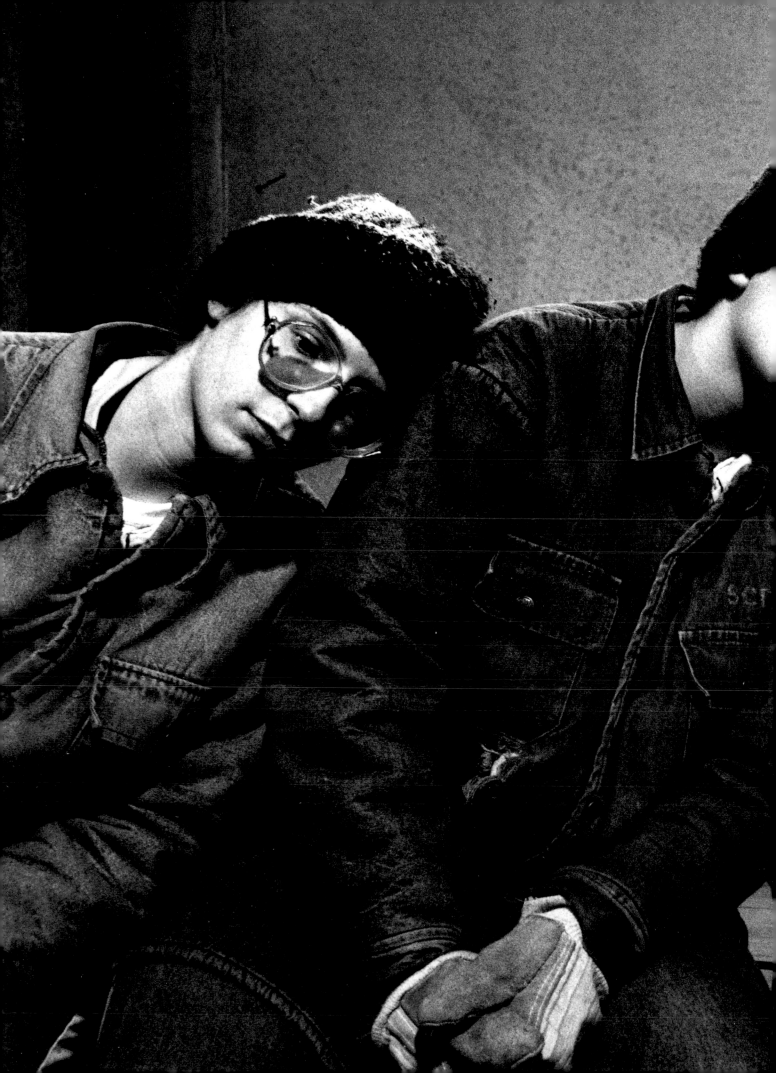

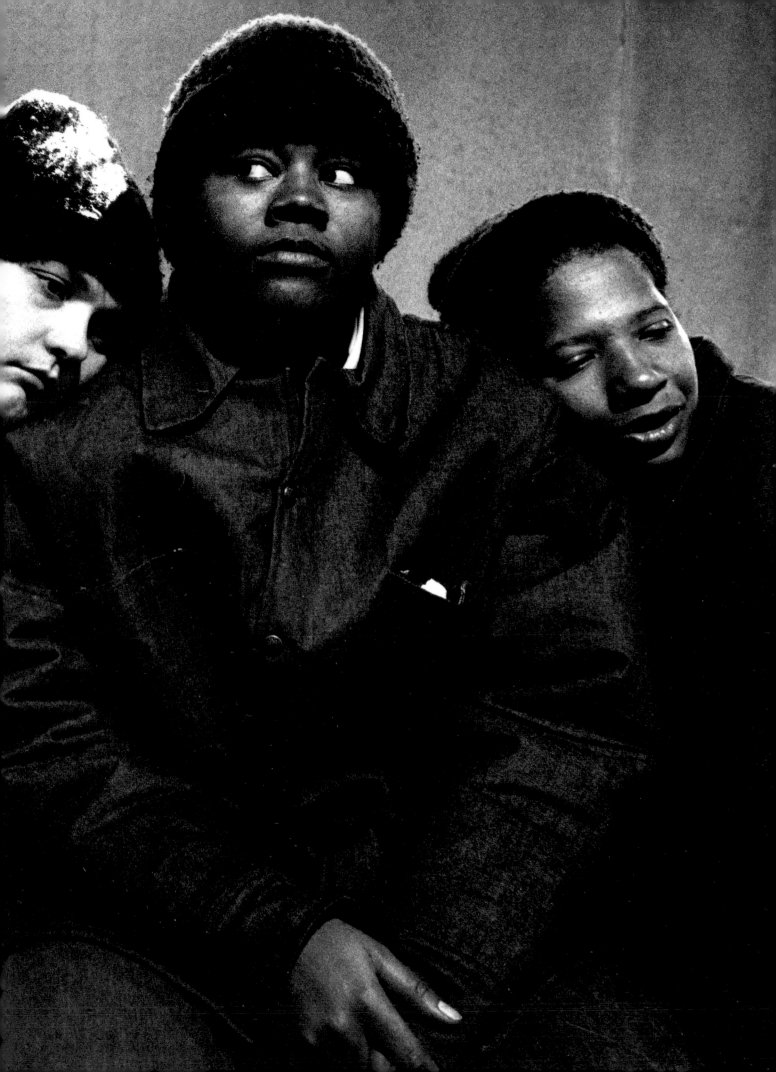

IN THE SUPREME COURT OF ██████████

AT ██████

STATE OF ██████████ : ██████ CRIMINAL NO. 2
 (No. ██████ Below)

 Appellee, :

 Offense: ACCESSORY BEFORE
 : THE FACT TO MURDER
VS. IN THE FIRST DEGREE

 :

██████████████ : AFFIRMED.

 Appellant. :

F I L E D

JAN 19 1988

██████████████

J U D G M E N T

 Came the appellant, ████████████████, by counsel, and also came the Attorney General on behalf of the State, and this case was heard on the record on appeal from the Criminal Court of ████████ County; and upon consideration thereof, this Court is of opinion that there is no reversible error on the record and that the judgment of the trial court should be affirmed.

 In accordance with the opinion filed herein, it is, therefore, ordered and adjudged by this Court that the judgment of conviction and the sentence imposed are affirmed.

 The death sentence will be carried out as provided by law on April 15, 1988, unless otherwise stayed or modified by appropriate authority.

 The case is remanded to the Criminal Court of ██████ County for the collection of the costs accrued below.

 Costs are taxed to the appellant, ████████████, for which let execution issue.

 1/19/88.

APPEAL DENIED FOR A WOMAN WHO WAS SENTENCED TO THE ELECTRIC CHAIR FOR HIRING SOMEONE TO KILL HER HUSBAND. WOMEN'S PRISON, U.S.A., 1988.

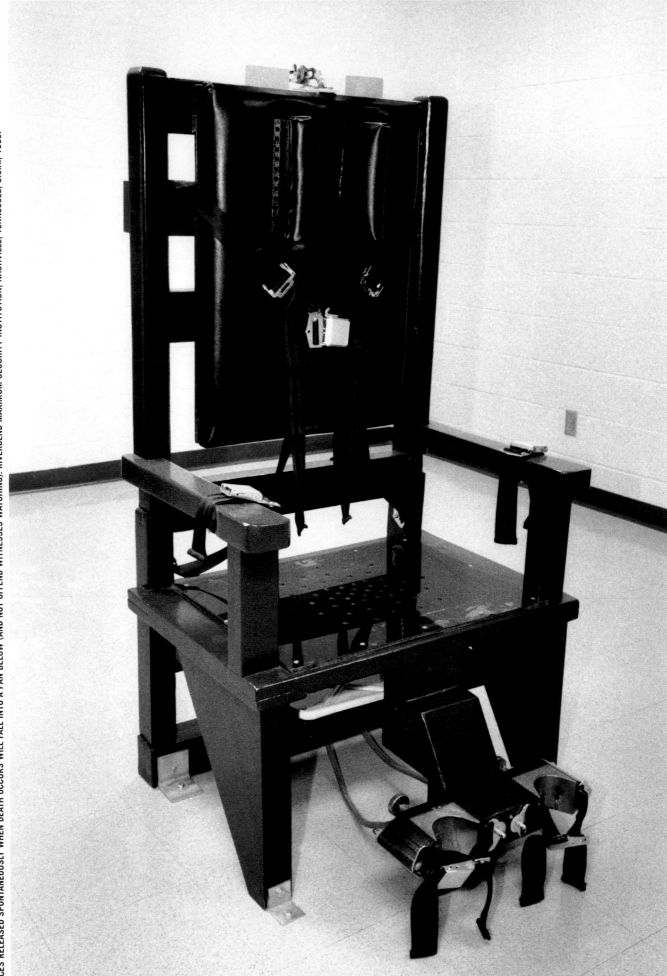

THIS ELECTRIC CHAIR IS SUPPOSED TO BE "STATE-OF-THE-ART," THE MOST MODERN IN EXISTENCE. IT INCLUDES A PLEXIGLAS SEAT WITH HOLES IN IT SO THAT THE URINE AND FECES RELEASED SPONTANEOUSLY WHEN DEATH OCCURS WILL FALL INTO A PAN BELOW (AND NOT OFFEND WITNESSES WATCHING). RIVERBEND MAXIMUM SECURITY INSTITUTION, NASHVILLE, TENNESSEE, U.S.A., 1995.

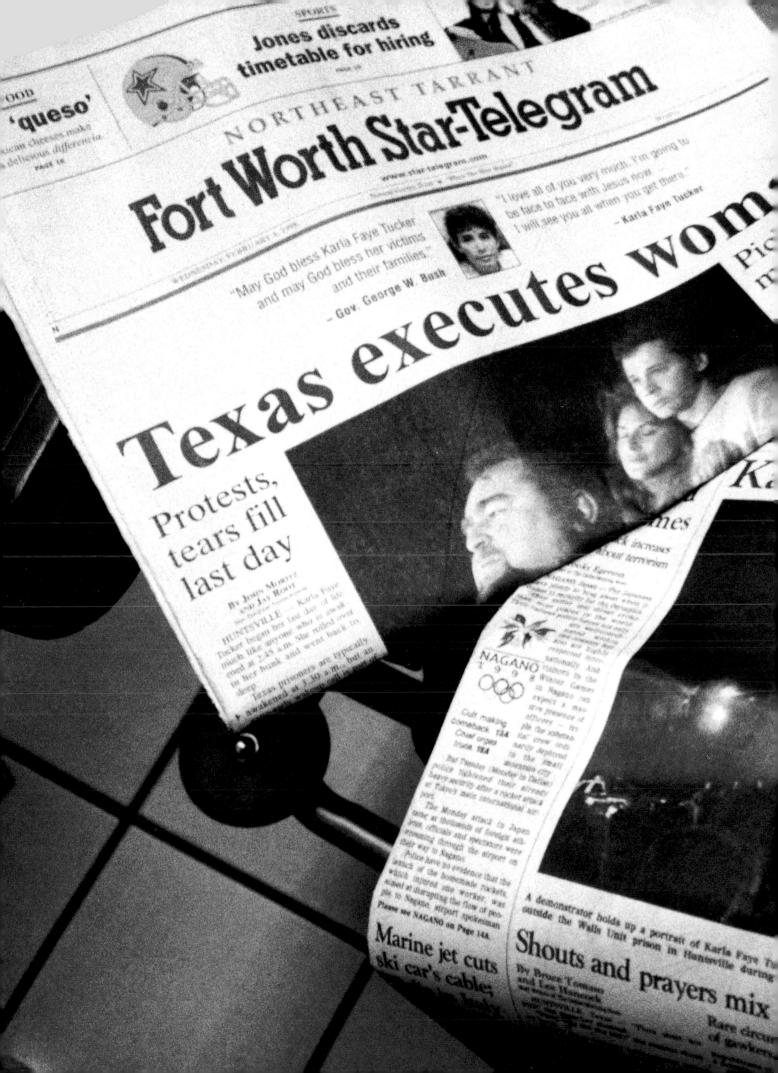

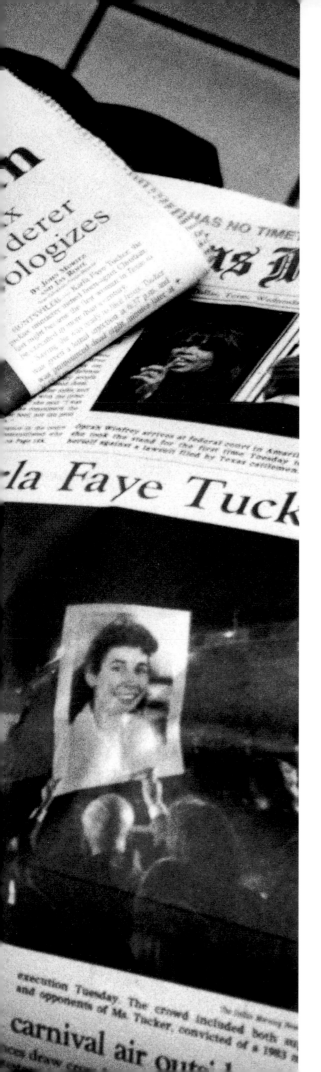

FEBRUARY 2, 1998

6:30 AM Arrived by airplane from Gatesville. Transported by van to Goree Unit.

6:58 Arrived at Goree Unit

7:45 Declined breakfast meal.

8:00 Placed collect call to her attorney George Secrest.

8:20 Phone call with attorney Secrest concluded.

8:30-9:00 Resting on bunk.

9:15 Sleeping

9:46 Talked with attorney David Botsford by phone

9:55 Escorted to visitation room.

10:00 Visiting with Dana Brown, husband; Lawrence Tucker, father; and Kari Weeks, sister

11:00 Refused lunch tray. Continues visit with family. Mood is upbeat with a lot of laughter passing between them.

4:44 PM Chaplain Jim Brazzil of the Huntsville Unit joins family visit.

5:45 Tucker praying with family members.

5:55 Tucker offers special prayer for her family.

6:00 All-day visit ended. Returned to cell.

6:06 Fax received from United States District Court denying stay of execution.

6:25-6:49 Talking with attorney David Botsford by telephone.

7:30 Taking a shower

7:33 Texas Board of Criminal Justice Chairman Allan Polunsky arrives at unit

7:56-8:42 Talking with Chairman Polunsky at cell door

9:30 Sitting on bunk talking to officers about her busy day and how worried she was due to the amount of stress her being at the unit has put on the staff.

10.00 Sitting on bunk writing. Stated she was fasting and that she was at peace.

10:15 Stated she was writing an outline for Chairman Polunsky on inmate rehabilitation to submit to the Board for future reference.

10:45 Lying on bunk looking at wall

11:00 PM-12 midnight Sleeping

FEBRUARY 3, 1998

12 midnight-2:45 AM Sleeping

3:00 Refused breakfast tray.

3:15-5:45 Sleeping.

6:00 Tucker awoken and given clean clothes to wear.

6:06 Declined the opportunity to shower.

6:14 Declined to watch television when asked if she wanted to watch the news.

6:27 Sitting on bunk writing a letter

7:30 Standing at cell door with a smile on her face talking with Warden Dessie Cherry.

LAST MEAL REQUEST
A banana, a peach, and a tossed salad with Ranch or Italian dressing.

CLOTHING TO BE WORN
Prison whites, personal shoes.

PRISON RECORD OF KARLA FAYE TUCKER'S LAST FORTY-EIGHT HOURS BEFORE HER EXECUTION. DEATH HOUSE, HUNTSVILLE UNIT, HUNTSVILLE, TEXAS, U.S.A., 1998.

there for a petty crime and most of them come in pregnant, and have their babies on the state, get some petty charge that is probably a two-year sentence, and they spend most of that time being pregnant, everything getting paid for by the state, and they get time to bond with their baby. They do that on purpose.

LOU ANN

I have no last name, I'm just plain old Lou Ann. I'm not trying to make somebody love me. I'm not trying to be fancy to get somebody to pay attention to me. I can't change what happened. There is no way I could. It will always be serious. But I can change me, and I have.

When I started seeing Tommy, Pete was in prison. We'd been married nine years. Tommy made me kill him. That was in February 1983, and I married Tommy two months later. I met Tommy when I was thirteen. He's the first guy I was ever with, very good looking, and I guess I always told myself I loved him. And then when he went and got married, I would see him once in a while and he was just a fantasy to me. Thirteen years later, after Pete was arrested and sent to prison, I met him again. I was at my sister's house one day, and Tommy came up there and asked me to go out with him. At first I told him no. But after one night he moved in with me, and it was like a fantasy come true. People always looked down on me and thought I was kind of trashy, but when I started going out with Tommy they started showing me respect, something I had never had when I was with Pete.

Pete was an alcoholic. He would work sometimes, but when he did, he usually took the money and got drunk on it. Then I would work and he would do the same thing, and if it wasn't for me and my mom, my kids would have starved and froze to death. I would have to write bad checks for food and clothes and heat or whatever, or steal the food. I was arrested several times for both of these. Or I stole money to pay rent or to buy them clothes or something. At times I would go into stores and just put the shoes on the kids and walk out.

I knew the cops were coming to arrest me because there was charges on me for forgery. I started to run, but they caught me and throwed me in this little bitty cell, and I was there for about two weeks before I was transported back here. Pete was arrested also for oral sodomy on a child. The child's mother found out that he had a wife and kids, and I went and met her and she dropped the charges. She didn't make it up. She counldn't have. And the child, it was a boy, it wasn't a girl.

When Pete's dad died in December, Pete got to come home from prison for the funeral. Tommy didn't like it very well, but I went, too. I had gotten divorced from Pete while he was still in prison. At the funeral I seen him and I held him and it was, I don't know, it was just so confusing to me, because I felt torn between both of them. He told me that he loved me. Then he got out of prison in January, on his birthday. I had took the kids out to Mom's so he could see them, and by the time he got out there he was drunk and he took them with him. I went looking for him, and finally he came back to Mom's. We got into an argument over the kids, over him having them when he was drunk, and he started to hit me, and I just looked at him and laughed, and told him he couldn't, because he loved me too much. Then in October I had to have surgery, and the day after, he showed up at the hospital. He had snuck in after Tommy left. He brought me a rose and told me he loved me and he wanted me to remarry him. He really meant it.

Two days before Pete was killed it was my birthday, and he was drunk. He came out to my trailer, straight on in because the door wasn't locked, and started arguing and fighting with Tommy, trying to get him. But I was pulling him from Tommy, me and this other girl both, we was keeping them apart. Pete wanted Tommy to go outside and have a shoot-out, and Tommy refused. Finally my brother went and called the cops, and they came and told Pete he would have to leave. Before he left, he looked at Tommy and told him that it would be over his dead body before he got me. And then he told me he loved me.

The next morning, me and Tommy got up and went to the police station. Tommy told the sheriff what happened the night before, and the sheriff told him that if Pete came back, for him to get a ball bat and knock him in the head, knock him out and call them, and they would come and pick him up, no problem. Or for Tommy to get a gun and shoot him but make sure his body is inside the trailer when he done it. So I went to my probation officer and I told her everything and she said that was no true statement. She said that if Tommy shot Pete he would go to prison, because Tommy has no rights in that trailer, to begin with. If anything happened and Pete was shot, she told me, I would have to be the one to do it.

So we left. Tommy went to his dad's house and got a twelve-gauge shotgun. He first put a deer slug in it, and then a regular shell, and then a deer slug. And when we got home he put the gun in the corner of the trailer. The next night, Pete showed up. We heard him coming, you could tell by the sound of the truck. So Tommy yelled at me to lock the door. Pete pulled up in the driveway, got out and come up on the porch and tried the door. Then he started yelling at me to open it. And Tommy started yelling back and said not to. Pete said, "I just want to talk to you." I

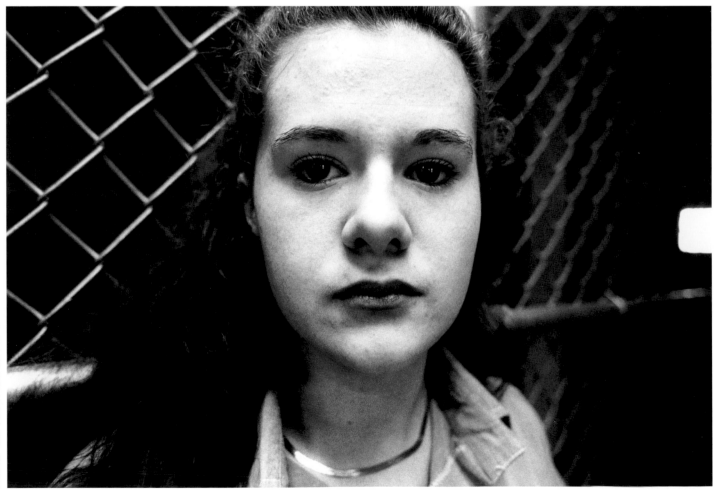

said, "Well, you have to talk through the door." And all this time Tommy is screaming at me to get the gun, and I'm trying to talk Pete into leaving. Pete started cussing and told me he was going to kick the fucking door down. And I started pleading with him not to do that, and Tommy is screaming at me, "Shoot him, shoot him!" and then I remember—I remember raising the gun and pulling the trigger, but nothing happened. Then Tommy screamed at me to take it off the safety. And I kept screaming back, "I don't know how." He walked over and took a hold of the gun. I remember Pete right next to me, reaching out for it, and then I pulled the trigger and I seen Pete look at me, and then cough, and then stumble, and then he said, "Why?" And then he fell. The last thing he said was that he loved me, and then he died. But I do not remember hearing the gun go off. I don't remember it even kicking me.

After he fell, I took the gun and wiped Tommy's fingerprints off it and then Tommy went with my brother to get the cops. When he was hit, Pete fell against the door, so Tommy had to step over him to open it. When he left, I sat down beside Pete and held his hand while he turned white as a sheet. And then I don't know, it was just going through my mind, he wasn't supposed to die, he was supposed to be tough enough to take the bullet. For some stupid reason I didn't think anything would kill him, because everybody was scared of him. When the cops came out, it wouldn't just be one cop or two, it would be three and four carloads of cops come after him. I was crazy—I thought nothing could kill him. I thought I could tell him the next day that I was sorry. And then I started just getting numb.

The cops questioned both of us for a couple of hours, and the next day Tommy had to take a lie detector test because they didn't believe me, and they didn't believe him. They thought he done it, and to this day think that he done it. When Tommy came out from taking the test, I went in and asked the guy if he wanted me to take a test and he said, "No, I've heard enough lies in one day to last me a lifetime." I had no idea what Tommy said. But since my fingerprints were on the gun, and since there was gunpowder on the gown I had on, they could do nothing to Tommy. And because Pete busted in the door, it was self-defense. But it wasn't, because Pete wouldn't do anything to me, I knew that. He wouldn't have hurt me if he got hold of that gun, he would have killed Tommy.

I didn't have a trial. They had a grand jury investigation. And it was self-defense because he busted in the door and he was reaching for the gun and he was drunk. After that, Tommy started getting really mean. He was like the pure devil. It got so if the children wanted something special to eat, I would have to wait until he left and then go get it for them. Tommy would not allow me to buy them

pop. He beat the kids an awful lot of the time, and he would talk to them like they was dogs.

Tommy thought he was better then I was; he thought he was better than my family. He wouldn't let my kids use the bathroom he used. He never mistreated them until their daddy was killed. No, he wouldn't have done that while Pete was still alive. My son James was left-handed, but Tommy wouldn't let him use his left hand to eat with. When James would try to, Tommy would tell him to go outside and eat with dogs. Once James left one of Tommy's ball mitts outside and it got rained on. The next day when Tommy found it, it was wet. James was lying on the floor watching TV, without a shirt on, and Tommy came into the trailer with the ball mitt and hit him as hard as he could on the back with it. James was only eight years old, but he stood up to him. He jumped up and said something, and then he started to run and Tommy chased him through the trailer to the bathroom and cornered him there. By the time I got to them, Tommy had his fist up, but I got James away from him.

My daughter Debby was four years old, and Tommy really hated her. He would ask her if she had peed in the bed and she wouldn't lie to him, she would tell him yes, and he would whip her. It got so that before he woke up, I would go and check her bed and see if she was wet. And if she was, I would change her bed, put the linen in the washer and change her, so he wouldn't whip her. The trailer we lived in was the one Pete was killed in. He died right there at the front door. When Tommy got really mad at Debby, he made her stand right in that corner where her daddy died at. She knew her daddy died there, and he would make her stand there.

My cousin Bart never did believe I done killed Pete. He was angry at Tommy over it, and he went around all summer long saying that if it was the last thing he did on earth, he was going to kill him. Then in August, after my second surgery, Tommy started being really mean and he didn't care how he hurt me, sexualwise either. I was scared to leave him. I was scared of losing everything I had, and the respect people had for me. I was just afraid of being alone. I knew he was planning on leaving, and I couldn't bear the thought of being left with nothing.

OPPOSITE HOLDING CELL IN THE "DEATH HOUSE" WHERE THE PRISONER AWAITING EXECUTION WILL SPEND THE LAST DAYS OF HER LIFE. NORMALLY, THE PRISONER IS MOVED HERE TWENTY-FOUR HOURS BEFORE, BUT PRISONERS ARE SOMETIMES BROUGHT HERE UP TO A WEEK BEFORE THE ACTUAL EXECUTION. THIS IS THE BEGINNING OF THE "DEATH WATCH," WHEN THE CONDEMNED WOMAN IS SCRUTINIZED TWENTY-FOUR HOURS A DAY BY GUARDS TO KEEP HER FROM KILLING HERSELF (THUS CHEATING THE STATE OF THE RIGHT TO KILL HER). THE DEATH CHAMBER IS OFTEN NEXT TO THE DEATH CELL SO THE INMATE CAN HEAR ALL THE TESTS AND RETESTS DONE ON THE EQUIPMENT THAT WILL KILL HER. RIVERBEND MAXIMUM SECURITY INSTITUTION, NASHVILLE, TENNESSEE, U.S.A., 1995.

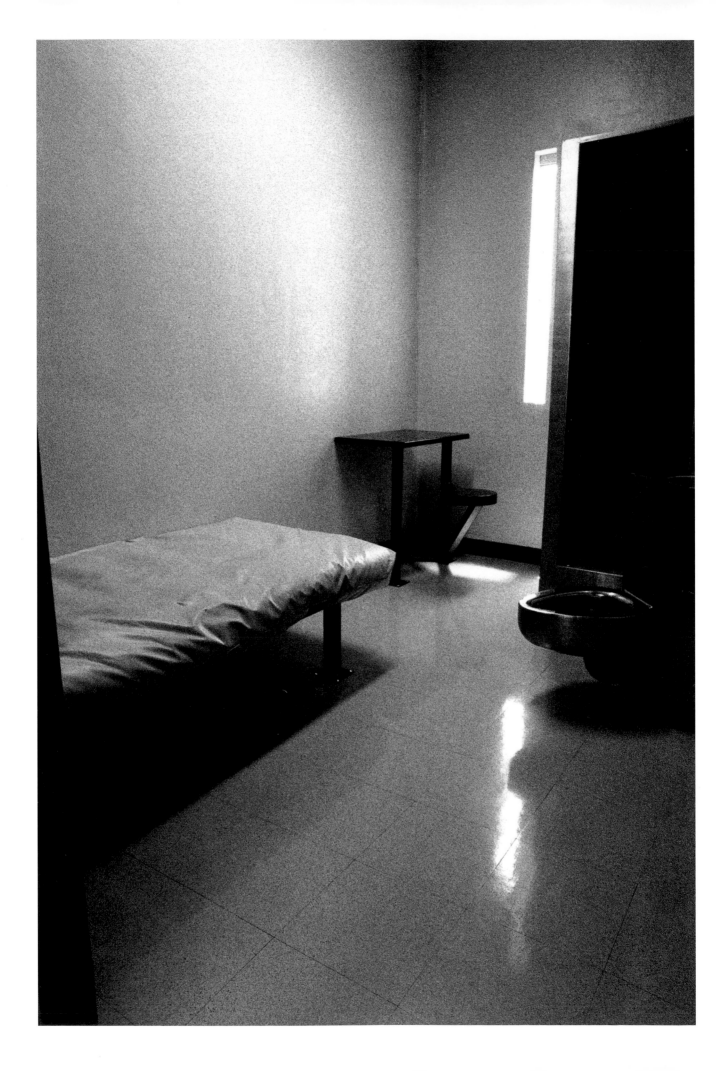

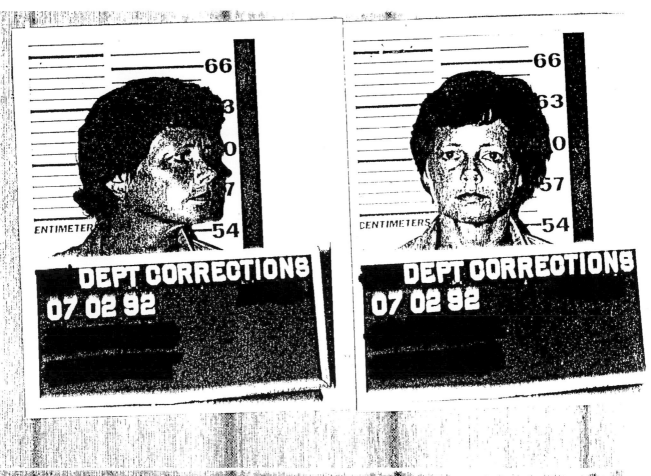

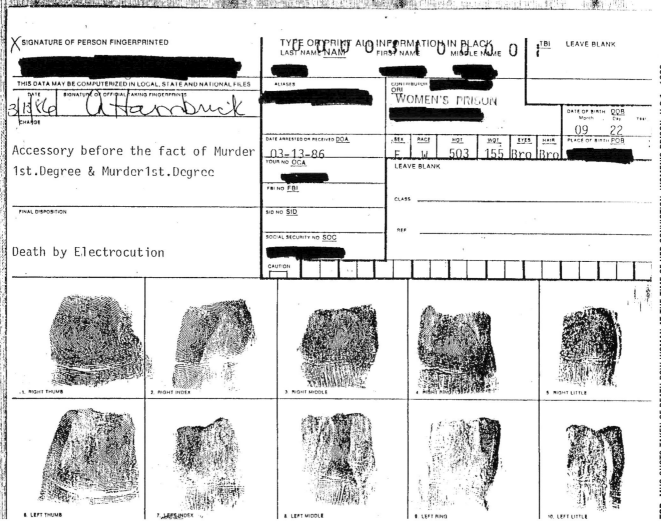

X SIGNATURE OF PERSON FINGERPRINTED

THIS DATA MAY BE COMPUTERIZED IN LOCAL, STATE AND NATIONAL FILES

DATE 3/13/86 SIGNATURE OF OFFICIAL TAKING FINGERPRINTS A Hambrick

CHARGE

Accessory before the fact of Murder
1st.Degree & Murder1st.Degree

FINAL DISPOSITION

Death by Electrocution

TYPE OR PRINT ALL INFORMATION IN BLACK
LAST NAME NAM FIRST NAME MIDDLE NAME

ALIASES

CONTRIBUTOR ORI WOMEN'S PRISON

DATE ARRESTED OR RECEIVED DOA 03-13-86

YOUR NO OCA

FBI NO FBI

SID NO SID

SOCIAL SECURITY NO SOC

CAUTION

TBI LEAVE BLANK

DATE OF BIRTH DOB
Month Day Year
09 22

SEX F | RACE W | HGT 503 | WGT 155 | EYES Bro | HAIR Bro | PLACE OF BIRTH POB

LEAVE BLANK

CLASS

REF

1. RIGHT THUMB | 2. RIGHT INDEX | 3. RIGHT MIDDLE | 4. RIGHT RING | 5. RIGHT LITTLE

6. LEFT THUMB | 7. LEFT INDEX | 8. LEFT MIDDLE | 9. LEFT RING | 10. LEFT LITTLE

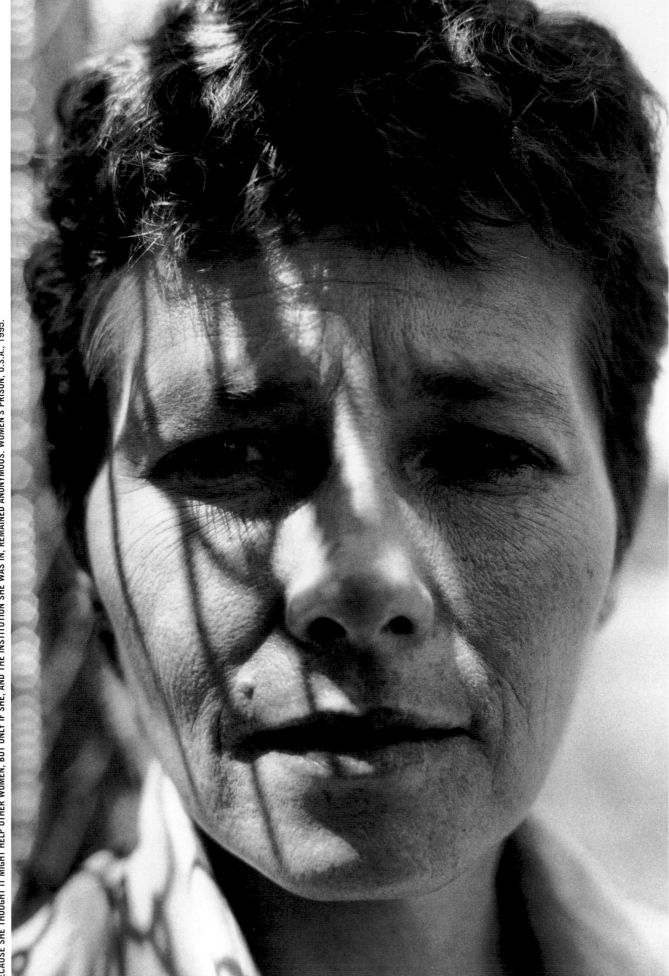

WOMAN CONDEMNED TO DEATH IN 1988 FOR HIRING SOMEONE TO KILL HER HUSBAND. THIS WOMAN AGREED TO BE PHOTOGRAPHED BECAUSE SHE THOUGHT IT MIGHT HELP OTHER WOMEN, BUT ONLY IF SHE, AND THE INSTITUTION SHE WAS IN, REMAINED ANONYMOUS. WOMEN'S PRISON, U.S.A., 1995.

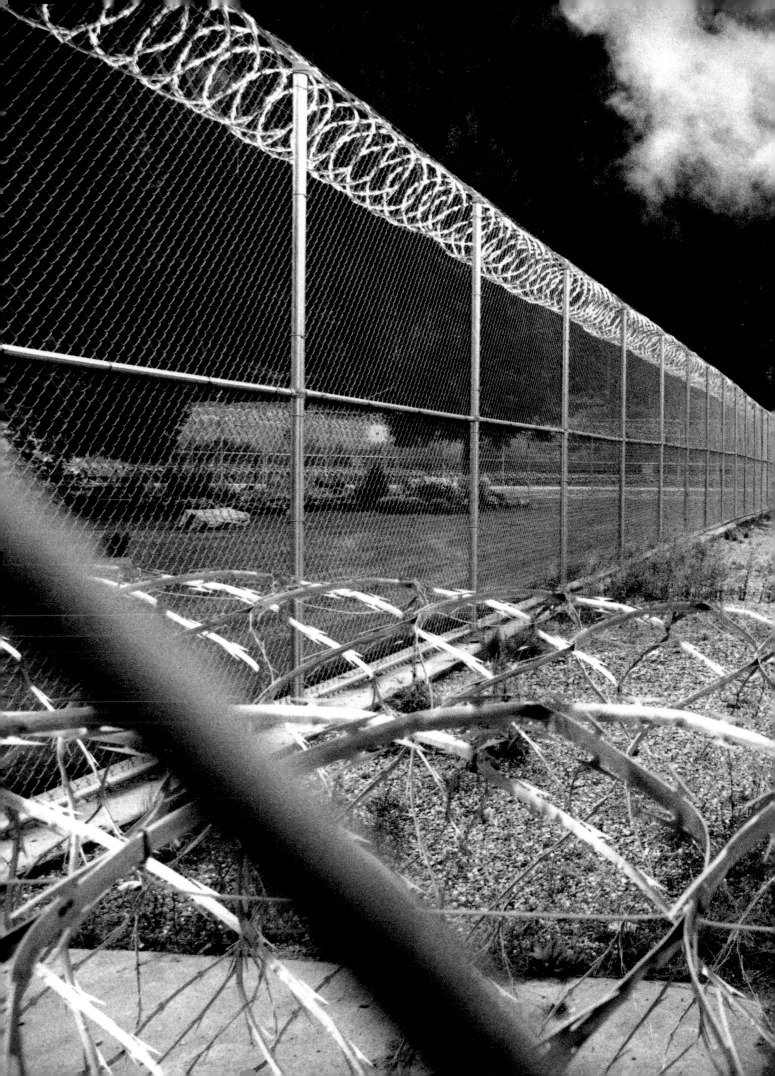

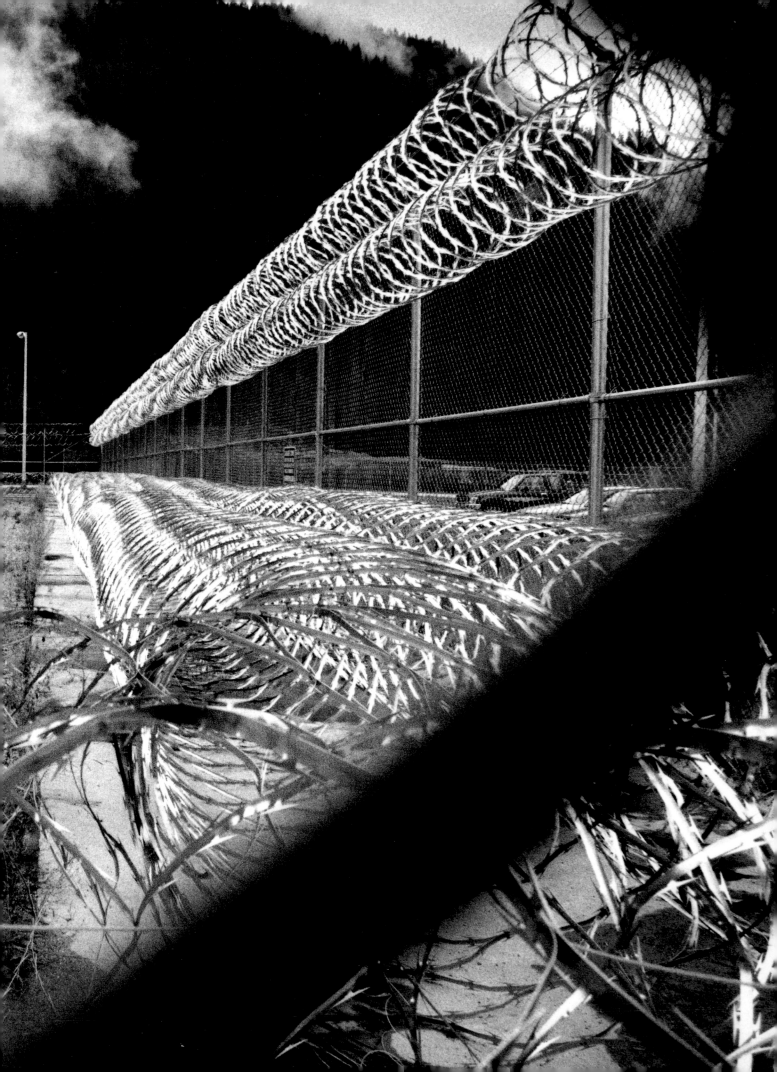

I went and talked to TJ, my sister's boyfriend, about getting somebody to kill him, and TJ told me he would do it. They put a log out in the center of the road so Tommy would have to stop when he got to it. He stopped and got out of the truck, and after he moved the log, he heard something in the woods. And then he started back to the truck, and one of them shot him in the back. They say he was laying near the road kicking and hollering, "Oh my God, oh my God," and then one of them walked up and shot him in the head. They left him there and ran. They left the truck at the scene, because it wouldn't start. They immediately suspected me. I was the first one they arrested.

My oldest daughter got the news clippings of my case and read them, and she said, "Mom, you didn't do all that by yourself?" I said, "What do you think?" She said, "Daddy did something." She was nine years old when she said that. She asked me again last year, and I explained what I did to them. I told the kids I made a big mistake, and my mistake caused everybody to suffer.

Women who end up killing their husbands or having them killed are scared to death. They know it's going to be them or him. Abuse gets so bad, so heinous sometimes, it will make you do crazy things, abnormal things not even in your character. And usually when a woman kills it is not when he is doing something to her. It's when he's asleep, or when it's unexpected. To catch them off guard. I understand this fear, that's why I chose to be a domestic violence counselor. All the hell I went through would be worth it If I could keep one woman from coming to prison for killing her husband and then have to explain to the children why she killed their father.

There is a girl who was raped, who's been here twelve, thirteen years. She saw the man who raped her three days later and shot him. Another case where a man, her mother's husband, had been raping this girl her whole life, and she told her boyfriend, "I wish he was dead," and her boyfriend went and killed him—and the mother went to prison. It happens so much. An officer here who is a cop on the outside, we were talking one day and he said, "Women are so stupid. We go there to arrest the man, and she is screaming and hollering, 'No, don't take him to jail.'" I said, "That's not stupidity, that's fear. That's because they are going to let him out of jail." You know you can get a bond for battery, probably five hundred dollars, and somebody's mom or dad or friend is going to come pay it, and then what's going to happen to you? You might have a black eye now, but when he comes home he is going to hurt you. It's fear, raw fear.

I'm here eleven years now. When I got here, I was upstairs on death row. The first in twenty years, or some-thing like that. At the time they didn't have nothing set up for death row. So they just put me in a room up there, the one with a toilet in it, for a whole year. The next year Judy came. They had to put us together, so they moved me and put us in the two very end rooms. And then two more came.

But the first appeal got me off death row. I'd been found guilty of murder by hire, and lying in wait. But there was no proof, because I did not give nobody no money and I was not ever there when he was killed; I was at home asleep. When they did change it, they took the death sentence away. Then I had to go back to court, and the verdict came in at sixty. That's thirty minimum. When the Lord is ready for me he will let me out of here.

I am sorry for what I did. Something you can never do is put back a life you have taken. No matter what you do in your lifetime, what you have accomplished or how much you pay, you can never get it back, and I've got two lives I've got to pay for. The hardest thing for me here is know-ing that I cannot be there when my kids or mom need me. I took something from my kids that they can never get back. All I can do is pray for them. The first five years they was in a children's home. It took Mom that long to get custody of them and my daughter.

Prison is harder for women because of the kids, but it's hard for men because of what happens to them in prison. That's what bothers me the most about my cousin, because I know what he is going through, and if I could take that away from him, I would. He is in prison because of me. I know they say he is the one that blew Tommy's head off, but I was the only one that got the death penal-ty, because they testified against me and took a plea bar-gain. I'm the main one they wanted. I felt like TJ and Billy made him do it. Because he don't have all those smarts— he is kind of a little slow. And the night that it happened, he came to me and we was in my daughter's bedroom and he told me he couldn't do it and he was almost crying, and I told him if he couldn't, don't.

I know I don't deserve a future, but I truly feel that my mother and kids have been through enough. They are the ones doing the hard time, not me. They are the ones that have paid the most. Mom has never con-demned me, she has never blamed me. I can't do any-thing to give back the time that has been taken away. My son's death by heart attack was the hardest thing that I have ever suffered. My baby brother died too, in '88. I went to his funeral, but they wouldn't let me go to my own son's funeral. And I wasn't even on death row then. I lost the last ten years of my oldest son's life, and I will never see him again.

I am determined to get an education. When I first came here I could barely read, just a little bit. The reading and spelling is the hardest for me. I've been to school ever since I've been off death row. I'm taking an accounting class, and after I get through I plan to go to business class. And I plan to have my GED this year. I'm working right now on trying to get a skill so I can support myself when I get out of here. What irritates me so much in prison is that people leave here and then they come right straight back. I'm not going to have to steal something to benefit myself or anybody around me, because I am going to support myself. I'm not going to depend on nobody. I know now I don't need a man to make me who I am. If you are going to be somebody, you have to do it on your own.

I know that I have to forgive myself, but I don't know how. How can I, for what I have done? I've also got to forgive Tommy, and I don't know how to do that. I mean, I could just sit here and say I have no bad feelings towards him, but that's not true. I don't see how anybody could just let it go when someone rapes and molests your daughter. She was only four when he did it to her. My daughter knows, she remembers it. And to this day she does not have no self-respect. I didn't know about it until after he was killed. Then I found out. She told other people. I think it was done twice. I don't feel like no therapy or anything like that is going to really take it away, you have to do it yourself. Time and the Lord is the only thing that is going to heal it.

JOANNA

I know this sounds awfully strange, but I still grieve the death of my husband. This is the man that, at one time, I thought the sun rose and set on. I still haven't gotten over the fact that I killed him. And I still haven't gotten over the fact that I didn't have any other alternative, any other decision.

He had always been abusive the entire time we were married. And then it just got worse. We were married about seven years. I have five sons, but just two with him. I just couldn't stand if a child was gonna be punished, or something taken away from, and when he got abusive to the children, occasionally I would try to stop him. Those were the times when I got my most severe injuries. He had a way about him—you could tell when he was gettin' ready to do something. He'd hold his cigarette between his teeth and he'd get this real cocky air, and you'd know that he was gonna fight, he was gonna do something, he was gonna tear the house up or some-

thin', and the kids would notice that and they would start gettin' nervous. It's like they know he was fixin' to explode, and they would try to keep everything calm, until they would trip over their own feet or somethin', and when they did, that would be all it took.

At first it was different, he was just so nice to me. I'd been living with a man that was twenty years older than me, who never said, "Gee, your hair looks nice," and all of a sudden, I'm with this man, who thinks that everything you do, every little thing, is just wonderful. But that changed once we were married. He was soon hateful, but not nearly as bad as he got later on. He would do things, like make the children work too much, and too long, outside, stuff like that. I knew it wasn't right, but it was better than when he would actually beat them with a belt he had with a big marijuana leaf on it. He wouldn't care where the buckle landed, and kept hitting— and that's when I would get involved and it would end up in fractured elbows.

But when he got crazy with the cocaine, it got real bizarre, because he really enjoyed doing those things. He tried to convince me that because I was older our sex life wasn't good anymore and perhaps it would be better if I would let him handcuff me. And it was at times like that that my labia was burned with cigarettes, that he found out that this was something that he enjoyed. He enjoyed terrorizing me. It got to the point, I would say that towards the end I had been hurt in every way possible. He knocked my front teeth up into my gums; he cut the tendon in my foot, he fractured my ribs, and I had to be cauterized three times after my hysterectomy because of him. My next to youngest baby wasn't a week old when he raped me, ripped the stitches open. That was physical pain that I took, but to me, it was nothing compared to the psychological things that he would do, like slip out of the window at night and walk around the ledge of the house and come up behind me. He'd come up behind me and grab me by the hair of my head and tell me things like, "Bitch, I'm watchin' you! I watch every move you make, everything you do, everything that's goin' on!"

This was a man that put me on the scales everyday. If I was over 126 pounds, oh, boy! I didn't get anything to eat. For about two weeks there, he was so crazy that, well, he took a pair of vice-grips and started to hit me over the head. He had dug a hole and told my children that I was dying of cancer, and that I wanted to be buried there on

the land. I had no doubt whatsoever that this man was going to kill me. And worse, I didn't know what he had in store for the children. After my hysterectomy, my oldest child came to me and said, "Mother, are you sick?" He's a "special" child—at that time he was seventeen—he's dyslexic, he has never been able to read or write, he has learning disabilities—God knows, he's got a lot of nervous problems because of the relationship.

During this time, my husband sodomized him. The woman that was with him at the house, that drove the car for him, told me that he was bleeding rectally. I went into his room and I found the child in a fetal position.

And I would say from that time on, I had just lost it. Because I felt like I hadn't done my job as a mother. I hadn't protected my children.

He would always have one or two of the children with him, or if I went someplace, he would make me leave one or two of the children at home. I had no way that I could get all five of my children together with me; and I would not have left one child there, anymore than I would have left three, or than I would have left five— because I felt like they were all in such danger.

When he was trying to hit me on the head with the vice-grips, my thirteen-year-old son held a shotgun on him and said, "You son-of-a-bitch, you've hit my mother for the last time!" And he kept telling me, "Momma, get out of the way!" And I begged him, "No, Billy, don't, don't shoot him! Just let him go, just let him go!" He turned around and he looked at Billy, and he said, "You little son-of-a-bitch, you're gonna be lookin' over your shoulder for the rest of your life." And this was a man that did not believe in punishing children, with a normal spanking or anything—he would talk about pistol-whipping them. The children were terrified. I went to take him a cup of coffee, and when I handed him the coffee—I was so nervous shakin'—frantic—that some coffee spilled onto his hand. He said, "You stupid bitch! I'm killing you and your goddamned kids!" I just pulled the gun out of my pocket—and after that, I don't know, I don't remember him falling down, I don't remember anything, any of the rest of it.

The girl that was there buried him, she buried him under the house. The girl that drove the car, she was there when it happened. I went on about my business, she told me to go to the store, and she called up the store and told me that I could come home then, that Jerry was gone. And I thought, well, he's gone. You know, it was just, I had been in such a state of shock. Afterwards, she told me: "He's under the house." Well, his stepbrother came over. I told him first thing, "I killed him, I killed him, I killed him!" He didn't say a thing.

He put a cement slab over where he was buried and put a freezer on top of it. They didn't find the body for seven years. He stayed buried under the house all that time. And nobody looked for him. His father didn't look for him, his family didn't look for him. I told them that he was gone, that he'd gone on a drug run and had gone into hiding, that we'd expected this. And I just stayed at the house. That was the time when I was so crazy. That was a time of madness for me. I wouldn't leave the house. I never saw him buried down there so there was the doubt in my mind that he was even there. I couldn't believe it, I really couldn't believe it, because I didn't remember the actual killing. I couldn't turn my back still being afraid a man would climb out of the bedroom window and go along the ledge, to come up behind me. I believed that there wasn't anything he couldn't do. It was only natural for me to believe that this man would come back from the dead.

I sat, and I waited. There were only two places where I would sit, and two places where I could see every entry. It was like that all the time. I was afraid to go to town, I was afraid to go anywhere. If I did have to go, I'd rush right back. It was like I was just sittin' there waitin'—waitin' for him to show up, or for the police to show up. And one day they came. My brother-in-law got a case in Huntsville, Alabama, and he wanted the law to lessen his charges so he told them that he knew where there was a body. And so they came up and dug up the spot and brought the body up. The first thing I did was say, "I DID IT!"

The girl who drove the car got two years' probation as accessory to first-degree murder because she told them that I'd pulled the trigger. In the trial they had pictures of me bound, beaten, and everything that they suppressed. It's in my transcript—you wouldn't believe the stuff that's in there. In the courtroom, they said that was kinky sex, that we both enjoyed. They said that was the case of a person saying no, and meaning yes, yes, yes; that that was a consensual case. And everyday that I have to be away from my children, when I stand up and I can hardly walk because I have such scars on my feet from those fucking shackles he kept me in against that bed—and know that they suppressed that evidence, I am very much aware that I am in prison because of a man.

The prosecutors were outrageous. They didn't have any premeditation other than the fact that my husband was shot twice, so they used that as premeditation. That's all they had. The gun was not reloaded or anything. I was willing to plead guilty to second-degree murder. I killed my husband. I've never denied that. If I had had any other alternative I would have taken it. I had no other choice. I think about it now, I wonder if there'd been any other way, what else

could I have possibly done? I was terrified of this man, but I couldn't go to the police. They would have come, they would have taken the children—he was a drug smuggler, after all. God knows, nobody has grieved this anymore than what I have. But I would rather be in here, and know that he is dead, and that my children are out there safe. They asked my child at the time, "How do you feel about your mother killing your father?" And that little boy told them, "I feel like I can go to sleep at night." They had been there, they knew what was happening, and they knew that I had no other choice than to kill him, no other choice.

I'm forty-eight. I have a life sentence for first-degree murder and I feel safe here. After I'd been here about a week I said, "Oh my God, I'm finally free." I'm finally free, and I am not chained to that man, or that damned body anymore. And I can get up in the morning and I can look in that mirror and I can recognize me: I don't have fractured jaws, I don't have black eyes, closed. I can recognize the face I see. And I know that when they lock that door at night, I'm a little bit safer, and when that car goes around that fence, I'm safer yet. I'm not afraid in here, but I'm afraid out there. I have no desire to even try and get outside this fence because I am so frightened of the free world from what I've lived through.

This is the most freedom I have ever had in my life.

LINCOLN DOMINO

They said the day the cops brought Lincoln Domino into the Wildwood Pre-Trial Facility, he was wrapped in bandages from top to toe like a mummy, rigid and tied to a board—just like Anthony Hopkins in *Silence of the Lambs*. This was a guy who, while sitting in a courtroom waiting to be convicted of one of the many felonies that had kept him coming back to prison for twenty years, wriggled his body so that the belly chain locked around his middle slid down and over his feet until it was free and he brandished it jangling above his head, taunting the law that sat gaping all around him. It wasn't the first time he had flaunted insolence in their faces. Wildwood was having a hard time getting information on him, but they did know that he was out on parole in California and had left for Alaska to see his people. There he stole a car and cracked it up. That's how they got him, drunk and raging, and then they found out who he was. One story said he had raped a woman in Hawaii and terrorized her so that she refused to testify against him. The case was dropped. Another story had it that Arizona wanted him for a murder charge. Lots of rumors ran about Lincoln Domino, and it was for sure he was a dangerous man.

It was impossible to know where rumor stopped and

truth began, but it didn't really matter because he was just so bad. "He'd kill you in a heartbeat," the superintendant said. They had him in a segregation cell off a dayroom to the right of the stairs that went up to the women's cells. The dayroom had bars all around it with Plexiglas, so you could see in everywhere. The seg cells were all along the back wall, one next to the other. Lincoln Domino was directly under the women, and he was bellowing like a wounded animal.

He paced around the small space the way the big apes do in their cages in the zoo. His arms were pulled in front of his body by the cuffs, and the belly chain puckered the red material of the prison trousers. The shackles on his ankles dragged across the floor when he walked. He was naked from the waist up. You could see the muscles in his arms and chest pulsing under the pale skin. Only his skin proved he was not a young man; he was fifty years old. He stood perfectly erect, in spite of the chains.

I was immediately afraid of him, afraid of his violence as he raged, afraid he would see my fear and try to hurt me in some way. It was irrational: he was behind bars, shackled and cuffed, and we were surrounded by guards. But I couldn't help myself. Our eyes locked. It was only a fleeting second, but I could see him recording my presence in his mind, filing it away for future use. I thought of an animal who suddenly smells something new in the forest, another presence. I followed the CO upstairs to the women's dorm. Domino was pacing again, but his steel eyes drilled into my back as we moved away.

The next day, two guards took me to Domino's cell. One of them opened the slot in the door, number 125. He told the prisoner who I was and asked him if we could talk. When Domino said yes, they brought over a chair and put it in front of the open slot. I sat down. I could see Domino's legs in the red prison pants on the bed. Then his face filled the open slot in the door. I moved back instinctively.

It wasn't a smile, but somewhere between a grin and a sneer. He liked the idea that "the journalist" had wanted to speak to him. He asked questions jeeringly, not waiting for the answers, plowing ahead with another inquiry or a snide comment, punctuating his remarks with short, hard laughs, mocking me. I sat stiffly on the hard little seat. My neck ached with the tension. Domino's cold blue eyes flickered over me. He was the one in the segregation cell, guards all around, hands cuffed and ankles shackled, yet I was the one who was afraid. How could a man so powerless exude such raw strength?

Domino wanted me to tell the judge the prison was mistreating him; I wanted to take his picture. He told me he would sign the photo release I needed only if I came to court with him. Was this unethical? I felt uncomfortable

with the deal, but I couldn't find a reason not to agree. When I told the prison authorities about it, they shrugged; it was curious but of little consequence.

Domino was brought out of his cell. They put the cuffs and shackles on him before unlocking the door of his cell through an opening in the door especially made for that purpose. Domino would move his body sideways until his calf was in front of the opening, then the shackles were put on. It was the same for his wrists: he would stand in front of the opening, be cuffed, and then back into the cell. Finally the door was opened. We were silent when he came out—there was only the sound of his chains as they dragged across the floor. He always looked around furtively, checking out the environment as if he were seeing it for the first time. But Domino's environment was always the same—guards, bars, the dayroom.

Domino sat on the edge of a table, his bare feet up on the bench. I told him it wouldn't make any difference what I said to the judge, but if he wanted me to come to court, I would. When he signed the release for me, he sneered, mockingly: "You better be there." It was a threat. I told him I would be. "OK," he said, "Go ahead and take your pictures!" It was an order. I made a few portraits, but Domino didn't like being photographed. "OK! That's enough!" he said abruptly. I stopped.

The courtroom was small, with a stage area and benches on two sides. Domino was already seated at a table with his lawyer when I arrived with the signed paper giving me permission to take photos during the hearing. Under "special restrictions imposed," the paper read "May not move around courtroom." Domino's "people" consisted of three women—one about his age and two older ones. When their eyes met his they smiled compassionately at him. "Why on earth would anyone want to lock a man like you up?" their looks seemed to say. Domino's lawyer spoke about him to the judge. Everyone listened and waited. I wondered if Domino would say anything about his treatment. In the end he did, and cited me as a witness to how he was being handled. The judge looked at the lawyer who stood up and explained that Domino was a max max security prisoner. The judge nodded and said that was that. We went out to the street where Domino clambered into the waiting police car, dragging his chains with him. Federal agents would be there the next day to fly him back to California.

In the morning, I could hear the shouts even before I reached the detention area. Domino was yelling, "I DON'T FLY! I DON'T FLY!" The space echoed with the rumble of steel. He slammed his feet against the door of his cell again and again. Upstairs, the women were going crazy. They told me he'd been at it all night.

The guards were going to use gas to force Domino out of his cell. Smoke him out, like they do with bees. They talked about the number of gas masks available. But first they'd give him one last chance to come out on his own. Four guards took up positions outside the prisoner's door. Jake was closest, since he'd be doing the talking. Jake started to explain what was going to happen. He said that Domino could come out and there'd be no trouble, or he could refuse, and it would have to get nasty. They were going to put him in a holding cell out front until the FBI got there. Then he'd leave with them. Finally, Domino stopped raving. They moved him.

The FBI showed up at the end of the afternoon. In their dark suits and shades they looked like Hollywood creations. No one knew how Domino was going to react. I was scared for him, despite the warning. *He'll kill you in a heartbeat.* I was afraid they were going to hurt him, and in spite of everything, found myself wanting to protect him.

Domino was in the back of the holding cell when the FBI went in. There were three of them, with the COs from the prison waiting outside. The cuffs were passed from one agent to another, and the prisoner was shackled and chained in seconds. He still acted proud, but he followed orders this time. The agents brought him out to the cop car. Everybody watched as the FBI drove Lincoln Domino out of sight. All these years the women I'd been photographing said they had fallen under the spell of a man. Someone like Domino?

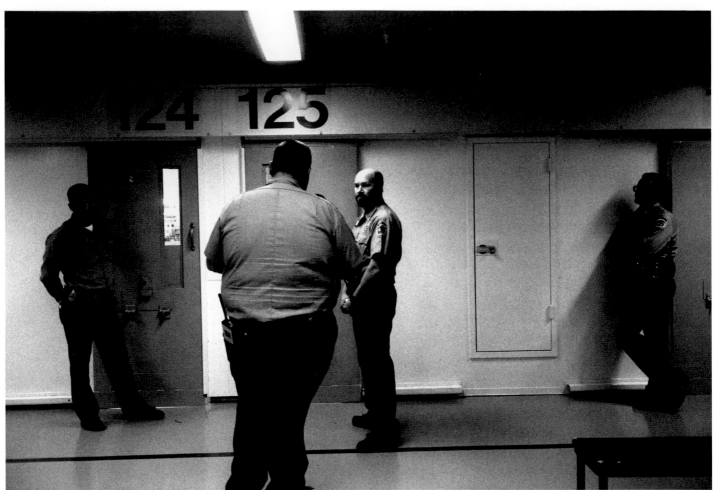

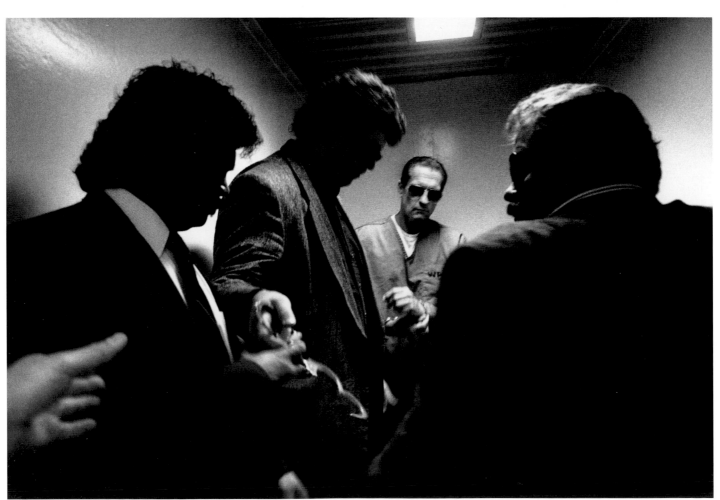

TOP CORRECTIONS OFFICERS PREPARE TO MOVE LINCOLN DOMINO, A VIOLENT MALE PRISONER, OUT OF SEGREGATION CELL #125, LOCATED UNDER THE WOMEN'S DORM. WILDWOOD PRE-TRIAL FACILITY, KENAI, ALASKA, U.S.A., 1993.

BOTTOM FEDERAL AGENTS PREPARE TO CUFF LINCOLN DOMINO TO SEND HIM BACK TO A CALIFORNIA PRISON. WILDWOOD PRE-TRIAL FACILITY, KENAI, ALASKA, U.S.A., 1993.

JANE EVELYN ATWOOD

Born in New York in 1947 and now living in Paris, Atwood is one of the world's leading photojournalists. Her approach reflects a deep involvement with her subjects over long periods of time. She has received many honors including the W. Eugene Smith Award and an Alfred Eisenstaedt Award. Her photographs have appeared in museums worldwide and in magazines such as *Life, Stern, Paris Match, The New York Times Magazine*, and *Géo*. Atwood's fourth book *Extérieur Nuit*, on the blind, was published in 1998.

FOR UMBRAGE EDITIONS

Editor Nan Richardson; Art Director Yolanda Cuomo with Kristi Norgaard; Assistant Editors Camille Robcis, Xenia Cheremetieff, Rula Rasek and Danielle Goodyear; Copy Editor Elaine Luthy; Texts edited by B.J. Atwood-Fukuda

AUTHOR'S ACKNOWLEDGEMENTS

This book could not have been completed without the help of many people. First and foremost, my deep gratitude goes to the female inmates all over the world who allowed me into their lives. Without their cooperation, this book would not exist.

My sincere thanks to the Erna and Victor Hasselblad Foundation for vital support of this long-term project; to the Ernst Haas Award (especially to Barbara Goodbody, who so generously financed the Ernst Haas Award the year I received it), the *Paris Match* Grand Prix du Photojournalisme, and the Canon Photo Essay Award for honoring one portion of this project (A Woman's Prison in the U.S.S.R.) I thank, as well, the Société Civile des Auteurs Multimédia in France for awarding this work their prize for portfolio of the year, and finally, Leica Camera for the Oskar Barnack Award.

I would like to express my profound appreciation and love for my sister, B. J. Atwood-Fukuda, who painstakingly edited the texts and tapes and gave unending encouragement and advice along the way. I am grateful to Robert Pledge, whose friendship and guidance over the years have been essential to me, and who always pushed me to do more. I am indebted to Nathaniel B. Atwood and Susan A. Parkes, without whose help and support the Alaska photos would not exist; as well as to Jana Varrati, for her advice in Alaska, and to Frank Sauser, Director of Institutions, for his help then and for his continuing support afterwards.

Grateful thanks also to many others close to me during that time: Judy Harrell, Tennessee Prison for Women, whose cooperation and kindness were never-ending; Stanislas Orloff, without whose presence as my interpreter, bodyguard, and advisor, the Russian photos would not have been possible; Clara Kundé, for transcribing tapes; Marianne Chopp, for constant encouragement; Dominique Deschavanne, for never-ending support and friendship; my lawyer, Aram J. Kevorkian, for valuable legal counsel; Yolanda Cuomo and her colleague Kristi Norgaard for inspired design, and Nan Richardson— editor, packager, advisor, and friend—who brilliantly tied it all together.

Very special thanks to John G. Atwood for his unending belief in me and my work, and to Sidney Stewart, both of whom, sadly, didn't live to see this book.

In addition, my heartfelt thanks to the following for their varied contributions toward the completion of this project: the staff of Contact Press Images (New York and Paris), especially Jeffrey Smith, Catherine Pledge, Nicole Prestat, Bernice Koch, Mahnaz Zahedi; Christian Caujolle and the staff of Agence Vu; Grazia Neri and Eléna Ceratti; Jean-Christophe Domenec and the staff of Publimod; Dany Mordac, Pierre Guillemain, and the staff of Pictorial Service; Barbara F. Atwood, Roger Atwood, Gabriel Bauret, Marianne Bine-Fischer, Charles Campbell, Georges Collon, Shirley Dean, Claudia Dowling, Stephane Duroy, Alain

Eluau, Donna Ferrato, Danielle Goodyear, Trish Hall, Ben Herren, Gueorgui Ivanov and his family, Jill Kearns, Adrian LeBlanc, Sherri Lewis, Lucie Mala, Pascal Maître, Sarah McDaniels, Carole Naggar, Paolo Nozolino, Peggie Peattie, Veronique Petit, Patty Piersol, Hardy Rauch, Marc Rykoff, Susie Steinbach, Dayanita Singh, Nony Singh, Victor Streib, Carla Timpone, Stephen Trombley, and Larry Wolhandler.

Thanks go to the editors and publications who gave me assignments that assisted me with hard-to-obtain access to a number of prisons. I am especially grateful to Kathy Ryan and Sarah Harbutt, *The New York Times Magazine*; Carolina Martinez, *El Pais*; Tiberio Cardu, *Das Magazin*; David Cohen, *A Day in the Life of Israel*; Yann Arthus Bertrand and Jean-François Leroy, *Trois Jours en France*. In addition, I must mention the magazines, newspapers, and TV producers who featured selections of this work in progress, aiding the financing of this project: Mitchel Levitas and Fred Ritchin, *The New York Times*; Didier Rapaud, *Paris Match*; Wolfgang Behnken and Harald Menk, *Stern*; Colin Jacobson, *The Independent* Magazine (whose further efforts toward death row access were greatly appreciated); Jean-Jacques Mandel, *Max* Magazine; *Marie-Claire* (Chinese Edition); Jean-Luc Marty, *Géo*, France; David Friend, *Life* Magazine; Alan Mingam, *Le Figaro Magazine*; Caroline Parent and Roland Allard, *Coup d'Oeil*; and Jean Pierre Krief, Alex Szalat, and Roger Ikhlef, *K.S.Visions*.

Finally, I thank the institutions and individuals whose intercession and generous cooperation allowed me to work inside, namely:

CZECH REPUBLIC Directrice Meclova, Vladimir Jablonsky, and the inmates and corrections officers at the Correctional Center for Women, Pardubice.

FRANCE Chantal Buigues, Ministère de la Justice, M. Argence, M. Botella, M. Brignon, M. Calandra, Mlle. Colin, M. Daguerre, M. Hurtado, Mme. Laveau, Mme. Lévy, Mme. Lotissier, M. Marchal, M. Marchati, M. Mounand, M. Moyon, Mme. Numelaine, M. Olivier, M. Paris-Zucconi, M. Philippot, M. Russenach, M. Rouveyrol, M. Sanchez, and Mme. Vas. Inmates and corrections officers at Maison d'Arrêt de Femmes, Toulon; Centre de Détention Régional de Femmes, Rennes; Maison d'Arrêt de Femmes, Metz; Maison d'Arrêt de Femmes, "Les Baumettes," Marseilles; Maison d'Arrêt de Femmes, Fleury-Mérogis; Maison d'Arrêt de Femmes, "Le Bordiot," Bourges; Maison d'Arrêt de Femmes, Dijon; Maison d'Arrêt de Femmes, Rouen; Maison d'Arrêt de Femmes, "Montluc," Lyon; Centre de Détention Régional de Femmes, Joux-la-Ville; Maison d'Arrêt de Femmes, Versailles, and Maison d'Arrêt de Femmes, Châlons-sur-Marne.

INDIA Kiran Bedi, Director of Prisons, and inmates and corrections officers at the Tihar Jail, New Delhi.

ISRAEL Geula Harael, Warden; Dalia Nir, Assistant Warden; and the inmates and corrections officers at the Névé Tirtza Prison for Women, Tel Aviv.

RUSSIA Captain Gennadiy Papulov, Raïssa Gilevitch, and Galina Tsybulskaya; and the inmates and corrections officers at the Perm Penal Colony for Women, Perm; as well as the Ryazan Corrective Labor Colony for Juvenile Delinquents, Ryazan.

SPAIN Concepción Yagüe Olmo and the inmates and corrections officers at Alcalá de Guadaira Women's Prison, Seville.

SWITZERLAND Peter Eccen and the inmates and corrections officers at Hindelbank Prison for Women, Hindelbank.

USA, ALASKA Frank Sauser, Director, and Allen J. Cooper, Deputy

Director, at the Division of Institutions; Alan Bailey, Ken Brown, Dan Carothers, Jim Symbol, Denise Templeton, Al Terreault, Lynda Zaugg, and Michael Weher; as well as the inmates and corrections officers at the Sixth Avenue Jail Annex, Anchorage; Wildwood Pre-Trial Facility, Kenai; Lemon Creek Correctional Center, Juneau; Fairbanks Correctional Center, Fairbanks; Meadow Creek Correctional Center, Eagle River; Ketchikan Correctional Center, Ketchikan; and the Yukon-Kuskokwim Correctional Center, Bethel.

ARIZONA Sheriff Joe Arpaio, Lisa Allen, and Captain Wilson, as well as the inmates and corrections officers of the Maricopa County Jail, Phoenix.

CALIFORNIA The inmates and corrections officers at the Central California Women's Facility, Chowchilla; the Northern California Women's Facility, Stockton; the California Institute for Women, Frontera; and the Valley State Prison, Chowchilla.

INDIANA Dana L. Blank, Warden, and Gary L. Scott, Assistant Superintendent, as well as the inmates and corrections officers at the Indiana Women's Prison, Indianapolis.

NEBRASKA Larry Wayne, Warden, and Mary Alley, along with the inmates and corrections officers at the Nebraska Correctional Center for Women, York.

NEW YORK Father Eugene Merlet of Pro Musici and the inmates at Riker's Island, New York.

SOUTH CAROLINA Robyn Zimmerman, Raymond Franks, Dawn Shaw, Sammie Brown, Karen Martin, Kewpie Sprott, and Mary Scott, as well as the inmates and corrections officers at the Women's Shock Incarceration Unit, Columbia, and at Cottages 8 and 9 of the Women's Correctional Facility, Columbia.

TENNESSEE Penny A. Bernhardt, Warden; Earline Guida, Warden; John G. Organ, Jr., Associate Warden; Pamela Hobbins, Public Information Office; as well as the inmates and corrections officers at the Tennessee Prison for Women, Nashville. Alton Hesson, Warden, and corrections officers at the Riverbend Maximum Security Institution, Nashville.

PHAIDON PRESS LIMITED
REGENT'S WHARF
ALL SAINTS STREET
LONDON N1 9PA

FIRST PUBLISHED 2000
PUBLISHED BY PHAIDON PRESS LIMITED
© 2000 UMBRAGE EDITIONS INC.

A CIP CATALOGUE RECORD FOR THIS BOOK IS AVAILABLE FROM THE BRITISH LIBRARY.

ISBN 0 7148 3973 6

PRINTED IN ITALY

STATEMENTS / REMARKS

This is your opportunity to make any statement you would like to have presented to the Court. It will be included in the Presentence Report just as it is written and will not be changed in any way. It may help to know that the Court is particularly interested in your statements about the following: (1) Your version of the offense—what happened? (2) Why you were involved—why you acted as you did: (3) How you feel about the offense, what you did, the results of your action for you and others: (4) What are your plans or goals? (5) Why do you feel you should not be sent to prison?

I have spent to much time in and out of jail — I am to old Now.

LEFT PRE-SENTENCE REPORT WHERE INMATE IS ASKED TO EXPLAIN IN HER OWN WORDS WHY SHE SHOULD NOT BE SENT BACK TO JAIL. MEADOW CREEK CORRECTIONAL CENTER, EAGLE RIVER, ALASKA, U.S.A. 1989
OVERLEAF DEATH ROW CHAPEL, DECORATED WITH POSTERS MADE BY THE INMATES. RIVERBEND MAXIMUM SECURITY INSTITUTION, NASHVILLE, TENNESSEE, U.S.A., 1996.
SECOND OVERLEAF A PRISONER RETURNS TO HER CELL. CALIFORNIA INSTITUTE FOR WOMEN, FRONTERA, CALIFORNIA, U.S.A., 1995

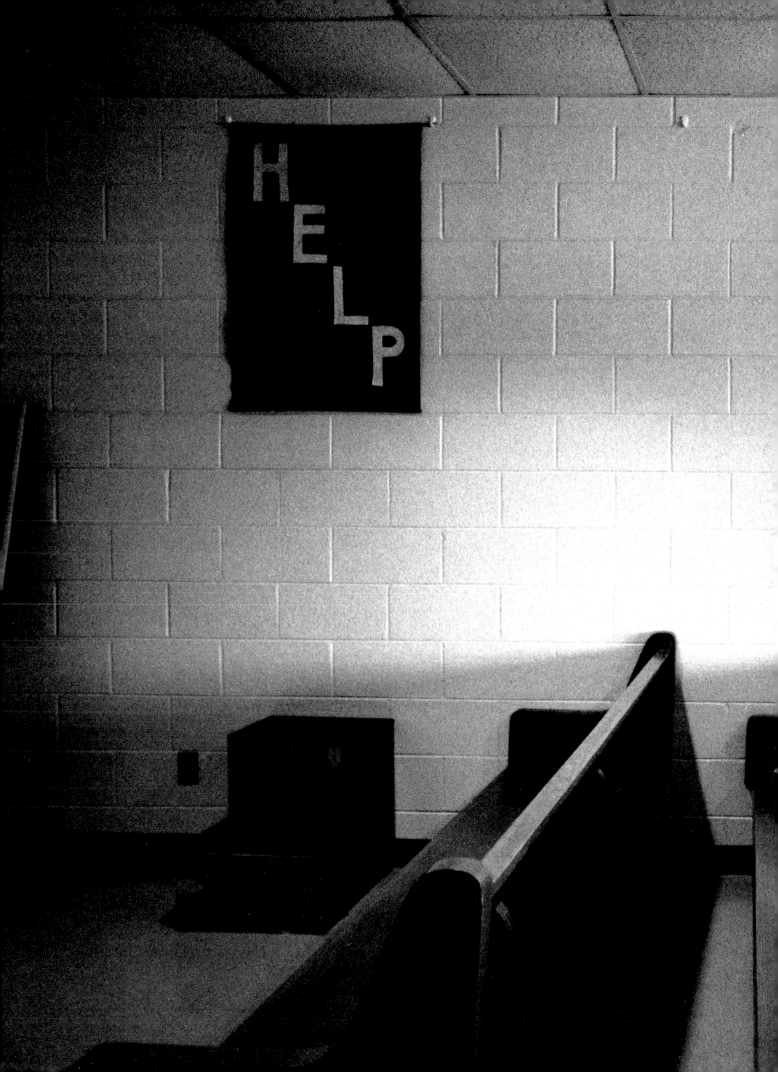

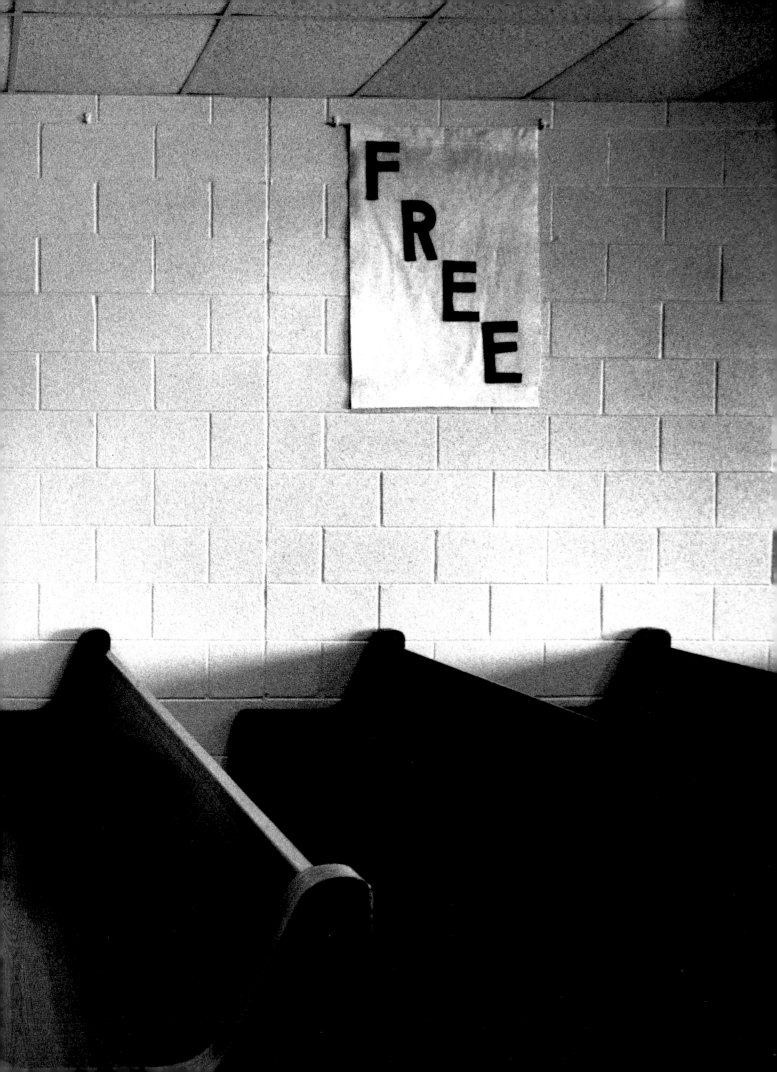

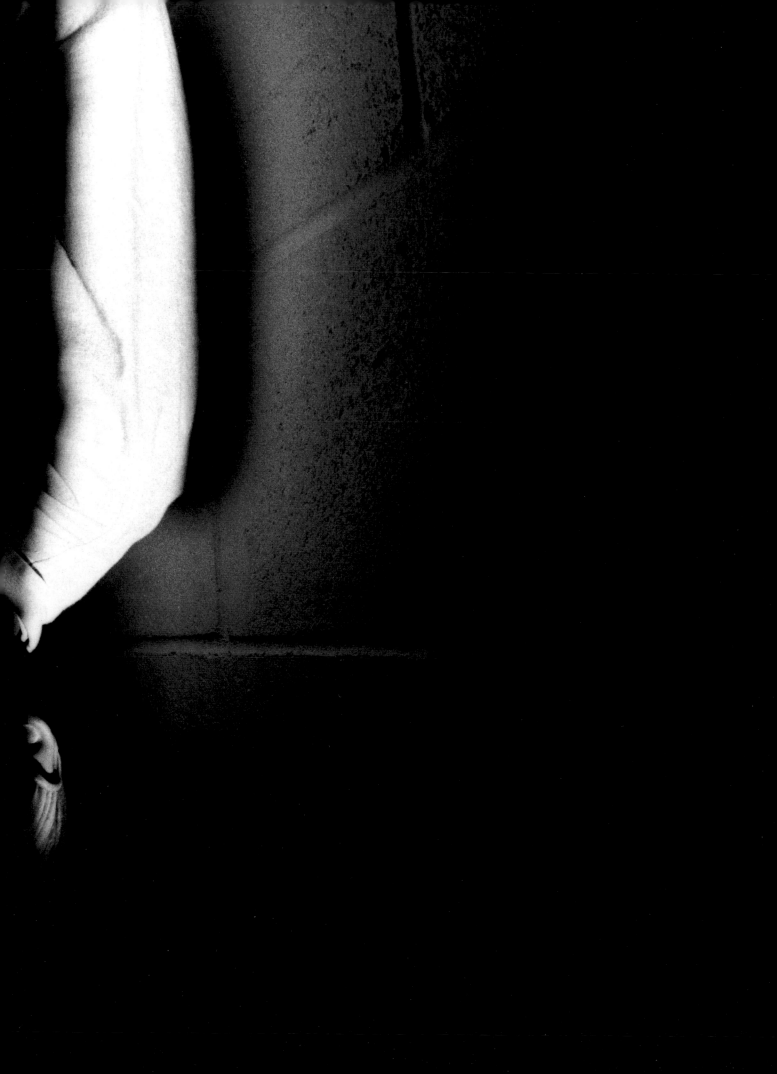

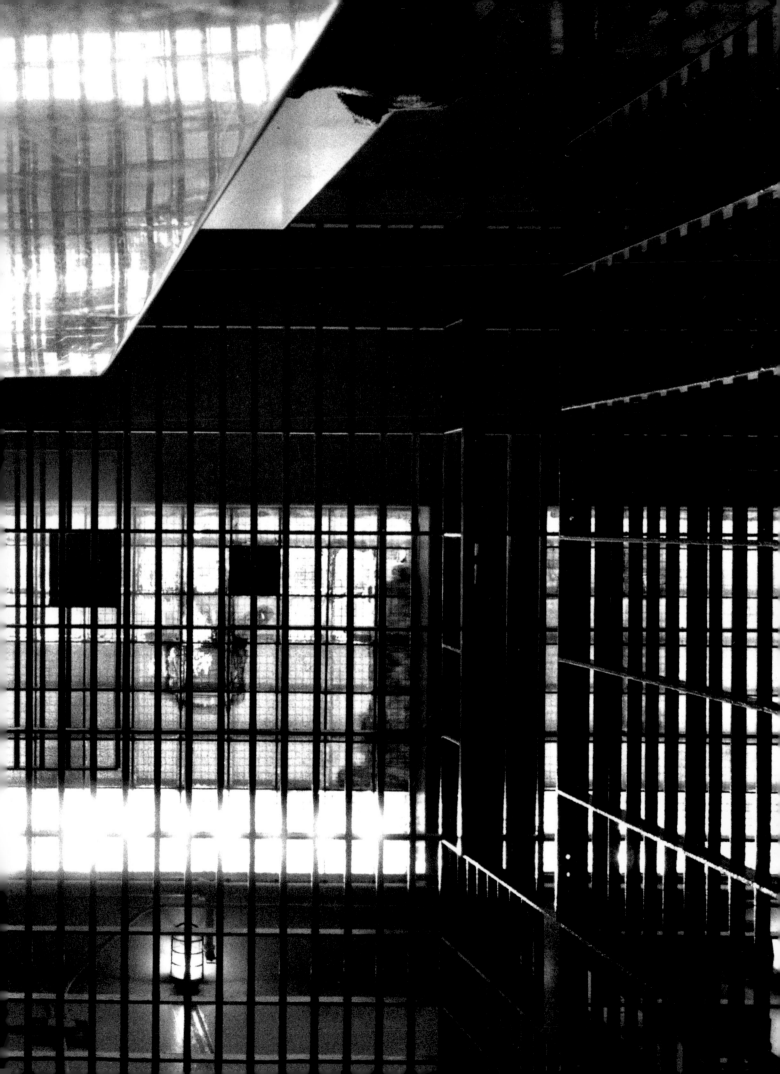

In every prison I visited, I found ignorant women conned by men into carrying a suitcase of drugs from one country to another in exchange for money. Typically these "mules" were mothers, desperately poor, struggling alone to support their children. They found themselves thrown into a foreign jail, tried and sentenced to eight to twelve years, unable to speak the language, therefore unable to defend themselves. Their lives were ruined because, in their own cultures, a woman who does time is abandoned by all. In some societies a man is considered a hero if he has done time; for a woman it is always a shameful thing.

The world of incarceration is shocking, but still less so than the fact that a country has the power to kill its own people. But the justification for the death penalty is ever more suspect when applied to women. It is well known that women do not kill at random, and that they rarely kill strangers. Almost always, when a woman kills, she does so to protect herself or her children. Of the forty-nine women awaiting execution in the United States today, more than half have been convicted of killing a spouse or a partner. But how many times did I hear this sad litany: "I was at the end of my rope; it was me or him."

I was often struck by the degree to which women prisoners acknowledged their guilt. Many who spoke with me asked that I not identify them by the crime they had committed. Others wished to bear witness to their crime, saying they thought it would help them to accept what they had done, and expressing the hope that it would help other women realize they are not alone. All of the interviews in this book were done in the United States, in part because taping was forbidden elsewhere, in part because of language barriers where it was allowed. Furthermore, it was in the United States that women were most willing to tell their stories openly. The pictures of strip searches were mostly done in Europe, where women allowed me to photograph them even in the nude.

As a courtesy, all the names in *Too Much Time* have been changed, but every woman whose photograph appears here gave permission to use it and in some cases, to tell her story. For each woman seen in these pages, there were hundreds more who declined, afraid of reprisals from people on the outside or from guards on the inside if they told the truth, if they brought attention to themselves. And there were thousands I was not even allowed to approach. All over the world prison administrators claim they are protecting inmates from exploitation; in reality, they are doing their best to keep inmates from expressing themselves about what it is

truly like inside. Some women are ashamed to talk; many more are afraid to. But the vast majority are simply silenced.

Human Rights Watch reports that in the United States there are now more male guards working in women's prisons than female guards. Why? And why do they continue to get away with serious abuse—merely to be transferred, rarely prosecuted? Why, in the United States, does the only alternative to traditional incarceration—the "shock unit"—mimic a male-oriented and inherently violent military regime? Eighty-nine percent of incarcerated women are in for nonviolent crimes. Do they really need to be there? Once in prison, their options are fewer than men's; programs and work for female inmates are limited and debilitating. Why are no practical skills being taught in prisons? Why aren't these women learning how to survive outside so they won't need to rob a gas station? In France, women are rotting in tiny, dungeonlike cells with nothing to do all day long. Surely, women so isolated cannot be expected to return to the society and fit in. Every woman told me that the worst thing for her about being locked up was the separation from the people she loved—especially her children. This deprivation is not addressed inside prisons, yet it clearly breeds antisocial behavior. What are the implications of a world made up of adults raised in foster homes because their mothers were doing time? And finally, why aren't women prisoners being counseled to be able to avoid choosing men unlikely to have their best interests at heart? For so many women, this first choice is their first wrong turn.

Look at the women in these pages. They have been courageous enough to assume their guilt, to try to change, and even to speak to us through words and photographs. These are the women we have turned our backs on.

Jane Evelyn Atwood
Paris 2000

OVERLEAF: DAYROOM, SIXTH AVENUE JAIL ANNEX, ANCHORAGE, ALASKA, U.S.A., 1993.
SECOND OVERLEAF: SEGREGATION, WOMEN'S CORRECTIONAL FACILITY, COLUMBIA, SOUTH CAROLINA, U.S.A., 1994.
THIRD OVERLEAF: CARD GAME IN THE YARD, MAISON D'ARRÊT DE FEMMES, ROUEN, FRANCE, 1990.

that pervades the backgrounds of most male inmates, but also by years, often lifetimes, of physical and sexual abuse at the hands of men. They are weakened in a way that men are not. A frightening majority of the women prisoners I met told me that they had been battered or sexually abused in childhood by male relatives. In India I spoke with women who had gone directly as children from their fathers' houses to prearranged marriages with husbands who beat them and even tried to burn them to death—because their dowries were insufficient, or because they gave birth to girls instead of the coveted boys. The 80 percent of incarcerated women who have children inevitably pass on to them their own set of handicaps. In a prison in Nebraska, when I asked how many women in the room had family members who had also done time, nearly all of the women raised their hands. Prison was something they were destined to experience, as their mothers had before them.

The strategy used in women's prisons now is one of humiliation rather than rehabilitation. Women who have been broken on the outside continue to be treated like second-class citizens when locked up. In France, toilets without seats or so much as a curtain for privacy were placed in the middle of cells occupied by up to six women. In most U.S. states, children are forcibly separated from their mothers at birth. Twenty percent of women entering prison are pregnant and give birth there, often in handcuffs. Conjugal needs are rarely taken into account—this becomes part of the punishment. Often, medical care is nonexistent. In Russia or India, you can die of a sore throat in prison, in France, of an asthma attack. In Arizona, women are chained together at the ankles and made to work on the highways. In prisons all over the world they suffer an accumulation of indignities until their spirits are broken.

AIDS, sexual abuse by guards, and homosexuality, all part of prison life, have not been specifically addressed in this book. These subjects remain taboo. The few women who spoke candidly about their lesbian relationships told me they had become involved with other women in order to assuage the loneliness of prison life.

Women tend not to be believed when they confide in someone about their abuse. I have deliberately included in this book details of what some women endured before their incarceration, because it is important to understand this in order to appreciate the depth of their terror about speaking out. Women photographed and interviewed here were simply too fearful much of the time to speak openly about abuse at the hands of guards.

death row cases. I spent more than a year dealing with officials in one state only to have my initial request dashed to the ground by the very inmates I was trying to meet. One woman said she would allow me to interview her only if I paid her two thousand dollars; others felt they had been betrayed by the press long since, and refused to see me. I could never get close enough to explain to them that my intentions were different.

Toward the end, with a body of work behind me, certain press assignments permitted access to places where I would not have been admitted on my own. But in no case, even once inside, could I predict how I would be restricted. Sometimes as many as four officials accompanied me everywhere. On rare occasions I was allowed to spend time with an inmate in her cell, locked, with no guard present. At other times the door to the cell was open and a guard watched and listened outside. In the United States I was sometimes required to meet with the inmate in an office, sitting across from her at a long table, a guard at my right, an American flag hanging limply from a pole in the corner, while the woman—often in tears—told me her story. Oddly, I had more access in Soviet Russia than in the United States of America. I learned something new in every prison I visited, and it was only by working in forty different places that I was able to piece together a picture that can be called representative of the world of incarcerated women.

Between each prison experience I found that I needed several weeks to digest all that I had seen and heard. I always requested to live at the prison. When possible, I stayed in the infirmary or in a guardhouse. Sometimes I stayed in a cell. In the United States, a statement of clearance from the FBI, attesting that I was not wanted for a felony in any state, was a prerequisite for admission. Depending on the facility, I was constantly searched: when I entered, when I left at the end of the day, in front of guards or inmates, after I'd used the toilet. In a holding cell, alone with an officer, the bottoms of my bare feet were inspected, my breasts and buttocks were patted, hands slid up and down the insides of my thighs. Every pocket, every bag, every container I carried, was opened and scrutinized. Sometimes before I entered a prison my equipment was counted, right down to the last battery or pen, and counted again before I left in the evening. No matter that I had obtained permission from the top—rules were rules.

From the very beginning, I was struck by how needy women prisoners are. They are handicapped, and in many different ways. They have been beaten down not only by the ignorance, poverty, and shattered family life

PREFACE

I have spent the last nine years photographing inside women's prisons. People often ask how I could pursue such a "sad" subject for so long. Curiosity was the initial spur. Surprise, shock, and bewilderment gradually took over. Rage propelled me along to the end.

In the early 1980s I first requested access to prisons in France, but was refused. It was not until 1989 that a chance assignment finally got me inside. At that time, like most people, I had never even thought much about women in prison. When the Ministère de la Justice in France refused me access to men's prisons because I was a woman, I subsequently found myself in a women's jail in Toulon. That first, very real, very harsh experience of prison life opened my eyes. I identified with the inmates I met; on many levels they were just like me. But what had happened to them was dramatically different.

Of the eighteen women in that first jail, all but one seemed to be incarcerated because of a man. They were doing time for things he had done, or for doing things they would never have done on their own. One woman told me her husband had forced her to set the alarm clock to have sex with him three times a night. She endured it for years and had finally killed the man who held her hostage. Another woman's husband was shot by their daughter after he had stabbed the girl in the arm as a "souvenir," poured hot coffee on his wife's head because she hadn't mixed in sugar, and urinated all over the living room floor when one of the children had refused to come out of the bathroom. The mother was serving time for "failing to come to the husband's aid."

I listened to their stories and left with one thought: *I have to tell people about this.*

I began reading. I learned that in the United States the female prison population has grown 10.2 percent annually since 1985 (compared with 6.1 percent for the male); that almost 80 percent of incarcerated women have children; that sentences for women are generally longer than those for men—for the same crimes; and that 89 percent of women are in for non-violent crimes. I learned that antidrug policies and changes in sentencing are two major reasons for the enormous growth in female incarceration and, in fact, it is a popular misconception that this increase stems from a "feminist" climate in which women feel freer, and are more likely to get into trouble than they were before. The truth is that more women are being arrested for drug offenses, convicted, and sent to prison in greater numbers. If anything, this reflects a backlash, not a surge in criminal behavior.

I decided to concentrate on women doing time for common-law crimes (thus no terrorists, no political prisoners). I wanted to know who they were, where they came from, and what it was like for them inside. For the next nine years, I photographed women in forty different prisons, jails, detention centers, and penitentiaries in nine countries. In France I worked in twelve facilities over a two-year period. The women I met in those places were guilty of ignorance more than anything else. I wondered if this was universal. A trip to Russia, where I was granted permission to photograph in two prisons, was pivotal in my decision to extend my project to prisons in Western and Eastern Europe as well as the United States. Limiting myself only to those places that gave me true access narrowed my scope considerably. For a photographer there is no magic formula for gaining access to a prison. Protocol is designed to de-emotionalize the incarceration experience and to keep critical people out. I learned to express myself in corrections jargon, writing hundreds of letters, many of which were never answered. I spent long months at home awaiting replies which, if they did come, had to be answered immediately so that the initial thread of communication, always so precarious when dealing with bureaucracies, remained intact. I sought information from organizations concerned with the world of incarceration: Amnesty International, the American Civil Liberties Union, the American Correctional Association, the National Coalition to Abolish the Death Penalty, and the Observatoire des Prisons in France. I followed stories in the international press and television that provided valuable information about American incarceration. I asked, listened, read, and followed every lead that might possibly get me access. Sometimes—as with Russia—against all odds, an official request was granted.

Capital punishment is American. It is, paradoxically, in the land of personal freedom, the most difficult aspect of incarceration to document. Getting past the administration to the prisoners themselves was nearly impossible in

ENDPAPERS THE VIEW FROM WITHIN. CENTRE DE DÉTENTION RÉGIONAL DES FEMMES, JOUX-LA-VILLE, FRANCE, 1991.

HALF TITLE PAGE SOLITARY CONFINEMENT CELL. CENTRE PÉNITENTIAIRE DE FEMMES, METZ, FRANCE, 1990.

TITLE PAGE A GUARD RESPONDS TO A CALL FROM A CELL. MAISON D'ARRÊT DE FEMMES, ROUEN, FRANCE, 1990.

PRECEDING PAGES LACERATED AND BURNED ARMS, NOT TRUE SUICIDE ATTEMPTS BUT SELF-MUTILATION COMMON AMONG FEMALE PRISONERS. CORRECTIONAL CENTER FOR WOMEN, PARDUBICE, CZECH REPUBLIC, 1992.

OPPOSITE ALTHOUGH THE STORY WAS A SCANDAL IN FRANCE, WHEN CORINNE'S HUSBAND SUED, THE LAWSUIT WAS THROWN OUT FOR "LACK OF EVIDENCE." CITY MORGUE, NANCY, FRANCE, 1991.

SLIMANE HELLIS BREAKS DOWN IN TEARS OVER THE BODY OF HIS DEAD WIFE, CORINNE.
CORINNE WAS A PRISONER IN A JAIL WHERE THE WARDEN RULED THAT INMATES COULDN'T CARRY
AEROSOL INHALERS FOR CONTROLLING ASTHMA BECAUSE THEY GOT HIGH WITH THEM.
CORINNE BEGGED THE AUTHORITIES, AND EVERY DAY WROTE TO HER HUSBAND, SAYING THAT SHE WAS
SUFFOCATING.
BUT THE WARDEN MAINTAINED SHE WAS EXAGGERATING HER CONDITION. EARLY ONE MORNING
CORINNE HAD AN ATTACK. ALL THE WOMEN PRISONERS SOUNDED THE ALARM BY BANGING
ON THE DOORS OF THEIR CELLS. FINALLY A GUARD ARRIVED, LOOKED THROUGH THE EYE HOLE, AND WALKED AWAY.
SHE RETURNED ALMOST AN HOUR LATER, BUT IT WAS TOO LATE; CORINNE WAS IN A COMA.
SHE DIED AT THE HOSPITAL TWO HOURS LATER.

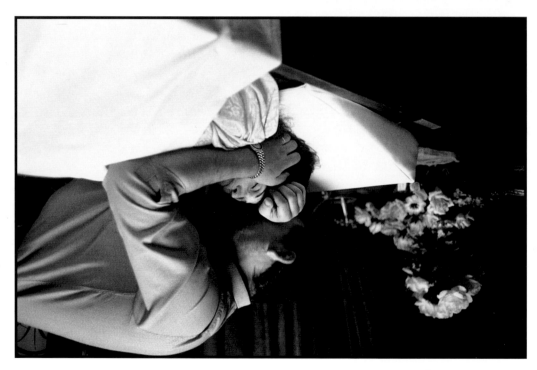

In memory of Corinne Hellis,
twenty-seven years old, who died of
medical neglect in a French jail
after suffering an asthma attack.
Her crime: writing bad checks.

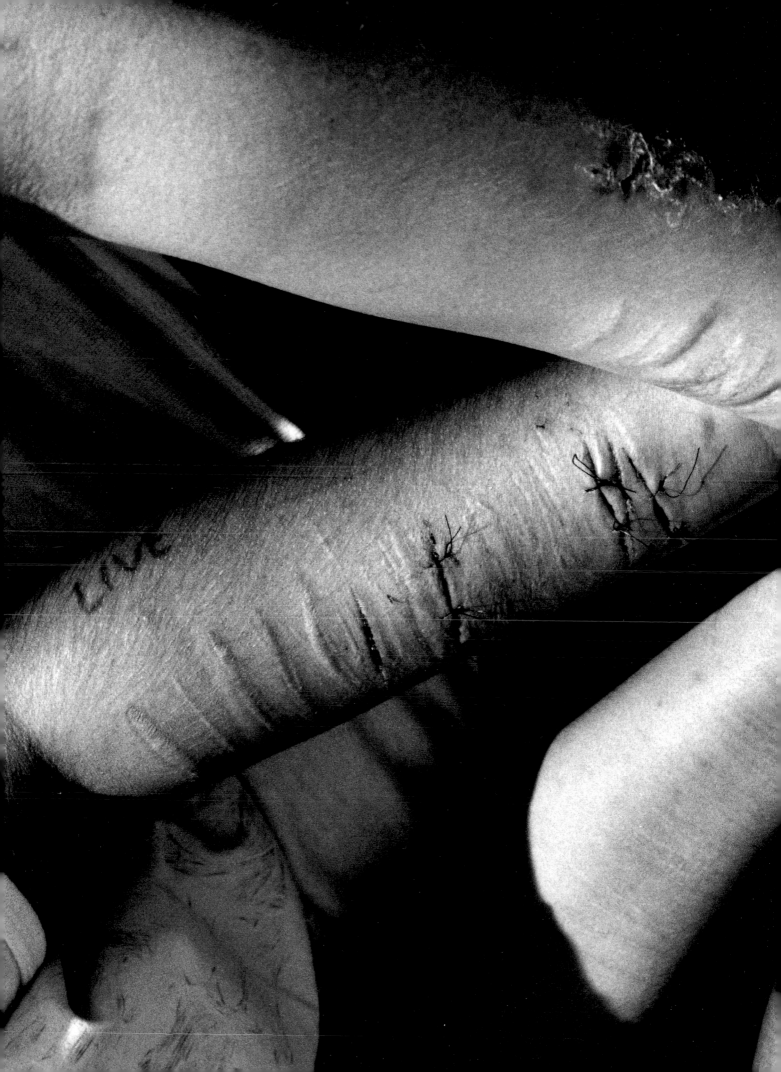

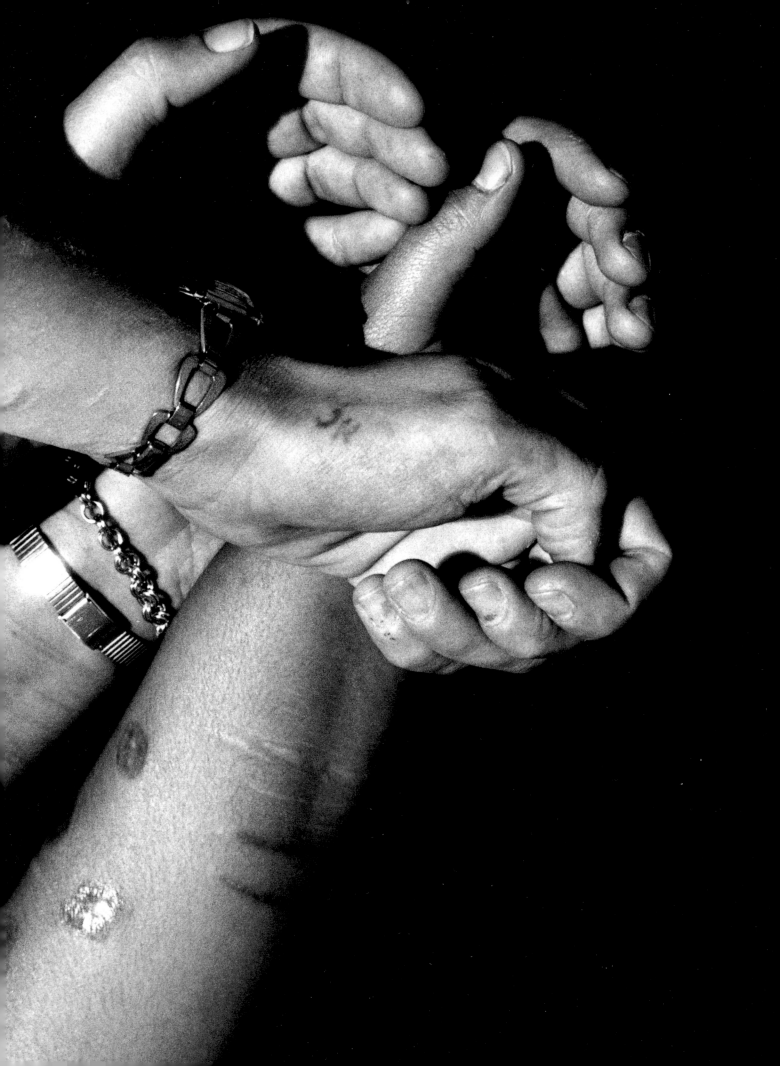

TOO MUCH TI